ERIC GILL

Fiona MacCarthy is a well-known writer and critic. Formerly Design Correspondent with the *Guardian*, she now reviews regularly for *The Times*.

She is an authority on British twentieth-century visual arts and her books include *A History of British Design* and *British Design since 1880*. She directed the 'Omega Workshops' exhibition at the Crafts Council in 1984, and 'Eye for Industry' at the Victoria and Albert Museum in 1986.

She is particularly interested in the idealistic counter-culture movements. *The Simple Life*, her recent book on C. R. Ashbee and the Guild of Handicraft in Chipping Campden, received much critical acclaim. She is at present working on a new biography of William Morris.

Fiona MacCarthy is married to David Mellor, the designer. She was awarded the Royal Society of Arts Bicentenary Medal for 1987.

ERIC GILL

Fiona MacCarthy

ff

faber and faber

LONDON · BOSTON

First published in 1989
by Faber and Faber Limited
3 Queen Square London WCIN 3AU
Reprinted in 1989 (three times)
This paperback edition first published in 1990

Phototypeset by Input Typesetting Ltd, London

Printed in Great Britain by
Richard Clay Ltd
Bungay, Suffolk

British Library Cataloguing in Publication Data
MacCarthy, Fiona
Eric Gill
1. English engravings. Gill, Eric—
Biographies
I. Title
769.92′4

ISBN 0-571-14302-4

CONTENTS

INTRODUCTION

Eric Gill was a great artist-craftsman. Others (though not many) matched him as a sculptor, wood engraver, letter cutter or typographer. But no one has approached his mastery over such a range of activity. In 1913 he was converted to Roman catholicism and became a focal figure in a succession of Catholic art-and-craft communities: at Ditchling in Sussex, at Capel-y-ffin in the Welsh mountains and finally at Pigotts near High Wycombe. In all these places Gill himself, in the familiar stonemason's smock (belted, worn with woollen stockings, never trousers), presided genially over a large household – wife, daughters and a whole extended family of craftsmen, priests and passers-through. His aura of holy domesticity invited comparisons with the household of St Thomas More in Chelsea. One susceptible visitor, sitting down to eat with the family at Ditchling after listening to the daily reading of the *Martyrology*, reported seeing the actual nimbus round Gill's head.

Gill's chief battle cry was integration. He objected fervently to what he saw as the damaging divisions in society, the rupture between work and leisure, craftsmanship and industry, art and religion, flesh and spirit. He believed that integration must begin with domesticity: the 'cell of good living in the chaos of our world' which he so obsessively set about creating. Gill wrote just before he died:

what I hope above all things is that I have done something towards reintegrating bed and board, the small farm and the workshop, the home and the school, earth and heaven.

Although he stood so ostentatiously apart, stranger in the strange land prophesying devastation, Eric Gill was in spite of himself a well-known public person. He was taken very seriously in his day. At his death, the obituaries suggested he was one of the most important figures of his

period, not just as an artist and craftsman but as a social reformer, a man who had pushed out the boundaries of possibility of how we live and work; a man who set examples. But how convincing was he? One of his great slogans (for Gill was a prize sloganist) was 'It All Goes Together'. As I traced his long and extraordinary journeys around Britain in search of integration, the twentieth-century artistic pilgrim's progress, I started to discover aspects of Gill's life which do not go together in the least, a number of very basic contradictions between precept and practice, ambition and reality, which few people have questioned. There is an official and an unofficial Gill and the official, although much the least interesting, has been the version most generally accepted. The anomalies have, for one reason or another, been ignored or glossed over by his past biographers with a protectiveness we would now consider as superfluous, if not verging on insulting. Gill is too original and too self-reliant as a human being, as well as too important as an artist, to deserve the kind of half-truth treatment to which he has been subjected through the years. The urge to conserve the conventional viewpoint reveals more, I believe, about the commentators than the subject. Most of these commentators have been Catholics. They have chosen to present Gill as a Catholic artist and Catholic thinker whose way of work and worship held together with a kind of sweet reasonableness, ignoring and evading the cumulative evidence suggesting great complexities beneath the surface.

Gill's appetite for sex was unusually avid. The diaries he kept with immense care and regularity from his late teens onwards, typically workmanlike records of events, reveal his sexual behaviour was start-lingly at variance with his image as father of the devout Catholic family or, at any rate (since Catholic fathers are allowed a little rope), puzzlingly at odds with his public role as sage, pronouncer on morality, upholder of decorum. There is nothing so very unusual in Gill's succession of adulteries, some casual, some long-lasting, several pursued within the protective walls of his own household. Nor is there anything so absolutely shocking about his long record of incestuous relationships with sisters and with daughters: we are becoming conscious that incest was (and is) a great deal more common than was generally imagined. Even his preoccupations and his practical experiments with bestiality, though they may strike one as bizarre, are not in themselves especially horrifying or amazing. Stranger things have been recorded. It is the context which makes them so alarming, which gives one such a *frisson*. This degree of sexual anarchy within the ostentatiously well-regulated household astonishes.

This is the crux of the question as I see it: Gill took the rules on board, even to some extent invented them, and then allowed himself to break them without very much apparent compunction or self-questioning. Yet he was not, I think, a humbug. So there remains the mystery of how the avowed man of religion, Tertiary of the Third Order of St Dominic, habitual wearer of the girdle of chastity, could be by conventional standards so unchaste. It is not a question Gill's adherents liked to ask. The material in the diaries would have been available to Gill's earlier biographer Robert Speaight, a Catholic and family acquaintance, whose *Life of Eric Gill* came out in 1966, and Donald Attwater, Gill's close friend and disciple, whose memoir *A Cell of Good Living* was published three years later. Neither of them chose to make much use of it, or of the mutual sex confessions *He and She* which Gill and his wife, in the wake of Havelock Ellis, exchanged in 1913, the year of their conversion. Both Speaight and Attwater prefer what one might call the 'wild oats' view of Gill, referring briefly to his youthful fling in his socialist period with Lillian Meacham, the Fabian New Woman. This affair, culminating in reckless flight to Chartres, is described by Gill himself, rather vaguely, in his memoirs. The episode is used by his biographers as Gill's one licensed aberration, with the implication that it had taught him the error of his ways.

But Lillian did not fade out of the picture, as Speaight so complacently assured his readers: it would not have been beyond the competence of a professional biographer of Robert Speaight's experience to establish the fact that Lillian, who eventually married George Gunn, Professor of Egyptology at Oxford, and whose son Spike Hughes delineated her fondly in his own autobiography, remained a family friend until Gill's death. Nor is it quite accurate to claim, as Donald Attwater does blithely, that after the Chartres escapade Mary and Eric 'had lived happily ever after'. That they were happy in a sense is beyond doubt. But their marriage had its storms and complications, and to suggest otherwise is surely to belittle the nature of a man 'fearfully and wonderfully made' – the 'adventurer in life' as Roger Fry described him – and an artist whose work is on the edge of a new phase of popularity. Gill speaks in our own language, with vigour and directness. In few other artists of this century are images of the erotic and domestic, the sexual and devotional, so closely and so disconcertingly related.

My own interest in Gill began in 1966, the year Speaight's book was published. I was then design correspondent on the *Guardian*. Father Brocard Sewell, who knew Ditchling well from the days when he had

worked at St Dominic's Press, suggested the Guild workshops still existing on the common might be worth investigating. On that visit I met several of the craftsmen who had known Gill well, including Joseph Cribb, his original apprentice. It struck me how vividly the place still bore the imprint of Gill's own personality It was, after all, forty years since he left Ditchling and well over twenty years since he had died. But he was still a central, and indeed a controversial topic of conversation, bearing out the comment of Gill's friend, Beatrice Warde, most articulate and sophisticated of his mistresses, who maintained that those who had known Eric Gill went on talking about him ever afterwards.

Certainly all those who met him have a sharply defined view of him. I have made the most of this in attempting what has sometimes seemed a foolhardy ambition: to make sense of Eric Gill, to penetrate the smoke-screen Gill himself and others so determinedly erected. (A number of deletions were made even in the diaries, presumably by Mary Gill after Gill's death.) My main evidence has been from the people who remembered him, a piecing together of impressions of the man and his attitudes from more than fifty interviews with those who knew and worked with him at all the stages of his life from Ditchling onwards: his children and his grandchildren, apprentices and pupils, clients, monastic colleagues, models, professional rivals. I have talked at length to people both inside Gill's circle and on the outer edge of it, who saw him at a distance. These memories, checked against Gill's own official account in the *Autobiography* and rechecked against the confidential entries in his diaries, make up my picture of Gill as I think he truly was.

At least I can be confident that Gill was not what he said he was. The *Autobiography* is full of obfuscation. Nor was he quite the person seen by those who came to visit him, or even those who lived in the same house with him. It has been surprising, in talking to people ostensibly close to him, who shared the routine of the households and workshops, how few of Gill's contradictions they suspected and how unaware they were of the resulting tensions. They thought – and liked to think, indeed depended upon thinking – that Gill, provider of the answers, giver-out of rules for life's conduct, was beyond questioning. I believe this was a role he created from inner necessity and, as time went on, grew more and more dependent on. His role, it seems to me, became a rather obdurate position which had within itself the power to destroy.

I have come to see Gill as a rather tragic figure, in spite of the vast energy and the extraordinary lasting qualities of so much of his design and workmanship, in spite of his own marvellous ebullience and charm.

My conviction, amplified by newly acquired material in the Dominican Archive at Carisbrooke, including documentation on the Guild at Ditchling and a revealing series of letters from Hilary Pepler, Gill's closest working partner, is that a chain of destructiveness began at Ditchling, not long after Gill's conversion to catholicism. Perhaps a part of his tragedy is that he was both ahead of his times and behind them. His urge to experiment with social conventions, especially the prevailing sexual mores, became more obviously and more painfully at variance with the Gills' accepted role as the ideal Catholic family, the public demonstration of fidelity and cohesiveness. It can now be seen that Gill's own leanings, in particular his sexually possessive attitude to his own daughters, led directly to his fatal quarrel with Pepler, destroying not only the coherence of Ditchling, so painstakingly built up over the years, but also removing the one person who was on an equal footing, who loved him yet was frank with him. From then on, Gill was dangerously on his own.

Eric Gill adored a theory. This almost became a mania. One of his great friends, Monsignor John O'Connor, maintained that Gill was fundamentally unable to let a proposition pass unquestioned: 'He would sit on the bed all night to get to the bottom of some theorem that was new to him.' He displayed unusual talent for promoting the argument which suited his own purposes, to pursue the theory which gave him licence to do what he wanted to do anyway; and his authority became more pronounced as he grew older and more eminent. In earlier years Eric Gill had alighted on and promulgated in his own version Ananda Coomaraswamy's Hindu doctrines of the erotic elements in art. Later on, at Ditchling, with the same conviction, he began propounding a complicated theory, or succession of theories, in which sexual activity is aligned to godliness, in which the sexual organs, far from their conventional depiction as the source of scandal, are 'redeemed' by Christ and 'made dear'. It is a very radical and interesting theory, where Gill challenges Christendom's traditional confrontation of matter and spirit, and indeed his theory is justified in part, at least for connoisseurs of art, by the wonderful erotic engravings of that period. But one senses something frantic in the zeal with which Gill exfoliated his passion, in contexts likely and unlikely, and in his evident enjoyment of the waves of consternation which followed, particularly from the monasteries.

Gill became a little silly as time went on. He knew it. He subscribed to Gilldom: Gill the great man; the eccentric. The scene at Pigotts, Gill the patriarchal figure surrounded by what at times seems dozens of his

children and his grandchildren, is also a scene of pathos, fertility run wild, the all-too-logical conclusion of his 'let 'em all come' theories. His openness had turned to a kind of a defensiveness. One senses want of order, an unnerving loss of clarity in the household where plainness had been law. At its most dramatic there was the painful drama, a family unravelling of the latter years of Pigotts, when Gordian, the son the Gills adopted as a baby, discovered, in his twenties, he was not Gill's son at all.

Gill put up a good show. But it is now becoming obvious he saw all the ironies, and had regrets about them. He had a veneer of certainty, even of complacency. But the diaries reveal not only more upheavals in his sexual relationships, which verged on the chaotic in the Pigotts of the thirties, but more sense of his anxiety than anyone who knew him was apparently aware of. The build-up of self-doubt surely precipitated the nervous breakdown which began in 1930 with a terrible amnesia. Petra found her father wandering across the central quadrangle at Pigotts and he could not remember who he was at all.

But deceit surely was not at all what Gill had wanted. One of his great crusades was, after all, against the furtive. (In one of his most characteristic utterances he attacks the 'spiritual fathers' for comparing life on earth with being in the WC: quite pleasant, not necessarily sinful but fundamentally a dirty function.) It was in his nature to want people to know, and it seems to me likely he intended the diaries as a kind of public, or a semi-public, record: if he had not meant them for scrutiny of others why would he so co-operatively have provided a key to his signs for sexual intercourse? The mischievously explicit little sketches, inserted in the diary as the mood takes him, have somehow escaped the black pen of the censor.

Nor do I feel he was entirely happy at the outcome of his *Autobiography*. There are signs, from Gill's correspondence with Jonathan Cape, his publishers, that his memoirs, so delightful but so guarded, were in early days intended to be much more revealing: 'I very much doubt', wrote Gill in 1933, 'whether you would dare to publish what I should dare to write for I do not see how my kind of life, which is not that of a big game hunter, could be written without intimate details.' By 1940, the year the book was published (in the month after Gill died), the intimate details had been regretfully minimized. Gill was, he said, afraid he might scandalize his friends. But there are still some very telling passages, more obvious in retrospect to anyone familiar with his entries in the diaries. It is as if the truths, painful issues, acute tensions are very

near the surface, almost struggling to get out.

He claims he had not wanted to seem other than he is because he hated lack of truth and also despised *nonsense*. For Gill, the public man of sense, this was a great dilemma. But, he adds, in a passage which shows Gill's very human, in some ways rather childlike acknowledgement of paradox and muddle, there is anyway one comfort:

It is thus: we human beings are all in the same difficulty. We are all torn asunder, *all of us*, by this disintegration of our flesh and spirit. And so if in this book I am appearing more spiritual than credible to some of those I have loved, let them examine their own consciences. I think they will discover, as I have done, that they also are torn asunder and that they also have desired to be made whole.

In his human feeling Gill was constantly engaging. No one who knew him well failed to like him, to respond to him. And his personality is still enormously arresting. In his agility, his social and sexual mobility, his professional expertise and purposefulness, the totally unpompous seriousness with which he looks anew at what he sees as the real issues, he seems extremely modern, almost of our own age. He raises so many of our own unanswered questions: of art and production; mind and matter; independence and obligation; sex and domesticity; the problem of clearing the space for contemplation in the daily onrush of ordinary life. He attacks and pursues such questions with a freshness which can still excite one: even some (though not all) of his jokes seem very current. But perhaps it was part of his tragedy that Gill in fact was trapped between the generations, the two worlds: his radical view of the sexual relationship and his innate curiosity about the sexuality of women were hampered, modified, by a Victorian inheritance which weighed so heavily upon him that he was unable to make the imaginative leap of, say, D. H. Lawrence. His Victorian past embroiled him. His cult of masculinity, his whole sanctimonious self-regarding *paterfamilias* outlook is terribly Victorian: he could not escape his missionary antecedents. He was, of course, a missionary. A missionary *manqué*.

SOUTH COAST

BRIGHTON
1882–97

Eric Gill was born in Brighton at 6.30 in the morning on 22 February 1882 and named after the hero of Dean Farrar's moral school story *Eric, or Little by Little*. With his characteristic extremity of statement he was, in later years, to turn against his birthplace and describe Brighton as 'a shapeless mess' and 'not a place at all'. But his upbringing, as second child of the large family of the Reverend Arthur Tidman Gill and his wife Rose, was even by his own account unusually happy. It was moralistic, strict, emotional, cosy and contained.

The sense of place was always very strong in Eric Gill. In a way, this sense of place became his motivating force in adult life as he moved with his considerable entourage from one part of the country to another – from Ditchling in Sussex to Capel-y-ffin in the Black Mountains of South Wales and then finally to Pigotts in High Wycombe – endlessly in search of an ideal environment, the perfect place to live and work, which always just evaded him. Although Brighton in some ways fell so short of this ideal, seeming to Gill in later years a prime example of just the sort of urban sprawl he deprecated, his memories of childhood there were vivid and affectionate. His *Autobiography* is full of fond and careful descriptions of the scenes remembered in the little streets of Brighton in the 1880s as the family moved from Hamilton Road to Prestonville Road to Cliftonville Road and finally to the road now known as Highcroft Villas. All these houses were within a stone's throw of each other and well within walking distance of the chapel in North Street where his father was the curate.

Architecturally the district is now nothing like as cohesive as it was. Gill's birthplace, 32 Hamilton Road, a small Victorian house – two floors with semi-basement – has had modern additions which destroy completely its original character of amiable primness. But in 1960, when

Rayner Heppenstall was gathering material for the chapters about Gill in his book *Four Absentees*, that area of Brighton was still much as Gill had known it as a child: 'a treasure-house of Betjemanesque architectural delights'. Even these days its Victorianism strikes one powerfully in the pattern of tightly built streets and public spaces: Dyke Road Park with its tennis courts and bowling green; St Ann's Well Gardens, where there is a scented garden for the blind. This is the railway district of Brighton. Narrow streets of mainly terrace houses rise steeply up above the main line station. Looking back and down over that complicated network of railway lines and tunnels it is easy to see how the scene must have impressed the child of the 1880s. Perhaps Gill's later tendency to seek out mountain dwellings – Capel, Pigotts Hill, the Pyrenees – went back to this scaling of the heights in childhood. The vista from the hilltops over Brighton made him king of the castle, monarch of the glen.

'The very first thing I can remember', wrote Eric Gill much later, 'happened in a house in a street in Brighton called Prestonville Road.' (This was their second house in Brighton, and Eric at the time must have been less than two years old.) The railway went under the street in a tunnel just before entering Brighton Station; the church of St Luke with blue bricks in patterns set in red brick walls was nearby:

At the back of our house there was a wooden staircase leading down from the back sitting-room into the garden. The other houses in the same row also had such stairways. All the gardens ran down to the ends of the gardens belonging to the houses of the Dyke Road, which was parallel with Prestonville Road. It must have been early summertime because everything was bright green and there was a misty shimmer of warmth in the air – not the shimmer of great heat but that of warm sunshine after rain, with a sense of everything growing and blooming. My father was standing by me at the top of the stairs. I think he had probably brought me there. He had a great eye for the loveliness of the earth and of trees and flowers and sky. Wooden staircases, red brick walls enclosing little flourishing suburban gardens in the Brighton of 1883, or thereabouts. A shimmering summer afternoon. A little boy and his father. Big trees somewhere in the background. Low bushes and small trees here and there, and we stand looking at it all and my father points to a friend of his – a neighbour working in his garden, just like Mr McGregor in the distance. I think it is all very beautiful. I have thought so ever since. I can see it now and think so still.

A very English scene described with the most English of perceptions: a love of the low-key; a feeling for the intimate and ordinary patterns of suburban life, the neat florid enclosed gardens, the gently sentimental father-and-son figures. It is the very graphic recollection of an artist in

whom the sense of domesticity was powerful. Eric's childhood sketches emphasize this genteel setting: suburban little houses, children, hoops, balloons.

The father points things out to his small child, as Eric Gill would point things out himself to his own children. Eric Gill was born into a missionary family, a household in which admonition and instruction were almost second nature, and in which suburban primnesses were counterbalanced by the more exotic family experience of missionary work in the South Seas. Eric Gill's grandfather, George Gill, a Congregationalist minister, had been a missionary and so had his great-uncle. In 1845 George Gill had gone out with the London Missionary Society to the Island of Mangaia in the Cook Islands, and Eric Gill's father, Arthur Tidman, was born in the South Seas in 1848. The baby was sent home with his mother two years later, in the mission boat, sailing round Cape Horn; and they were followed later by George Gill and his two older brothers who made the journey home, again round the Horn, in the sailing ship *John Williams*. On this voyage Gill's grandfather was captain of the ship.

The missionary instinct was still dominant enough in the third generation for two of Eric's brothers, Romney and Cecil, to be Anglican missionaries in Papua New Guinea. Gill's sister Madeline, who became a Church of England nun, spent much of her life in mission work in Poona. No doubt some at least of Eric Gill's own zeal to change the world, and what D. H. Lawrence was to describe as his propensity to 'argefy', went back to his relations' long experience in the missions. So also, in later life, did Gill's own remarkable appearance: 'When I first saw Eric Gill I thought he was a Dutch missionary,' René Hague, Gill's future son-in-law, remembered.

As time went on Gill grew shy about acknowledging his missionary antecedents. 'I look back then to my childhood', he tells us in his memoirs, 'as one looking back to a different world.' This was partly because his conversion to catholicism blotted out much of his early spiritual history. (A common enough cycle: there are dozens of examples in the annals of twentieth-century English literary-artistic Catholics alone.) It was also a particular facet of Gill's temperament – his urge towards the contemplative – to distrust and be embarrassed by evangelical soul-searching. He came to see the Congregationalist way of worship as unbearably individualistic. Besides, he was too self-centred and conceited to welcome the idea of inherited experience: all his life he wanted to be first. For all these reasons, the missionary background is

5

skated over in Gill's *Autobiography* which is our main source for Gill's view of his own childhood. But it is treated very much more fully in the long and unpublished memoirs of Gill's brother Cecil, and has remained a subject of great interest to the descendants of the family. One of Gill's great-nieces, in the 1980s, set out on a voyage of rediscovery to the South Seas, to the haunts of the Gill missionaries in Mangaia and Rarotonga.

Cecil Gill's memoirs are entitled *Awara; being the Professions and Confessions of a Thirteenth Child*. (Cecil was the youngest of the family.) *Awara*, a familiar term of native New Guinea, can best be translated as 'all right, all's well'. AWARA: it was a word which Eric Gill was later to carve on the gravestone of Cecil's daughter Frances Mary who died of a fever out in Papua in 1929, when she was not quite three. All through *Awara* one is very sharply conscious of such contrasts, of the two intertwined worlds of the Gills' childhood: the life of the missionaries out in savage countries in contrast with, and yet in close relation to, the life of the Gill family back home in England. Eric chose to gloss it over, but it must have been important. It could have been the start of his life-long fascination with the extremes of experience. In Prestonville Road, Brighton, the Gill children were encouraged by their father to read coral islanders' romances: *The Young Marooners, Masterman Ready, The Swiss Family Robinson*. The true tales of their relations could be even more fantastical. Cecil, for example, had once returned home with an everyday drama from one of the villages of Eia in New Guinea. A boy had been swallowed whole by a crocodile. The villagers killed 'the dragon' and when they cut it open, in an orgy of slashing knives and thrusting spears, they found the body of the boy inside it. There was then a time of mourning in the village: the women encased themselves from head to foot in white clay and covered their heads with matting in despair.

Arthur Tidman Gill, Eric and Cecil's father, was originally ordained as a Congregationalist minister to a chapel in Burnley in Lancashire. But in 1878, four years before Eric's birth, he had resigned and travelled south to Brighton. He had left his Congregational church, denomination of his forebears, because he could not stomach the doctrines of hellfire and damnation which at that time were still common in Dissent. He spoke out against them in his chapel too vigorously for his congregation's taste. It had been an awkward episode, for him and his relations. But the need to act according to one's conscience was not questioned. Eric Gill was brought up in a household so religious that the life of the spirit was in a way disregarded, so everyday was it, just a part of the routine.

But as he wrote later, admittedly with hindsight, 'taking things for granted doesn't mean you aren't interested in them or that, on occasion, you won't be very interested indeed'.

By the time Eric was born his father had become a clergyman of 'the Countess of Huntingdon's Connection', a curious eighteenth-century sect of Calvinist Methodists. Selina, Countess of Huntingdon, otherwise known as 'the English Deborah', had founded the 'Connection' in Brighton in 1760. The countess was a woman of exceptional force of personality. Contemporary portraits emphasize her firmness of demeanour: she is shown wearing a formidable bonnet, surmounted by a large flat bow. She had first become famous in Methodist circles for the power with which she gave extempore addresses to her congregations, instead of merely reading from the book. She was an inspirational preacher. Then a dangerous illness, from which she almost died, opened her eyes to what she saw as an even truer form of faith, George Whitfield's variant of Methodism. From then on the countess had gone from strength to strength. She was particularly fond of Brighton, and Brighton was the place she chose as the starting point for her religious activities. She built the first of her dozen or so chapels in her own house in North Street, selling her jewels for £698 to do so. She appointed her own chaplain to lead the public prayers, the countess giving the proceedings a high degree of moral support. *The Life and Times of Selina Countess of Huntingdon*, a pious biography, describes a double act between the chaplain and the countess:

Whilst he was employed in proclaiming the glad tidings of salvation she was engaged in pouring out her soul before the Great Shepherd and Bishop of Souls to bless his own word . . . And when the service of the sanctuary had ceased, she withdrew to her closet, and earnestly implored the benediction of the spirit to accelerate the labours of his servants.

This was the highly emotional background to the chapel where Arthur Tidman Gill was now assistant minister. The chapel itself had been rebuilt, in Victorian Gothic style, but it still stood on its original site in central Brighton (and in fact has only been demolished very recently). In its practices the Countess's Connection had oddities. The congregation – notably idiosyncratic as Dissenters in their usage of Church of England terminology – referred to the assistant minister as 'curate'. The sect was also peculiar in its use of the Anglican prayer book. As a child, Gill was exposed to that fine sixteenth- and seventeenth-century prose.

The Countess of Huntingdon's Connection is played down in Gill's

account in his own memoirs. His later tendency to underestimate the influences of his Nonconformist origins is again obvious. To someone so definite in his reactions to forceful women – women of the type which later in his life both repelled and attracted him – Gill's apparent lack of interest in the charismatic countess is unconvincing. But the picture he gives us of his father in the chapel, self-consciously imposing in the noble and voluminous black gown of his calling, reveals his true feelings perhaps more than he had realized. The intensity of his reactions to his father – the mingled love and horror, the desperate protectiveness – comes over in Gill's memoirs with a directness reminiscent of Edmund Gosse's *Father and Son*. The two books describe childhoods poignant in their similarity.

His father's image, to Gill as a small child, was that of a rather good-looking bald-headed clergyman with a trim beard. He was kind and conscientious and tremendously theatrical, filling his children with embarrassment at his dramatic renderings, in public and in private, of his best-loved passages of Scripture or poetry or his favourite prayers from the prayer book. Once in the pulpit in Bognor he recited the whole of 'Where did you come from, Baby dear?' with appropriate gestures. He was a rather Tennysonian figure and indeed he adored Tennyson. When the poet died in 1892, he took his eldest daughter Enid, then eleven, to Westminster Abbey to the memorial service.

Arthur Tidman Gill also admired such writers and philanthropists as Thomas Carlyle, Dean Farrar, George Macdonald, Charles Kingsley, F. D. Maurice, founder of the Working Men's College. He was an avid reader of the religious novels of F. W. Robertson: such works as *High Church*, *No Church*, *Church and Chapel*. His heroes are an interesting combination of the literary romantic and the radical socialist muscular-Christian tendencies of that period, and he looked to this tradition to supply the names for many of his numerous children. Eric's six brothers listed out in Arthur Tidman's orderly manner, with that love of accuracy which Eric would emulate, are:

Leslie MacDonald:	6 October 1884
Stephen Romney Maurice:	5 January 1886
Evan Robertson and Vernon	
Kingsley (twins):	24 April 1892
Kenneth Carlyle:	9 August 1893
Cecil Ernest Gaspar:	7 May 1897

8

The six girls were named:

Enid Rose:	12 January 1881
Cicely Eleanor:	8 March 1883
Lilian Irene:	16 September 1887
Madeline Beatrice:	27 November 1888
Gladys Mary:	18 September 1890
Margaret Evangeline:	29 January 1895

The girls have the names of the heroines of Victorian romance: Enid Rose, for example, is a Tennysonian lady. The boys are knights in armour, drawn from real life or fiction. Eric, asked to choose a name for one of his new brothers, had himself selected Vernon, the younger (better) brother in Dean Farrar's novel, which was known in the Gill family, that house of secret jokes, as *Eric, Gradually*.

Eric's father named his children hoping to inspire them. How much, one might then ask, was Arthur Eric Rowton influenced by his own namesake? *Eric, or Little by Little*, subtitled *A Tale of Roslyn School*, was first published in 1858, and dedicated to the Right Revd G. E. L. Cotton, Lord Bishop of Calcutta. As the Preface to the twenty-fourth edition points out, it was a book 'written with but one single object – the vivid inculcation of inward purity and moral purpose, by the history of a boy who, in spite of the inherent nobleness of his disposition, falls into all folly and wickedness, until he has learnt to seek help from above'. The tragic hero of the book is Eric Williams, the boy sent back from India, at the age of twelve, to boarding school in England, far from his father's watchful eye and benign influence. Eric Williams is described as 'truthful, ingenious, quick': he has 'the ability to acquire almost without effort any subject that interested him'. Here there are some obvious parallels with Gill, who moved with such high speed on any project which engaged him. Eric Williams develops, after trial and tribulation, what were thought of as the ideal public-schoolboy's virtues: the confidence to stand up for the right, the courage of conviction, the Christian martyrs' stand. Here again, the theatricality is Gill-like. (Eric Williams is however very *unlike* Eric Gill – the Gill of later life – in his intense modesty: indecent words in the dormitory, for instance, reduce him to sheer horror, 'blushing scarlet to the roots of his hair, and then growing pale again, while the hot dew was left upon his forehead'.) Though Gill later came to repudiate so much of that muscular-Christian tradition of his boyhood, it left its mark upon him. Indeed, ironically, a passionately pacifist letter written by Gill to the *Tablet* in 1939, when

war had been declared was headed 'Eric, or Little by Little'. He was still the son of Arthur Tidman.

He was also, in particular ways, his mother's boy. From Rose Gill he inherited his musical ability and also his considerable talent for performance. It was a family legend that Arthur Tidman seized his wife from off the concert platform. She had been a professional singer, performing on the late-Victorian light operatic circuit. She was then Rose King, but performed as Rose le Roi. Eric Gill liked to look back on his mother as 'a beautiful black-haired young woman' with a lovely big contralto voice, who sang divinely. Her father, Gaspar King, was the manager of a timber yard in Brentford, a yard which supplied wood to build Lord Brougham's well-known carriages, and she had inherited much practical good sense. Rose Gill had a certain sturdiness of attitude, which one comes to recognize later on in Eric, and a rather similar sardonic use of language. It was just as well, she said once, that 'In my Father's house there are many mansions' since there were a lot of people she would not want to live with in the after-life. She did not suffer fools gladly and was sharp with servants, tending to ask too much of them. The result was that the household was almost always servantless. Mrs Gill, with thirteen children, was extremely overworked. In a letter to a family friend, written when he was eleven, Eric takes upon himself the role of mother's agent:

Mother has not got a servant yet, but she has an old woman staying here to do the work, and mother has her nurse; but she says she would be very pleased if you could find one for her.

When looked at closely, Gill's depiction of his mother in the *Autobiography* is not completely accurate. He liked to romanticize his working-class origins, as one sees from the references in his memoirs to 'the inestimable blessing' of his 'good "working-class" blood' and his sentimental depiction of Dear Grandpa King with his complete outfit of clacking false teeth and his large library of more or less worthless second-hand books. But the recollections of other Gill relations suggest that the King family was in actual fact more middle-class than he made out. Indeed the whole ethos of the Gills, both then and later, is a very middle-class one. Middle-class in its clannishness, its liking for the family gathering, for marking the occasion, its dependence on forms and ceremonies in behaviour, its emphasis on social and professional betterment: this was the recruiting ground of minor public schools. Eric himself would have gone to Bradfield School if he had been more proficient at

Latin; two of his younger brothers were sent to St John's, Leatherhead, where children of poor clergy were offered reduced fees. The Gills' was a family which believed in the keeping-up of appearances. Though Eric later on so ferociously opposed the values and predilections of the bourgeoisie in general, he always remained close to his own very bourgeois family. Again, he plays this down in the *Autobiography*, with its emphasis on the 'before' and 'after': the Gill family, being part of his pre-Catholic past, are banished from the chapters which follow his conversion. But the diaries show this was a long way from the truth. He took on his younger brother and nephew as apprentices. Relations with his sisters always edged beyond the affectionate towards the amorous. The great Gill family, with all its genteel snobberies, remained with him all his life – and even afterwards. One of the largest Gill gatherings took place at Eric's funeral at Pigotts in 1940.

It is striking how many of Gill's adult attitudes can be traced back to his Nonconformist childhood. When later in his life Eric Gill extolled the virtues of holy poverty he was inevitably recollecting life as it was lived in the succession of cramped houses around Brighton by the large Gill family on its total income of £150 per year. There were the negative aspects of poverty: the fears of bills and debts were ever present (Eric Gill's finances were always most precarious). But there were compensations, indeed the basis of a whole philosophy: positive poverty, as he came to see it, a necessary discipline, reduction to essentials. You do not buy the loaf you do not need.

There is a nice description in Gill's *Autobiography* of his father cutting up one cold sausage very skilfully into enough thin slices to give all his children a few slices for their breakfast. They were very good at making the most of what they had. They entertained themselves with puns and word-games and with a little home-made periodical, the *Monthly Magazine of Fun and Frolic*, a touching foretaste of the many polemical pamphlets Gill produced. Some still exist in the Eric Gill collection at Chichester, and with their childish sketches, their private references and, running through them, a slight tone of moral uplift, they give one a great sense of that affectionate clannish unsophisticated household, with the children more or less living in each other's pockets. From force of circumstance there was a real need for organized family activity, and again Eric Gill would himself emulate this, perhaps more self-consciously, in his own family communities. It was part of that whole way of life which later commentators saw, admiringly or with occasional cynicism, as 'the sanctity of the everyday'. Eric's childhood jobs included

the cleaning of the knives and the laying of the table. The Gill household had high standards. Out of poverty arose the concept that jobs mattered in themselves and not just because they paid.

The life was in a sense claustrophobic, and for Gill this seems to have intensified his visual awareness. His memoirs include a vivid, curious description of having tea *en famille* in the front room in the basement of one of the Brighton terrace houses of his childhood. The street level is about six feet above the basement, and so the pavement railings are well above his head. He can see the iron gate and a flight of ten brick steps or so which lead down to the area. Suddenly – to the wonder of the child sitting at the tea table – descends a man, or a boy, with a hip bath which he carries over his head like a vast bonnet. He seemed not to be a man but a hip bath walking. It is a scene of late-Victorian England recalled with a surreal accuracy.

The oddnesses of life seemed even older in this atmosphere: close, secretive, familial, with no chance of escaping intimations of mortality. Two of Eric's sisters were to die within his childhood, and again in his *Autobiography* there is a terrifying passage recalling a dream of his father's, that he saw a group of men coming along Prestonville Road carrying a shutter – one of those long panels used to cover up shop windows, to secure them for the weekend – and lying on the shutter was Eric's body, drowned. At the same time, simple pleasures of his childhood seemed more pleasurable, more enthralling, rarer, in the everyday domestic context of privation. The Jubilee fireworks, let off from the West Pier, inspired lyrical descriptions from Gill many decades later: the 'rushing hiss' of golden rain, and then the grand great curve ascending, 'and then that marvellous slowing down as the thing reaches its apogee and then a myriad new curves of light rushing towards you in all directions of perspective with new-born speed'. Though Gill, typically if perhaps unconsciously, turns the childhood memory into an adult image of triumphant sexuality, he never lost his childlike spontaneity. His quick response to quite uncomplicated pleasures was to remain one of his most attractive qualities. He went on liking golden rain (and Catherine wheels) for life.

David Jones, an artist associated closely with Gill and the Gill family, once made the comment, apropos of Eric's background of High Thinking and Plain Living, that three-quarters of the chaps in the *Dictionary of National Biography* shared these antecedents. In other words that sons of certain sorts of clergymen were well prepared for worldly success in later life. Eric Gill would certainly have combated this theory, as he

combated most theories; but there seems little doubt that the toughness in his character was to some extent encouraged by the vigour and heartiness with which he was surrounded as a child. How could it not be, with his father's strict regime of the cold bath in the morning? This bath was taken, according to Cecil, 'with much splashing and swishing noises, like an ostler grooming a horse, in all hirsute manliness'. Arthur Tidman believed in the physical challenge, once testing Eric as a little boy with a 'burning glass' which he pulled out of his pocket and held on his son's palm until he cried with pain. He then rebuked him, reminding him of how the Roman boy had held his hand in the fire until it burned. The sons of English clergymen should also be unflinching.

Eric was brought up with the eye of God upon him – literally so. His father, in many ways a simple-minded man, quite unlike the subtle priests who later became friends of Eric, pinned up a large card in the breakfast room depicting, very naturalistically, a great eye. The text this illustrated was 'Thou God seest me'. The all-seeing eye of his childhood was an image which recurs in a succession of Gill's later engravings: the eye-in-the-hand, the spiritual witness.

Eric Gill's was a Victorian childhood in its mixture of terror and sentimentality. His own characteristic combination of the serious and frolicsome, noted by David Jones again, was very much a part of his Victorian inheritance. He shared his father's fascination for the mechanical world as well as the spiritual. They both loved a contraption: a telescope; a microscope; the mirrorscope which so delighted Gill's own children. Outside his own window stretched the evidence of burgeoning technology. The railways, close to home, were a great source of inspiration and even when very young he was obsessed with drawing engines, bridges, signals, tunnels. Even then he liked the rational: the hard and clear and clean.

There were many opportunities in Brighton for Ruskinian self-improvement. Just around the corner from the Gills, in Dyke Road, stood the Booth Bird Museum (known in the Gill household as the Birds' Museum, since the children imagined it belonging to the hundreds of stuffed birds displayed within it, warblers and buzzards and bitterns). The Booth Museum was and still is an extraordinary monument to Victorian enthusiasm, the urge to collect and collate. Edward Thomas Booth, who formed the collection, was a wealthy man whose preoccupation with birds approached mania: he once kept a train under steam in Brighton Station for a week waiting to rush him to the Highlands as soon as his gillies had informed him that the white-tailed eagles were

nesting. The Gill children would also almost certainly have visited the chalk fossil collection in Brighton Museum, near their father's chapel. This had been assembled by Henry Willett with the serious intention of improving the masses. He wrote confidently:

If the inspection of this collection should help one young man to find his pleasure, and to spend his spare time in this direction, rather than to waste it in billiards and idleness, it will not have been formed or presented in vain.

Though so thoroughly Victorian, Willett's view of useful leisure is not so far from Gill's much later writings on the subject, in *Work and Leisure* and in *Work and Property*.

Though it had its pretensions to culture the Gill household was not an academic one. Eric once described his father, with determined candour, as 'from a "high-brow", intellectual, agnostic point of view a complete non-entity'. Eric's formal education was quite casual. His first recollections of what he termed 'discipline' were connected with a lady called Alice Blanche Carpenter, alias 'A.B.C.', from whom he learned his letters in the nursery at home. Then, from the age of six, he was sent somewhat intermittently to a Brighton kindergarten kept by the Misses Browne, daughters of 'Phiz', illustrator of Charles Dickens. He was a slow learner and, ironically for a future expert in typography, at the age of eight could only read three-letter words. In retrospect it seemed to him that his slow progress was in fact caused by the vagaries of English spelling which bored him, as construing Latin bored him later, because of its uncertainties: 'It seemed too much like guesswork.' Eric Gill preferred precision. Another early memory, from kindergarten days, was of a class in clay modelling in an upstairs room, which was very grey and gloomy. He was handed out some clay, about the size of a plover's egg, with the suggestion that he should make something out of it by squeezing it. This flummoxed him completely since he was given no instructions. The scene is interesting in the light of Gill's development, spiritual and artistic. He relied upon instructions, even if not necessarily complying with them. 'I remember clearly the grey light and my impotence.' Without instruction, he would tend to feel at sea.

Eric was then moved on to the more advanced curriculum, and the more competitive masculine society, of Arnold House School, Hove. This was, he wrote, 'a real school', in other words a small and conventional boys' day school of the 1890s. His father had taught there when he first arrived in Brighton: the school in those days had been known as Western College. In general Eric did not shine at Arnold House, but his

natural quickness with arithmetic and Euclid gave him that sense of confidence he lacked in other subjects. He was also above average in grammar and perspective drawing. Again his attraction to the *definite* is obvious. He always disliked languages, and indeed had reservations about 'foreigners' in general. He liked things to go together: in arithmetic he warmed to 'the lay-out of the figures and the neatness of the writing all combining with the orderliness of the proceeding'. Orderliness; predictability; control; the meticulous tidiness of his surroundings, which became a kind of fetish: these ideals, fundamental to his way of life and work, can be easily traced back to the households of his parents, so imbued with the Victorian disciplines and carefulness, and in some degree to his experience of school.

For a man whose public image later became so *outré* it is in a way surprising that his schooldays were so calm, so unexceptional. In most aspects of school life he was an average performer, and indeed in later years his pose continued to be that of 'a quite ordinary person who is interested but not learned'. His favourite author as a boy was G. A. Henty and the only prize he ever won at school was *Through the Sikh War*. After the prize-giving he walked home in the moonlight with his mother and father in 'a daze of exultation and pride'. He was always rather good at sports and played in the school football team, beating every other school in town and neighbourhood, including the junior school of Brighton College. His account of team triumphs might have been written by the Eric of Dean Farrar:

We have only played one football match yet at school and our side beat by an astonishing amount of goals 13 to 0, just fancy, and we left out our best players too. I played in that but did not kick any goals.

The young Eric Gill was also keen on cricket and remembered the impression made on him by the legendary grace of Ranjitsinhji batting. ('Even now,' he wrote in 1940, 'when I want to have a little quiet wallow in the thought of something wholly delightful and perfect, I think of "Ranji" on the County Ground at Hove.') The impression made on Gill by Ranji, the Indian prince who played for England and who made a century on his first appearance for Sussex, is particularly interesting in view of Gill's later enthusiasm for the arts of India, in particular the sensual figurative sculpture. His memories of Ranji were not simply kept as memories of superlative style and body beautiful but became a kind of symbol of discipline and craftsmanship and – the basis of his view of art – of truth to nature, of playing according to the nature of the thing.

The predictable life of an ordinary boys' school, where the teaching seems to have been routinely uninspired, rather suited Eric Gill. Later, he was caustic about the prevailing educational methods, maintaining that the whole of his education had been simply 'learning things out of little books and being able to remember enough to answer questions'. But he managed to be kind about and grateful for his teachers. They did no good but, more important, did him no harm either. Though in later years he came to reject much of the specific vision of the world which his teachers put before him, as he also turned so diametrically against the religious practices of his father and his grandfather, he saw that his schooldays had given him 'the tools' – an image few but Gill could have employed with such conviction. He used it metaphorically, in the sense of mental agility. His school had at least trained him in the tricks of memory. He also recollected his first sight of real true tools, the tools which were the basis of his trade and his vocation. Gill was introduced to practical crafts by a boy who was at school with him, a tall, lanky, clumsy boy who was outspoken and unpopular because his view of politics was much too radical for the simple patriotic boys of Arnold House. Eric did not really take to this boy either, but used to go to visit him (he too was a day boy), feeling disgusted by his own reluctance. But in fact these visits taught Gill a double lesson. He learned about tools from looking round his classmate's carpentering shop and, perhaps still more essential, he discovered moral courage. This boy 'was of the stuff of which martyrs are made'. He perceived, for the first time, the virtue and the power of the iconoclast.

At this stage Gill first perceived the special status of the artist. The place of the artist in society became one of the favourite topics of his adult life and indeed one of the bases of his critique of society. At school his adeptness in drawing locomotives gave him the prestige he would otherwise have lacked: his first taste of what he came to describe as 'Art-Nonsense'. As he wrote to Everard Meynell years later, in 1911:

How extraordinary that Percy Lucas, whom I have not seen since he and I were little boys at school, should still keep one of my steam engine drawings! I was supposed to be a great authority on the subject when I was about 12.

One of his teachers once said of Eric Gill, 'It's a pity he's so easily led.' He kept this in his mind. He did not wholly disagree with it. He saw he responded very easily to influence. But the point, he later commented, was: 'how good the leaders?' It could be a jolly good thing to be led well. It took him years to realize this, but the virtue of his upbringing was his

ability to be gregarious, his ease both in giving and accepting leadership where the leaders measured up to his exacting standards. He learned the joy, which never left him, of companionship and friendship, the spontaneous affection, the seizing of the moment: the qualities which made Eric Gill so attractive to those who knew him, so excessive and outrageous to those outside his circle. Such as the day out on the Downs, while he was walking with his sister, he suddenly flung off his clothes and they continued naked. A passing shepherd stared.

Gill's earliest remembered friendships were with his sister Cicely and with 'Bunny' Browne. He commented, 'when I consider those friendships and ask myself how they differed from friendships I have had with grown-up people, I can only say that I discover no difference whatever, unless it be that those friendships of childhood were even better than any others, clearer, brighter, lovelier, more unselfish. They were a union of minds, of souls. And they were human too. There was nothing of the disembodied spirit about them. In a real sense we enjoyed one another's bodies too.' The physical propinquities, enforced intimacies, of the succession of cramped and happy houses around the suburban streets of Brighton, seem to have encouraged Gill to view the female body, the bodies of his sisters from the early days of childhood, the bodies of the women of his own domestic entourage, as a never-failing source of interest and delight.

His sense of maleness derived closely from his father and his father's strong *paterfamilias* persona. This was intensified by the traditions of the mission where the missionaries were figures of great potency, even of adulation, in the primitive communities of the South Sea Islands, living in large bungalows with native servants, with their womenfolk in useful but subsidiary roles. Cecil leaves a revealing description of his missionary brother Romney, lording it with the Anglican Mission out in New Guinea: 'He had his foibles; mother used to call him "the potentate", so used was he to ordering his own life and his entourage of devoted disciples.' As Eric grew older the band of devoted disciples became essential to him too. The Gills' father, Arthur Tidman, was a vain man, rather lazy, and one of his wife's functions was to protect and cosset him, giving other people the impression that his work was tremendously important and also very tiring. Particularly after busy Sundays, father was not to be wakened or annoyed. 'In these and in countless hardly remembered but pervasive ways my mother built up in our minds the immense importance and dignity of the minister of religion and the father of the family,' wrote Eric later. 'It was not at all his fault

if he more or less basked in this sunshine.' Eric too perceived the charms of the male-centred household and admired what he saw to be his father's male directness: the fact that he saw things as ends in themselves, nothing simply as a means. His father was for example especially enthusiastic about sharpening pencils, and sharpening them properly, preoccupied not just with using the right method but even more with reaching the desired result in the form of a well-sharpened pencil. Young Eric Gill's absorption of this basic philosophy, an early domestic induction into many of the right-doing, right-thinking theories of the Arts and Crafts movement, was important. As he came to realize, 'There's quite a lot in sharpening pencils.'

A facet of the male directness of the household was its warlike spirit. Its patriotism verged on the extreme. In Gill's memoirs, written at a time when he himself was an extreme pacifist, this embarrassing inheritance is glanced at but not dwelt on: it is dismissed as 'jingo imperialism'. But again, Eric's brother Cecil fills out the picture in a way Eric himself felt disinclined to, showing the extent to which war and soldiering were accepted as the noblest of callings in that household. The patriotism, strong enough at the time of the Boer War, reached its climax in the First World War when a huge map was hung up in the dining room with little flags marking the positions of opposing forces. Photographs of the King, Lord French, Kitchener of Khartoum and General Roberts were pinned up round the walls, and Arthur Tidman's sermons began verging on the bloodthirsty. Cecil describes his father as 'intensely patriotic in the grand righteous manner, bordering on self-righteousness'.

From his father's household Eric Gill drew many of the principles of life and work one finds resurfacing in his art and his polemics, especially his view of active male and passive female: man providing the direction, intellectual and spiritual; woman the emotional support and sustenance. Education for girls was not considered necessary. Madeline, the cleverest of Eric's sisters, 'the bookworm of the family', envied Eric's schooldays. This was the sister who went into the convent.

When Eric was fourteen there was another great upheaval, the result of a fresh paternal *crise de conscience*. Arthur Tidman had decided to leave the Countess of Huntingdon's Connection and join the Church of England proper. Eric's first intimation of the change was when his father took him, after his usual Sunday morning service in the chapel, to an unfamiliar Anglican church, to hear the tail-end of the sermon there. Eric was at first disconcerted, partly because the building itself seemed bare and gaunt after the familiar comforts of the little Gothic chapel

with its upper gallery, its curtains and its carpets and its nicely intimate lock-up boxes of family prayer books. At the same time he realized, with the child's sharp instinct, that this was a momentous occasion and his life too would be changing. And he soon became excited. He always enjoyed changes, if the change was not too drastic, as the chance for a renewal. The decision once taken, it was acted on quite quickly. Arthur Tidman Gill preached his farewell sermon; the 'hat' was passed round the small shopkeepers and other lower middle-class citizens of Brighton who had mainly composed his congregation; bills were paid (with some relief); and the family prepared to transport itself to Chichester, where Eric's father had, with the approval of the bishop, enrolled as what would now be called a mature student at Chichester Theological College.

The episode is described in Eric's memoirs in that jaunty tone one comes to know well, and suspect. One recognizes it as a kind of danger signal. It alerts one to the subjects Gill feels nervous of developing. The decision of his father to abandon the Dissenters at that moment was a strange one. This was after all the high noon of Dissenting chapel building, when the galleries had never been so full of worshippers. These were years of excitement and expansion: the 1906 election was to symbolize the peak of Liberal Nonconformist social gospelling. *Why* then did Arthur Gill feel impelled to go and start again, at the bottom of the ladder, in the Church of England in Chichester? And why was this a question Eric was apparently so disinclined to ask?

Eric was always prone to embarrassment and maybe there was something in his father's volte-face which he found worryingly close to home. Perhaps, retrospectively, it reminded him a little too acutely of the whole family tradition of domestic – and public – reversals of allegiance. There were his own switches from Anglicanism to agnosticism to catholicism; from military service in the First World War to his fierce pacifism in the 1930s. There was his brother Cecil's decision in mid-life to abandon his Anglican parish in Wales and become a Catholic. (Cecil Ernest, named after the Bishop of Chichester: the sequence of events had a peculiar force of irony.) The sons, like the father, were romantically restless, susceptible forever to the charms of moving on.

As it turned out, Chichester, much more than Brighton, was to be a landmark and a milestone in Gill's lifelong search for the near-celestial city. It was a place which influenced him lastingly. But before the family left Brighton, there were two events which had a marked effect on Eric: one painful, one ecstatic. The sad one, in 1897, was the death at the age of thirteen, of his beloved sister Cicely, his first and closest friend and

'little mother' figure in that pullulating household. He had not, he explained later, 'known' death before, except as a fact of natural history: 'I had not known death in the sense in which we may be said to "know" a lover ("and he went in unto her and *knew* her").' Their father kept Cicely's old toys as kinds of relics in a glass-fronted cabinet and he would sometimes get out a favourite grey elephant and groan with sorrow over it. Both father and son had a slightly mawkish streak. Eric, in that dream-world he inhabits in his memoirs, claims he could not remember the slightest thing wrong with her. Cicely is the first instance of that figure so familiar in Gill's later history, and in his drawings and engravings: the idealized pubescent girl.

The other main event which shattered the even tenor of his life, towards the end of his schooldays in Brighton, was Eric Gill's discovery of the male organ. He describes this at length, in terms of great intensity, in his *Autobiography*. One must remember that the *Autobiography* was written later in life, when Gill was nearing sixty, after a few years of intensive amatory turmoil and at a time when he had become a kind of guru, with a public always avid for pronouncements about sex. All the same, his description is convincing and endearing, radiant with his very particular sense of the power of the phallus and its comic possibilities, and nobody but Gill could ever have arrived at it:

But how shall I ever forget the strange, inexplicable rapture of my first experience? What marvellous thing was this that suddenly transformed a mere water tap into a pillar of fire – and water into an elixir of life? I lived henceforth in a strange world of contradiction: something was called filthy which was obviously clean; something was called ridiculous which was obviously solemn and momentous; something was called ugly which was obviously lovely. Strange days and nights of mystery and fear mixed with excitement and wonder – strange days and nights, strange months and years.

CHICHESTER
1897–1900

At the end of the summer in 1897, when the Gill family arrived in Chichester, there were eleven surviving children. Enid, Eric's elder sister, with whom his relations were always rather fiery, was then sixteen; Cecil, his youngest brother, was still a tiny baby. They took up residence in a house completely different in shape and atmosphere and architectural merit from any of the run-of-the-mill suburban villas into which the family had packed themselves in Brighton.

Not that No. 2 North Walls, the 'little squashy house' in Chichester, a Georgian terrace building, was particularly glamorous. It reflected a serious lowering of the Gills' standard of living, modest enough before. Eric's father, once he had completed his studies at the theological college, became a curate at the sub-deanery church of St Peter in West Street, taking a drop in stipend from £150 to £90 a year. The children's bedroom window looked straight on to the neighbour's backyard. There was only one door which opened directly on to the pavement; two steps led down into the entrance passage. It was inconvenient and rather unhygienic: Eric was haunted by the memory of innumerable black beetles in the kitchen. But the good thing about it was its lack of all pretensions. Though the house is now demolished, old photographs reveal it to have been a modest but quite handsome urban dwelling, pleasing in its proportions with a neat pedimented doorway. Perhaps it taught Gill something of the dignity of plainness. There was no tradesman's entrance; there were no bay windows; there were none of those modern 'improvements', signs and symbols of the bourgeois instincts for respectability and self-aggrandizement which were to become such anathema to Gill.

No. 2 North Walls had a view inwards to the medieval city surrounding the cathedral and a vista outwards from the Roman walls to the green

fields and the country. Living there gave Eric an immediate new sense of possibilities, quite different from life as lived at 'Preston View' in Brighton. However unidyllic in some ways the conditions of family life, the town itself inspired him in a way he had never imagined that towns could. Chichester was so important to Eric at the time in teaching him something he had never comprehended in the shapeless and soulless sprawl of Brighton: that towns could in themselves have character and meaning. It was also to become a lasting symbol of perfection, the ideal of the good city, human, decorous, coherent. The vision of Chichester always remained central to Gill's passionate urge to achieve an integration of life and art and work and worship, his sense of his own mission – often thwarted – 'to make a cell of good living in the chaos of our world'.

In Brighton Eric Gill had been obsessed with drawing engines. In Chichester, with similar energy and method, he began recording the buildings of the town. The small plan of Chichester included much much later in Gill's *Autobiography*, nicely shaded in by Denis Tegetmeier, his son-in-law, shows what it was in Chichester that Eric Gill responded to. It was, first of all, the scale: the city was then relatively small, with a population of about ten thousand. It was, too, the sense of enclosure and containment, a quality which always especially delighted him artistically, sexually, domestically. The life of Chichester took place within its walls. There was also an oddity in Chichester he liked. The layout of the town, although so well-defined and tidy, was not, he pointed out, mathematically symmetrical. The houses in the town, many of which Gill drew, had the quirkiness and irregularities inherent in the architecture of the seventeenth and eighteenth centuries. Eric Gill got great enjoyment from a modest aberration; it was part of his engaging Englishness of character. There was nothing more lovely, he thought, in the whole of England than the little stretch of six or seven Queen Anne and early Georgian houses in the East Pallant in Chichester: 'They are not big and grand', he wrote, 'like the one ascribed to C. Wren at the corner, but little and perfect. I trust they are still there.'

There had originally been a plan for Eric to become an engineer. Early on he had been taken by his father for an interview with an engineer acquaintance. But the interview depressed him greatly: it seemed deadeningly technical. He could not get excited about stresses, strains, hydraulics and the planning-out of reservoirs. Engineering seemed much duller than he had imagined in his years of engine worship. He quite quickly changed direction and by the time the Gill family reached

Chichester it had been decided, more or less, that Eric Gill would be an artist. His father, using one of the sonorous phrases which used to embarrass his children so from the pulpit, told the master at Chichester Art School that Eric intended 'to embrace a career of art'.

This was not in fact so unexpected a choice of career for the son of an impoverished clergyman as one might imagine. The Gill household had always had artistic interests, not just through Mrs Gill, once so active on the concert platform, but also through Gill's father, an amateur painter, who was apt to say he should have been an artist rather than a clergyman. (To which Eric responded, 'I'm very glad he wasn't.') Arthur Tidman Gill was said to have produced some quite respectable paintings, especially early on when he admired Meissonier and did sunsets and landscapes in a conventional manner, and before he took to a provincial English version of French Impressionism. At one stage he had even taken on school drawing classes in part-payment for his children's fees. In any case, the households of the Gills in Brighton had been, as such households go, a little bit Bohemian. There was a hint of raciness, as when Mr Gill, himself a smoker, once said to his son that 'smoking a cigarette in a holder is like kissing a lady with a veil on'. Later on Eric, surprisingly, would always use a holder.

In 1898, when he was fifteen, a few months after enrolling at the art school, Eric Gill began a diary. The Collins Handy Diary, which was the first volume of a lifetime series, kept up until Gill's dying days in Harefield Hospital, is inscribed 'To dear Eric from Father, Xmas Day 1897'. Eric Gill's first entries set the pattern for his diaries for the forty years to come. They are tight, straightforward, almost obsessively methodical records of events, details of expenditure, itemizations of work done and to be charged for. They are almost wholly factual. Few views, no flights of fancy. None of the nostalgia, the retrospective vision, which makes Gill's *Autobiography*, although charming, in places somewhat suspect. The diaries are duller and more totally believable. Gill begins by recording that in 1897 'Mr. Firth gave me for sketching his church for his Mag. 7/6d.'

Eric Gill was conscientious about keeping up his diaries, even from that early period, and they gave one a remarkably accurate picture, so far as they go, of how he spent his days. On the whole his activities were very ordinary. Later friends and commentators were to dwell on Gill's quality of extraordinary ordinariness, the real-life personality which was so much at odds with his public image of blatant eccentricity; and the early diaries, with their accounts of Eric Gill in his mid-teens, growing

up in such a quiet, predictable environment, show that his taste for routines and domesticity began at quite an early age. He seems to have accepted and enjoyed what he was offered. The art school in the daytime, often in the evenings too; services in the cathedral, described with great enthusiasm; parish social evenings at the sub-deanery, sometimes including dancing, which he found 'awfully jolly'. There is an obvious happiness, a feeling of belonging. There is no sense at all at this stage of Eric Gill's quite savage sense of irony and satire. There is however an interesting sign of his early entrepreneurial spirit – for Gill, though he denied it, was always a good salesman – in the mention in January 1898 that he was considering doing a series of architectural sketches of Chichester Cathedral and sending them up to London 'to the publisher of those little books'.

Gill's diaries, then and later, are a wonderful example not just of human energy in filling every minute but of human purposefulness, a supreme Victorian virtue. No one was ever better at the improvement of each shining hour. Gill was constitutionally incapable of just doing nothing, as an ex-apprentice later wrote with feeling: 'He instinctively filled the interstices of time with making, mending, setting things to right.' Some of this zeal of course came from his father who taught him not only the rigorous technique of perspective drawing, without which he felt he might perhaps have wandered away into mere artistic romanticism, but also the importance of a framework of orderliness in life itself, the duty one has to organize one's time constructively. His mother's boundless energy was also influential. She was the sort of person who, after all the household tasks involved in bringing up a family, large by any standards, with few outside resources, found time to read her favourite George Meredith and George Eliot and to practise her singing. She was very open-minded, and she liked discussing new ideas, much more so than her husband. She was marvellous at holding her large family together, and even after rising very early to do the heavy washing she would still be sitting up till 2 or 3 a.m. writing letters to any of the children who happened to be away from home. This was a well-remembered family tradition, for these letters would be lined up on the table in the hall for the others to add to if they wanted before posting. Indefatigability, as well as a strong sense of family commitment, was part of his inheritance; and Eric, like his mother, needed very little sleep.

However, though so close, Eric's relations with his father and mother were in the Chichester days not totally harmonious. The diaries as well as the memoirs reveal tensions. Nor is it so surprising. They were all

strong characters. Eric and his mother, with their frenzied energy, had endless squabbles, most of them domestic. Eric's more fundamental opposition to his father, most painful in his adolescent years, took the form of challenging his patriarchal attitudes and habits. 'Ericcy boy', as his father used to call him in his wildly sentimental correspondence, with its frequent admonitions to Eric to 'be good', could not resist sometimes behaving very tactlessly, embarking on actions which were bound to end in outrage. So much so that he once sent a letter to his father at Chichester Theological College starting 'Father', with no prefix of 'dear' or 'my dear'. Mr Gill was much offended, a response which Eric later recorded as an early example of the impossibility of getting people to be reasonable. Cecil recollected later an awful scene in Sussex at a quiet country church when, with his father in full flood in the delivery of one of his Tennysonian sermons, Eric and one of his young radical socialist friends got up and stalked out of the church.

This intemperate behaviour was not typical of Eric, as Cecil indeed noted. He was not a cruel person. He was usually very controlled in confrontation. So it does suggest a depth of underlying tension between Eric, as a young man, and his father, and maybe explains partly the desperate intensity of his adolescent search for father substitutes, his almost inordinate urge to hero worship; the pattern of progression from the heights of optimism to the depths of disillusionment which became a feature of his early male relationships.

His first hero in Chichester was George Herbert Catt. 'Mr. Catt the Art Master', he wrote in his new diary, 'is awfully nice. I go to tea with him very often.' His diaries and memoirs of these years are full of references to talks, walks, even holidays with Mr Catt. Mr Catt represented the good and true and beautiful; Eric hung on his words and followed him about like a devoted dog. His approval of Eric's work in class was recorded with triumph. For instance, 26 October 1898: 'Design class in evening. Very good. Mr. Catt said my design was best. I am glad.'

Though later on he turned against the regime at the art school (as he turned against so much, with such great force of opposition), the very conventional and highly structured training in fact suited him extremely well to start with. As at Arnold House, it was a negative advantage. There may not have been much positively right about the routine training in techniques then in force at the Chichester Technical and Art School, as in the many other comparable art schools up and down the country (part of a whole national network of art instruction rigidly controlled

by the Department of Science and Art, aftermath of the Great Exhibition of 1851). But nor, as far as Eric was concerned, was there much wrong with it. If he had found very little positively stimulating about the so-called South Kensington system, dominated by exam curricula and aiming mainly to produce still more art teachers, he did at least acquire great technical confidence from his early, exact training in such crafts as woodcarving, gesso, tempera and sgraffito. His diary records the usual art school exercises: design for a painted plate; design for a doily (just the sort of artefact which Gill would later pour such scorn on), carried out without complaint and with a moderate success. Although he never got a medal he did win a Queen's Prize for his perspective drawing at Chichester, and he gained a useful grounding in the sheer professional skill which later on in life enabled him to carry on working while conducting a hard conversation, a knack which never failed to intimidate spectators.

Mr Catt made great efforts to broaden his experience. He taught him about styles of medieval architecture and how to tell the dates of buildings. He was, like Eric's father, a great Tennysonian and quoted *In Memoriam* on every conceivable occasion so that Eric too soon knew quite a lot of it by heart. He remained particularly fond of the passage about the routine of rural agriculture:

> As year by year the labourer tills
> His wonted glebe, and lops the glades.

Whilst his actual grasp of the realities of agriculture was never especially convincing (this was a department of life he usually deputed to the women in his family), Gill's romantic interest in the idea of the life of the earth and man's work on the land was always fervent and indeed quite Tennysonian. His perception of nature began in Chichester, and with it the ideas of the natural balance of living and working which he was to pursue in his succession of rural communities. He also gained from Chichester his own first creative orientation, his earliest real sense of his own interests and abilities.

At Chichester Gill became – his own word for it – 'mad' on lettering. This was not, he claimed, a too inaccurate description for an interest which was to dominate and enchant him for his whole working life. In his earlier railway period in Brighton, in his beautiful, meticulous wash drawings of the engines caught in action emerging from the tunnel, slowly climbing the steep track alongside the Gills' garden, each engine's name and number carefully delineated, he had first become aware of the

potential of lettering, aesthetic and functional. He knew then it excited him. But it was only later on in Chichester, under Mr Catt's protective, fond instruction, that he discovered the true identity of letters, saw that 'letters were something special in themselves'. He praises Mr Catt for that, but rather typically came to blame him too for letting him get carried away into what seemed to him later 'the worst perversions and eccentricities in the way of "new art" lettering'; and certainly the early examples of Gill's lettering are very far away indeed from Gill Sans rationality.

In fact it was another father figure, Dr Codrington, prebendary of Chichester Cathedral, who encouraged his interest in older forms of the alphabet. 'Began notes on Classic Architecture in eve,' says his diary, 'also copied alphabet from Domesday Book of Sussex which Dr. Cod lent me.' Dr Codrington's loves were very antiquarian. He was a Doctor of Divinity and an authority on Pacific island culture and an enthusiast for heraldry and medieval architectural archaeology. He, like so many of the Gill relations, had been a missionary in the South Seas, but now lived alone with his cat, in a cluttered and eccentric house in the cathedral close, full of the relics of his days in Melanesia. He had a banana tree in the garden, to the wonderment of Chichester children, and was known for his past associations with cannibals. Eric's brother Cecil remembered him as 'a delightful fellow', a 'very benign, learned, friendly old chap'. But he also had a faintly cussed side. He could be very critical of the more conventional aspects of cathedral life. He asked some awkward questions, and it seems quite likely that one of the lessons learned by Eric when he, as so often, took tea with Dr Codrington, friendly by the fire in the medieval twilight, was the tendency to query, inclination to debunk.

But you only debunk what you know and understand. This rule of life, as well, he absorbed from Dr Codrington. His sense of the intimate interworkings of religious communities, which was so important in his later life, began to dawn upon him in those years in Chichester when Eric lived almost on top of the cathedral. The cathedral was part of his existence, a part which he accepted in a matter-of-fact way: see his laconic diary entry 'I go in for bell ringing here and am one of the cathedral junior singers.' He treated the cathedral a bit as if he owned it: 'he went through it with a toothcomb', recollected Cecil. He persuaded the head verger to hand over the keys to him and described with what a sense of great adventure he got to know the building in its very bones: the mysterious circular staircases, dark places over the vaulting. He

climbed the spire and walked around the galleries and clerestories. It became a place of great familiarity. He claimed to have known the fabric of the building at least as well as any of the clergy. He kept an immense awe for the great religious buildings of all denominations (though unable to stomach St Peter's in Rome, which he could not help comparing to the Ritz Palace Hotel, an amalgam of the worst hotels he could imagine). But he also saw great churches almost as domestic buildings, approachable and useful like so many of the Nonconformist chapels: a cathedral was a building made by 'chaps' to pray in, as Bernard Wall expressed it. This was very much Gill's view.

Eric Gill was not attuned to appreciate the church architecture which surrounded him in Brighton, the 'ecclesiastical *fleuraison*' of Victorian Brighton which Pevsner later taught us to admire. But Gill was temperamentally ideal for Chichester: the idea of the cathedral right inside the city, giving shape and point to it, and drawing its own life from the fact of its proximity; the nature of the building, its lovely random Englishness, described in *The Buildings of England* as 'a well-worn, well-loved, comfortable fireside chair of a cathedral – St Francis, not Bernard: St Augustine of Hippo, not St Augustine of Canterbury'; the dramatic impact of the medieval spire seen from the flat countryside around it. Gill always had a taste for such spiritual vistas, as when later on at Ditchling he erected a large crucifix and planned an oratory building to be seen for miles around. His rather childlike love of symbols, his fascination with the phallic, with the surge of upward movement, shows from those early days the basic tension in his nature, seeking release in a fusion of the erotic and the sublime.

In Chichester Cathedral there are two extraordinary sculptures, stone panels carved in relief, Anglo-Saxon or early Norman, one showing the Raising of Lazarus, the other Christ Arriving at Bethany. Henry Moore, when he first saw them in the early 1920s, never having known about them even from photographs, describes standing before them for a long time: 'They were just what I wanted to emulate in sculpture: the strength of directly carved form, of hard stone, rather than modelled flowing soft form.' Eric Gill had seen these carvings, of course, years before Moore had. Though, oddly, he does not refer to them in the *Autobiography* or any of his writings, their influence is obvious on his own most characteristically two-dimensional stone carvings, in particular the Westminster Stations of the Cross. He told Philip Hagreen, who worked with him at Ditchling and at Capel, of the impact they had made on him, saying with deep feeling (for Eric, all his life, remained tremendously

emotional), 'I have seen those stones many times, but never without tears.'

Chichester Cathedral had high musical traditions. The great Elizabethan composer Thomas Weelkes had, for instance, been the organist and *informator choristarum* from 1601 or 1602 and the best of his church music probably dates from those early years in Chichester. The music, in Gill's time there, was being taken very seriously, and one of Eric's secret pleasures, in exploring the heights of the cathedral building, was listening to the music through the holes in the bosses of the vaulting. The assistant organist, Osmund Daughtry, became a friend of his, another of the 'leaders' whose tastes he chose to follow. He later said that Daughtry treated him as an equal, though Daughtry was a man and Eric still a boy, and persuaded him away from his old childhood allegiances to Mendelssohn's *Lieder ohne Worte* and the Chopin *Nocturnes*, which his mother used to play for him, towards the baroque masters – Handel, Bach, Corelli, Purcell – and the early English composers of church music. Feeling gave way to structure.

He had, he thought later, arrived in Chichester at exactly the right age. He was 'mentally bursting like a bud and physically too'. The quiet routines and the understated interest taken in him by the cathedral community settled him and stimulated him. The ladies of the close patronized him gently, lending him art books, looking through his sketches and even sometimes giving him a small commission (such as one from Mrs Glover, recorded in his diary, to sketch her garden and the cathedral from it). He had a certain status within the neighbourhood, something which was always, in a way, important to him. When a minor celebrity, Sir Arthur Blomfield, the architect, came to survey Chichester, it was Gill who was allotted to him: 'Up Cathedral all day with Sir A. Blomfield,' runs the entry for 4 May 1899. 'He is very nice, showed him my sketches.' Already Gill sounds confident: not cowed or overawed.

This was of course a time of spring awakening for Gill. In what almost amounted to the Chichester version of Wedekind's play of small-town adolescent longing, Gill fell in love for the first time with Winifred Johnson, who was at art school with him. He was sixteen, she was nineteen. The atmosphere of art schools at that time was especially conducive to romance. They were *mouvementé* places and relatively flexible socially, with classes running through the whole day, from morning training in such subjects as drawing and shading, water colour and oil painting, generally held for ladies only, to evening classes for ladies and gentlemen as well as special classes for 'artizans and teachers',

since one of the main aims of the South Kensington system was to improve the aesthetic judgement of industrial workers. The provincial art school of the late nineteenth century was an environment which, if by no means *louche*, was certainly more easygoing than most of the homes from which its pupils came, a pattern which continued right through to the 1960s, with an evident effect on British visual culture. In Gill's day the sense of new freedoms was infectious. Picturesque scenes of female students in long overalls painting vases in the Modelling Room or decorously sketching from the life-size classical casts in the Antique Room could hardly have failed to affect the male students, even those a great deal less susceptible than Gill.

'You know, I have always been interested in love,' as Eric Gill told his brother Cecil in 1939, ill in bed in the Welsh mountains, in reminiscent mood. This, as it had turned out, was something of an understatement, which gives a particular poignancy and sweetness to his accounts of early love affairs in Chichester. His romance with Winifred seems to have aroused great disapproval first from Eric's parents and then from Mr Catt, who foresaw it reflecting badly on the reputation of the art school. Only Winifred's mother seems to have been sympathetic, as suggested by Eric's diary entry 'Introduced to Mrs. Johnson at school in eve. She is v. nice indeed, v. sweet. Like her! hee! hee!' But in the event the affair was much more harmless than anybody, certainly Mr Catt, imagined. As Gill himself narrated it years later in the sex-confessional manuscript *He and She*, it had never been at all a physical affair. He had loved Winifred wistfully from afar, never having thought of asking for or taking any liberty with her body whatsoever, never having even actually kissed her. A letter which he wrote her in 1898, on holiday in London, which begins 'My dear Miss Johnson' and which tentatively suggests he would have liked to go with her to the Burne-Jones exhibition, shows nicely the tone of camaraderie between them. Gill, typically (for he always kept his head however much he was in love) asks her to return the letter to him later, as a record of the things he saw in London, 'as it will make a much better diary than I should ever trouble to write'.

If his first love was an art-school love, his second, and much deeper, more enduring love affair was a cathedral one. Eric Gill's slow courtship of Ethel Moore, the sacristan's daughter, the girl he was to marry, took place in a setting and indeed at a pace almost totally Trollopean. She glimpsed him first, having heard about him from her sister. They were all in the cathedral. She described it very simply: 'he sat just behind us one afternoon – and my sister told me it was Eric Gill.'

Mutual attraction, the basis for the sudden sense of recognition between two people, is always difficult to define exactly. But Gill had a great love of and need for the familiar, as well as great talent for the deviation, and there was already a reserve of shared experience with Ethel. He knew her father well. Henry Holding Moore, the sacristan or head verger of the cathedral, was the man who had apparently so irresponsibly, but with such understanding of the nature of his future son-in-law, handed over the cathedral keys to him. They already shared a milieu and a setting. She too had had a recent and devastating family bereavement: she had been brought home from boarding school to nurse her brother, who had died when she was seventeen. She was older than Eric, as Winifred had been. Indeed, there were four years between them, and again this was a very likely reason for attraction. She had been to a finishing school in France; she had worked on the Isle of Wight, briefly, as a governess: Ethel had seen life, in a way which he had not. She could offer an accumulation of experience. Influenced no doubt by the image of his mother at the hub of her large family, busy yet reposeful, Eric always saw the woman as the refuge, the good manager. Ethel fitted this view of things ideally, for as well as the extra maturity of years she was by temperament very sensible and settled. This was the quality which David Jones noted later: 'She was totally English, frightfully English, but she was also like a French woman.' Even at an early age it was quite obvious she had great astuteness and practical sense.

Unfortunately Eric's parents were no keener on this romance than on the previous one. They had a small-town snobbishness and despised Ethel's father's business, a successful plant nursery in Chichester. 'Mr Gill was a curate and my father was a florist,' as she put it, in her usual very matter-of-fact manner. Besides their opinion of the social imbalance Gill's parents were worried about Eric's youthfulness. But the affair went on quite gently and defiantly through autumn and winter 1899, with entries in the diary recording suppers, concerts, readings out loud to Ethel from *Morte d'Arthur*. Once the entry is just 'lovely, lovely, lovely'. Physically, things went cautiously, from the kissing of the hand to the rubbing of the wrist, each new move recorded accurately in Gill's diary. It was a courtship of great charm and happiness.

It coincided with another big decision in Gill's life. He had made up his mind that he could never be an artist; or rather, that he found the idea of the 'career of art' as envisaged at the art school of little interest to him. He completely turned against the built-in-system of training

SJohn's, Bognor.

2 *St John's, Bognor*, the parish to which Gill's father went as curate
after he had joined the Church of England.
Pen and ink drawing, 1899.

artists to become art teachers to train yet more art teachers. This meant,
of course, turning against Mr Catt as well.

Turning away from the place which once delighted him; losing faith
in his old heroes, quarrelling with his great friends: all these are recurring
patterns in Gill's progress, in his almost compulsive movings on from
place to place, from allegiance to allegiance. There was always a great
tension between repose and restlessness. He was always all too tempted
to bite the hand that fed him: 'Mr. Catt say nuffin' hardly,' he wrote
wanly in his diary, after his announcement that he was leaving the art

school. Much as he had loved it and would later on defend it, he had realized that Chichester was 'not only "no abiding city" ' but a city in which he was 'no longer able to abide'.

By 1900 Gill had also become very disenchanted with his home and his parents and even his religion. The Church of England, where he had worshipped with such hopefulness when his father left the Countess of Huntingdon's Connection, now seemed to him lacking in force and fire. No martyrdom. Too many of its clergymen now struck him as asses. He was looking for more drama, and he could not find it here.

But although Gill was so prone to disillusionment he also always had an aptitude for finding an alternative. He never left a place without a sense of disarray but also never without a longing and excitement for the next place. The next place now had to be London. The next focus of ambition, the new role in life he fixed on, was that of architect. It appealed to his developing sense of social fairness. He saw himself as leaving the intangibilities of the life of the fine artist for the positive goodness of constructing not grandiose places like palaces or cathedrals, but honest houses for ordinary people. When Gill set off to London it was country-cottage building, architecture of the simple life, that he had in mind.

He liked things very plain, and to Eric Gill the cottage was a symbol. As he said, a sort of talisman. The quasi-peasant life became a strong ideal to him, the basic cottage plan an image of security. At this time in his life, when he was young and starting out, in a state both of optimism and confusion, he referred everything back to his idea of the cottage, the child's story-book building, a 'little house – four square, with doors and windows and a roof'.

LONDON

3 Self-portrait.
Wood engraving, 1908.

CLAPHAM

1900–2

When Eric Gill arrived in London aged eighteen he was, he said himself, a fairly perfect specimen of the earnest and enthusiastic boy from the provinces. He had romantic images of past visits, mainly day trips made when staying at Blackheath with his father's sister, his Aunt Lizzie. He knew Westminster Abbey and best, St Paul's Cathedral where, at that very impressionable period, everything seemed perfect: building; music; kindly vergers; foggy mist around the dome. St Paul's, so vast in size, seemed to express his aspirations: what could be more surprisingly wonderful, he asked, to someone young and small and burning with virginal enthusiasm than a building so large that it seemed to contain the very sky?

Gill's relationship with London became a great love–hate one. Like other back-to-the-landers he resented the confusions, both physical and moral, which men had created in their cities; but at the same time he always needed London as a stimulus and as a source of work, and he rationalized his feelings in a typical Gill manner, claiming that only he who loves Pimlico has any right to pull Pimlico down. But his early view of London, before the usual Gill complexities set in, was almost totally affectionate. He lived first of all in Clapham, in lodgings found for him and indeed paid for by Dr Oliver Codrington, the brother of the prebendary who befriended him in Chichester, and Clapham became a kind of home from home.

Eric's parents had supported this new move. Architecture was, in their eyes, a respectable profession, one which Eric's brother MacDonald (known in the family as Max) was also to pursue; and probably they hoped that a few years' separation would dampen Eric's ardour for Ethel, the florist's daughter. His mother brought him up to London from Bognor, where Eric's father had now been appointed curate, on 3 April

1900 by the 10.27 (train times had an almost mystical significance to Gill, and recur in his diaries like a kind of incantation), returning by the 1.52 next day from the Junction. She had settled him into his rooms at St Saviour's Church House next door to the church with its remarkably fine organ where the organist, Mr Keene, greeted him eagerly. It was almost a repeat of the Chichester routine. He was back in a known world of choir practice, sausage suppers, parish whist drives; and the Clapham Dr Codrington was 'too kind to be true'.

In London he found a much loved figure from the past, his 'Darling Heddie', Helena Hall, the nursemaid from the Brighton household where she had worked briefly, at the time when Mrs Gill was giving birth to twins. Eric, then a child of ten, had adored Helena, writing precociously to her as 'My Dear Sweetheart' and showering her with drawings of boats, trains and railway tunnels. Under her wing, in London, he went off sketching with her. She too was artistic and, as Gill was later, a student at the Central School in Edward Johnston's class.

Gill was also on familiar ground, to some extent, in the architect's office where he was enrolled as pupil. This was the office of W. D. Caröe, whose large, successful practice in Westminster, conveniently close to the abbey, was predominantly ecclesiastical. Caröe, son of the Danish consul in Liverpool, had as a young man been chief assistant to the great church architect J. L. Pearson and had worked on the drawings for Truro Cathedral. He was a traditional though by no means a dull architect, a Gothicist who later moved towards a quite exuberant baroque. Gill's own great enthusiasm, after locomotives, had been for church buildings and of course predominantly Church of England buildings (Roman Catholic churches were not part of his childhood: he did not even enter one till 1898). It had been a Church of England parish church, at Portfield, which Gill drew as his first official commission, and it was the familiar architecture around Chichester which gave him his first awareness of the meaning both of buildings as buildings and buildings as churches, his perception of the church as a kind of architectural icon, the manifestation of public worship. So there was, on the face of it, a certain logic in his pupillage with Caröe, architect to the Ecclesiastical Commissioners, with his burgeoning church practice. In theory, the pupil and the master were well matched.

If it did not work out quite like that the fault was partly the sheer success of Caröe's practice at that period. He does not actually seem to have spent much time in the office. ('Caröe away. Consequence – !!!' says Eric's diary.) There were also Eric's simple-life ideals to consider.

His vision of the four-square country cottage would perhaps have made him a more suitable pupil for a humbler, more arts-and-crafts orientated architect. Artistically, if not religiously, he was more of the school of Philip Webb. But his three years with Caröe, the 'big gun' among church architects as Eric called him, were certainly not wasted. The disciplines he learned there in architectural drawing and the techniques of building were always to stand him in good stead, to such an extent that he clung to the theory that all painters and sculptors, even poets and musicians, should have architectural training. He saw the art of building as the central one, in which all other arts are contained.

Eric Gill was very much a creature of routine, and he got a London routine going quickly. Every morning and evening he made the journey between Clapham and the office in Whitehall Place by horse tram or, for a change, by bus, also horse-drawn, across the old spider-web suspension bridge to Victoria. Sometimes he walked: he always enjoyed walking. He often spent his dinner hour sketching in the abbey and one day in his first week he went over the new Westminster Roman Catholic Cathedral with one of Caröe's draughtsmen. This was the Byzantine-style building by Bentley for which Gill would later carve his famous Stations of the Cross.

To the rather naïve boy from the sheltered life of Chichester Cathedral close the life of Caröe's office was at first quite startling in its raucousness and cynicism. Eric Gill, who joined the office as a very lowly pupil, having been accepted at a reduced premium as the son of a poor clergyman, was assigned to the lower decks. Literally so, for Caröe's office was divided into upper office, where the all-too-gentlemanly archi-tects had premises, and basement where the draughtsmen, pupils and assistants were assembled: there was little contact between floors. Gill would not have seen himself among the gentlemen, for he did not share his parents' innate snobbery. Rather the reverse. But he was too fastidious by nature and by upbringing to ally himself with his contemporaries' crudenesses. Gill was always to be adept at distancing himself from aspects of life which he found unsympathetic; and putting himself under the fatherly protection of the head draughtsman, an agnostic but a pious one, he managed to preserve a kind of state of innocence. He played up his abnormalities: his Nonconformist conscience; his 'poor-relation complex'; his rather deliberately unfashionable appearance; his apparent lack of interest in any girls but Ettie; his hatred of parties; his hopeless-ness at dancing. Already he was taking refuge in a role, that of the out-sider and the oddball, that one way or another he kept going all his life.

The letters he wrote home during those early months in London were in some respects the letters of the most conventional, dutiful curate's son and cheery elder brother. A joke letter goes to Evan, in red ink on patriotic khaki paper, written out in capitals with appended explanation:

I AM WRITING THIS LETTER IN PRINTING NOT BECAUSE YOU CANNOT READ THE OTHER SORT OF WRITING BUT BECAUSE I AM AFRAID YOU WOULD NOT BE ABLE TO READ MY WRITING WHICH IS MOST ECCENTRIC I AM TOLD.

Gladys gets a comic sketch of Eric falling off his bicycle in Whitehall, tangled up with an umbrella, and signed the 'circus boy'. But beneath this surface jollity there are a lot of signs of Eric changing and developing. At this same period he writes to tell his father he has exchanged one of his own sketches of St Paul's from Fleet Street for a fine reproduction of one of Rossetti's pictures of Mrs William Morris – the enigmatic Janey. His visual taste had become sophisticated.

Although he rejected the social life of Caröe's office as a whole he made some influential individual friendships. First of all with de Grouchy, one of Caröe's assistants, who took him home and showed him 'some beautiful things, books lettering furniture etc.', a visit which may have inspired Gill to redecorate his own sitting room at St Saviour's. He repapered this with brown paper in the rather avant-garde manner of that period (just as Charles Rennie Mackintosh was doing up in Glasgow, putting stencil decoration on a ground of wrapping paper), and made himself some silver-paper ornaments. The other, more important, friendship of those early days was with George Carter. He was also Caröe's pupil, but older than Eric and from a very different stratum of society. His parents had a house in Holland Park. Carter soon became the focus for Gill's hero worship, filling the vacuum left by Mr Catt. Gill was hopelessly emotional about those whom he loved, male as much as female, and his retrospective comments about George Christopher Carter, who seems to have become a fairly undistinguished church architect and restorer, are impenetrably gushing. He was 'a revelation'; a new kind of being, hitherto unsuspected; his mind was clear, his body beautiful (which, according to Gill, amounted to the same thing), his manner cheerful and gay. Carter was one of the few heroes Gill stayed constant to. He was never, like so many others, quarrelled with, discarded. The reason for this was perhaps that their friendship was in fact fairly short-lived: Carter died young; there was no time for disillusionment. Gill lettered his friend's tombstone: d. November 1907.

It was also that George Carter seems to have encouraged Gill in a belief which he was always to adhere to, a belief so fundamental that it affected his whole life's work: the perception that architecture was not just a matter of building or 'designing' but reflected whole philosophies, how people live and pray.

'It all goes together': Gill's long search for the integral quality of life, in later years expressed in a whole succession of these catchphrases and jingles, started in the London years of friendship with George Carter. 'George Carter, the integral man!', as Gill described him. It was Carter who showed him what was so unintegral about the view of work, and indeed life, in Caröe's office: the lack of liaison between architects and builders, reflecting class divisions between artisans and gentlemen; the lunacy of building sham Gothic churches of great elaboration in an age of mass-production. Gill's concept of himself as the reasonable person locked in combat with the social forces of unreason dates back to his days in Caröe's office with George Carter, reading *Bishop Blougram* and stirring up subversion.

His diaries, so meticulous and detailed, reveal from day to day all the books which Gill was reading: *The Prisoner of Zenda* as well as Walter Pater, and Carlyle's *Sartor Resartus*, devoured over breakfast in his Clapham lodgings over many months. They show how he was spending his ten shillings a week. His slightly manic habit of listing every item of expenditure – down to 'W.C. 1d.' – started very early. His diary also enters all the people he was meeting. For instance, on 1 February 1902:

> To tea and chat with
> Ed. Johnston
> 16 Old Buildings
> Lincoln's Inn EC

Gill's friendship with Edward Johnston, the great Arts and Crafts calligrapher, was in its early years a close discipleship. It came at a time when he was getting bored with Clapham; the visual surroundings and the routines of church life there were beginning to depress him. St Saviour's sausage suppers quite soon lost their charms for Eric. The meeting with Johnston was also a salvation from his great dissatisfaction with architectural practice as interpreted in Caröe's office. His reading of Fabian tracts and Rationalist Press Association pamphlets, and his natural affinity for the views of Ruskin and Morris on art, labour and the craftsman, had stirred up his discontents with a kind of architecture so far removed from the actual skills of building. He was at the early

stages of a philosophy he developed much much further: that of seeing himself as the maker and the workman. He already knew he needed a more direct involvement. So, at the suggestion of his *alter ego* Carter, he decided to miss out on the evening classes in architecture which all Caröe's pupils were expected to attend, and instead enrolled in classes in practical masonry at the Westminster Technical Institute and classes in writing and illumination at the Central School of Arts and Crafts in Upper Regent Street. Edward Johnston taught the classes at the Central.

The Central School was then a very new school, founded in 1896 and radiating the ideals of the Arts and Crafts movement. It was the antithesis of Gill's old school in Chichester. The co-principal was W. R. Lethaby, an architect imbued with the philosophy of Morris, amongst whose well-known stock of aphorisms was the typical 'only daily-work art is worth a button'. Lethaby, too, had immense influence on Gill who later on referred to him as one of the great men of the nineteenth century, one of the few men whose minds were enlightened directly by the Holy Spirit.

His radical regime at the Central had recruited, for its teachers, not other art-school teachers but practising architects, arts and craftsmen. Some teachers there were female. Women were seen as comrades: May Morris, for example, took the classes in embroidery. The idea of the school was to give a practical grounding to designers and to enlarge the experience of the craftsmen: the emphasis was very much on technique, on skill with one's tools and on real knowledge of materials. The atmosphere was very informal; rather rugged, with that familiar heartiness of arts and crafts endeavours; and by all accounts a little bit chaotic, in an improvisatory building consisting of two houses joined together by a ramshackle conservatory, with odd corners, creaking staircases and classrooms overflowing with keen students. It suited Eric wonderfully well.

Edward Johnston was a classic Lethaby appointment. As a young man who had studied medicine in Edinburgh he had arrived in London aiming to take up art. But once he had met Sydney Cockerell in the Manuscript Room at the British Museum he became addicted to lettering completely. He knew then that his life's work was 'to make *living letters* with a formal pen'. He made contact with Lethaby, hoping to join a lettering class. Lethaby, who in fact was more inspired and reckless than his somewhat prosaic exterior suggested, appointed Edward Johnston to take a class in calligraphy himself. The class had begun in 1899 and Eric Gill joined it in 1901. It had an effect on him so powerful and lasting that the recollection of Edward Johnston, even many decades later,

launched him into one of the most emotional passages in his whole
Autobiography:

the first time I saw him writing, and saw the writing that came as he wrote, I
had that thrill and tremble of the heart which otherwise I can only remember
having had when first I touched her body or saw her hair down for the first time
(Lord! what the young men have lost since women bobbed their hair!), or when
I first heard the plain-chant of the Church (as they sang it at Louvain in the
Abbey of Mont César) or when I first entered the church of San Clemente in
Rome, or first saw the North Transept of Chartres from the little alley between
the houses. Many other things, a million, million, other things are equally good.
I am only saying that these are, for me, the things that stand out. On these
occasions I was caught unprepared. I did not know such beauties could exist. I
was struck as by lightning, as by a sort of enlightenment. There are indeed many
other things as good; there are many occasions when, in a manner of speaking,
you seem to pierce the cloud of unknowing and for a brief second seem to know
even as God knows – sometimes, when you are drawing the human body, even
the turn of a shoulder or the firmness of a waist, it seems to shine with the
radiance of righteousness. But these more sudden enlightenments are rare events,
never forgotten, never overlaid. On that evening I was thus rapt. It was no mere
dexterity that transported me; it was as though a secret of heaven were being
revealed.

What then was so special about Edward Johnston that Gill should think
back on their relationship as on a love affair, albeit a Socratic one,
remembering how he sometimes trembled physically at the mere thought
of seeing Johnston? Edward Johnston was in some ways a very acquired
taste. Even then, in his late twenties, he showed many of the traits of
personality, extraordinary slowness and deliberation of thought and
action, which later acquaintances often found dementing. Another of
his very early pupils at the Central, Noel Rooke, described the initial
impression he gave as one of 'lassitude, of physical strength drained right
out'. Edward Johnston seemed to have been old before his time,
habitually dressed in a brown tweed jacket of superb cloth, cut well: the
sort of classic English garment which became obsolete after the First
World War. Johnston already had an old man's habits and out of his
side pockets would produce, as required, scissors, knives, pliers, little
strips of tin, magnifying glasses, bits of ivory and sometimes a carefully
wiped, scrupulously clean, small oil-stone. Johnston was an oddity, and
as Gill admitted he could have seemed a bore to anyone who wasn't, as
Gill was, 'mad' on lettering. But once Edward Johnston began to talk
on lettering he seems to have been seized with sudden clarity, vivacity,

advancing plans for forming whole guilds of calligraphers, all experimenting and sharing their discoveries. His students were enthralled.

This was of course a period of frenzied rediscovery of long-forgotten craft techniques in many other areas. The Arts and Crafts movement was very much a movement for getting back to basics, for revival of old methods. This was part of its excitement. In his revival of the techniques of calligraphy Johnston had been building on William Morris's earlier enthusiasm for old manuscripts and the scripts, mainly based on Roman letter-forms, which he himself adopted. Johnston's researches were characteristically slower-moving, more exact and thoroughgoing than Morris's had been, and by a painstaking analysis of the actual pen shapes of letters in the British Museum he discovered how these letters in fact had been arrived at: not, as has been imagined, by letters done in outline which were then filled in by brushstroke but a more fundamental skill in letter-forms created by a certain type of pen held at a certain pressure and from a certain angle. He found out again how to cut and sharpen reeds and quills, experimented with skin-surfaces for writing, inks and pigments. The curriculum he established at the Central School was practical as well as inspirational. The notes for his first class give the spirit of it nicely:

<u>Writing and Illuminating</u> – A practically lost art worth reviving – MSS the matter for illumination, therefore writing the main point – the qualities of good writing – Readableness, Beauty, Character – Materials, Parchment (skins), Pens (quills), Inks (Indian). <u>Preparation</u>. Estimating, cutting, cleaning, 'pouncing' – cutting pen, form and manner. Ink (soln.) Practice for copies (rough), Ditto (careful).

The whole approach was careful, systematic; beyond the romanticism there was scientific method. Edward Johnston's urge to know, his very dogged curiosity, was much in tune with aspects of Gill's own inquiring spirit.

It was the certainty of lettering which so delighted them: the fact, as Gill once put it, that letters are things, not pictures of things. An A *is* an A, not some vague approximation. The cult of forthrightness was central to the Arts and Crafts as was its corollary, a very deep suspicion of the high-falutin and the airy-fairy, and Gill and Edward Johnston both subscribed to it. The Arts and Crafts obsession with tools and techniques; the insistence that craftsmen were workmen not fine artists; the idea of precision as a kind of be-all, end-all; all this Gill at this stage responded to with eagerness. It was to some extent familiar from his home

background, from his father's insistence on the right way to peel the apple, the proper sharpening of pencils. But it was something Gill took many stages further, as for instance in the detailed instructions about tools in the chapter he contributed to Edward Johnston's treatise *Writing & Illuminating, & Lettering*. This is a model of informative exactness: 'Above all things the chisels must be of the right temper,' writes Eric Gill, 'and sharp.' And how sharp is sharp? A footnote gives the answer: 'Really sharp, i.e. sharp enough to cut a piece of paper without tearing it.' One might argue that this knowingness, this sense that all the questions should be asked and could be answered, was in fact to prove his limitation as an artist, as it might also be claimed that his curiosity about the relations between humans would rebound on him. By this stage certainly the questing instinct was formidable, and it remained a part of the quintessential Gill.

Eric's father, who was proud of his neat handwriting and the nicely scripted titling he put on his own books, always claimed that Eric's lettering had been inspired by him. And possibly it was. A very early lettering design, a visiting card for a competition in the *Studio*, strikes one as being very much his father's sort of thing. But even before the classes at the Central he was showing signs of branching out beyond pure lettering, in the sense of handwriting, flat upon the surface, to three-dimensional lettering, inscription on stone. His first inscription, labelled as such by him in the great inventory of Gill's inscriptions made by his brother Evan (from 1 to 762), was for a memorial tablet, seven by eleven inches, JANE LISTER A DEAR CHILD, obviously derived from the poignant little panel on the wall in Westminster Abbey which reads 'IANE LISTER dear childe died Oct. 7 1688'. (Gill's inscription is now at Kettle's Yard in Cambridge.) His next piece of work in stone, the tablet in Chichester Cathedral in memory of PERCY JOSEPH HISCOCK, has a pencilled note 'A.E.R.G. 1901, before attending LCC & before E.J.'s teaching'. Gill already evidently had a sense of his direction, which in fact was sculptural as much as calligraphic, and the classes in masonry which he attended concurrently with Edward Johnston's classes at the Central confirmed his early instincts. He enjoyed the scope of lettering on stone; its physicality. He liked the fastness of the action. Gill's early designs for stone were carried out directly, at full size, with a large reed or a cane pen.

One of his very early jobs was for a tombstone, now in Brookwood Cemetery in Surrey. This came about when a well-known painter, J. D. Batten, arrived in the lettering class one day inquiring if anybody there

could cut a tombstone inscription: Eric was suggested. It took him three months, working in the evening, and he was paid £5 for it. Although he was not pleased with it, looking back on it as an 'exceedingly amateurish' exercise, it launched him on his professional career.

At the time of the cutting of the tombstone Eric Gill recorded an equally significant experience. This was the time he first 'went' with a woman. The two events were, he maintains, lodged firmly in his mind together. And one can well believe it, for his careful, almost humdrum method of recording the incidents of day-to-day life in his diaries show that in fact his creative and his sexual activities were rated as events of equal interest. They are given the same weighting, as if somehow complementary.

The account of sexual indoctrination that Gill gives us in his memoirs bears this out. It is put over less as a great breakthrough of experience (it seems to have been only a moderate success), more as an illustration of his own recognition of the influence in general of the erotic appetite upon his working life. He puts forward the argument, surely very partial, that lettering and masonry are not trades for eunuchs, but quite different sorts of priesthood. It is a spirited performance, very Gill-like in its show-off, slightly tongue-in-the-cheek language, pursuing the argument that for the architect, the draughtsman, the stone carver 'the exuberance of nature' is an essential factor. You can see the masculinity:

It either flows forward in a rich stream of enthusiasm or meanders in emasculate hesitancy. The urine of the stallion fertilises the fields more than all the chemicals of science. So, under Divine Providence, the excess of amorous nature fertilises the spiritual field.

Gill attributes his encounter with the prostitute, picked up prosaically enough in Piccadilly, to his need for knowledge about the female body and in particular woman's pubic hair, a matter of most *burning* curiosity: the italics are Gill's, reflecting an obsession which had been going on for several years since the rather chance discovery in Chichester, on being shown a photograph, that adult females do have hair on their bellies. This, the realization which had apparently so tragically disconcerted Ruskin on his wedding night, had for Gill been a source of wonderful excitement, which pervaded his mind, 'filled all the nooks and crannies of thought, both day and night, for several months'. In some ways it evidently never really left him. Gill's fascination with the hair of the female, hair of the head as well as of the belly, its waviness and density, its soft but springy texture, its symbolic use in both attracting and

concealing, recurs all through his work, from his very early sculptures to the last of his nude drawings in the year in which he died.

Eric seems to have told Ethel most of what he did, wisely or unwisely. His confessional streak first surfaced in his frequent accounts of masturbation, in his later days in Chichester and early years in London, entered rather desperately in his diary, day after day, encoded as BAD, BAD, BAD. Ettie was always nice and comforting about it, probably a good deal less anxious than he was: she was, after all, older; sexually more experienced, having been courted energetically by a schoolmaster in Sussex till her parents put a stop to it; and she was practical and tolerant in outlook, willing to overlook most of Eric's foibles. She was always, up to a point, willing to regard him as the wayward child. He told her about his experiences with prostitutes, cleverly asking her to lie with him to save him from temptation and – a good Gill touch – even sending her a very precise diagram explaining the principles of contraception. His diaries at this time have many references to Ettie, touching, wholesome references, as for any courting couple, of his bicycle journeys to Chichester to see her; her visits back to him, which always bring an increase in his London levels of expenditure, carefully computed: e.g. 1s 6d for hansom cab, 2s for theatre tickets, 1s 11½d for gloves, 2d for silk. Such entries can be read, to some extent correctly, as the normal activities and treats of engaged couples heading towards a happy domesticity. But at this same London period Gill recorded a particularly curious sexual encounter on Clapham Common with an old lady, an encounter which in retrospect he seems to slightly shudder at. There was in his behaviour a peculiar correlation between normal and outrageous, domestic and bizarre.

He had not ever truly settled down in Clapham. His sexual irresolutions kept him much on edge. Spiritually he found Clapham less and less appealing: he even gave up going to St Saviour's church on Sundays as the habits of a lifetime were undermined by the worldly mood of Caröe's office and the influence of Fabian free thought. Topographically Clapham seemed increasingly impossible: as shapeless and disconsolate as Brighton, perhaps more. In 1902 he decided to leave, suddenly. It was a move which at the time seemed quite inevitable, though later, as usual, Gill felt very guilty at his heartlessness in leaving benefactors high and dry. It was an idea which had come from Edward Johnston, who wrote from his Lincoln's Inn rooms to his fiancée:

I have been thinking about a plan to let a deserving young architect have the

other half of my bedroom. It will make a considerable change in my régime, tho' it will not affect expenses at present one way or the other. I hope Mr. Gill will earn more money presently, and then he will be able materially to reduce my rent. He is the stone-mason who is cutting the tombstone for Mr. Batten. I hope the plan will be good.

LINCOLN'S INN

1902–4

Edward Johnston's chambers, in the sixteenth-century Old Buildings at Lincoln's Inn, were very beautiful, austere yet comforting: the kind of atmosphere which Eric Gill most liked. They had white painted panelling and a fine vaulted ceiling, and Johnston kept two cats: a black female cat called Pounce, after the powder Johnston used for treating the surface of his vellums, and a kitten known as Higgins after Higgins' indian ink. The feeling of the place was very restful, almost countrified:

It is the most lovely clear, cold, starry dark outside, and here is brightness and whiteness and a glow from the red grate. I have just heard the postman slam the door of the pillar-box below, and then the gate into 'The Fields' shutting after him.

This was Johnston's description, in a letter written just a few months before Eric Gill moved in.

In Gill's search for the perfect resting place on earth, Lincoln's Inn – along with Chichester and Salies-de-Béarn – always rated very high. Its collegiate character especially appealed to him: the way the buildings grouped themselves so well around the gatehouse; the way the architectural layout both reflected and made practical the purpose of the place. Arriving there he felt how he imagined it must feel for an undergraduate starting life in college or a novice entering the monastery; and in view of Gill's later Dominican connections it was a curious coincidence that Lincoln's Inn had been founded on land which originally belonged to the Dominican order, before the Dominicans moved on to Blackfriars. Gill always loved the sense of rules and regulations, as he enjoyed breaking them, and he appreciated the way the gates clanged shut each evening at the appointed time, shutting him away from dissipations of the street. Though Johnston was of course simply a tenant of the Inn of

Court, not an official member, he and Gill still felt themselves a part of the community, accepting the unwritten rules of suitable behaviour. After the rather dislocated life of Clapham, Lincoln's Inn seemed 'Light's abode, celestial Salem'. With a half-embarrassed hindsight Gill wrote 'I know it must seem absurd, but it was no less than heaven to me.'

Gill had not been completely isolated in his Clapham lodgings: church-club life had been well-meaning, though he found it very irritating; friends from the office would come back to supper with him, and he would sometimes visit them at home. But, unlike many of the people he was coming into contact with at Caröe's office and the Central School, he had never in his life so far experienced the everyday life with like-minded companions, the sort of easy-going camaraderie his contemporaries from public schools and universities took more or less for granted. To some extent the male world had been closed to him. Perhaps he even found the give-and-take of it quite difficult. There is a revealing comment in his diary, slightly complaining at the visit of Harold Shaw, a friend from Chichester: 'We don't get on very well now somehow. He never agrees with a single thing I say.' But the question of agreement was irrelevant with Johnston since they shared a freemasonry, a craft and its mystique.

Greta, Johnston's straitlaced intellectual Scots fiancée, had been dubious about Gill. She had a definite resistance to him, then and later on at Ditchling; perhaps because so many women found him so enchanting there were other sorts of women who held out against him strictly. Johnston defended his decision, saying, 'I believe his coming is a good thing, any small inconvenience that may arise can be made to help me and I think it will really help Gill.' A few days later he was writing to tell Greta that Gill had settled in and was improving on acquaintance. Johnston loved expounding: he liked to think aloud about whatever was preoccupying him and would share his train of thought in a random way with anyone, with shop assistants, or porters at the station. Gill too, of course, liked talking. But he was a good listener. And because he and Johnston were such opposites in temperament – Gill being so fast-moving and direct, Johnston so diffident and so laborious, taking a whole term-time to describe the inscription on Trajan's column before he even reached letter C – they got on well together, arguing and arguing, starting the succession of late-night discussions on very abstract topics such as Truth, Right, Faith and Dogma which was to continue for another twenty years or so. Intellectual conversations with chosen male

1 Eric, an early portrait by his father, clergyman and amateur painter.

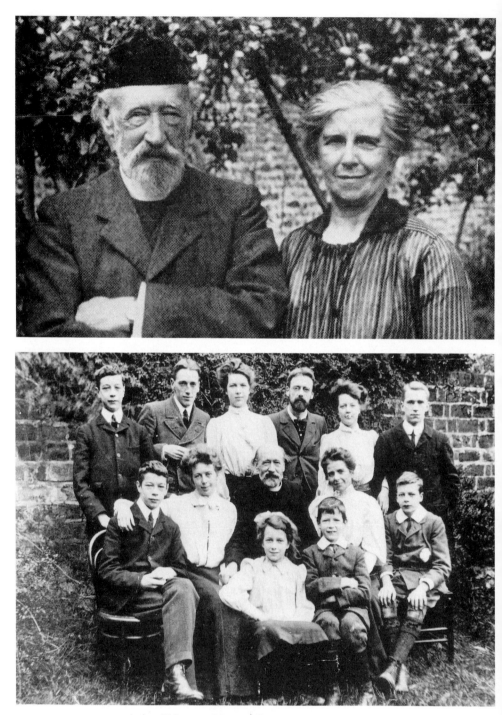

2 Arthur Tidman and Rose Gill, Eric's parents.

3 The Gill family: *l. to r., back:* Vernon, who emigrated to Canada; MacDonald, calligrapher and muralist; Gladys, embroideress and painter; Eric; Madeline, Church of England nun in Poona; Romney, missionary in Papua New Guinea. *middle:* Evan, compiler of Gill *Bibliography* and *Inventory*; Enid, poet and Catholic convert; Arthur Tidman and Rose Gill; Kenneth, killed in First World War. *bottom:* Angela, mother of John Skelton, sculptor and Christopher Skelton, printer; Cecil, medical missionary converted to Catholicism.

4 Portrait of Eric's mother, Rose Gill, 1909. Pencil and watercolour.

5 Portrait of Eric's father, Arthur Tidman Gill, 1909. Pencil and watercolour.

6 *The Countess of Huntingdon's Chapel in Brighton*, where Eric's father
was assistant minister. Ink drawing, *c.* 1896.

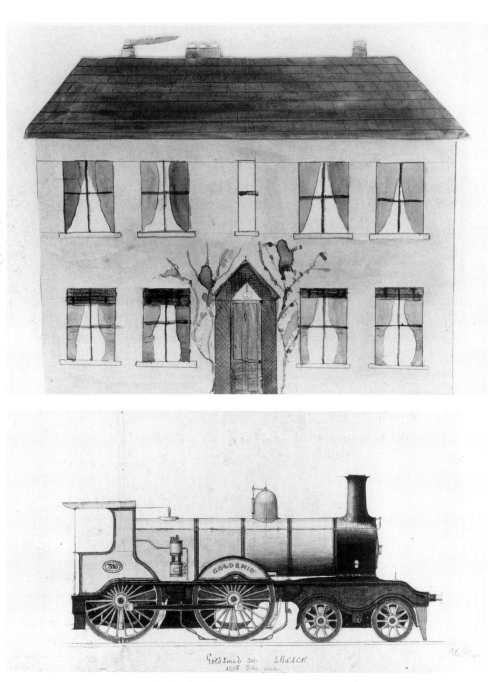

7 Design for his ideal 'four-square' house, by Eric aged ten.
Pencil and watercolour. Inscription on the back reads, 'This is the house
I shall build for us to live in in Preston.'

8 Goldsmid 316, an engine of the London, Brighton and South Coast Railway.
Ink drawing, 1896, when Eric was fourteen.

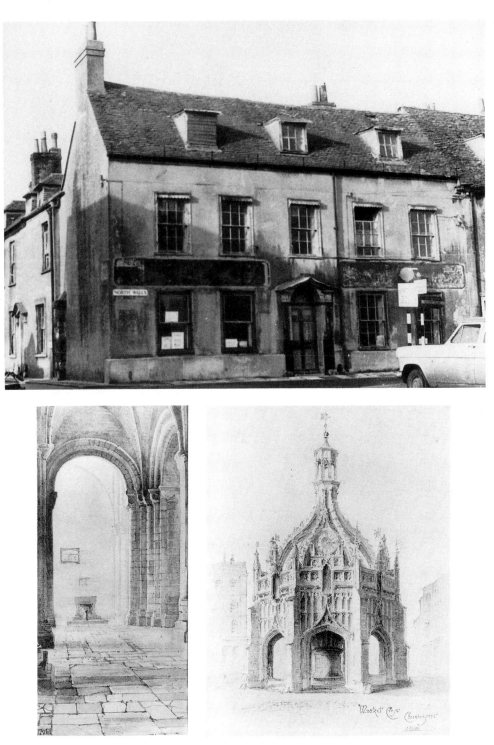

9 2 North Walls, Chichester (now demolished). The Gill family moved here
when Eric was fifteen.

10 *Chichester Cathedral*, view from the south aisle towards the font. Watercolour, 1900.

11 *Chichester Market Cross*. Wash drawing, *c*. 1899.

CLAPHAM
LONDON:

19 : 5 : 1900.

MY DEAR EVAN :

THANKS VERY·MUCH·FOR·YOUR
LETTER : I·AM·GLAD
YOU·LIKE·ME·TO·WRITE·TO·YOU
I·CANNOT·WRITE·VERY·MUCH·TO-
NIGHT·BECAUSE·I·AM·VERY
TIRED·AS·I·HAVE·DONE·A
GOOD·LOT·OF·WALKING·TO·
DAY. THIS·IS·JUST·TO
SHOW·YOU·THAT·I·HAVE
NOT·FORGOTTEN·YOU·ALL
I·PUT·TOO·MANY·O's·UP
ABOVE·I·AM·AFRAID
FROM·YOUR·LOVING·ERIC

12 Letter to his brother Evan, written soon
after Eric Gill arrived in London, 1900.

13 Rubbing of Eric Gill's first letter-cutting
in stone, c. 1901. This was inspired by
the wall tablet to Jane Lister in
Westminster Abbey cloisters.

My dearest Mother: This comes wishing you Many happy returns of the day ∴ ∴
I hope you are very well & will have a very happy birthday, & will like the little
present that I am sending you by the next post. On Saturday I went down to
Hastings for Johnston to take a book which there was not time to post withall.
I arrived there about 2.30. P.M. & after delivering the book & having dinner I had
a very delightful walk along the fore-shore under the cliffs: otherwise the cliffs.
Returning to London by the 5.48, by which time, it being dark, I did not see
the use of staying, a stranger, in a strange-land. I am hoping you will do as you
did: last year and have a day in the land of 'fog & mist', outherelse if dept London.
I wish you would. Do. Now I expect you. Please forgive this too hasty and scratchy
writing: the usual excuses: So now goodbye, with very much love from your son ∴

ERIC

14 Lincoln's Inn, view to the south-west. From 1902, Gill shared lodgings
with Edward Johnston on the top floor of No. 16.

15 Johnston portrait, 1902.

16 Letter written to his mother in Gill's Lincoln's Inn period, c. 1902–3,
showing the influence of Johnston's calligraphic style.

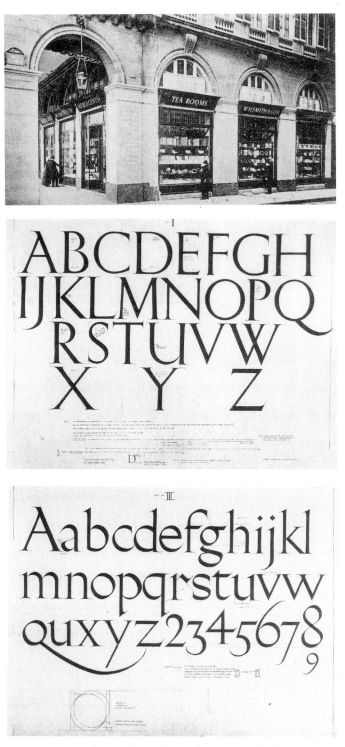

17 W. H. Smith shop in the rue de Rivoli in Paris. Gill's hand-painted
 lettering on the fascia was carried out in 1903.

18 & 19 Alphabets and numerals designed for W. H. Smith, 1907.

W. H. Smith and Son. 114.

May	13	Scarborough Shop. Sign writing.	$\frac{1}{2}$					$1\frac{1}{2}$
"	31	"	23			2	13	0
June	6	"	1					2
June	13	"	$1\frac{1}{2}$					2
"	"	P. Smith's Account				22	5	8
		Extra work re enamelled lettering on glass — say	3				2	6
"	"		32	4	0 0	25	1	$7\frac{1}{2}$
		+25%	1	0 0	= 30	1	$7\frac{1}{2}$	

Send acc. as estimate
at £7. per week + expenses = £32 10 0

Do.
Sun Blind. 22 $\frac{3}{4}$ 1 $\frac{3}{4}$

June 6 " = 2 17 0

 2 18 $\frac{3}{4}$
Send account £ 3 10 0 5% 15 0
 3 13 $\frac{3}{4}$

N.B. June 26.
W.H.S paid £50 on acc
 of 97, 109, 114
∴ 16 : 17 : 0 in
 1 still unpaid.
N.B. Sept. 8.
 Rec^d £2.0.0
 on acc
 ∴ £14. 17. 0 still owing

£ 16 17 0
£ 14 17 0

20 Page from Eric Gill's job book, showing his methodical approach
and modest charges, 1905.

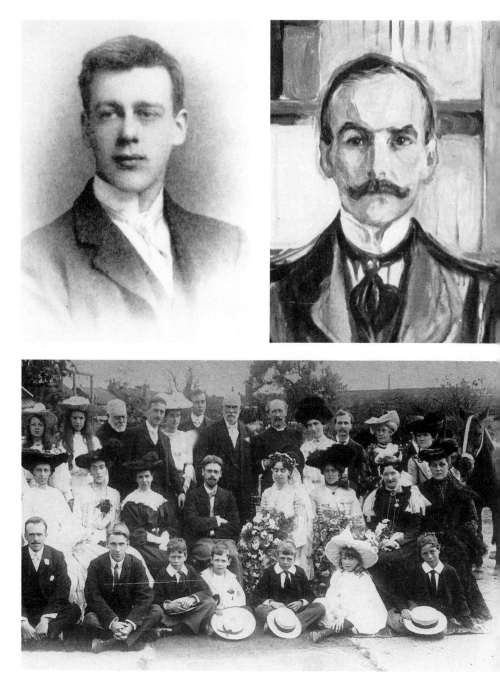

21 Eric Gill aged twenty-two.

22 *Count Harry Kessler*, Gill's first important client. A detail from an oil painting by Edvard Munch, 1904.

23 Gill and his wife Ethel (later, after her conversion, known as Mary) on their wedding day in 1904. Gill's father stands behind the bride and Dr Codrington, who carried out the ceremony, behind the bridegroom.

POST CARD

Plus chère
Toujours
Vivre avec moi
pour les en—
fants

+

Mrs A E R Gill
20 Black Lion Lane
Hammersmith

24 20 Black Lion Lane, Hammersmith (now demolished). The Gills lived here for two
years after their marriage, and Petra, their second daughter, was born here.

25 Loving postcard from Gill to his wife, 20 July 1907, four months after his
return from Chartres.

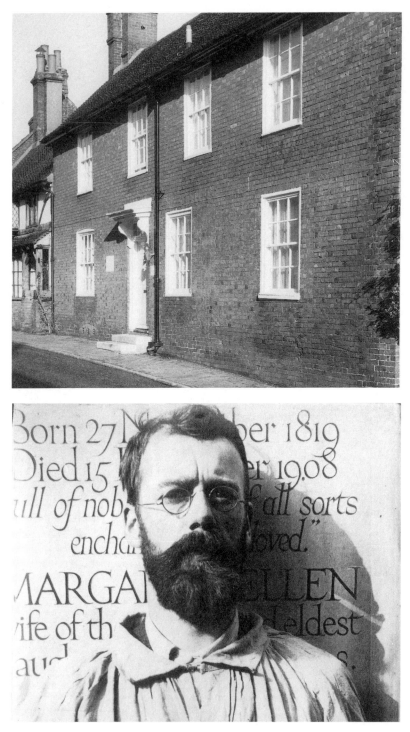

26 Sopers, the Gills' house in Ditchling village. They lived here from 1907 to 1913.

27 Eric Gill soon after his arrival in Sussex, *c.* 1908–9. The stonemason's smock, the garment of his trade, is in evidence already.

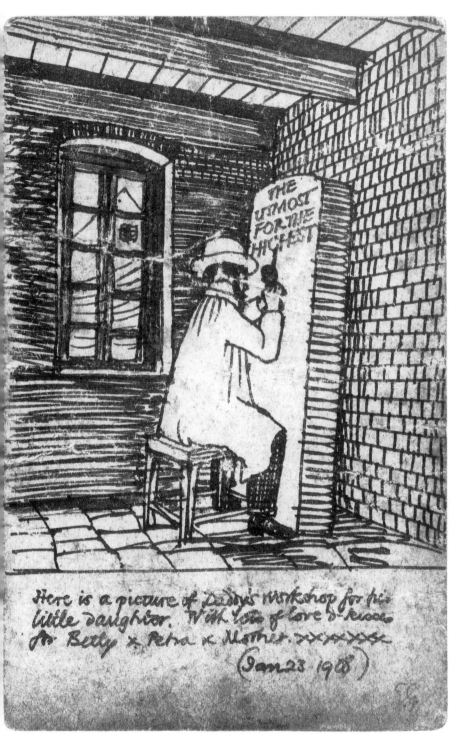

Here is a picture of Daddy's workshop for his little daughter. With lots of love & kisses for Betty x Petra x Mother. xxxxxx.

(Jan 23 1908)

28 Self-portrait in the workshop, drawn for his daughter, Betty, 23 January 1908.

29 A. R. Orage, founder of the Fabian Arts Group and editor of *New Age*.

30 Ananda Coomaraswamy, *c.* 1909, at the time Gill first met him.

31 Study for *Estin Thalassa*, Gill's first stone carving of the human form, 1910.

32 Jacob Epstein with plaster model for
Dancing Girl, one of the figures for his
British Medical Association frieze, 1907–8.

33 *Cupid*, otherwise known as *Cocky Kid*.
Portland stone, 28 cm high, 1910.

34 *Eric Gill and the Artist's Wife*, c. 1913.
Oil painting by Sir William Rothenstein.

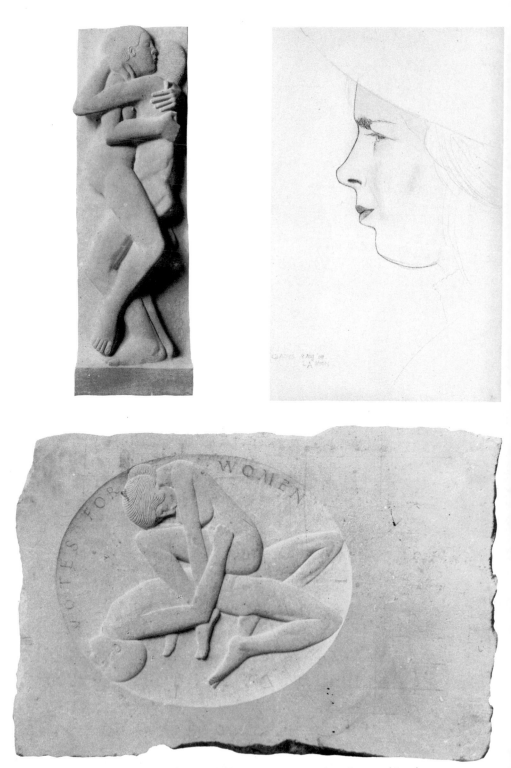

35 *Ecstasy*. Stone, 137 cm high, 1911. This carving was recently rediscovered in a boat
house in Burchington-on-Sea by Gill's nephew, John Skelton.
It is now in the Tate Gallery.

36 Portrait of his sister, Gladys. Pencil drawing, 1909.

37 *Votes for Women*, 1910. Small stone carving which once belonged to Maynard Keynes.

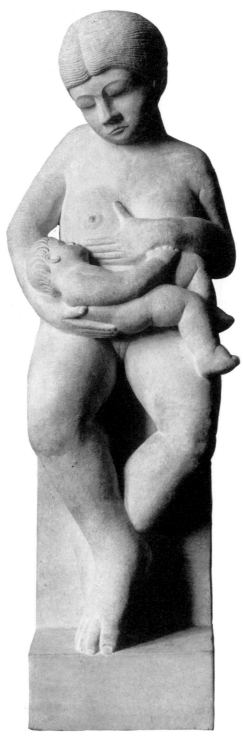

38 *Mother and Child*, 1910. Portland stone carving, 62 cm high,
originally bought from Gill by William Rothenstein.
National Museum of Wales.

39 Hopkins Crank, Ditchling Common, photographed soon after the Gills
moved there in 1913.

40 Postcard showing the Gills on Ditchling Common, 1914. Mary Gill with Joan; Betty
on pony, Petra holding bridle. Eric Gill seen back-view by hedge in hat.

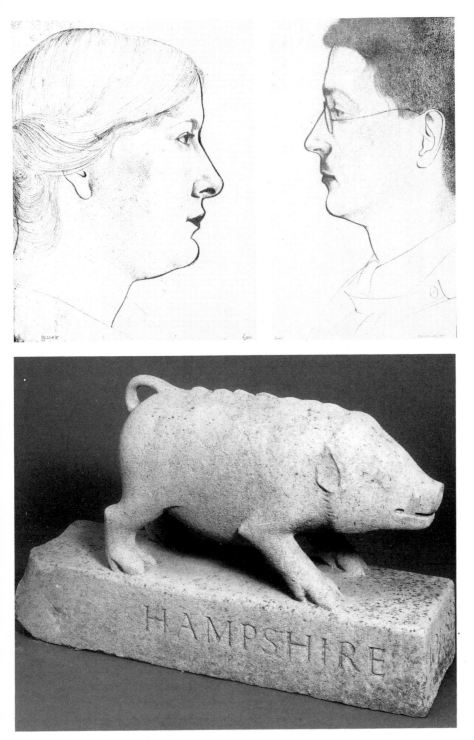

41 & 42 *Agnes Weller* and *Joseph Cribb* engagement portraits.
Pencil drawings, 1915. British Museum.

43 *The Hampshire Hog*. Stone, 50 cm high, 1915. Carved for the Hampshire House
Workshops in Hammersmith, of which Douglas (Hilary) Pepler was a founder.

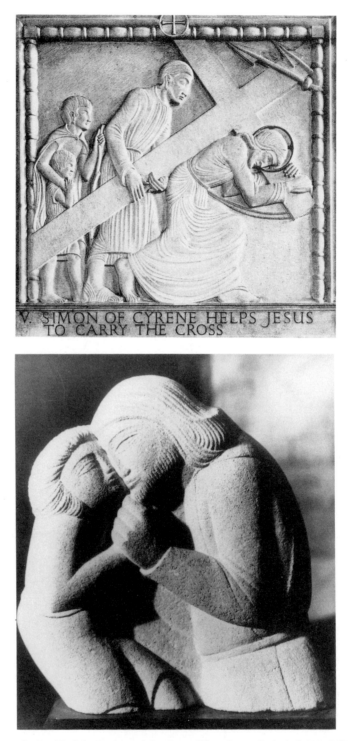

44 Station V of the Stations of the Cross, Westminster Cathedral, Eric Gill's
first significant sculptural commission. He began the work in 1913.
Each of the fourteen panels, in Hoptonwood stone, is 170 cm square.

45 *The Foster Father*. Bath stone, 1923. 25 cm high.

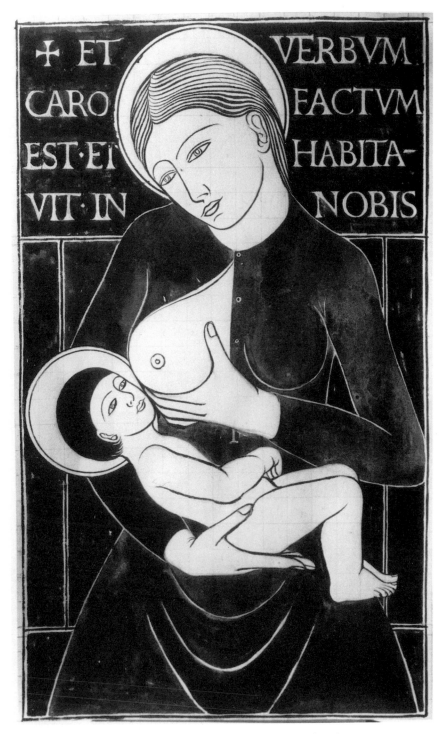

✠ ET VERBVM
CARO FACTVM
EST·ET HABITA-
VIT·IN NOBIS

46 *Madonna and Child*, 1914. Pencil, ink and wash.

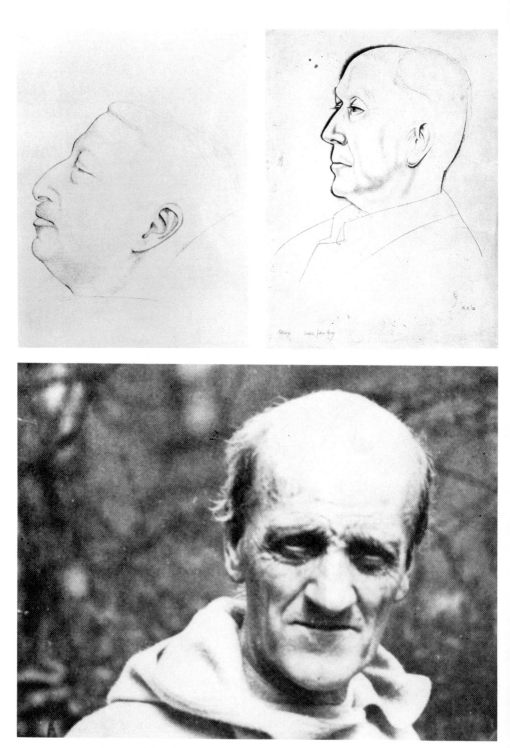

47 *André Raffalovich*, an enthusiastic patron of Eric Gill from 1914 onwards. Pencil drawing, *c*. 1920.

48 *Canon John Gray*. Collotype of pencil drawing, 1928.

49 Father Vincent McNabb in the 1920s.

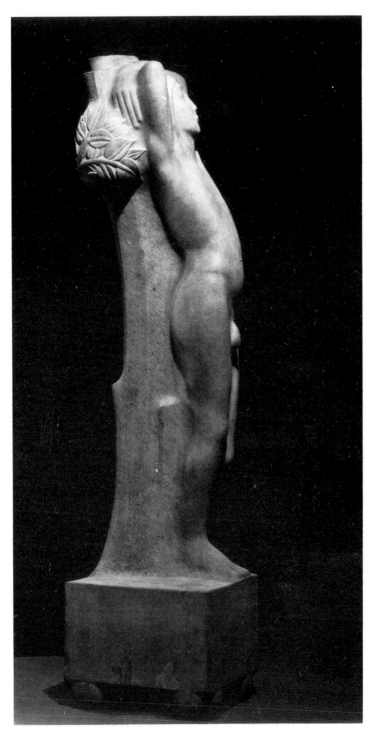

50 *St Sebastian*, commissioned by André Raffalovich, 1919.
Portland stone, 100 cm high. Gill used himself as the model for the figure.
Tate Gallery.

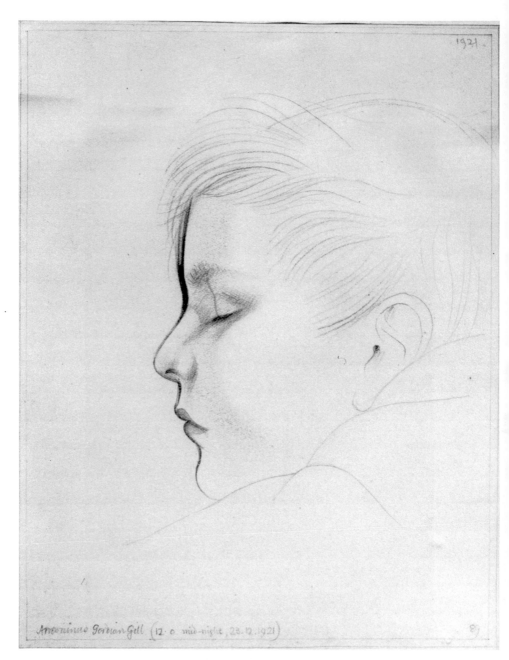

1921

Antoninus Gordian Gill (12·o mid-night, 23·12·1921)

51 *Gordian Gill*, asleep, aged four. Pencil and watercolour, 1921.

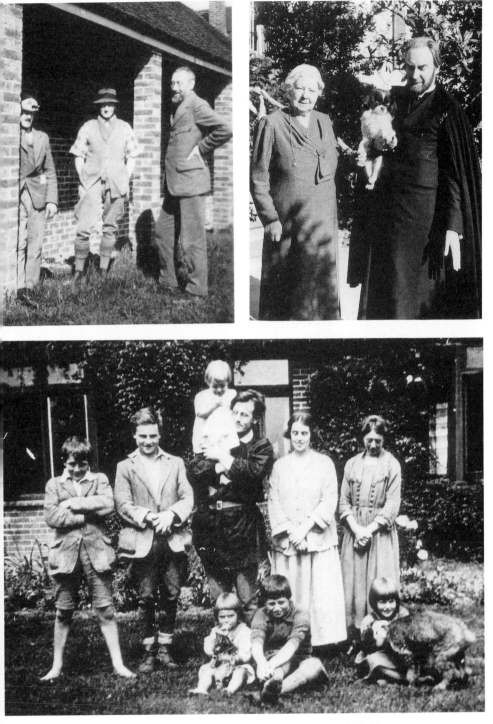

52 Guild craftsmen in the cloister at Ditchling in the 1920s. Joseph Cribb, stone carver;
Valentine KilBride, weaver; Philip Hagreen, carver, painter and engraver.

53 The Revd Desmond Chute with his mother, Mrs Abigail Chute.

54 The Pepler family outside Fragbarrow Farm, 1921. David, who married Betty Gill,
is second from the left. Hilary Pepler in normal working apparel: a black smock, belted.

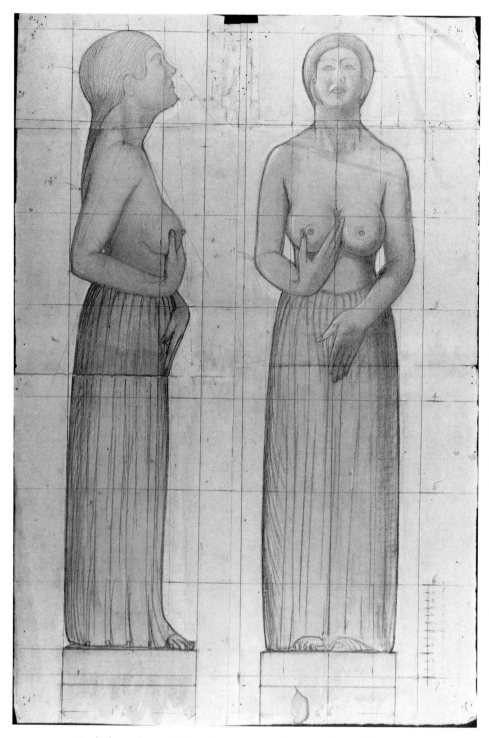

55 Study for sculpture, *Mulier*. Drawing in pencil, watercolour and ink, 1911.

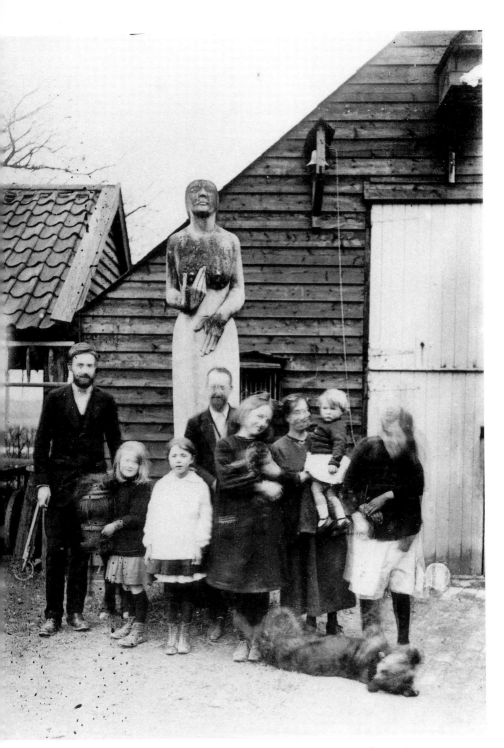

56 The Gills outside the workshop on Ditchling Common with the *Mulier* carving, now on the campus at the University of California, Los Angeles. *l. to r.*: Desmond Chute, Joan, Mary Gill's niece Cicely, Eric Gill, Petra, Mary Gill holding Gordian, Betty.

The Camp, Lewes Race
Course. August 3. 1915.
My dear Betty. I hope
you are quite well. This
is the view I see before
me now as I write.* We
have just come in from
a drill. It is 3. 0. This morning as it
was wet we did not go out until 10.30 &
then we marched into Lewes and some of
us were allowed to go to the open air

57 Letter to his daughter Betty from short-term army camp at Lewes during the First
World War, August 1915. Gill was not in fact called up until 1918.

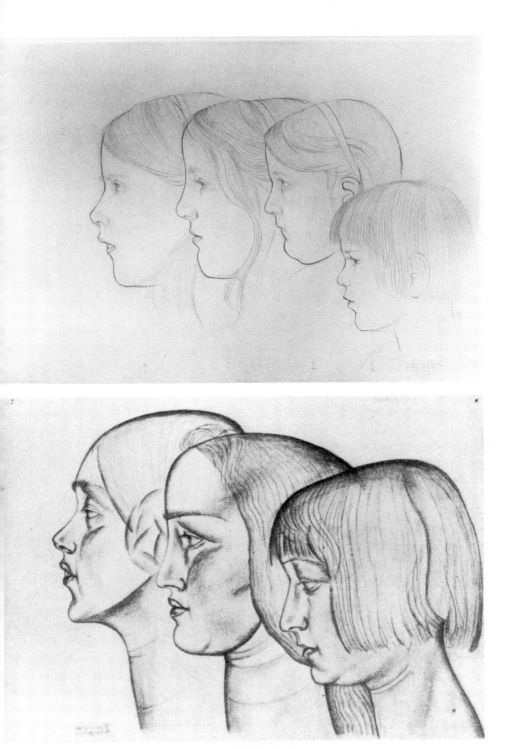

58 *Elizabeth, Petra, Joanna and Gordian Gill*. Pencil drawing, 1914 and 1920.

59 *Elizabeth, Petra and Joanna Gill*: version of Gill's portrait by David Jones, 1924.
Pencil and wash.

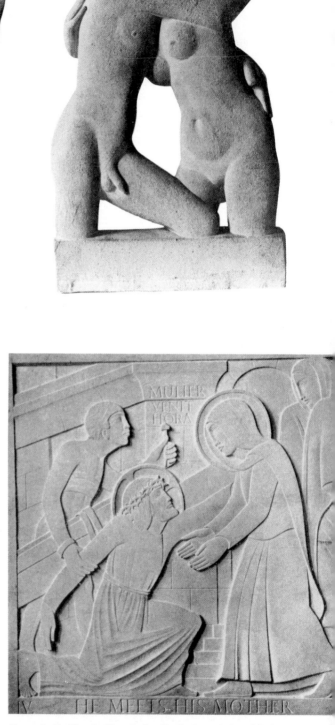

60 *Splits No. 2*. Beer stone,
56 cm high, 1923. Hair and
bracelets painted yellow,
eyes blue and mouth red.
University of Texas at Austin.

61 Fourth Station of the Cross, St Cuthbert's Church, Bradford. Commissioned by
Father John O'Connor. Desmond Chute collaborated with Gill on the Stations.
Beer stone panels, 76 cm square, 1921–4.

62 *Adam and Eve*. Corsham stone, 42 cm high, 1920. University of California, Los Angeles.

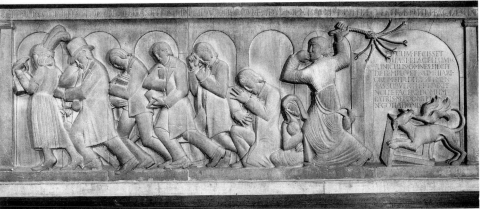

63 A detail of a page from Eric Gill's job book, June 1920, including *Adam and Eve*.

64 *Christ Driving the Moneychangers from the Temple*. Leeds University war memorial. Portland stone, 168 x 459 cm. The Hound of St Dominic is at the heels of Christ, encouraging His followers.

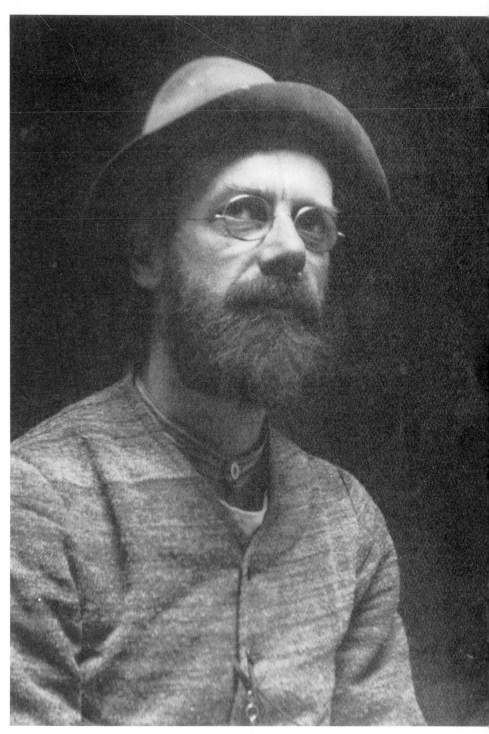

65 Eric Gill in 1924, in felt hat and jerkin made of wool woven by Petra.

companions (for Gill considered women were no good at abstract argument) were to go on till the small hours of the morning all Gill's life.

Another enduring habit which began in those days in Lincoln's Inn was the cult of dropping in, the easy workshop welcome. Again this was a part of the freemasonry of craftsmen. Edward Johnston was of course the key figure in his craft, the *ipse scripsit* of the calligraphic revival. Almost everyone of note in the world of Arts and Crafts scribes and illuminators had been, or was being, taught by Johnston. His chambers became a kind of social centre as well as a scriptorium, a lettering laboratory. His closest disciple Graily Hewitt, by profession a solicitor, lived in Lincoln's Inn as well, and provided Johnston with the services of his own admirable laundress, Mrs Phelps. She looked after Johnston fondly and respectfully, once leaving him a note to say that she had 'taken the liberty' of making him a rabbit pie. Noel Rooke would arrive often, sometimes cooking breakfast while Johnston soaked in his bath, luxuriously, on Sunday. Lawrence Christie, another of Edward Johnston's pupils, was part of this same group, as was Gill's friend from the office, 'integral man' George Carter. Johnston always fed his visitors on toast; he was, it seems, a kind of toast fanatic and would give people instructions on toast-making with the same care with which he taught them how to letter. Sometimes they had what was referred to as 'a flourish' and went out in a group to dine at Gatti's or at Roche's or go across the road to the Cock Tavern for calligraphic conversation. It seemed a period of immense dawning possibilities, and Edward Johnston's chambers were the centre of this world.

Eric was then twenty-one, in some ways still quite young for his age, with relatively unformed views. He still belonged, for instance, to the Queen's Westminster Rifle Corps, and his letters home contain enthusiastic references to early morning shooting practices at Wormwood Scrubbs (*sic*) and inspection by Lord Roberts ('I shall have to go to that shan't I?' Eric adds). But the diaries show the ever widening circles he had access to. The small world of the scribes and the illuminators was part of a much larger world of Arts and Crafts in general, and this again was a kind of subsection of a whole Edwardian-radical group movement, with ideas flooding in for the reform of art and life.

Eric Gill went several times to the Arts and Crafts Exhibition Society show in 1903, though he did not in fact exhibit there till 1906. (The exhibitions were held triennially.) This exhibition was a national one, important in its demonstration of the size and the strengths of a movement which had started back in the 1880s. It was a workshop

movement, very much inspired by Morris. The scribes and the illumi-
nators, individual practitioners by the nature of their craft, were always
slightly on the fringes of a movement which by then was toying with
ideas of communities of craftsmen. This was the great period of craft
guilds, a hopeful – in some ways an over-hopeful – decade in which the
aspirations for handicraft revival could be seen overlapping with the
back-to-the-land movement, ideas about proper working in natural
surroundings, ambitions for revival of the English village. One of the
guilds exhibiting in 1903 was C. R. Ashbee's Guild of Handicraft, a
large mixed-craft guild which had just moved out from London to begin
a new life in Chipping Campden in the Cotswolds. This was a group
with which Gill and his own Guild, later on at Ditchling, had a great
many connections. They were not dissimilar.

The idea of unanimity began to fascinate him in his days at Lincoln's
Inn. He could see it on a small scale in the group of friends round
Johnston: people living side by side and sharing an ideal. Their ideal –
a revival of the lost art of hand-lettering – was pursued with quasi-
religious intensity: letters should be made to live 'that men themselves
may have more life'. Gill was also impressed by what he perceived of the
life of the Inn of Court itself, its built-in rhythms, its historic solidarities.
It was partly a perception of the delights and the potential of neighbourli-
ness of a kind he had not experienced back at home in Sussex: the sense
that neighbourliness could be a meeting of the mind and a communion
of soul, not merely a question of domestic proximity. It led to a great
love of, and dependence on, male company. The man's world, the world
apart, the community enclosed. There can be no doubt that the years in
Lincoln's Inn, with its decorous austerities, years in which Johnston was
starting, very very slowly, his long treatise *Writing & Illuminating, &
Lettering*, helped to develop Gill's taste for the monastic. Much as he
adored women his male loyalties went deeper.

Eric was greatly shaken when Johnston left to marry. It was not till
Greta died, in 1936, that he confessed to Johnston how much it had
affected him, and how it was tied up with his own feelings for Ettie:

I was so moved, excited, all of a tremble, that I stood in the middle of the street
outside what was then the Central School . . . so that I might see you through
the window of the room where the writing class was. I was so overwhelmingly
in love with my girl, and with you. Your marriage was a type of all heavenly
fruitions and consummations. I had to look at you from a distance, in secret,
before I dared approach.

The excess of amorous nature? There were many sources of inspiration at that period. First of all, Gill's depth of feeling for Johnston. Then the sight of his first woman naked at the life class, which he notes in his diary as 'a priviledge [sic] I am not yet oblivious of'. Then there was the success with which he had persuaded his fiancée to accompany him to a hotel in Fleet Street and the adoration with which he had watched her take off her skirt and blouse and her little white corsets. The scene is described delicately in *He and She*:

Then for the first time I saw that she was a woman. I saw the dark full growth of hair on her belly. I touched it and kissed her. By now she was naked. Her breasts – her little tender nipples were against me – Her hair down and covering my face – our lips kissing. So we lay together for the first time.

Whatever the stimulus, Gill's early work in lettering has an extraordinary confidence and zestfulness. The stiltedness has gone, the legacy of Mr Catt. He has by this time become marvellously free both in the way he lays out an inscription, running on the text informally from line to line, and in the idiosyncratic way he forms some letters. A sudden elongated L or T, for instance. An unexpected exaggeration when the mood takes him as, in the Ten Commandments written on to the oak panels of the church at Charwelton near Daventry, the Y in ADULTERY is elongated startlingly, and decorated prettily with swirls and coloured flowers.

By the middle of 1903 Gill was contemplating leaving architectural practice to concentrate on lettering. The sequence of commissions which had started with the tombstone, leading on to an inscription for Holy Trinity, Sloane Street, showed no signs of dwindling: in fact his inscriptional work kept coming in from then until the day he died. Letter-cutting was quite simply a skill that people could make use of. As he himself explained it, he had had the luck to hit on something which no one else was doing at the time. Some jobs came from architects needing letters for new buildings, wanting someone who understood the technical requirements and could save them the trouble of making full-size drawings. Gill hated measured drawings; they reduced the craft to hack-work. Other commissions came in from private clients, the little pool of discriminating people who patronized the workshops of the arts and crafts. Kind relations could be useful. One of Gill's first enterprises, recorded with his usual meticulous efficiency in the job book which from 1902 he ran in conjunction with his diaries, was 'Writing out Beautiful Zion for Uncle Fred.'

In Caröe's office Gill was by this time being regarded as the in-house

letter cutter. He cut the foundation stone for, for example, one of Caröe's strongest, most original church buildings, St Barnabas and St James the Greater in Walthamstow; and some of Caröe's standard office alphabets, especially Caröe's Lombardic letters, were of Gill's origination. He was the person who was always chosen to draw out the inscriptions which came into the office. Gill was a favoured pupil. But he was becoming less and less in sympathy with Caröe's ideas about the function of the architect. His Arts and Crafts and Central School connections were bringing in new work from a different group of architects, the Art Workers' Guild architects, whose philosophy of building was both more idealistic and more down-to-earth than Caröe's. Their offices were smaller, their approach was more Ruskinian. They had theories about the contribution of the craftsman. Names like Beresford Pite, Detmar Blow, Halsey Ricardo, Heywood Sumner, Reynolds Stephens, start appearing in the diaries. Gill was being drawn into that whole brother-hood of architectural craftsmen who tended to see lettering not as an afterthought but as intrinsic to a building, important to its character. It was Charles Harrison Townsend, the architect of the Whitechapel Gallery and Horniman Museum, in both of which the lettering is of the essence, who gave Gill an important commission at this period: the lettering of the lich-gate for Townsend's great religious *tour de force*, the church of St Mary at Great Warley in Essex. Gill's incised inscriptions were done *in situ* on the three thick ten-foot beams of the porch. He liked working on site: it appealed to his romantic craftsman's instincts. He took overnight lodgings in Ingatestone, working daily at St Mary's. He noted 'It is a beautiful place.'

The move from Caröe's office was finally precipitated by another of the Art Workers' Guild architects, the radical, irascible, rumbustious Edward Prior. Prior was a pioneer of community architecture, propounding the theory that the best architecture tends to happen when 'instead of art being the province of a sect, the whole people combines in the pursuit of beauty and becomes endowed with the faculties of artists'. His enthusiasm for lettering on buildings, which labelled them and made them more accessible, was logical. He came across Gill through a protracted correspondence in the *Chichester Observer* about the restoration of the market cross in Chichester which is interesting partly as the first extant example of Gill's life-long, and pugnacious, succession

DANS·LES·CHAMPS·DE·L'OBSERVATION·LE·HA

4 Lettering for the Medical School, Downing Street, Cambridge, 1903.
Gill's first work as a professional cutter of inscriptions.

of letters to the editor, and also as a firm and early statement of belief in
aesthetic honesty and basic craftsman's common sense, advanced in a
tone which one might call Gill Irrefutable: 'Do not let us pretend we are
Gothic workmen when we are not.' The correspondence continued for
two years, with Prior, who lived in Chichester, also contributing in
defence of Eric Gill and in opposition to restoration. Finally he seems to
have invited Gill to tea. The result was a commission for Gill to do the
lettering on Prior's new Medical School in Cambridge, a job which Gill
could hardly contemplate refusing but which he could not carry out
while still articled to Caröe. He did not regret the move. In fact Gill
never minded moving. He remained extremely grateful to Prior, the
provider of what he recalled as his 'first public work' at Cambridge as
well as real artistic influence and friendship. From Prior onwards, such
close ties, such emotional rapports, with his main clients became very
much the the rule.

At the end of 1903 Gill, the inveterate hater of garlic, was in Paris. He
was there to paint the letters W. H. SMITH & SON on the fascia of
Smith's Paris bookshop. He was also commissioned to paint lettering in
the English tea-room which formed part of the Smith's complex, an
outpost of old England in the rue de Rivoli. This was the first of a number
of fascias hand-lettered by Gill for W. H. Smith at the instigation of St
John Hornby, a director of Smith's, a great Arts and Crafts patron and
connoisseur of lettering. His own private press, the Ashendene, is one of
the most famous of its period. His choice of Eric Gill to paint Smith's
signs was an inspired one; whilst other letterers might have treated them
elaborately Gill's approach was absolutely clear and workmanlike.
Although Gill himself only continued the hand-lettering till 1905 when,
on grounds of cost, it was delegated to Smith's own sign-writers ('I do
not mean', wrote Hornby, 'that we consider your charges in any way
excessive . . .'), Gill had established a style which was adhered to by
W. H. Smith for many years to come. It was, as the design historians
would later comment, one of the very first examples of corporate identity.
Not that, at the time, Gill realized such implications. He was preoccupied
with Paris living, tourist pleasures, listing his expenditure on lunch,
stamps, postcards, Eiffel Tower and *bateau* (one of the few times Gill's
accounting ventures into French).

Gill may have been encouraged in his plans to fix a date for his

ARD·NE·FAVORISE·QUE·LES·ESPRITS·PREPARES

marriage to Ethel, at long last, by the way his letter-cutting practice was developing. Looking back on it he wrote:

So one job led to another and if you do all the work yourself and think two shillings or half a crown an hour jolly high pay (that's one advantage of being one of thirteen children – you have pretty low standards), then, as some jobs may take a week and others a month or more, it is clear that you don't want a very large number of jobs in a year.

In fact, from the evidence of Gill's job book, his total of jobs had risen quite dramatically from eight in 1902 to twenty-nine in 1903, the year he had left Caröe. 1904 was looking still more promising. Caröe, from whom he had parted amicably, was still handing on jobs to him. Work for W. H. Smith was accumulating fast: as well as the hand-lettered shop fronts he was occupied with lettering a hundred special bookcases for the Tabard Inn library which Smith's were setting up. He was getting commissions as a type designer: a title-page for the Garden City Association, lettering for advertisements for Heal's – this twenty years before he began to work with Monotype, which most people imagine as his typographic début. The £75 he earned in his first year working on his own account made him confident that enough commissions would come in to marry on. 'Oh, what sport! Oh, what bliss!' Gill wrote. He liked the thought of marriage.

In his idyllic visions of the craftsman's life with Ethel, Gill was also inspired by the example of the domesticity of Edward Johnston. He and Greta were still living near at hand in a small, very plain flat in Gray's Inn, while Eric stayed on in his old chambers, sharing with his brother Max. Max was also enrolled in Johnston's classes. Gill's natural tendencies towards the simple life must have been much reinforced by the life-style of the Johnstons who believed in bare essentials: plain white china, plain deal furniture, and for relaxation a deck-chair padded with Johnston's brown plaid travelling rug. The ideals of honesty were so strictly adhered to that even the hole in the carpet had to be revealed to public view. Gill still spent a good deal of time with Edward Johnston, especially when Greta had gone home to Scotland for the birth of her first baby, and there is a good description in one of Johnston's letters of Gill and Noel Rooke appearing for the night: 'Gill shall have the sofa and Rooke the camp bed. Gill is now preparing dinner, a large tongue, toast, nice butter etc., etc. I am going to take this to Euston, where the late fees are collected, and as Gill likes engines, etc., he's coming with me.'

Through Johnston Gill had discovered the rational approach to lettering. And Johnston was also influential in Gill's concept of a rationality in life, a harmony of surroundings, the idea that domestic equanimity was an essential background for good craftsmanship.

Early in 1904 Gill listed neatly in his diary the necessities for starting married life. This was his shopping list:

> Kettle
> Tea pot
> Small saucepan
> 3 chairs
> Plate Rack
> Double bed
> Broom
> Porridge saucepan
> Sink dish

All these were ticked off with the exception of the bed, which got a cross with a little note appended: 'Double bed try in Walworth R not far from Elephant on rt. hand side.'

BATTERSEA

1904–5

On 4 August 1904 Eric Gill, Calligrapher, married Ethel Moore in his father's church in Chichester. The ceremony was performed by Dr Codrington, Prebendary Codrington, Eric's old mentor, from whom he first learned the strange delights of ancient lettering. Eric was twenty-two; his wife was twenty-six. The bridegroom was conventionally dressed, with a cravat, a butterfly collar and top hat. Wedding photographs show Gill, for the first time, bearded. The reception was held in the long conservatory going back behind Ethel's father's flower shop.

They took a tiny flat in a tenement in Battersea. Gill had a romantic view of Battersea Bridge Buildings, which he saw as a working man's counterpart to Lincoln's Inn with its dwellings grouped around the courtyards and playgrounds and the opportunities it gave for fellowship and neighbourliness. He liked to consider himself an artisan and explained it was by claiming his rights as a working man and letter cutter (and no gentleman) that he was able to start his married life in so propitious a setting. The 'communal dignity' of Battersea Bridge Buildings struck him as much healthier than the suburban streets of modern England. Even though their wedding night was a peculiarly disturbed one, with a fire which started in the timber yard next door and filled their room with smoke and lit it with a fierce red glow, Gill was not to be disconcerted. He and Ethel spent the next few hours watching the blaze and then went back to bed. They got up, had eggs and bacon for breakfast, then retired to bed again. Gill's 'enchanted garden of Christian marriage' had begun.

Sexually he and Ethel were idyllically matched. Whereas his descriptions of his early visits to prostitutes in London have a sense of uneasiness – one, picked up in Bond Street, complains that his male organ is too big and hurts her, and there is cryptic reference to 'a girl in a house in Fulham

who he did not like' – his accounts of sex with Ethel are rhapsodic; her shape suits him:

The roundness and largeness of her legs and thighs and hips, the sudden smallness of her waist and splendid fatness and softness of her buttocks, the thick hair on her belly are beautiful and very exciting.

As in life so in his art. Gill's early female images all tend towards rotundity: this was how he most loved women. Angularity came later. Ethel's pleasures too are evident from her rather quaint and motherly description of intercourse with Eric in *He and She*, with its references to his 'dear body', his 'dear penis'. She writes of a perfect ecstasy of joy and love.

Ethel was soft and pliable, sweet-natured and forgiving. She also had a certain element of briskness. Cecil, Gill's youngest brother, remembers her around the time of the marriage driving over from Chichester to Bognor in her little pony trap and taking him out for a quick ride in it. (The pony trap and the pony, Lasso, remained part of the Gill household for the next twenty years.) She already had considerable family feeling. She was cheerful at the centre of family activity, holding things together. In her unostentatious domestic determination she was much like Eric's mother. Both had artistic backgrounds: Ethel as a girl had been a water-colourist, and under Eric's influence was by now embarking on lettering and gilding. But for Ethel, as for Rose, such things were thought of as subsidiary. She saw her life's work really as that of wife and mother. This view of woman's role suited Eric perfectly.

The day after their wedding Eric and Ethel went parading happily in Battersea Park with all the other married couples. There was a sense in which Gill welcomed, even gloried in, the absolute ordinariness of married life. He paid great attention to the home and things about him, organizing an exchange, after a few months, of the small tenement flat for one just slightly larger with a bigger bedroom, a wider kitchen, an inside closet instead of an outside one, and 'last but not least windows looking out to the south and west right over the river! So therefore all the morning and afternoon sun!' They were certainly not rich: they sometimes had to pawn some wedding presents, choosing the ones Gill considered the most tasteless. But Gill quite liked the idea of the dignity of poverty. He did not think of the future. The work seemed to be enough.

Early in 1905 he did a little sum:

I start the year as follows: – In bank

	11	15	4
	5	10	6
	17	5	10
I owe	7	8	3
I am owed A	45	2	10
B	13	3	0
C	7	0	0
Credit	75	3	5

Ethel also had a small amount invested: there is a certificate among her papers, dated 1905, for twenty shares in the Gold and Platinum Dredging Company of Boston. An ironic legacy in view of Gill's anti-capitalist principles, but as he admitted with his disarming robustness he was not ever one to look a gift horse in the mouth.

In fact, by and large, in those early months of marriage Gill came genuinely closest to the life of the honest workman which he always cultivated. It was one of the great dreams of Arts and Crafts, the movement with which Gill was then so deeply implicated, to achieve the simple life, making useful things by hand, improving the world with one's integrity of purpose and enlarging the vision of other working people. Gill was in actual practice fairly near the breadline and although not working-class in origin, nor indeed in education, he was as near to working-class habits and environment in Battersea Bridge Buildings as he was going to get. His adherence to the motto 'Never buy what you can make' was not an affectation, as it was for many of the Arts and Crafts practitioners: for Gill it was a practical reality. Cutting the foundation stone for the Working Men's College in Camden Town, laid by HRH the Prince of Wales, there would certainly have been no doubt about Gill's loyalties. Betterment of working people, the Ruskinian optimism about workmen's creativity, were things Gill then believed in. But at the same time there was an element of play-acting in Eric Gill the artisan. The question of sincerity applied to Gill is treacherous since Gill had many layers of sincerity and his surface feelings could be in themselves authentic. His delight in the assumption of the role of working man is a very good example of the schizophrenic Gill, partly solemn, partly clowning. He would use a rather jokey kind of working man's phraseology, as Morris and Burne-Jones had done a generation earlier. See, for example the self-consciously comic description of his early days of marriage in his *Autobiography*: ' "Always ready and willing" was our motto with respect to lovemaking and "let em all come" was our motto in respect of babies.' Although in courtship days he had appeared

to favour birth control he later became one of its most passionate opponents. He and Ethel smoked a lot. 'Cigs for Ethel' feature often in the entries in his diary. One gets the impression that though maybe they liked smoking, the cigarettes were also used to demonstrate democracy.

Artisans need patrons as rich men need to patronize (as Gill's later acquaintance Hilaire Belloc was to comment). It was fortunate that one of Gill's most fervent, demanding, loyal patrons was just at this period appearing on the scene. This was Count Harry Kessler, introduced to Gill on the Arts and Crafts circuit by Emery Walker. Kessler was born in Paris, son of a Hamburg banker married to a famous Anglo-Irish beauty, the former Alice Bosse-Lynch. He was godson of Kaiser Wilhelm I, and was one of the most glamorous, fastidious figures of the age. He was a diplomat, a writer, an intriguer, and a great typographical impresario.

Kessler was the first of Eric Gill's grand patrons and their relationship is an interesting one because it set a pattern of success which was continued and which brought him commissions of the calibre he needed. Gill got on with his patrons so marvellously well because he remained himself. He could not be obsequious. This was not in his nature. So even then, though Gill was young and fairly inexperienced, the tall flamboyant figure of Kessler with luxuriant moustache and penetrating glance, the man painted by Munch in a broad-brimmed yellow hat, would not have disconcerted him. In fact rather the opposite. Perhaps he sensed the competition and played up to it. This is where the 'Eric Gill Workman' image dwindled. Or rather it became more subtle and more complex. Eric Gill's relations with his most important clients, with Kessler and later on with Stanley Morison, another of the maestros of the letter form, were more meetings of equals than of artisan and patron. Gill's first job for Harry Kessler, entered in the job book, was to design the title pages for a connoisseur's edition of Goethe's *Schiller*, to be published for Kessler by Insel Verlag.

Although he had work coming in in quite good quantity, including a memorial inscription for Dean Farrar (*Little by Little* still living on to haunt him), Gill's workshop arrangements in the Battersea period were never satisfactory. This was one reason why, after a year or so, he started considering finding somewhere new. He had taken a workshop for a while across the river in Upper Cheyne Row in Chelsea but this was very much an enclave of fine artists who apparently complained about the noises and commotion of Gill's monumental masonry. So Gill was shifted out again. Perhaps this marked the start of his bitter, long

campaign against 'Art-nonsense' and fine artists' pretensions. In any case he never enjoyed the separation of living and working. It seemed to him unnatural. He had Arts and Crafts ideals of fusing work and leisure. In practical terms this meant living where you worked.

There was another reason for househunting: the arrival of Gill's first child Elizabeth, conceived with predictable alacrity and born on 1 June 1905. The name BETTY is entered uncharacteristically untidily in her father's diary, as if scrawled in excitement. With Elizabeth's birth a new phase was beginning: a much longed-for embarking on what Gill always envisaged as the true family life, the traditional vision of children, home and hearth.

His first year in the enchanted garden had confirmed all his ideas of the right pattern for marriage. These ideas, with some small variations, were his views for life. A wife's place was in the home, and if she didn't like the home she would be better off unmarried. Marriage was for procreation: if it weren't for babies there wouldn't be marriage. (If pressed, he could be made to claim there would be no sex either.) His view of Christian marriage and the balance of the sexes was not at all dissimilar to that of his own parents: men central, women in support; men talking, women toiling. There had been a lot of that in Brighton. Perhaps his attitude was now a little more sophisticated, closer to the theories advanced by G. K. Chesterton, a Battersea neighbour whom Gill soon got to know. In an article on 'Woman', written in 1906, Chesterton argued that women in fact had their own freedoms: that within their own four walls they were allowed to be the despots. With this Eric Gill would very likely have concurred. But his view of Christian marriage always was, and always would be, that whilst it imposed many mutual obligations it allowed the men more interesting choices. This view was expressed later with extraordinary clarity in a passage in *Typography*:

Moreover it seems clear that as a firm and hearty belief in Christian marriage enables one not only to make the best jokes about it but even to break the rules with greater assurance (just as a man who knows his road can occasionally jump off it, whereas a man who does not know his road can only be on it by accident) so a good clear training in the making of normal letters will enable a man to indulge more efficiently in fancy and impudence.

Efficient indulgence: this became almost a habit. He was never to allow that women had such confidence.

HAMMERSMITH

1905-7

In 1905 Eric moved from Battersea to Hammersmith. This was his period of red-hot socialism, when his red socks and red tie showed his affiliations clearly. Wrote his brother Cecil:

I can still see Eric as he was then: he had a rather pale complexion, wore glasses and a flaming tie fastened by a ring at the neck: his clothes were not tailored, and not at that time nor at any time that I know of did he have a crease in his trousers. He wore his hair rather long and untidy, not unkempt but merely unregarded. His voice was gentle and evenly pitched and I never remember him shouting. But his mildness of manner cloaked an uncompromising mind.

For an artistic socialist Hammersmith was then, of all places in London, perhaps the most ideal. Kelmscott House on the riverside at Hammersmith had been the home of William Morris and, in his more revolutionary phase, the Hammersmith branch of the Socialist League used to meet on Sunday evenings in the coach house attached to the main building. To some extent Hammersmith still reverberated with the hopes and the excitements of the 1880s, the radical fervour encouraged by these meetings and by the Sunday suppers held afterwards round the great family table when Morris, like some vast Victorian actor-manager, would lead the discussion with unmitigated energy, crashing his fist down on the table, firing rhetorical questions to and fro. In some ways Gill grew very much like William Morris, not just in his enormous range of arts and crafts activities but also in his need to theorize about them. Gill too liked to be the centre of attention and the vivid memories of Kelmscott House on Sunday evenings, revolutionary talk in a serene domestic setting, the father of the family controlling the discussion, were scenes which Gill himself emulated endlessly.

Hammersmith also seemed a good place for Gill to settle because it

was already a haven for fine printers. The tradition had been started even before Morris with the Chiswick Press, an excellent trade printing press, closer in fact to Gill's ideas of proper printing than to the more self-conscious private presses of that period. Morris's Kelmscott Press began in 1891 and the Doves Press, in Hammersmith Terrace round the corner, had been set up in 1901 by Emery Walker and T. J. Cobden-Sanderson. This was perhaps the finest and the most influential of all the private presses, embodying many of the interesting paradoxes of the Arts and Crafts style: classical but never boring, luxuriant, romantic, English, confident, correct. At the time Gill came to Hammersmith the Doves Press was completing its most ambitious project, *The English Bible* printed in five volumes bound chastely in white vellum.

They were by this time the old guard in Hammersmith: the gentlemanly, reticent, revolutionary typographer Walker who had worked with William Morris at the Kelmscott Press and organized the Sunday evening lectures in the coach house; and Cobden-Sanderson, the strange, charming, slightly crazy visionary bookbinder. Walker and Cobden-Sanderson were a kind of Laurel and Hardy of fine printing; one of those comically ill-assorted, exceptionally creative balances of personality. Each in his way summed up Hammersmith in 1900, the Hammersmith Gill found, a place of history, activity and quiet eccentricity, dominated by the changeable landscape of the Thames. In a journal entry of 1900 Cobden-Sanderson described the faintly antiquated scene:

All day, and for many days, a drenching rain has been washing the atmosphere. It has now abated; the clouds have cleared away; the faint light of the set sun still lingers in the west; the dear, white stars come to shine for the night; the full river spreads its mass, and flows downwards to the sea; the lighted barge glides by. How beautiful it is. And within my room the lamp spreads its light, and the fire burns, and the flames flicker. From next door comes patient practising – May Morris, or another. What peace. The soul pauses to take it in, and to say once more, How beautiful it is.

Edward Johnston, inevitably, had preceded Gill to this fine printers' heaven. He and Greta had left Gray's Inn early in 1905 to take over Emery Walker's old house in Hammersmith Terrace. (Walker himself had moved a few doors further on, with that Arts and Crafts dislike of too dramatic an upheaval.) Johnston had been working on *Writing & Illuminating, & Lettering* till 2 a.m. on the day he moved to Hammersmith, but even so the riverside prospects much delighted him and he was soon writing enthusiastically to a friend describing the joys

of a house 'having the advantages of country (very nearly) and town combined' at a rent of about £60 per annum.

So when Gill and Ethel arrived to take up residence in Black Lion Lane the Arts and Crafts atmosphere in Hammersmith was strong. The Arts and Crafts households were mainly in the Terrace, a little group of sixteen eighteenth-century brick houses, not unlike the houses in Chichester but plainer and more urban, with gardens running down to the river, in which the swans still swam. At No. 3 there were the Johnstons; at No. 7 the Emery Walkers; at No. 8 May Morris, William Morris's daughter, by then in her forties, still suffering the ill-effects of her Mystic Betrothal to George Bernard Shaw; at No. 9 the metalworker Edward Spencer of the Artificers' Guild; and at about the time the Gills arrived in Hammersmith the Peplers moved into No. 14.

It was an immediately gregarious community. The Terrace residents, with so many common interests and the *bonhomie* of Arts and Crafts to link them, were in and out of each other's houses frequently. Even the mysterious Miss Morris came to tea with the Gills soon after their arrival. Emery Walker was friendly and paternal and lent Gill £100 (at 3 per cent). But the closest of the Gills' relationships in Hammersmith was with the Pepler family. Douglas Pepler (known as Hilary after his conversion) was a Quaker, social worker with the LCC, and organizer of the first school meals service for schoolchildren in London: an idealist, an enthusiast, a man of charm and energy. Though their friendship at this stage blossomed fairly slowly, Pepler became one of the key figures in their lives.

The houses in the Terrace, though by no means ostentatious, were town houses of some substance. The Gills' house in Black Lion Lane was closer to a country cottage. Ethel had an attic workroom reached up a steep loft staircase, where she pursued her gilding in a pleasurable if somewhat desultory manner: there is a fairy-tale picture of her holding an agate stone to her hair to create electricity.

She and Eric worked together to produce a little series of mirrors, carved by Eric, gilded afterwards by Ethel. They gave one to the Johnstons who hung it in their drawing room over the mantelpiece; another of these mirrors is now in the Victoria and Albert Museum, not a great work of art but an endearing one and a nice memento of the closeness of the early, youthful years of the Gills' marriage. Ethel gilded the mirror, which bore Eric's inscription 'My love is like a red, red rose'.

Husband and wife collaborations were very common in the Arts and Crafts world: it was one of the ideas of the period, prime example of the

overflow of work to domesticity. It was never, however, a very equal balance. For a mixture of reasons, artistic, economic, professional, maternal, husbands tended to be the dominant partner. This was especially true of the Gills. Eric's heart was not really in working alongside his wife, still less in gilded mirrors: he was too impatient, too ambitious and in a way too conscious of his maleness. He needed independence and alongside the cottage in an old stable building he established his own workshop for what he would have seen as the more masculine crafts of letter-cutting and stonemasonry. It was his first real workshop, and in 1906 he took on his first apprentice, Joseph Cribb.

Hammersmith was for Gill, as Chichester had been, a very important period of development. He did his best work against a background of rhythm and repose, and this he found, as he had done in Chichester, in the sedate conviviality of his surroundings. The physical strains of the workshop were much eased with the arrival of fourteen-year-old Joseph Cribb to help with the stone-shifting, although Gill's official agreement with his father, a well-known cartographer and friend of Emery Walker's, undertook not to give the boy more work, or heavier work, than he could reasonably perform. The rather haphazard student-workman days were over. Gill was in his mid-twenties and at Hammersmith he entered into an official partnership with Lawrence Christie, another Johnston pupil. A neat oblong card was printed announcing 'Mr. A. E. R. Gill and Mr. H. L. Christie having entered into partnership in the business of Inscriptional Carvers and Calligraphers are prepared to carve inscriptions on buildings and memorials in wood, stone and marble.' It sounds quite confident and a little self-important. The signs of professionalism have crept in.

Gill's energy, of course, had always been phenomenal and even in the years before he employed any assistant a hundred or so lettering jobs had been recorded: as well as the tombstones and the architectural lettering and the early typographic work for printed books he had got involved in such recondite commissions as heraldry and lettering for repoussé metalwork and the painting of letters on a dome. After Joseph Cribb arrived his output of inscriptional work was almost doubled, and the Hammersmith years saw the beginning of experiments in other *métiers*. Gill was a great experimenter. He had a child's delight in new possessions, as for instance in his 1906 diary entry 'Bought a Kodak, and films £4.8.0,' followed two days later by 'Camera came played with it all morning.' A few months later new enthusiasms surfaced: 'Tried Wood Engraving a little in evening!' This ability to throw himself into

new activities, a temporary focus for most passionate interest, may in the long run have limited his reputation but it still seems one of his most enduring charms.

Gill immersed himself in the life of Hammersmith just as he had quickly settled in at Lincoln's Inn. The one was in a way an extension of the other. This was notably true of the plain living: the Gill and Johnston houses were still plainer in their décor than the houses of the William Morris generation which had always had a certain richness and ornateness. Walls in Gill and Johnston houses were painted white not papered; floorboards were left bare, strewn here and there with plain rush matting, in an early illustration of the decorative style Osbert Lancaster defined as Cultured Cottage. Plain living was intended to stimulate high thinking and this too was transplanted from Lincoln's Inn to Hammersmith: the familiar atmosphere of intense work and solemn pleasures, the hushed mood of the scriptorium, the scratching of quill pens, the mystic sense of craftsmanship. Hammersmith felt so secluded that Cobden-Sanderson, in a curiously prophetic journal entry, wrote:

I want to become a monk. To live in an aerial cell, and do my devotions unseen. I will convert my writing, printing, and binding, into a novitiate with the Higher Life. And I will try to train my pupils, so to write, print and bind.

Such visions appealed to the contemplative side of Gill.

He was back on the old close terms with Edward Johnston: daily communication; endless technical discussions; philosophical debates; supper parties; folk songs. And one day in July 1906 he recorded: 'EJ read Plato to me and Ethel in the workshop.' But their relationship was changing subtly. The intense one-to-one friendship, the disciple and his master, was altered by the new dependency of both on Pepler. It soon became a threesome: three young men, familiar figures as they strolled along the Terrace, chatting by the bus stop, stopping on the doorstep. They had an evening ritual, since all were in the habit of writing late-night letters, of meeting at the post-box (just before the midnight post, that long-lost rendezvous). Johnston's daughter, then a child, has described how long it took them to get home again to bed, where their three wives, the 'letter box widows' as they called themselves, awaited them. They would often go on talking about art and mass production, or maybe faith and reason, until 2 or 3 a.m.

Though Hammersmith was very much a male-centred society and though it could feel deadly quiet, cut-off and monastic, it also had its

more rumbustious familial quality. There were quite a number of young families with children living around the Terrace and Pepler, a natural entrepreneur, organized parties – firework parties, Boat Race parties – with great vigour. The views of the river from the upper windows and the balconies of Hammersmith, and especially the scenes of animation at the Boat Race when, with a stretch of the imagination, Hammersmith could seem to be a homely kind of Venice, have always delighted the artists and designers who have tended to colonize the area: Eric Ravilious, for instance, based a series of his Wedgwood decorations on the thronging Boat Race scenes. Gill enjoyed the children's parties. But this sort of activity brought out his latent instincts for self-preservation: unlike Pepler he was wary of demands on time and energy. He liked it but he did not like it all the time.

Work and leisure; property and morals. As a family man, with one small daughter and another on the way, Eric Gill was becoming increasingly concerned with many of the questions he was later on to tackle in his lectures and his pamphlets. He had already, he tells us, grasped the notion that a good life wasn't only a matter of good politics and good buildings and well-ordered towns and justice in economic relations. He had begun to realize that these same moral principles applied to domesticity: that (in the inimitable Eric Gill phraseology) 'men and women were not just rabbits snuggling down into comfortable little fuggeries when their day's work was done'. He had always had his image of the four-square cottage. He was still in search of the proper definition of the four-square life to match and in 1905, after the publication of H. G. Wells's *Utopia*, he and H. G. Wells attacked the problem of immoral architects and uncongenial buildings in a very sympathetic and amusing correspondence. The result of this was that Wells became a member of Eric Gill's and Edward Johnston's Housemakers' Society.

The Housemakers' Society, which originated in the unlikely venue of Lyons' Smoking Room, was radical in outlook. Its official object was 'to discover the needs of man in relation to the house and in relation to all things connected with the house' and it was concerned with such topics as whether it is better to remove or avoid nuisances (the nuisances including household dust and so on), and the prospects of simplification by science. The Society aimed to minimize domestic labour. Its common-sense approach was close to that of the contemporary socialistic Garden City architects. It forecast some of the attitudes of the Design and Industries Association members in its attack on the shoddiness and

poverty of domestic fittings as opposed to industrial machinery. It was an early bid for efficiency style, for the application of logic in the home; but it was also a matter of morality, a question of achieving four-square lives in four-square homesteads, a starting point towards Eric Gill's cell of good living. Its idealism certainly affected H. G. Wells. When the Society wound down and Johnston, as Treasurer, returned Wells's subscription he replied:

Your noble behaviour shall live for ever in my memory. I am sending you as a modest acknowledgment *Ann Veronica*, because I am fond of her, and in Swedish – lest she corrupt you.

In his socialist years Eric Gill was spending quite a lot of time at meetings of societies: The Housemakers', the Calligraphers', the Art Workers', the Arts and Crafts Exhibition Society, the Fabian Society where John Middleton Murry first encountered him, a 'silent figure in a shabby mackintosh', sitting rather gloomily at a committee meeting rolling his own cigarettes from tobacco in an old tin box. Gill was just beginning, in his days in Hammersmith, to find his feet as a public figure and communicator. He was impelled to do it. He had the lay-preacher style, but there are signs he did not find it altogether easy. The hand-written scripts of his early public lectures are crossed through and through with second thoughts, and he always had some problems in the hall or lecture theatre in making his voice carry. Only will-power got him through.

As a communicator Gill was really at his best in the informal circumstances of the workshops. In the practical sense Eric Gill was a born teacher. 'The drawing and cutting of the Roman letter is by no means an easily acquired art, but Eric, I do believe, could teach it to literally anyone,' as René Hague later pointed out: the sort of skill he taught could not be conveyed by the printed word since it was a matter of workshop practice, of doing, then and there, a particular thing to a particular material, for a particular purpose. Whereas on the platform he was nervous and pontificated, in the workshop he was totally confident, in charge, demonstrating with that immense technical bravura which impressed all his apprentices from Joseph Cribb onwards, reminiscing, philosophizing, missing nothing. He would warn them, with the sort of pun he found so irresistible, 'I have the eye of an E. Gill.'

By 1905 or 1906 Eric Gill was becoming very well known in his sphere. No longer the pupil but now himself the teacher. He was back at the Central, teaching alongside Johnston, sometimes filling in for

him, and was also teaching monumental masonry and lettering for stonemasons at the LCC Paddington Institute. Johnston, who wrote his reference, made the perceptive comment 'Mr. Gill's work is made the more valuable by his sense of architectural fitness.' In this, in the scribes' world, he was unusual. Gill's specialist reputation was confirmed by the publication, at long last, of Johnston's book *Writing & Illuminating, & Lettering* to which Gill had contributed a substantial chapter. This book, which became the standard textbook on its subject, saw the light of day with a great domestic flurry. Gill helped Johnston do up the final parcels for the printers and they literally ran with them to the pillar box. In his relief Johnston told the postman it was a book he had been writing for three and a half years.

Comparing Gill's chapter 'Inscriptions in Stone', originally written in his time at Lincoln's Inn, with his writings and lectures of the Hammersmith years one is struck by how far he had travelled and how fast. 'Inscriptions in Stone' is very sound and very technical, closely concentrated upon its subject: 'Arrangement – The Three Alphabets – Size & Spacing – The Material – Setting Out', and so on. But two or three years later, in his early lectures printed in the *Swallow* and delivered to the Fabians, he is soaring off into philosophy, abstractions. Under socialism:

There will be no artist craftsmen because all men will be artist craftsmen, and no one will talk about it. It will be quite the thing for chairs, bridges, tea pots and butterfly nets to be beautiful.

Eric Gill the workman, with views on the right sharpening of chisels, had begun to see himself as a propounder of ideas.

How had this happened? It was partly no doubt the atmosphere of Hammersmith and the influence of Pepler. Pepler's view of life was broader and his personality more robust than Edward Johnston's: in 1907 he was one of the co-founders of a Club for Working Men in Hampshire Hog Lane in Hammersmith, in a picturesque panelled manor house with a large garden. This was very much a set-up of its time, offering immediately accessible good-fellowship with the chance of more rarefied cultural improvement: Hilaire Belloc, Edward Carpenter and William Rothenstein lectured there; Ellen Terry played Portia in one of the productions of the dramatic society; local artists, Frank Brangwyn, Muirhead Bone, William Richmond showed work in the Annual Picture Exhibition with crafts from Cobden-Sanderson, May Morris, Johnston and Gill. Pepler was a romantic whose practical experience of social

work had not impaired his faith in the working man's potential. He was deeply interested in the theory of craftsmanship and in the possibilities of workshop communities and when, a few years later, Pepler and his partners set up the Hampshire House Workshops, Gill carved a Hampshire hog in stone. His hog became their logo.

Hammersmith just then was right at the centre of what one might call the workshop culture. It was the home and workplace of a surprising number of intellectual craftsmen, of whom Cobden-Sanderson, with his profound theories of craftsmen and the cosmos, was perhaps the ultimate example. But there was also, for example, Romney Green, poet, mathematician, once a Cambridge wrangler but inspired by William Morris to abandon teaching and live by the work of his hands: his tendency to work out his furniture designs by a complex process of mathematical calculation provoked some cutting comments from more down-to-earth art workers. There was also Arthur Penty, pioneer of collectivist theory in relation to the craftsman. His *magnum opus*, *The Restoration of the Gild System*, came out in 1906, whilst Eric Gill was still in Hammersmith. Gill was apt to be patronizing towards Penty, whom he once described as 'a dear, comical sort of man, a naïve person, innocent with the air of "one who knows", provincial, with a veneer of British Museum, one-eyed and a bore but full of zeal and friendliness'. But Gill himself admitted that the idea of revival of the guilds, the organization of trades and crafts by the tradesmen and craftsmen themselves under the protection of national government, a theory so intertwined with developing Distributism, was due as much to Penty as to anybody.

Art and production; workers' responsibility for what they manufactured; democracy of labour and workshop profit-sharing: all these were very much the topics of the day in the more advanced craft circles in which Gill was by then moving. The logical conclusion – workers' control of the factories themselves – arrived for Gill only in the 1930s, in his most thoroughgoing communistic phase. But there was certainly in the early 1900s an intense concern not just with the techniques but also with the destiny of craftsmanship amongst what one might call the thinking craftsmen, the broader-minded brethren of the Art Workers' Guild, of which Gill was then a member, and the Arts and Crafts Exhibition Society, to which he was elected in 1905. This was a group of people greatly influenced by Morris, both in its attitude to the theory of craftsmanship and in its semi-revolutionary political stances. For Gill to see himself as the heir of William Morris would have been quite natural. They had so much in common: early years of training in

architecture; love of lettering; practical skills and grandiose ideas; a facility with words and an innately Victorian sense of mission, sense of duty. Both were grand proselytizers, and both inspired devotion. But Gill was in some ways an avoider of the obvious, and typically he rather by-passed William Morris in the list of his allegiances, judging him lacking in the spiritual qualities as well as short-sighted in his political activism, and settled his life-long loyalty on the remoter and to him the grander figure of John Ruskin. 'He is to be remembered', wrote Gill, 'as one of the few men of the nineteenth century who saw clearly that the roots of human action, and therefore of human art, are moral roots.' What Gill claimed for humanity, and in particular for British working people, was their right to their own view on how they spent their working hours, and an end to the psychological division between working time and leisure time. Gill was demanding a basic workers' freedom which was a freedom of choice and of decision. This amounted to the right to decide for themselves whether they agreed with Ruskin or not.

These were questions on which Gill, precociously at twenty-four, tackled the Fabian Society. He joined the Fabians in 1906 and almost immediately started to harangue them on the inadequacies of the socialist view of art. In lectures and papers he vigorously opposed the view that, as he put it, 'even Socialists hold' that art is something more or less supplementary, subordinate, unimportant. Eric Gill spoke passionately for the centrality of art. Over the next few years, in a succession of serious attempts to persuade the Fabians to get to grips with the fundamental questions of the factory system, trade unionism and machine production in relation to art, it is striking to see the surfacing of the Eric Gill shock tactics, the techniques he developed in his long and energetic career as a polemicist: as when he accuses the Fabian Society of 'still floundering in the Benthamite bog of "the greatest happiness of the greatest number" ', or attacks the trade-union movement as 'an organisation of craftsmen that knows nothing about art'.

Eric Gill rushed headlong into the activities of the Fabian Society with his usual enthusiasm for fresh starts, new pastures. For a time, yet again, this seemed to be the answer. He even went to one of Mrs Webb's notorious 'At Homes' in the house in Grosvenor Road, where the wallpaper, ancient, yellowish and grained to imitate wood, cannot have met with his approval. He discussed the Arts and Crafts with Bernard Shaw: 'had talk about A & C with GBS!' The Fabians themselves were at a fairly crucial period of rethinking and Gill found this stimulating. In December 1906 a quite emotional passage varies the shorthand of

normal diary entries: 'Report of Spec. Com. Great Excitement. I am heart and soul for the Special Committee and reorganisation.' The prime mover in the shake-up of the Fabian Society was H. G. Wells, already at this period one of Gill's friends and heroes (though the friendship is exaggerated in Gill's memoirs), and Gill was naturally on the side of the young Fabians and the Nursery, a group of young reformers within the main society. H. G. Wells was the star performer at the Nursery, increasing the intoxication of the atmosphere with his vision of the futuristic scientific universe and his delineation of the Fabian 'New Woman', the woman untrammelled by conventional mores: two subjects Gill found ambivalently attractive.

The Fabians published lists of members willing to give outside lectures, and on one of these – alongside G. A. Gaskell of Newington Green Road, offering 'Hospital Nurses; their Long Hours and Overwork', and Miss Helena Hadley of Christchurch Place, Hampstead specializing in 'The Old Teetotaller and the New' – we find A. E. R. Gill of Hammersmith Terrace, West London, available to lecture (though not on Mondays) on 'Socialism and the Arts and Crafts'. Of these no doubt Gill would have attracted the most takers. He was popular, already a little bit notorious.

It is ironic, since Gill was in his way just as earnest on his subject as any other Fabian, that he tended to be thought of as a kind of soft option, almost as an entertainer. It was a recurring problem which can partly be attributed to his subject, art still seeming rather *outré* in socialist circles, partly to his idiosyncratic personality, and it was a lasting dilemma because Gill needed an audience just as audiences welcomed what they saw as his performances. The Fabian Arts and Philosophy Group, founded by Gill, Orage and Holbrook Jackson in March 1907, never for example really succeeded in its ostensible purpose of pursuing the ideal relationship of crafts and industry, the craft guilds and the trade unions, and examining the theories of individualism versus collectivism in the context of production. But as a fashionable meeting place and forum in which questions of modern manners and morals were discussed in an atmosphere of wit and candour it was, like many of Gill's later similar enterprises, a success.

Gill influenced the Fabian Society enough to be taken on as typographical adviser for *Fabian Essays*. His comments on the proof of the title page are terse, characteristically confident already:

the block seems on the whole a good one. The only definite errors and blemishes

in it, and which can hardly be due to hasty printing, are in the amperzand following Annie Besant's name, which has had its extreme top cut off, and the s at the end of Wallas wh. has lost a bit of its righthand edge. These are probably the fault of the idiot of a camera.

Gill has so often been put over, and so wrongly, as the champion of anachronism it is rather pleasing to see the common sense and the persistence with which he tries to get the Fabians to modernize their methods. Why had the title of *Fabian Essays* not been set in *type*?

there is so much really excellent type actually in use that it seems silly to use a zinc block which can never print as well as type and is more expensive. It is only a question of good legible type and good arrangement.

At the same time the Fabian Society was educating Gill. This was his education in political direct action. In March 1907 Gill was canvassing in Deptford all day for Sidney Webb. ('Webb got in!') A few months later he was in Trafalgar Square taking part in a large-scale demonstration against the Anglo-Russian alliance. This was followed by what he called a Small Riot in Whitehall. As the demonstrators, four abreast, marched down towards Downing Street to deliver a petition hundreds of police rushed in from the side streets to break up the procession. It was a political awakening curiously parallel to that of William Morris on the famous 'Bloody Sunday' in 1887, also in Trafalgar Square.

But the effect was opposite. Morris's direct involvement in a blatant, ugly scene of repressive violence seems to have confirmed his belief in change by revolution, however far away. Gill's riot in Whitehall proved to him, twenty years later, the futility of so-called peaceful protest against a political system already so hopelessly corrupted. In a sense it pushed him into a retreat from public life. The riot in Whitehall was the experience of a nightmare to someone with Gill's very intense sense of physicality: in later years he could revive the exact feeling of the firm hand of the policeman on his neck.

It was also, by this time, a question of the spirit. He had begun to realize how little he really had in common with Fabian attitudes, to the whole idea of patient systematic progress in the betterment of the human condition. He too had a tidy mind but he was also a very great romantic and his instinctive antipathy to Fabianism as embodied by the Webbs was nicely summed up by his friend Douglas Pepler in *Libellus Lapidum*:

> We are for the PLEBS
> said the Webbs,

The Mess they are in
wants organisin'
they shall toil while we spin
any number of webs.

First apprentice; first camera; first wood engraving; first (and last) official partner; first (and last) riot. Gill's Hammersmith years were influential and eventful; new experiences pile in, all recorded with exactness. Nor were these the only firsts. There was another, of significance. On 14 June 1906, Gill entered in his diary with the same matter-of-factness 'first time of fornication since marriage'. This was a domestic unfaithfulness with Lizzie, the Gills' maid, the maid-of-all-work, paid 5 shillings a year. 'I said to her', wrote Gill, 'wd. she let me lie with her as Ethel was with child. She agreed.' The ⚌ sign, which Gill was using in his diary to signify the sex act, appears again several times over this period, and on 18 August there is the entry 'PETRA born.' It is not clear whether Ethel knew of this liaison. It seems in fact unlikely, since in *He and She*, compiled a few years later, Eric makes several mentions of sex with prostitutes but includes no reference to sex with maids. The Lizzie episode is not so interesting in itself, since it seems to have been short-lived and, from Gill's point of view, relatively unimportant, but it shows a certain *droit de seigneur* attitude in Gill and the ease with which his sexual desires were fired by domestic proximity. He was always attracted, he told Philip Hagreen, by farmers' wives and housemaids – not parlour maids, but old-fashioned skivvies, the category into which Lizzie fits precisely. Gill added, as a general rule, that these last were willing but inordinately modest in refusing to undress.

If Lizzie exemplifies the furtive side of sex, the domestic fumblings Gill found so irresistible, his next love, Lillian, became the exact opposite, Gill's one publicized mistress, his licensed aberration. Lillian Meacham, whose advent is recorded in the diary early in 1907 and whose short tempestuous affair with Eric is described in a tone of intense retrospective passion in his *Autobiography*, was the ultimate example of the Fabian 'New Woman'. They discovered one another through a mutual enthusiasm for Nietzsche, a great wave of which was then engulfing the younger, more adventurous Fabians. He and Lillian read *Thus Spake Zarathustra* together in the evenings, and then a few days later 'Lillian's 1st writing lesson' is noted in the diary; three days further on the second; two days further on the third. It was a whirlwind romance, very much one of its period, carried out in the intervals of listening to Orage

lecturing the Theosophical Society on 'Human Consciousness' and William Rothenstein on 'Art and Religion' at the Fabian Arts Group. It was very intellectual and also very physical. Gill was to describe it as 'a genuine mixture of matter and spirit – both real and both good'.

If Lillian, formidably literate daughter of a Surrey company director, was the diametric opposite of Lizzie, the Gills' skivvy, there were also ways in which she was the opposite of Ethel. Ethel was soft and placid, Lillian tall, bony and nervy. (Gill's daughters, later on when she lived near them at Ditchling, found her rather peremptory manner disconcerting.) Ethel was by no means stupid or ill-informed or politically uninterested: she was a Fabian Society member in her own right. But she lacked Lillian's intellectual flair, inquiring spirit. The suggestion that she, Eric and Lillian should form some kind of *ménage à trois*, which seems to have been tentatively mooted, she could only have regarded with dismay. Although the implications of the affair with Lillian are skated over easily in Gill's account of it in his autobiography, the diary account conveys considerable tensions. For instance 8 February 1907: 'To Lillian in eve. Ethel came too but couldn't get in!' By 8 March, after several experimental outings all together, Ethel and Lillian have decided to have nothing more to do with one another (and, in a prim note of return to duty, 'AERG decides to fulfil all obligations to E'). But the next day he has already changed his mind: 'To see Lessore in eve. To L. after.' Two weeks later he is off to Chartres with Lillian, a New Woman's holiday, free love and architecture, taking in a performance of Wagner's *Valkyrie* at the Paris Opera on the way home.

Gill's description of Chartres with Lillian is more high-flown than his account of Italy, the spring before, with Ethel. This had been a kind of Cook's tour of Rome, financed by the £20 prize he had won at the LCC Central School for an inscription, and it had been a more professional visit with Eric examining the Roman inscriptions from the letter cutter's and signwriter's point of view. Chartres was rather different. The atmosphere was heightened not just by sexual rapture, but by the rapture, which was intertwined with sex, of aesthetic experience: his first sight of Chartres Cathedral. Chartres, which he revisited again and again, was Gill's ideal building. He admired it both for its perfection of detail – the western doorways, the north transept, the sight of the apse from the eastern terraces, the western windows, all of which he described in almost carnal terms – and for its whole internal rhythm. He considered it the most perfectly proportioned stone building in the world. He appreciated it as a great feat of engineering, something solid and precise.

He saw it, too, as the most wonderful of mysteries. Chartres moved him as nothing had ever done before:

Oh taste and see how gracious the Lord is. I did taste. I did see. And though when I first went there, in 1907, I was not aware of such things in these words, I was inebriated with more than a sensual delight; for my sensual delight was, as sensual delight should be: an attraction to the truth.

Despite Chartres's profound sensual delights, Eric Gill did not forget to send a postcard home. He was very good at postcards: his succinct style was made for them. And though this, one might have thought, was a situation to tax the most hardened adulterer, Eric wrote to Ethel with his usual aplomb. The postcard from Chartres which still exists (now in the Gill collection in the University of San Francisco) is addressed to Mistress Ethel Gill and bears the message:

Doesn't the Cathedral look splendid from this view. I only wish I had time to make a large water colour drawing of it. Lucky bugger old Rooke is. There is such heaps to draw here and I am so out of practice. Still I'll try and make one or two good sketches. I wish you and the kiddies were all here. Some day we'll come won't we? We are staying here till Wednesday night then on to Paris and home on Thursday. Eric.

This postcard shows clearly the continuing pull homewards. It also implies his utter confidence in Ethel condoning, if complainingly, his infidelities. The trip to Chartres with Lillian was, for her, the test case. He never seemed to question that she would have him back.

Lillian and Gill returned. The situation settled down. Lillian, at her own suggestion, was taken on as Eric Gill's apprentice, on a three months' trial. In summer 1907, with Ethel and the little girls away in Croydon, Lillian and Eric were playing lots of tennis. Lillian was good at tennis: a sharp, resourceful girl. Though the period of high passion in their affair was over – and the holiday in Chartres was referred to in Gill's memoirs as an efficient means of getting sex out of the system – she and her several husbands remained friends with the Gill family, and her last appearance in the diary is in 1940, only weeks before Gill's death.

A few months after Chartres, in July 1907, Eric went on a sedater foreign journey, an Arts and Crafts outing to Bruges with Sydney Cockerell to see the Tournament and Exposition of the Toison d'Or. Emery Walker and Katharine Adams were also in the party where Gill, far removed from his role as the philanderer, seemed a figure of some pathos who was much teased by the ladies. It is striking how the latent

qualities in Gill, the most important type designer in Britain in this century, were quite unrecognized by the leading lady bookbinder, for Katie Adams was especially dismissive of Eric Gill in Belgium, 'a very shabby silent little fellow in a child's hat'. Nor was Cockerell himself impressed by Eric's personality, though to some extent he revised his first opinion, writing later with a patronizing primness:

Gill was a more remarkable creature than he appeared to be at Bruges, and he wrote and drew exceedingly well. His tendency to be preoccupied with sex was, I think, a great pity.

It is possible that Gill's dismissal as the shabby silent little fellow in the larger Arts and Crafts world, and his ambiguous role as workman-craftsman in a society in which for all its democratic theories the gentlemanly snobberies were still profound, had influenced Gill in his decision to leave Hammersmith soon after his return from the trip to Bruges with Cockerell. Eric Gill did not like to be the little figure. He embraced humility, but only on the terms he chose.

There were other reasons why the Gills' Hammersmith household had been starting to wind down: the amatory dramas; disenchantment with the Fabians; the physical problems of London with small daughters, where the park attendants would forbid them to pick flowers. There was also Gill's old restlessness which surfaced very easily and led to snap decisions to pack up and change directions. He claimed that Ethel too had felt impetuous: ' "Oh Hell!" I said,' he wrote, describing the decision, 'and I think she more or less said the same.'

They had already contemplated moving back to Chichester, the town of both their adolescences, where they still had many ties. Gill and Edward Johnston had, over the years, discussed returning there together: a Chichester scriptorium was an alluring prospect. But as it turned out the Gills' move was more dramatic. It was a move right out of London to the country, to Ditchling, a village a few miles out of Lewes. The Gills found themselves a house there in summer 1907.

On 10 August, Gill tidied up the workshop in Black Lion Lane and they held an 'At Home' from 3 to 7 to which Miss Morris came, as well as Harold Stabler. This, said Gill, was 'a very decent succes'. All in all the years in Hammersmith were certainly not negligible: Gill had made great advances professionally. He had made a mass of contacts. He knew almost everyone of interest and influence in the London art world and the radical-political coteries. His own sphere of activity was widening: he was by this time writing for Orage's *New Age*. But there was still a

sense of lingering disquiet as the Gills packed to leave Hammersmith, the busy river scene, the Gas Light and Coke Co. barges, the pleasure boats with trippers playing tunes on scratchy gramophones:

> Hullo, Hullo,
> A different girl again.

In Hammersmith, Gill had achieved a new perception of the prospects for activity, political and personal. It was a period both formative and frightening: he grasped his possibilities and saw his limitations. He was on the verge of the years of his maturity, in which his growing certainties and powers as an artist were encouraged by the settled semi-reclusive life of Sussex. But it was not quite so simple. It was also an evasion. There can be no question that the move to Ditchling was in one sense another of his great escapes.

SUSSEX

5 *Hand and Cross*, 1920. Wood-engraving.

DITCHLING VILLAGE

1907–13

Early in 1908 Gill wrote to his new friend William Rothenstein from Sopers, Ditchling, Sussex, with the following bulletin:

I have now moved my workshop to the above address & am enjoying myself hugely. Hammersmith will see me no more (as inhabitant). I shall be in London from Tuesday afternoon till Friday, *as a rule*, & my address there you know. (Lincoln's Inn, 16 Old Bgs.) We are having the telephone fixed & our number will be 1143 P.O. City.

Eric had kept on his rooms in Lincoln's Inn, still sharing with MacDonald Gill his brother, but although he always kept up his connections with London he was never again to live there permanently. He found the country more practical, congenial, and also potentially better for the soul.

The Gills had looked at three possible houses in Ditchling and had settled quickly on Sopers. This house, in the village, is a smallish, prepossessing Georgian brick building with a pretty porch and canopy, two sash windows to the right, one to the left and four above. Of all the Gill family homes Sopers was the one which came closest to Gill's vision of the 'four-square' building. It was back to the conventional house of children's building blocks, architecturally regular, homely and demure. Down the path was an outbuilding which would make Gill's workshop. The integral family life seemed very feasible. Sopers seemed to have so many of the attributes Gill needed for his ideal of rational existence.

Ditchling itself, described by Pevsner as 'a cross-shaped village', had great promise. It was, and to some extent still is, the charming backwater, a reticent, self-consciously minor sort of place with houses with quaint names: Pardons and Cotterlings and Crossways. Anne of Cleves' house, a timber-framed building with decorated bargeboards standing near the

church, is the epitome of prettiness. Ditchling has attracted several generations of artists, architects and craftsmen of a certain slightly awkward and reclusive personality – Frank Brangwyn, Ernest Richmond, Ethel Mairet the weaver, Amy Sawyer the calligrapher, Fred Partridge the jeweller. Bernard Leach, the potter, at an especially emotionally fraught period of his life, pitched a caravan at Ditchling looking over the flat land behind the South Downs where he and his friend Laurie lived what he described as a quiet, rather remote but healthy life walking miles over the grasslands, seeing friends in Ditchling village, gathering mushrooms, yellow wild raspberries and plums in a deserted garden. In that English arts and crafts world Ditchling had a special resonance. It came to seem a kind of refuge, a panacea.

Eric Gill already knew the surrounding area well from childhood holidays spent on a farm not far from Brighton. In his *Autobiography* he described in vivid detail a sketching afternoon at Westmeston Church under the Downs, when he was ten and the twins were in the cradle, with four of the Gill children sitting in a row on the grass on the north side of the church when, to their astonishment, a maidservant immaculate in cap and apron appeared from the vicarage behind them with tea and cakes for four served on a silver tray: a lasting vision of enchantment. From those days he remembered Lewes in great detail, Shoreham, Steyning and the Ouse, Patcham, Poynings, Bramber, Beeding and the route over the hill to Clayton and to Ditchling itself in the days before the motor car. The Downs inspired Gill to the intensest of nostalgia, amounting almost to a lament for a lost purity of vision:

If you have been a little child brought up in these hills and in those days, you will understand their mortal loveliness. If in your childhood, you have walked over them and in them and under them; if you have seen their sweeping roundness and the mists on them; and the sheep, and the little farmsteads in the bottoms, then you will know what I am talking about – but not otherwise. No one who was not there as a child can know that heaven, no grownup can capture it.

In this retrospective view – a middle-aged man's memories, with all its wistful phrases, its fond words of physicality – one senses recollections of Gill's early married life.

Gill saw the move to Ditchling as an escape from the trap, the trap of London life. In this he was following the pattern of the time: the pattern of retreat from the squalor of the cities, the ruralist revival of Edwardian free-thinkers. Petra, the small child, was impressed with an enormous 'Back to the Land' banner being stitched in the Gill workroom. He also

saw the move as a statement of intent, a gesture of defiance against the town-centred industrial system and mass production. It was his very heartfelt affirmation of the principle of self-sufficiency: the principle that a workman is fully responsible only for what he does himself. Here, too, he was of course in tune with other craftsmen's thinking. Moving to the country was the logical conclusion of many of the theories of craftsmanship then current in Art Workers' Guild circles. But although Gill's move to Ditchling was part of a whole exodus of craftsmen at that period – Ashbee to Chipping Campden, Gimson and the Barnsleys to Sapperton, Godfrey Blount to Haslemere and so on – Gill's aims were in comparison quite small-scale and informal. It was in the beginning a fairly private gesture, an attempt to solve the problem for himself and his family. He had no ambition to set up a craft community. He did not get involved with grandiose polemics, as Ashbee did, about reviving national moral fibre. Although later events were to alter the whole balance, and indeed to destroy the original intentions, Gill's early motivation in the move to Ditchling was as much as anything domestic and familial. 'There were things', he later wrote, 'about our life in Ditchling, when the children were children,' which – like the best times later at Salies-de-Béarn and Capel – had 'the same quality of paradise'.

The months immediately before the move to Ditchling had been a bit unsettling and alarming, with Ethel ill in hospital in Chichester with peritonitis. She was operated on twice during the period that Eric was packing up and moving into Sopers. However, perhaps partly encouraged by the photographs of Eric in the nude which he himself had taken and sent to her in Chichester Infirmary, she recovered well enough to be let out of hospital after eight weeks, on St Etheldreda's Day. Eric made the thankful diary entry 'Met E. and the children and we came at last to Sopers!' After this the Ditchling days settle down into a healthy and happy routine: walks over the Downs; tea in the fields for Betty's birthday; playing in the hay with Ethel and the children. 'Up the beacon with Ethel in eve,' runs one entry. The diaries of these years are full of hearty pleasures, full of cheerful annotations: 'Great fun!' 'v. jolly!' 'Rippin' day!'

'E. is a dear between you and me,' he touchingly confided in early 1908. As Gill's mother had once been, now Ethel was the focus of Gill's family activities. In his later descriptions of those Sussex summers, when he would take the day off to go walking with the children over the Downs, beginning by the mills at Clayton, tramping on up to the Devil's Dyke to Fulking, the journey always ended in reunion with Ethel who

would drive over in the pony trap to meet the walkers at the Shepherd and Dog inn. They would then all have tea with boiled eggs and bread and butter and jam, 'and then, oh God!' recalled Gill, passionate with the nostalgia of such long-remembered pleasures, 'we elder ones would walk home in the balmy beneficent evening under the Downs'.

It is important to realize that Gill, whatever his current amorous preoccupations, whatever his workload, was very seldom fundamentally distracted from his domestic loyalties. They kept the strongest hold on his imagination. The image of the mother and the children, home tenderness, home welcomings, was almost an obsession, reflected in his art. It was his feeling for the nature of the family, and his instinct that the family was more cohesive in the country than in the city, which had chiefly prompted the move from Hammersmith to Ditchling. Gill had no special yearning for the country *per se*. Indeed in some ways he was impervious to rural beauty. Basically he was an urban person. He tended to regard a country walk not so much as an occasion for communing with nature, more as an opportunity for searching conversation. Philip Hagreen (his companion on many walks) once made the comment that he might just as well have been in Battersea Park.

But to him the country provided fertile soil for his theory of integration to take root. This he later explained as 'the idea that life and work and love and the bringing up of a family and clothes and social virtues and food and houses and games and songs and books should all be in the soup together'. In the country there was room to move and breathe. At Sopers the Gills had a proper entrance hall instead of a poky hallway passage, as at Hammersmith. They also, most importantly, had a substantial kitchen. From Sopers onwards the Gills' kitchens were spacious, an important asset to a family whose breaking of bread was to become a central, and symbolic, feature of their life.

As a boy Gill had been unusually aware of bread: the holy bread of the Communion in his father's Brighton chapel; the disreputable bread mass-produced at Clark's Steam Bakery, with its tall chimney and large roof-top advertisement, CLARK'S MACHINE-MADE BREAD, close to the Brighton house. Once, horror of horrors, it got around the neighbourhood that in one of Clark's loaves a black beetle had been found. This set up a whole sequence of worries and imaginings in Eric's little mind: 'Where did the beetle come from? How did it get there? Was it alive? Was it poisonous? Was Mr. Clark a very wicked man? Were all the people wicked who bought his bread? Would they all die?' Such questions never really left him, and it was surely partly the horror-struck reaction

to Clark's Steam Bakery in childhood, a disgust first aesthetic then by extension moral, which made Gill so insistent on real bread in later life. Home-made bread meant wholesomeness, family harmony, decorum. This was a ritual which first began at Ditchling. The smell of new bread being baked in the brick oven soon became a folk memory of life in Gill households. But, though visitors would write about it rapturously, it could also (when not so new) prove something of an ordeal. Geoffrey Keynes, a very early Ditchling visitor, had still not forgotten when he came to write his memoirs almost seventy years later the difficulty he had had in eating 'the very hard bread' prepared by 'Eric's dear wife'.

6 Christmas card design incorporating male stone-carving tools and female painting/gilding equipment.
Wood-engraving, 1908.

Mrs Gill was indoctrinated into the rural rites of bread-making by helpful neighbours, old Mrs Bourne, the wife of a farm labourer, and the policeman's daughter, Miss Collins, who also taught her how to handle a pig's intestines and gave her instructions in what Eric cavalierly termed 'a host of other domestic doings': things which appealed much more to her than him. Ethel was in fact very keen on country life, which was just as well since they soon accumulated chickens and a cow and a pig, followed by piglets. These were emphatically her responsibility. Farmyard, as well as kitchen, was the Gill woman's domain. Ethel and Eric were very well aware of the growing pressures for a new balance between male roles and female, and in 1908 they attended (together) a suffrage demonstration in Hyde Park. But their division of labour was always most conventional. Eric might give progressive-sounding lectures, as he did at this period to such bodies as the Liberal Christian League on 'Politics Male and Female', arguing that the tendency towards reform in modern politics was undoubtedly a tendency towards feminism and putting forward the theory, still somewhat surprising, that women

manage commerce better than men do because they take it much more seriously. But back within his own four walls in Ditchling, Sussex, his view of sexual politics was anything but pliable. The practice of the household was in essence medieval, and in the way responsibilities had been allotted already, so early on in marriage, with Ethel at the centre of the complex mechanics of the household and the smallholding, the pattern was established which was to last for ever.

This is not to say that Eric took no part in Gill home life. It is only to say that there was no escape for Ethel, no possible alternative if she had ever wanted one. Eric was, when he felt like it, a devoted and ingenious *paterfamilias*, making dolls and doll's houses, surprise presents for his daughters, setting up the mirroscope, decorating Christmas trees. He was an inspired practitioner of the domestic arts. He believed there would and should be art in all domestic rituals. This he spelled out in a lecture of the period which has some tender echoes of George Herbert's *Elixir* and the ecstasy of drudgery divine:

When a man dresses himself in the morning he is consciously or unconsciously an artist, when a maid lays out the table for lunch or blacks her mistresses boots she is consciously or unconsciously an artist.

Here were the first signs of the philosophy of rational and ordinary art which Gill developed with such vigour, his embracing of the 'arts' – with a small 'a' and an 's' – as opposed to Art and the art world which was quite another thing. Art of cooking; art of painting portraits; art with function, art in reason. Gill's view of art was anti-mystique, perhaps too much so; and it sprang from his experience of private domesticity.

He moved into his new workshop beside Sopers in April 1908, officially dissolving his partnership with Lawrence Christie (though Christie later gravitated to Ditchling too). He was busy sorting out practical details, writing a hundred change-of-address cards, organizing return-to-Ditchling labels for the crates which he sent out containing stonework. These labels stated with precision 'Slings to be used not hooks'. Eric Gill was very tidy and dogmatic in the workshop. It was partly the family tradition, inherited as well by Gill's younger brother Romney, the missionary in Papua New Guinea, an excellent self-taught carpenter and plumber whose workshop was a model of discipline and method, with tools all arranged in order and scrupulously kept. It was also, as far as Eric was concerned, the conscious antithesis of Bohemian squalor, of the view of the artist as the inspired outsider, to whom normal rules of life do not apply. And yet Gill's own household could itself seem

fairly *outré*. This was one of the great paradoxes, summed up nervously by Cecil:

Later, as a schoolboy, I visited him at Ditchling and read, 'A bad workman blames his tools: because a good workman does not use bad tools', writ in large letters in his workshop. There was an atmosphere there which, even in my childhood at that time, smacked of 'free thought', 'free living' and even perhaps – oh dear! 'free love'. I remember drinking beer in a pub before breakfast, after a walk on the Downs, and feeling a little sick.

Gill had extraordinary feeling for his family, a feeling which emerged in the regular long, gruff, informative and very hearty letters he exchanged with his brothers and sisters through the years. The tone of these communications never varied. However much and sometimes however disconcertingly he seemed to diverge from them socially and spiritually they were still affectionate and cohesive as a family, with family visits, celebrations, reunions appearing in the diary at very frequent intervals. This was specially true of the early years at Ditchling. Bognor, where Gill's family were living, was quite close. His brothers would come over in twos and threes on visits; Vernon was at one time taken on as an apprentice, but did not survive the first month's trial. Because he was

7 Designs for stationery for the Fabian Arts Group.
Wood-engravings, 1908.

still sharing the flat at Lincoln's Inn, up the dark and winding staircase, with his other brother Max, the family meetings went on in London too and Eric at this stage became especially attached to his sister Gladys, the rebel of the family, in temperament most like his Fabian love Lillian, a complex, witty girl, strong-willed and independent. She too was artistic, and studied at the Royal School of Needlework.

Since the idea of Ditchling as the rural retreat is such a strong one, an idea which Gill and his admirers propounded with such passion in later life, it is in fact surprising to discover from the diary how much of his time he was still spending in London. In the first few years of Ditchling, before Gill became a Catholic and before the Catholic craftsmen and their families assembled around the Gills on Ditchling Common, Gill's connection with Sussex was in practice more or less that of the glorified

commuter. He spent many of his weekdays in London or on travels to carry out commissions or see clients, returning usually, though not always, at the weekends. Professionally, he obviously needed to keep up his contacts: London was where the work was. Perhaps he still needed London emotionally too. Ditchling, though he loved it, could not totally engage him. He seems to have enjoyed the schizophrenic pattern. In his fairly frenzied mid-weeks in sophisticated London he spent much of his time with Gladys and the man she was soon to marry, Ernest Laughton, a rather rough-neck radical and *louche* free-thinker of whom the Gill family did not approve.

Eric went with Ernest Laughton to see Isadora Duncan in July 1908 at the Duke of York's Theatre. 'Isadora Duncan!!' Gill recorded in his diary; 'She had a lot of little girl dancers with her!' The next night he went to see her again. And then the morning after he visited her at noon, Ethel in attendance. There is a good Gill legend that Isadora Duncan wanted to have a child by him. Though evidence is thin it is not perhaps unlikely. They shared a view of the force of natural appetites which was so romantic it could verge on the absurd.

For years before Ditchling took hold of him completely, London stayed his main place of entertainment and experiment, providing the intellectual stimulus Gill needed. He was still in the course of what sometimes seems a lightning progression through all the radical movements of the decade: Gill as Mr Toad. First it had been the Arts and Crafts and then the Fabians. Now he was entering his *New Age* period. Every phase had its hero, its collaborator figure, the man Gill went around with, was inseparable from. For a while this role, once occupied by Carter, then by Johnston, was taken by one of the strangest and most interesting intellectual figures of this period, A. R. Orage.

Gill had designed the masthead for *New Age* when Orage and Holbrook Jackson first bought it, an ailing magazine, in 1907. (He also designed Orage's *New English Weekly*, the *New Age* reconstituted, in

8 Masthead for *New Age*.
Wood-engraving, 1907.

1932: he had a great gift for the continuing relationship, with his clients and his men friends as well as with his mistresses.) Gill and Orage were in some ways very much alike. They had both come to London in the early 1900s; they had both joined the Fabian Society and both found it wanting, for rather the same reasons. It lacked the spiritual dimension they needed. Orage, son of a schoolmaster from Yorkshire, whose first wife was an embroideress in Morris & Co.'s workshops, was by temperament more in tune with the old socialism, the socialism which traced affiliations to theosophy, arts and crafts, vegetarianism, ideas of a simple life and even spiritualism. There was, it seemed to Gill, a sense of the musical glasses somewhere in the background. He recognized Orage as a kindred spirit, writing later in an obituary letter: 'We had intimate friends in common, common enthusiasms, common appetites for earth and heaven. Then we drifted apart – he to Fontainebleau, I to Rome.'

In the period of convergence, before Orage went to France as a disciple of the Russian mystic George Gurdjieff, before Gill became a Catholic, they were involved together first in the Fabian Arts Group and then

onwards in sweeping schemes to reorganize society. They both abhorred wage slavery – what *New Age* knew as wagery – and saw Guild Socialism as the practical alternative. The vision of society as an organism made up of all the various groups of producers, each organized by itself according to its own principles of association, an anti-collective, quasi-medieval system, had an obvious appeal to Eric Gill.

Orage, himself a powerful and generous literary critic, was a great collector-in of other writers of any and every political persuasion, so long as they were good. These were halcyon days. As Augustus John once said: 'The literary generation of his time owes much to Orage. Under his editorship the *New Age* became the best and liveliest weekly.' This was partly because he cultivated conversation with his contributors – Clifford Sharp, G. K. and Cecil Chesterton, Dr Eder, H. G. Wells – who would gather in the Smoking Room of the ABC restaurant in Chancery Lane either after lunch or around tea-time. Gill, being naturally disputatious, found the *New Age* ambience greatly to his liking. Although Gill was a solitary, and made much of it, he needed to be seen to be alone in public, and he much enjoyed the talking-shop, the social centre. He was capable of arguing until the cows came home.

Gill, so well informed, pugnacious, unexpected, was an ideal *New Age* contributor. He could certainly have been a successful journalist: he had the inquisitiveness and the stamina. An early article on art and engineering, in which he argues that engineering work is often extraordinarily beautiful, in the living sense that beauty is power made visible, and that the best buildings are pure works of engineering, is convincing as a journalistic performance, with the confidence and punch of an earlier Reyner Banham, and also interesting as a statement of Gill's taste. When it came to aesthetic understanding Eric Gill was more broad-minded than most people imagine. He had great appreciation of the unselfconscious beauty of functional buildings. He once listed, for H. G. Wells, the London buildings he would defend most strongly against potential demolishers. These were New Scotland Yard; Bentley's Cath-olic cathedral, 'with its "Factory Chimney", as they call it'; the old Lambeth Suspension Bridge ('than which, by the way, I think there is no decenter looking piece of engineering in London'); the LCC model dwellings at Battersea and Millbank; and the new Battersea Power Station. Gill was also particularly fond of the Forth Bridge.

He knew what he liked. He had the plain man's firmness. Cecil once asked him, when they were walking over Ditchling Common, how he could recognize a good picture. He simply replied, ' "Oh I have a flair. I

can flick over the pages of a book of reproductions and tell at a glance." '
He had, more unusually, the same confidence with buildings, and a sense
of the rights and wrongs of modern buildings which have to rely not
upon ornament but on what he termed 'grandeur': their integrity and
size. At a very early stage, in the first years of the century, he had arrived
at his own sort of perception of the modernist theory of form following
function, and his feeling for a style of visual clarity stayed with him. In
the early 1930s, in another of those lists of loves which Gill enjoyed
compiling, he composed a kind of hymn to functional beauty, to the
beauty of necessity which pleases by being made apparent: 'Such is the
beauty of bones, of beetles, of well-built railway arches, of factory
chimneys (when they have the sense to leave out the ornamental frills on
the top), of the new concrete bridge across the Rhine at Cologne, of plain
brick walls.'

This respect for spareness, purity, blatant honesty of structure, was
something Gill had learned in the days of Arts and Crafts. Gill's list of
approved objects – bones, beetles, railway arches – was just the sort of
list which W. R. Lethaby, his patron and mentor at the Central, would
have arrived at. But Gill's faith in Arts and Crafts had by now definitely
wavered. He had begun to get impatient with the theory of it. He saw,
as indeed, Morris and Ashbee had done earlier, that it was economically
impossible for craftsmen to sell except to dilettante markets and that it
was all too easy for the mass-producers to imitate and so debase the
work of the handcraftsmen. Lethaby accused him of crabbing his own
mother as Gill began writing and lecturing pugnaciously on where the
theories of the Arts and Crafts movement had gone wrong. But it was
not just that. Gill was also irritated with the whole mood of the
movement: the dogged, static quality of its aesthetics; its mild conviviality
and endless good-fellowship. The Hammersmith names – Cobden-
Sanderson and Cockerell, Walker, Stabler – now appear less frequently
in Eric's diary, superseded by more cosmopolitan connections with
William Rothenstein and Roger Fry, Augustus John and Jacob Epstein.
Gill, with that perverse disloyalty he summoned up so easily, began to
attack his old friends on grounds of dullness and too much moral probity.
'You can *see* the boys don't drink– you can see they're not on speaking
terms with the devil.' Gill had a rather horrible ability at sneering and
he jeered at Arts and Crafts for being gutless and emasculate.

'I spend all my spare time doing all I can to smash the arts and crafts
"movement" – if you know what that is,' Eric wrote to Romney; 'If you
don't so much the better.' Arts and Crafts by this time seemed to

him the merely arty-crafty; he attacked the movement on grounds of affectation, maintaining that beauty is better left alone. He mentioned that he himself was trying to produce, or to get produced, some modern furniture whose only novelty was good construction, 'and let art take care of itself as it very well can'. Gill always had his idea of the moment. He allowed his current theory to invade him, to obsess him, and the sound construction principle, as he explained to Romney, seemed at that time to be the secret of existence:

I'm doing all sorts of lettering for a living and between times writing, argueing, preaching, jawing, persuading anybody who cares that good construction is the only thing that can be taught or talked about . . .

From the above you'll see that mine is a very simple life and a very simple creed.

Though Gill's life was never quite as simple as he claimed, it was working out well technically. His income from lettering was just about providing the £200 per annum he reckoned as the minimum subsistence he and his family needed. From his work for inscriptions he had progressed to lettering for books which in turn had led to wood engraving. Gill had taken to engraving, encouraged by Count Kessler, because he was dissatisfied with the reproductive qualities of the photographic line block for his chapter headings and title pages: instead of drawing his designs out for process reproduction he preferred the directness of engraving them on wood. The first, very confident and beautiful example is his lettering for the Insel Verlag *Homer*, produced under Kessler's auspices: it uses a serif letter-form, light, clear and rather springy, the antithesis of Gothic, with – for 1907 – an extremely modern feel. Gill was also enlarging his practice as a signwriter and employed a pupil to help him, as well as Joseph Cribb, his apprentice in the stone shop. He sometimes took on masons to assist him with the tombstones when several orders came in simultaneously. His practice in lettering by now had much expanded from the early days with Johnston. Gill was involved with many different sorts of letter: letters penned, drawn, carved and chiselled out, engraved. His range of work was much more varied and inventive than that of any of his calligrapher contemporaries. But it was still lettering. Gill's was still essentially a one-track workshop.

In late 1909, all this changed. At the age of twenty-seven Eric Gill became a sculptor. According to his own account it was sexual deprivation which started him on carving. He was going through a period of 'comparative continence' while Ethel was pregnant with her

GOETHES
DRAMATISCHE
DICHTUNGEN
BAND I

LEIPZIG
MDCCCCIX
IM INSELVERLAG

9 Lettering for title page of Insel Verlag edition of
Goethe's *Dramatische Dichtungen*, 1909.

third child. Because the real woman was not accessible he had the idea of making a stone substitute. He remembered the delight of this first woman long afterwards:

And so, just as on the first occasion when, with immense planning and scheming, I touched my lover's lovely body, I insisted on seeing her completely naked (no peeping between the uncut pages so to say), so my first erotic drawing was not on the back of an envelope but a week or so's work on a decent piece of hard stone . . . Lord, how exciting! – and not merely touching and seeing but actually making her. I was responsible for her very existence and her every form came straight out of my heart. A new world opened before me. My Lord! can't you see it – Lettercutting – a grand job, and as grand as ever – the grandest job in the world. What could be better? If you've never cut letters in a good piece of stone, with hammer and chisel, you can't know. And this new job was the same job, only the letters were different ones. A new alphabet – the word was made flesh.

Gill had never seriously contemplated sculpture before. He had seen himself as the pure and simple craftsman. This was partly because of the conventions of his world: first the built-in artist–artisan divisions of the art schools, followed by the inverted snobberies of the Arts and Crafts cliques he had gravitated into, where craftsmanship was seen as something separate and sacred. This background had up to then induced in Gill an unquestioning acceptance of what was artist's work and what was craftsman's. Human figures had seemed to him impossibly ambitious. So much so that when a customer asked for a cherub on a tombstone Gill would call in a sculptor friend to do the job for him. In retrospect he found these inhibitions puzzling: after all, he had studied ancient carvings and should have realized that there was no intrinsic difference between the skills required for medieval English carvings of angels and saints and the techniques used for decorative floral and heraldic stonework. It was Gill's great talent, one might say his great temptation, to do what he felt like and then find a theory for it. In a way he acted himself into theorizing, and his early experience of sculpture is perhaps the ultimate example of this trait. From a starting point of simple human longing, of wanting to make in solid stone 'round and smooth and lovely images of the round and smooth and lovely things' which filled his mind, he worked himself up towards the highly complex theory which people now see as the quintessential Gill philosophy: the concept of the artist as skilled person, the artist as creator in a context of ordinary everyday community activity. He had an immense coolness and put forward his proposals – for the artist to be treated both as man of imagination and as workman – as the

absolute epitome of common sense, the reuniting of what should never have been separated. In analysing his progress as a sculptor and intellectualizing an impulse which was basically human and erotic, Gill arrived at his own view of the centrality of art.

He liked to describe himself, jocularly, modestly, as a letter cutter who had taken to sculpture. From carrying out lettering on the pedestals of statues he had graduated to the statues themselves. Gill enjoyed the *faux-naïf*, and claimed to see no difference between lettering and sculpture. He was over-simplifying for he knew there was a difference; but it was a difference less marked in Gill's own sculpture than in that of most of his contemporaries. Gill's sculpture was very much the sculpture of a craftsman in its feeling for material, the stoniness of stone, and in the direct vigour with which he approached carving. He rejected the usual method of the day, which was the translation of the master sculptor's model, made in clay, into a stone sculpture by mechanical means by an artisan assistant. He did not exactly disapprove of the modelling-and-pointing-machine method, but it was not his way of doing it. He disliked the whole idea of the division of labour, and anyway the carving was the point of it, the fun. Robert Gibbings, his friend and patron at the Golden Cockerel, understood this instinct well and remembered how Gill shocked two rather prim studio visitors by telling them that working on *Mankind* was like undressing a girl, each layer of stone a garment: first one got rid of the rough woollies, finally the delicate silk.

In London, Gill showed his first carving, *Estin Thalassa*, maiden of eternal seas, to Count Kessler who was enthusiastic. Kessler showed it to Roger Fry, who liked it too. The friends and connoisseurs who had hitherto seen Gill as a pure letterer approved of him in his new incarnation and he went back to Ditchling 'very much bucked'. This encouragement continued. William Rothenstein, on receiving a postcard from Gill with a sketch of a slightly later carving, the sculpture known as *Cocky Kid* (or Cupid), was – even for Rothenstein – enormously effusive:

It is as though I went to the door to take in the milk and find Venus in person, without any clothes on, handing it to me. Damn you sir, a few more P.Cs. and you are the first artist in Europe. When, how, and where did you make the young sun god? He is a wonder – as witty as he is beautiful, as virile as he is short and tubby, and I love his bad temper . . . Send a card of him to B. Berenson, i Tatti, Settignano, Florence.

But pleasing as it was to Gill, this sudden adulation, so different in tenor from the bluff words of approval he was used to amongst craftsmen,

also caused him some misgivings. He stood on the brink of the world of *cognoscenti*. Was this inevitable? Was he getting close to Art?

Certainly as a sculptor, with a sculptor's need of patrons, he was entering a very different social world from the one he had envisaged only six years earlier when he and Ethel had claimed their workers' birthright in moving into Battersea Bridge Buildings. Gill was by nature socially mobile: dining with duchesses held no special terrors for him (though he did admit to a certain embarrassment when once, on a visit to a country mansion, the manservant carefully unpacked his case of tools for him and laid them all out on the table in the bedroom). At the same time he was conscious of his status as a craftsman, so central to his theory of relating art and life. It was not long before the London social whirl was claiming him in a way which must have posed some challenge to his workman's credibility. 'Saw Ed. Lutyens – nice chap,' he recorded in the diary. There were evening 'At Homes' with Lady Ottoline Morrell, events famous for the merging of art world and aristocracy: Gill makes no comment, beyond noting that one night, after leaving Lady Ottoline, he had been fool enough to go home with a girl in Guilford Street. But the tension of loyalties cannot have been lost on him. When he gave a Fabian Arts Club lecture on 'The Artist as Flunkey' he complained that everybody 'of course' misunderstood.

Gill was shepherded along in the high art world by Rothenstein, and it was Rothenstein who introduced him to Ananda Coomaraswamy, the philosopher and critic, expert in the arts and crafts of India. This was an inspired move: they were made for one another, and when Gill heard Coomaraswamy lecturing on 'Indian Art' at the Art Workers' Guild, the words '*a most splendid* paper' (Gill's emphasis) were written in the diary. Coomaraswamy was a Hindu from Madras, son of the anglophile Sir Mutu Coomaraswamy. His mother was English and his first wife Ethel, later Mrs Mairet, became a well-known weaver, one of the main forces in the revival of hand-weaving in this country. She eventually went to live and work in Ditchling too.

Ananda, with his profound concern with the erotic, was prophetically named, for the name has fourfold nuances: the particular delight of lovers making love; God's own enjoyment of the art of creation; the dénouement of drama or 'aesthetic' ecstasy; and finally approach to the Buddha, for Ananda was the name of Buddha's favourite disciple. Coomaraswamy had other links with Gill on the more mundane level of the Art Workers, for he had been associated with Ashbee's Guild in Gloucestershire. It was from Coomaraswamy that Gill borrowed the

pronouncement which he used so often and with such conviction that almost everyone supposes Gill invented it: 'An artist is not a special kind of man, but every man is a special kind of artist.'

10 *Girl with Deer*,
bookplate for Ananda Coomaraswamy.
Wood-engraving, 1920.

Gill later described Coomaraswamy as the wisest and most truthful of all living writers on matters of art, life, religion and piety. Coomaraswamy was important to Gill and essential in this phase of his development. He clarified and intellectualized and made respectable the ideas and the instincts which were latent in Gill's mind, in particular his interest in human sexuality. For Augustus John to claim crassly that Gill was impressed by the importance of copulation because he had so little to do with it in practice was to misread Gill's whole outlook. He liked copulation and had quite a lot to do with it and he insisted, with a determination his friends would from time to time find tedious, on pursuing the basis of eroticism into realms aesthetic, anthropological, philosophical and above all spiritual. It was this which had first made Coomaraswamy seem inspiring in the almost comically incongruous setting of the Art Workers' Guild meeting hall in Queen Square. With a certainty unknown in the circles of the Art Workers they agreed on the essential sacredness of sensual art. Gill from the West, Coomaraswamy from the East, by some convergence of temperament more than education

99

(though Coomaraswamy went to Wycliffe College), had both indepen-
dently arrived at recognition of the ritual religious quality in art. They
both also revered workshops, the traditions of making, the importance
of the craftsman to the balance of all cultures and the sense of nationality.
In Indian art Gill responded to Coomaraswamy's stress not just on the
frank sensuality but on the uncomplicated process of making. As
Gill wrote in his introduction to *Visvakarma*, Coomaraswamy's own
selection of one hundred examples of Indian sculpture:

They avoided the model but carved that which they loved and as they loved it.
They were clear, clean and hard about everything from the beginning to the end.

Clear, clean and hard: Gill had an urge for the ascetic. By comparison
Fabian Socialism seemed almost sentimental.

Coomaraswamy was a tall and graceful man with pale olive skin and
shaggy thick black hair, a contrast in physique to the small, strong, wiry
Gill. He was at the time something of a cult figure, the exotic new arrival
in London artistic-intellectual circles. The Indian poet Rabindranath
Tagore was similarly received when he arrived in England. This was a
period of Indianization in intellectual England, and Rothenstein was
very much involved in the whole movement. The India Society, which
he had helped found in 1910, aimed to bring the British public to a
proper serious understanding of the arts of India, beyond the surface
charm of the primitive and strange. He was also a prime interpreter in
Britain of the Ajanta frescoes. This extraordinary series of murals and
religious carvings based on the birth stories of Buddha had been recently
rediscovered by the British in caves excavated in the side of a ravine
outside Hyderabad.

Ajanta! The idea intoxicated Gill. It became a kind of focus for his
spiritual longings and he wrote to Rothenstein – at the time in India – 'I
agree with your suggestion that the best route to Heaven is via Elephanta,
Elura & Ajanta. They must be wonderful places indeed.'

Gill never actually got to India himself. He was not very adventurous
with foreign travel. He liked outposts, but outposts he could rapidly
return from. His most far-flung expeditions were in the mind. He lacked
confidence abroad as was all too evident in a rather farcical episode in
Paris which took place at this period. Gill was summoned over by Count
Kessler, his main patron. He was just beginning to perceive the tricky
problems of the patron and the patronized, problems more acute for the
sculptor than the letterer because the relationship was harder to define
precisely. Rothenstein, for example, was partly friend and partly patron,

and in both these roles he was inclined to be demanding. Kessler was a dramatically over-active patron; people he patronized became more or less possessed by him. His typically generous and high-handed scheme was to bring Eric Gill to France as an apprentice-assistant to the sculptor Aristide Maillol, another of Count Kessler's long-term beneficiaries. He imagined that Maillol's maturity and confidence could help to lift Gill out of his 'naïvety' as a sculptor: he also hoped Gill's technical skill would be of use to Maillol in the carving of his statues. Gill was slightly tempted, but when he got to Marly-le-Roi to meet Maillol and saw the house which Kessler had actually found and leased in advance of his arrival, he took fright. The house, 'a typical French suburban villa', was far from dreams of the integrated life. Gill could not bear the thought of the unknown and the upheaval: 'Fancy leaving our beautiful house in Ditchling village and leaving God knows what else besides.'

Gill knew that Kessler's scheme would be unworkable but could not quite bring himself to say so. The Marly episode is interesting in the way it shows Gill, the man of candour, the iconoclast, behaving less decisively than one might have expected. It also reveals the unimpressive figure he could cut in those days when transported out of context. When Count Kessler told him to book himself a room in the Grand Hotel in Paris on his return journey the hotel staff took Gill for an imposter and evicted him from the first-floor suite with gilded bed and red-draped canopy when he was half-way through unpacking. Here he was still the little man, the Charlie Chaplin figure in the shabby childlike hat.

Gill escaped. Without much dignity perhaps, but he escaped, as he always did from situations he suspected. Embarrassing though the episode had been, Gill never regretted his decision. He admired Maillol: 'in his own line of business', he wrote, 'I think Aristide Maillol is the greatest man in the world.' He was amused and flattered when later the Tate Gallery got him to repair a Maillol sculpture damaged carelessly; the staff wanted the job done so that no one knew the difference, and Gill liked the idea of being a Maillol substitute. But as far as an apprenticeship went Gill knew quite certainly that Maillol was no use to him: not just for the simple reason that the traditional modelling techniques generally used by Maillol were irrelevant to someone who had made up his mind to be a carver, but also for the much more complex apprehension that he was himself too much in tune with Maillol's views. He sensed that their relationship would lack the necessary tension to be of any artistic value. As he tried, haltingly, to explain it to Count Kessler in a letter of apology after his departure:

The similarity in our ideas, if I may so presume to speak, would be so seductive (Oh! this is an awfully difficult point!) that I should cease to oppose.

Gill needed to oppose. This was a perspicacious comment. The need for opposition was a need deep in his nature. It was what he found so satisfying about stone-cutting: the shock of the action of the chisel on the stone. It was also what he found so pleasurable about love-making, his lyrical perception of the hardnesses and softnesses. To some extent the contrapuntal urge explains his restlessness, more obvious at this period of his life perhaps than ever: life in Ditchling, life in London; country rhythms, urban pressures; Ethel, others. He got back to Sussex with relief, and with devotion. But the opposing urges were always very strong.

When he got back from Marly, early on in 1910, the quiet life of Sussex seemed especially alluring, the soothing routine of country workshop, wife and babies. His third daughter Joanna was born a week after his return. His records are full of small domestic tasks and pleasures, such as 'Mended chair for Ethel'. This took him two hours, as he noted carefully. Family life could make him almost radiant with contentment. It gave his life a necessary framework and stability. But his contrasting yen for the sensational, the raffish, the *mouvementé* life of London, was never so pronounced as at this time.

In London, he was moving into high Bohemian circles. Gill's role at the centre of a grandiose idea for a New Religion, a new community of artists, was described a little rudely by Augustus John in retrospect:

At Eric Gill's instigation, Jacob Epstein, Ambrose McEvoy and I used to gather at my studio in the King's Road, Chelsea, to discuss the question of a New Religion. Gill's idea took the form of a Neo-Nietzschean cult of super-humanity under the sign of the Ithyphallus. Epstein, more simply, would be realised by the apotheosis of himself on a colossal scale, alone, and blowing his own trumpet. I was in favour of the rehabilitation of the Earth-Mother and Child, whose image installed in a covered waggon would be drawn by oxen and attended by dancing corybantes.

Art, Nietzsche, phallus worship: beneath the Chelsea rhetoric one sees again resurfacing Gill's old ideas of fusing work and worship and his visions of exile, the quasi-religious brotherhood, leading lives of quiet reason in defiance of the world.

Of the artists involved in ideas of New Religion, Jacob Epstein and Gill were much the closest. Their work at that time was peculiarly parallel, with its reference back to the primitive sculptures of Africa and

India and their shared obsession with the erotic, especially the images of female fecundity. They were also both sun worshippers. In 1910, their year of greatest intimacy, Epstein had recently completed his frieze of eighteen larger-than-life male and female figures for the British Medical Association building in the Strand. This work had caused a public furore. Gill had entered the controversy in support of Epstein. Their joint plan for a twentieth-century Stonehenge developed through that summer with many London meetings and weekends down in Ditchling, with much photographing of nude adults and nude children. It is an interesting sidelight on the view of things taken by the censor of Gill's diaries that the reference to nude adults was deleted (inefficiently); only the nude children were permitted to remain.

Epstein and Gill were intending to collaborate on a series of immense human figures standing like gods and giants in the Sussex landscape ('as a contribution to the world', as Gill bigheadedly described it). They visited Stonehenge itself for inspiration. They searched out their ideal piece of land four miles south-east of Lewes, a six-acre plot in a valley in the hills with a reasonably large house and some farm buildings. This site, Asheham House, found a niche the next winter in literary history as the house rented by Vanessa Bell and her sister Virginia shortly before she married Leonard Woolf.

Rothenstein had given Gill's schemes an emotional response:

You are wonderful [he wrote] and I believe quite irresistible . . . You shall save a little corner for me, and you shall carve neatly on it – here lies one who loved more than he was loved and Epstein shall carve Shaw nude and you shall make Wells glitter in the light of the sun.

But Gill and Epstein's Stonehenge never did materialize, although at this period both of them did several carvings whose obvious celestial connotations make them look as if intended as the figures of the temple. It later seemed a sadly wasted opportunity that Epstein's enticing, erotic pencil study 'One of the hundred pillars of the secret temple' never saw the light of day in its Sussex destination. The idea lingered on in the imagination, inspiring jokes in *Punch* even in the 1930s, a symbol of grand failure, a lost city of the sun.

The friendship with Epstein was intense for a short time. It was both a social and a working relationship. Epstein worked down at Ditchling on the Oscar Wilde tomb, the great flying sphinx figure for the Père Lachaise Cemetery, 'getting into the way' of carving in stone, and Gill himself provided the inscription, Joseph Cribb being sent over to

Paris for the job. It was characteristic of Gill's pattern of male friendships that his relationship with Epstein while it lasted was extraordinarily close, in some ways an over-friendship. It cut out Gill's other friendships; it seems somehow disproportionate. In autumn 1910 they saw each other almost daily. One night they were watching Marie Lloyd at the Tivoli; the next day visiting the Indian Museum at South Kensington and afterwards admiring the Japanese wrestlers, having dinner with them after their performance. Their friendship was by this time so intertwined domestically that the Epsteins spent Christmas 1910 at Ditchling. But then, all of a sudden, typically, it was over. Gill's closest male friendships, especially those which were also working partnerships, had a habit of rift and conflagration. There were lingering disputes about tools, boots, work unfinished, charges for Cribb's labour, and a more bizarre memento of past friendship: the scar on the wrist of Eric's sister Gladys, inflicted in the heat of the moment as Epstein pursued her round the kitchen table with the carving knife. 'Quite mad on sex' wrote Gill about Epstein in his diary, in the later days of disenchantment. It is pertinent to wonder in fact who was the madder, for the work of both could be quite blatantly erotic in the years when Epstein and Gill were young. Gill was perhaps the eagerer with copulation images. This was the period of his *Votes for Women*, a semi-relief carving showing the act of intercourse with woman ascendant, man semi-recumbent. It is a composition which manages to look both very pure and very shocking. It was bought by Maynard Keynes, who paid a fiver. 'What does your staff think of it?' asked Keynes's brother. 'My staff are trained not to believe their eyes.'

Gill preferred not to use outside models for his sculpture. He liked people close at hand, people he was used to; his friends and relations 'or whoever was willing to take his or her clothes off'. This came to be accepted as more or less a matter of course in the Gill households: the euphemism for it was 'helping Mr Gill'. The models were his sister Gladys and her husband Ernest Laughton for the carving which Gill entitled *Fucking*. This pair of lovers standing, now retitled *Ecstasy*, belongs to the Tate Gallery and was shown in the British Twentieth-Century Art exhibition at the Royal Academy in 1987. Like the sculptor, the models too were interested in experimental sex, and the carving acquires further piquancy since at the time it was in progress Gill was embarking on the incestuous relationship with Gladys which lasted almost all his adult life. Gill also had certain voyeuristic tendencies.

Whilst the carving was taking shape at Ditchling Joseph Cribb, the young apprentice, was stationed to keep guard outside the workshop door.

On the subject of incest Gill was later rather casual, referring in *He and She* to relations with his sisters – almost certainly Angela (Margaret Evangeline) as well as Gladys – almost as if it were not a taboo subject. The other women he had 'known' since his marriage, he asserted, had all been prostitutes 'except for my sisters' and 'a young woman (since married)' – presumably Lillian – with whom he had had an affair, 'very passionate and serious at the time'. Perhaps in the claustrophobic households of his childhood, with his father's suffocating fondness for his daughters, some kind of an approximation to incest in fact was ever present. In later years he gave Philip Hagreen the impression that Arthur Tidman Gill had had incestuous leanings, and his mother had protected the daughters from their father. Modern studies of the patterns of incidence of incest lay stress on just this sort of familial history.

In the households of the Gills, as indeed in many Victorian families where the standards of morality appeared to be so stringent, there was much more elasticity in general than one might have imagined. When Eric's sister Enid, then unmarried, announced that she was pregnant the news caused some dismay, Mrs Gill holding her errant daughter in her arms all night; but Enid was forgiven and Evelyn, her daughter, was brought up mainly by her grandparents in their (by then) Church of England household. There was family acceptance on top of the tendency towards forgiveness which was deep in the liberal Nonconformist tradition. There was also the family habit of intransigence. When the matron of the London home for fallen women, to which Enid had been taken by her Auntie Lizzie, suggested she might like to give birth under some pseudonym she refused. She preferred to call herself Miss Gill.

This was the background to Eric's own insouciance. He had inherited a certain unconventionality. It is also clear that he greatly enjoyed teasing. One of his remarkable traits, in life and art, was his ability to move with almost acrobatic ease between concepts other people found impossible to reconcile. From the image of his sister *in flagrante*, for example, to the Madonna figure. Round this time he made a series of exquisite small Madonnas in plaster. Some of these were cast in brass.

In January 1911 Eric Gill had his first exhibition of sculpture at the Chenil Gallery in Chelsea. The exhibition was surprisingly successful. Even John Knewstub, the owner of the gallery, was astonished by the press attention it received. Since in a way Gill never quite fulfilled this early promise, the unanimity and seriousness of these early reviews are

the more striking: he was already being seen as a new force on the international scene. He seemed to be almost speaking a new language. Critics wrote of revelations. In fact it was the close-to-home quality in Gill, the primitive candour in his carving which had people comparing him first with archaic Greek, Egyptian and Indian sculpture and with early Romanesque and next with the Post-Impressionist art of Gauguin, Cézanne and Van Gogh. Roger Fry's first Post-Impressionist exhibition, which introduced these artists to a startled British public, had opened in London only a few weeks earlier so these were names uppermost in critics' minds. Gill's mother-and-child images had made the most impression on *The Times* art critic, Arthur Clutton-Brock, who analysed Gill's especially expressive qualities. In neither of the two small mother-and-child sculptures could the mother be described as, strictly speaking, beautiful, since Gill is aiming at something much more personal in which conventional ideas of beauty are irrelevant:

Mr. Gill has tried to express the instinct of maternity and that alone. In his work it seems both animal and pathetic, not triumphant, as in Michael Angelo's 'Virgin' in San Lorenzo. But the animal and pathetic part of maternity deserves to be expressed in art, if it is expressed without mockery or sentimentality. Mr. Gill has expressed it so, and both his groups have a beauty which comes from the simplicity and force of the expression.

Roger Fry, Gill's most valuable supporter at that period, wrote a long and ecstatic review in the *Nation* suggesting that Gill's outstanding quality was innocence, his art being an art which was rooted in reality, each of his carvings a vividly apprehended emotional experience:

The result is that these figures are not more or less successful copies of that desperately unreal and fictitious thing, the model posing in the studio but positive creations, the outcome of a desire to express something felt in the adventure of human life.

The local Sussex paper recorded Gill's success in an article headed 'Fame for a Bognorian: Mr. Eric Gill as a Post-Impressionist Sculptor', and Gill's own mother, then in her mid-fifties, wrote from Bognor, 'You make me feel a rich woman – so proud am I of my son "Young Eric Gill".'

There was bumptiousness in Eric at this period. Wyndham Lewis, whilst admiring Gill's exhibition, and describing his works as 'small, excellent and ribald', found Eric himself extremely irritating: 'an obtrusive, eager and clumsy personage'. This was the kind of cheeky-chappie personality which some people, meeting Gill, found an insuper-

able barrier. His mischief-making tendency could be a little daunting. When even Roger Fry, his friend and public champion, was forced to turn down the statue of the Virgin Gill had been carving for him, on the grounds that it would offend the susceptibilities of people visiting the house for his sister's philanthropic meetings, Gill turned a little nasty and wrote caustically to Rothenstein, 'I think he's frightened of it and, as my brother said, it hardly goes with strawberries and cream and tea on the lawn at Guildford.' Gill could be quite schoolboyish and, as Fry himself later discovered, frighteningly naïve.

This parochialism emerges all too clearly in Gill's own verdict on the Post-Impressionists. He felt that the show represented a *reaction*, a transitional phase which he himself had by this time passed beyond. This even gave him a right to feel superior to Matisse (though he did admit some awe in the face of Matisse's sculpture). Gill was then, and was proud to remain, the Little Englander. Apart from some rapport with Modernism in the thirties he stayed consciously apart from the European scene.

As David Jones has pointed out, in the most intelligent assessment so far made of Eric Gill as sculptor, Gill evolved his own separate tradition. His work possesses distinguishing marks of a rather peculiar kind.

Between, shall we say, Brancusi and Harry (*sic*) Moore, in spite of their very other aesthetic feeling and intention, there is a link – they are, speaking broadly, differing expressions of one movement. With Eric Gill we have to deal with a different *kind* of otherness.

Whether Gill was correct in assuming that this otherness was a *superior* kind of otherness is of course quite another matter. From today's perspective it seems extremely doubtful. And yet, though his self-conscious simplicities could irritate and in the end suggest his limitations as an artist, it was Gill's naïvety, his total freshness of reaction to things, ideas, people, which always enchanted those who knew him. Rothenstein's *Men and Memories* provides this portrait of Gill on holiday in 1910 at Vattetot, near Dieppe.

He was delighted with the barns, the carts, the flails still in use, and the reaping hooks; he played disarmingly on the penny whistle, and astonished visitors at Étretat whenever we went there, with his sandals, his red beard, and his hatless head.

This scene reminds one of the day in London when Eric, emerging from Victoria Station to hear the sound of the fife-and-drum band coming

down the road from Buckingham Palace, could not resist joining the procession, marching with the troops until they went into the barracks. The Vattetot description has the same spontaneity – a captivating image of Eric Gill as Pan.

Gill, as Roger Fry had said, was more than almost anybody of his generation an adventurer in human life. He had courage and enormous curiosity. His delight in the curious was carefully recorded month by month in the diary. Perhaps the recording was a part of the enjoyment. On 2 February 1911 for example, after visiting his exhibition at the Chenil Gallery, Gill had his first Turkish bath, an excitement recreated two days later back at home in Ditchling where, in the workshop, Eric took a Turkish bath with Ethel and her brother-in-law Ernest. Curioser and curiouser. There is a passage in *He and She* describing how Ethel had been influenced by her husband's relations with his sisters, and 'out of a sort of idea of keeping him company' once allowed her brother-in-law to 'play with her body' in bed.

Public gathering places of a rather bizarre nature – Turkish baths and music halls, circuses and brothels – appealed to Eric Gill. He had a broad and very English view of entertainment, which extended in those years from Pavlova to Little Tich. Artistically, he enjoyed the contorted and eccentric images of speed and motion, a taste he shared with, for example, Duncan Grant and Laura Knight with whom Gill later corresponded, exchanging information about the feasibility of acrobatic poses. Gill's succession of moving figures, tumblers, boxers, night-club ladies doing the splits, began around this period, and in 1912 his diary recorded 'Sold Acrobatic paperweights to Dr. Coomaraswamy for £25!' Gill was very ebullient at this sale.

Both Gill's predilection for a certain sort of wickedness, a kind of high low-life, and his interest in ideas of art as public statement, found an outlet in a notorious project of its period, the Cave of the Golden Calf. This was a night-club cabaret, set up on the satiric continental lines by Madame Strindberg, ex-wife of the Swedish playwright, an over-powering and self-dramatizing woman then in reckless sexual pursuit of Augustus John. Perhaps it was John who had suggested Eric Gill as one of the artists to collaborate on the decoration of the Cabaret Theatre Club interior in a large cellar underneath a warehouse in Heddon Street, a small loop-through street off Regent Street. The other artists were Spencer Gore, Charles Ginner and Wyndham Lewis, whose chief contributions were large murals and stage décor, bold, hotly coloured, jungly, almost cubist in their feeling; and Epstein whose massive decorated

columns for the Cabaret, iron pillars supporting brightly painted plaster sculptures, heads of hawks, cats, camels with the details coloured scarlet, were suitably sensationalist, a night-club revival of the past schemes for sunlight and Stonehenge.

Eric Gill had the job of the Golden Calf itself. This was the central motif of the club, based on the calf idol in the Book of Exodus worshipped by the Israelites in revolt from Moses. It was taken as the symbol of dissent, excesses, forgetfulness, false glamour: an irreligious animal. With the confidence with which Gill later used, in so many permutations, the Hampshire Hog symbol of Pepler's workshops, Madame Strindberg's Golden Calf appeared in different guises: printed on the membership card; stamped in gold on the card cover; carved in stone on a bas-relief hung up on the door beside the Cabaret Club entrance; and finally carved in three dimensions in Hoptonwood stone and erected on a pedestal. In June 1912 Gill noted in his diary that he went 'to see abt. gilding of golden calf'. The calf was the centrepiece of Madame Strindberg's night-club, self-consciously phallic, glowing symbol of misrule.

The Golden Calf had an ironic end, however. Madame Strindberg was unable to pay for it, and Gill let Roger Fry borrow it for the second Post-Impressionist Exhibition at the Grafton. There it was the only sculpture put on show in the Octagon Room, with paintings by Matisse, Cézanne, Derain and Picasso on the walls around it. This transmutation looked odd, for whilst Gill's Golden Calf was an icon of urbanity it was also very much an English farmyard animal. Like Gill himself the calf in this setting seemed displaced. In the end it was sold to Cyril Butler of the Contemporary Art Society. Gill noted in his diary that he could not stand Butler, and refused when invited to stay the night.

'What ho! for the Golden Calf', Gill commented despairingly. The Cave of the Golden Calf had been an episode, like many in Gill's life, which did not fulfil its promise. The idea of artists working together on large projects was to Gill in some ways extremely sympathetic. He believed in the whole concept of art beyond the gallery. But one wonders how far he felt in tune with the art at Madame Strindberg's as a whole. Gill concurred in theory with some current works of art which in practice he found baffling and distasteful. This especially applied to Fry's community endeavours. His comment, for example, on Fry's project for the London Borough Polytechnic murals, with which his brother Max had been involved, was 'Very interesting and in many ways admirable but terribly stylistic and wilful. EG take warning!' And two years later, when he went to see Roger Fry's Omega Workshops, he made no

criticism but one senses some disapproval. There were aspects of the progressive London art world with which Gill was definitely out of tune aesthetically. Soon he was to quit the scene.

More than ever, with a sense of arriving at a crisis, Eric Gill was obviously in two worlds and in two minds. Part of him liked the idea of the clamour of the subterranean night-club where people did the tango, exchanged esoteric jokes and laughed and flirted noisily; where Frank Harris told melodramatic Russian stories and violent Vorticist dramas were enacted in the intervals between the dances. (So far as one can tell Gill did not join the dancing.) But the Cave also came to resemble his most fervid nightmare, a summing-up of so much he most hated. At times he longed quite simply for solitude and space.

A great bare white stone room where you paint a book of songs or prayers with red & blue & gold. A great bare white stone room that is itself a work of the most splendid skill – and what is more austere than a chisel and a hammer. They are hard & shapely and yet wonderful & beautiful to hold and with them you can sing the tenderest songs & shriek the awfullest curses – and a woman's eyes don't really need a suite of Maple's furniture to set them off. Then there's the physical endurance necessitated by hard work and the psychical temerity by long prayer and think of the grand solemn chanting in a great long chapel with a high stone roof and the cold light coming through from outside.

This letter from Gill to Jacques Raverat, written a few months before the gilding of the calf, shows the monastic reverie ascendant, as he veered from the chaotic to the austere.

By this time he was even *looking* quite monastic. A contemporary painting by William Rothenstein, *Eric Gill and the Artist's Wife*, shows Gill already wearing, in a Hampstead drawing room, the workman's smock which became his kind of trademark and which was inevitably taken for a monk's habit. Gill always insisted it was rational dress, the clothing of his trade, and indeed it had a precedent within the Arts and Crafts tradition in the blue craftsman's smock as worn by William Morris and Cobden-Sanderson, the garment of the Hammersmith fine printer. But somehow Eric Gill managed to wear it differently, and as time went on he came to wear it constantly, in summer weight or winter weight, with drawers or without. In later years he had a special pair of red silk underpants which he wore under his smock for an occasion which justified it, such as the Academy dinner. Even at this early stage the significance of Gill's manner of dress was grasped quickly by John Rothenstein, the young son of the household, a perspicacious child. He

realized that Eric Gill's clothes had their own language. They immediately announced, to those who did not know him, that this was someone different, an odd and special person, an impression underlined in William Rothenstein's strange painting, a scene of some Pre-Raphaelite twilight: artist's wife in flowing velvet cape, her elbow on the chimneypiece, Gill in red robe in an armchair in a contemplative pose.

Rothenstein had been a great confidant of Gill's: they shared a quality of quick enthusiasm, and a year or two earlier, in the Stonehenge period, Gill had confided his visions and hopes about the form of the new religion he envisaged springing up again in England. This was to be 'A Religion so splendid and all-embracing that the hierarchy to which it will give birth, uniting within itself the artist and the priest, will supplant and utterly destroy our present commercial age'. Since then these religious aspirations had developed; in some ways they had been modified, in other ways intensified. They had in any case become much more specific. It had been becoming gradually clear that the religion towards which Gill was striving, the New Religion he thought he was inventing, already existed as an old religion. Gill was veering towards Rome.

It may well be asked how Gill, who described himself correctly as the son of a Nonconformist parson and the grandson of a missionary, had even begun to contemplate Roman catholicism. It was partly the Gill family's own militant tendency, shared by father and son: catholicism simply seemed the right and proper opposite of socialism, Fabianism, all the other 'isms' which Eric had previously adhered to. Gill looked for certainties and of all religions catholicism struck him at that time as the most certain, most complete. To a man who believed that fundamentally normal everyday community activities, bricklaying and turnip-hoeing being his prime examples, mattered more than high art, his own transition from letter cutter to sculptor had posed a rather tortuous problem of identity. Catholicism could potentially solve this for him. At last he thought he saw an answer to the question: what exactly is a sculptured figure for?

This was of course a very Cambridge question. Temperamentally Gill was always more a Cambridge than an Oxford kind of person, though some of his best work was to be done in Oxford: the Cambridge open mind, the taste for abstract speculation, suited him and stimulated him and in the period of run-up to conversion Gill's time was spent increasingly with that group of Cambridge male and female intellectuals which Virginia Woolf had christened Neo-pagans, the frank, free, highly educated, hearty and poetic, closely intermarried groupings of

Cornfords, Keyneses, Darwins. He responded to their style. Never mind if most of them were defiantly apostate – 'Atheistical beggars', noted Eric in his diary when Rupert Brooke and Edward Marsh came to lunch at Ditchling – they were spirited, well-practised and tireless conversationalists and for Gill argument was of more value than agreement. He enjoyed the atmosphere staying in Cambridge with the Cornfords, Francis and Frances. In their house he had carved the inscription when they married, 'Francis Darwin built this house for Francis and Frances Cornford 1909'. Frances, Mrs Cornford, particularly loved him for the fact that he talked to her of what she called 'real things'. Gill recorded several highlights of his Cambridge visits. Fancy dress on the lawn, after seeing Marlowe's *Doctor Faustus*. And later: 'Walk to Madingley in morn with Cornfords. Talked about religion all day.'

Though Gill had many friends from quite wide-ranging circles, from the craftsmen of the simple life to Bertrand Russell, it is surprising to discover that he knew very few Roman Catholics at this period. He had hardly any contacts with the Catholic world. It was fortuitous that in the normal course of business, for tombstones were still his primary source of income, Gill was asked to carve the tomb for Francis Thompson in St Mary's Roman Catholic Cemetery in Kensal Green. This tomb bore the inscription from Thompson's 'To my Godchild', LOOK FOR ME IN THE NURSERIES OF HEAVEN. This commission brought him into contact with the Meynells, the Catholic family who had supported and protected Francis Thompson: it was Everard Meynell who gave Gill the commission. This contact had materialized at precisely the right time, when Gill was needing desperately to ask questions. An early letter written by Gill from Ditchling to Everard's father, Wilfred Meynell, shows the urgency of his need for *information*, for the many facts that only a Catholic could give him, and the extent of his sense of isolation. He wrote that he felt 'awfully alone down here'. Soon he was at Greatham for a weekend with the Meynells, walking back to Ditchling through the snow.

In May 1912 Eric Gill travelled to Louvain, to the abbey of Mont César, the Benedictine monastery. Gill was now known as a carver of Madonnas; he had even carved a Madonna with a halo. He was assumed to be a Catholic artist and he had been invited to send work in to an exhibition of religious art in Brussels. A few days at the abbey *en route* had also been suggested. Gill did not immediately take to Mont César, a huge, barren, barracks-like building, to judge from the picture postcard

he sent back to Ditchling. The atmosphere was not very friendly. Gill was the only visitor, sitting by himself conspicuously in the middle of the very large refectory, with monks arrayed on both sides at long tables. 'There seemed', he recollected in the *Autobiography*, 'to be a smell of bad breath about the place.' Then, just in time perhaps, Gill met a monk called Father Anselm. Father Anselm took charge of him for an afternoon, a comical encounter with much muddling through the dictionary, since Gill could speak no French and Father Anselm spoke no English. But there was a spiritual communication. They started to argue about the divine mysteries. When Gill, in his dictionary French, began suggesting that only part of Catholic doctrine should be taken as the literal truth, the rest to be interpreted symbolically, Father Anselm would not have it. 'Pas symbolique, pas symbolique,' he carried on insisting with such a simple certainty that Eric was won over. He had a natural craving for authority; and when he thought about it later, in those two words 'Pas symbolique' everything seemed suddenly quite clear, resolved, explained.

What had impressed Gill more than anything at Louvain was the plainchant. Not surprisingly perhaps in a champion of plain living – plain houses, plain cooking, plain clothes, to some extent plain women ('straight-up-and-down' as one of his young sculptors described the women of Gill's household) – Gill was overwhelmed by the purity of the singing in the monastery church. This was his first experience of plainchant and when he first heard it he was so moved he was almost frightened. It aroused in him a powerful physical reaction, as at other essential moments of his life: the time he first saw Edward Johnston writing, the time he first saw Ethel naked. He describes it with a similar fluidity:

At Louvain, after the slow procession of incoming monks and the following short silence when I first, all unprepared and innocent, heard: *Deus in adjutorium* . . . I knew, infallibly, that God existed and was a living God – just as I knew him in the answering smile of a child or in the living words of Christ.

In embracing the Catholic faith at that time Gill was cutting himself off, perhaps more than he realized, from his old haunts and his old habits, and he was drawing the boundaries of his art, on his way to becoming the 'Catholic artist'. The label both belittled his achievements and in a sense reduced his possibilities. To understand this one has to realize that for Catholics in England this was a very different period from the years between the wars when the floodgates opened and it seems hard to find an English intellectual who did not contemplate conversion, seeking one

sort of authority or other, Marxist authority if not Roman. Gill, in 1913, was much more on his own. Some of his old friends were definitely hostile. His new-old religion was one of the strong reasons for the rumbling disagreements with Rothenstein which started at this period, and Roger Fry was also extremely disapproving. When Gill went to stay the night with Fry at Guildford to arrange about the fixing of his statue in the garden (the replacement for the statue earlier rejected) he found himself involved in fierce religious arguments: 'Fry v. antagonistic re. Catholicism,' he recorded in his diary. Wyndham Lewis, he notes, was there as well.

The disputatious public side of Gill enjoyed such confrontation. In the process of conversion there was much which appealed to his histrionic nature: the gesture of defiance, abnegation of the worldliness and vices of the London art world, what he called the 'hot-house' culture with its unnatural undertones. Gill saw himself as the prodigal son, returning to his senses. The drama, the extremities of his experience, delighted him greatly on a very simple level. At the same time he was conscious, in more solemn private moments, that whether he enjoyed it or not was quite irrelevant. It was not a question of what might or might not suit him, not like other ways of life and doctrines he had toyed with, socialism, Nietzschism. Arts and Crafts and so on. This was not a doctrine, it was something which had happened. One of his most sympathetic friends, Jacques Raverat, married to Gwen Darwin, together the most visually aware of those in Eric's Cambridge circle, understood this very well; as he wrote to Gill, 'It is aweful, almost frightening about Christianity: the way God enters into your life and takes your soul by storm.' He saw that particular violence of experience, relating it to Eric's craving for the key, the secret, the integrated life: 'And then you have to accept the whole of it, suddenly, because it is all so marvellously welded into a whole.'

After Louvain, there was a slow inevitability in the sequence of events: conversations with an English Benedictine, Abbot Ford, the Prior of Ealing, who came to visit Gill at Ditchling; talks with Father King at Ely Place in London; then formal instruction from Canon Connelly at Brighton. Ethel, who became a Catholic with her husband, accompanied him to Brighton once a week to take her own instruction at a convent. Gill had admonitions from his first contacts at Louvain telling him to hasten on to his confession and first communion and not waste time in examining a state of mind which had been examined more than enough already. But Gill, although painstaking in mapping out his faith, was at least in theory a Catholic already, knowing he believed and welcoming

the nature of belief which was bestowed on him. It was homecoming, a return to the familiar, but it also had its sense of the supra-ordinary, the outlandish, like erotic experience of the highest order:

I would not have anyone think that I became a catholic because I was *convinced* of the truth, though I *was* convinced of the truth. I became a catholic because I fell *in love* with the truth. And love is an experience. I saw. I heard. I felt. I tasted. I touched. And that is what lovers do.

In the months while Eric was receiving his instruction he was working on the carving of a life-size marble phallus. It was his own, a perfect copy with dimensions meticulously taken and relayed to his acquaintances with satisfaction. On Saturday 22 February 1913, his thirty-first birthday, he and Ethel went to Brighton to be received into the Church by Canon Connelly. 'Deo Gratias,' wrote Gill. Ethel changed her name to Mary. They went home to tea at Sopers. Leonard and Virginia Woolf arrived for the weekend.

The next morning after mass and first communion they went for a walk with 'the Wolves' over the hills.

DITCHLING COMMON
1913−24

In 1913 a Catholic family bought a house and two acres of land at the south end of Ditchling Common, one mile from S. George's Retreat. Their object was to own home and land and to produce for their own consumption such food as could be produced at home, e.g. milk, butter, pigs, poultry and eggs, and to make such things as could be made at home, e.g. bread, clothes, etc.

This is how Gill himself, in a kind of manifesto, produced for the Guild of SS Joseph and Dominic, describes the beginnings of the second phase at Ditchling, once the Gills had left the village and moved out to the common. It is this second phase, in which the Gills' religious life was at its most intensive and their attempts at self-sufficiency most determined, which is the one most people mean when they talk of Gill at Ditchling. These were years of self-conscious reclusiveness which also, with one of those ironies with which Gill's life is littered, turned him into a well-known public figure and which exerted a strong and lasting influence on the imagination of almost everyone who went there. Wrote one early visitor: 'Those WERE the days on Ditchling Common − no clouds in the sky, first fervour, and a fascinating sort of communal early Christianity.'

Hopkins Crank, the Gills' new home, was about two miles from the village. The house was called the Crank not with any implication of crankiness, although inevitably this became the local joke as the Gills' appearance and behaviour diverged so blatantly from that of other Ditchling families. It was in fact the Crank because it sat within an angle between the main road across the common and a side road. Hopkins had been a previous owner. Again it was a four-square building, not so elegant as Sopers, but fitting Gill's specification for plain and proper houses. Desmond Chute called it 'a neat square toy of a

house on the western fringe of the Common, an untouched Georgian squatter's cottage, preceded by a porch and diminutive fenced garden'. It already had outbuildings and land suitable for farming, and Ethel's uncle had lent the money for the Gills to buy it. Eric, writing to tell Rothenstein, sounds very slightly shamefaced: '*I shall pay the interest* – I hope.'

Gill's idea was to return to what he thought of as 'the normal life' of his ancestors before the modern worship of town life and its cheap manufactures existed. Normal medieval life had involved much manual labour. Manual labour was the order of the day on Ditchling Common. Gill first built himself a workshop, shifting banks of earth across the yard to make some room for it. They also built a shed to house the cart and dug out a ditch for drainage. 'Very muddy job,' Gill comments. Then, because the ground was heavy clay, apt to be soggy, they found they needed to construct themselves brick paths from the house to the outbuildings. Next they realized they needed a fence across the paddock to stop the animals from straying into the orchard. Gill's diaries for 1913 and 1914 are full of references to the new rural economy: 'Made chicken run for E'; 'home in middle of day to light baking oven'; 'stacking faggots etc. all morn'. The building works at one point revealed a little mystery: through a hole cut in the wall in the Crank living room they found embedded there an icon and a lamp.

11 *View of Ditchling*, 1918.
Wood-engraving for
Ditchling Women's Institute.

The rigours, the remoteness, the privations pleased Gill. He felt he was beginning life again, comparing himself, delighted with his isolation, to Robinson Crusoe on the desert island. As a favourite domestic ritual the bread-baking of the Gills' days in the village was supplanted by a new, more metaphorically vigorous activity: the ancient art of scything. First the sowing, now the reaping. Years later an article in the *Adelphi*,

'The Scythe', prompted Gill to an outpouring of old memories of scything back in 1913 on Ditchling Common:

We had a man who worked in our garden and he was the best man with the scythe I ever knew – nor do I believe there could be a better. The way he walked through it was literally 'heavenly'. He was that rare scyther who hardly bends his back at all, so that he never tired. We used to do the field in the day – I did about the ¼ acre and he did the acre! *And* he put such a divine edge on the scythe that it was 'a fair treat' to use it. Every now and then when he saw my painful struggles he would come and 'give me a sharp'. But what times those were! How adorable is labour, the labour of man with man-made tools!

The removal of the household from the village to the common, like so many of Gill's moves, was inherently symbolic. It was anti-village. It meant a separation. Gill had never been a great enthusiast for village life; he was much too impatient and he did not like gentility. He had however made occasional appearances at flower shows and would be prevailed upon to take the chair from time to time at village lectures. He had up to a point accepted a role as village intellectual and Ditchling artist-craftsman. But once they reached the common the position was different. Now the Gills' separation from the village was near-total. This was not just a question of the new religion, though Eric Gill's progression from free-thinking to catholicism must have caused some puzzlement among the villagers. It was also a matter of uncompromising life-style. The Gills' life on the common was deliberately rugged, a triumphant demonstration of ideals of holy poverty. Gill sent Evan, in Canada, a picture of the family outside their new home on the barren-looking common: 'It looks like a Daily Mirror picture entitled – "British women in Canada".' A tone of self-satisfaction has crept in.

When the Gills moved to the Crank the three girls were still quite young. Betty was then eight; Petra was just seven; Joan was three, a sturdy little figure in muddy boots and ankle socks. The children of course had now been baptized into the Catholic Church, and their religion alone set them apart from the children of the village in a way which it is difficult to comprehend today. (Harman Grisewood, growing up in those same days in rural Oxfordshire, remembers *stones* flying at the four children of his family, including the babies in their pram, when they took a short cut through the Church of England churchyard with their nanny and their nursemaid, such was the feeling of menace then engendered by what seemed strange and foreign religious practices.) The children on the common were also set apart by differences of knowledge.

The regime of self-sufficiency included education. In the early years Gill himself taught them arithmetic, drawing, elementary Latin, history and geography. Mary, in between her many labours in the house and fields and farmyard, gave her daughters lessons in reading, writing, sewing, 'tables', and what Gill sweepingly describes as 'all domestic accomplishments'. A touching little letter from Petra to her father in London while he was working on the Stations of the Cross at Westminster Cathedral suggests the limitations of the education programme as well as the discomforts of a winter on the common: 'Dear Daddy, I hope you got to London safely, it is a very Cold day and We are nearly all fruzed.' They absorbed their parents' vision of the world. At five or six, directed by her father, Joan was producing little pictures showing Rich People's houses and Poor People's houses, Pre-industrial and Post-industrial dwellings: on the Post-industrial side, ugly rows of dingy villas inhabited by mean, unhappy people; on the Pre-industrial side, charming cottages with happy smiling people, spinning, weaving, brewing. The girls also absorbed at a very early age the sense that life, though cheerful, was a solemn undertaking, and that there was no subject too abstruse to be discussed. At the same time, it was a childhood full of practicalities. When they visited Gill's workshop they were treated seriously and they would be given their own chunks of stone to carve.

Joseph Cribb, Gill's first apprentice, was still an essential part of workshop life at Ditchling. The overflow of workshop into family relationships, which is such a fascinating and infinitely subtle side issue of the history of Arts and Crafts in Britain, is especially obvious in the story of the close, even intermarried, Gills and Cribbs. When Joseph Cribb's apprenticeship ended in 1913, Eric Gill returned his articles and Mr Cribb senior came to supper. It was an eventful week, for just a few days later the Gills went into Brighton to be witnesses of Joseph's reception into the Catholic Church. This was not a condition of his continuing to work with Eric Gill, though later the workshops became exclusively Catholic. It was more, one imagines, the result of close proximity to Gill's evolving thoughts over the past few years. Gill talked while he worked and he was a persuasive talker. In Gill's Fabian years Joseph Cribb had been a socialist. Now Gill had become a Catholic, Cribb too became a Catholic. It seemed in a way just the natural progression. Cribb in a sense was an extension of Gill.

In 1915, when Cribb announced he was engaged to Agnes Weller, a local farmer's daughter, the nursemaid at the Crank, Gill drew both their portraits as an act of celebration: this was the sort of family art

which much delighted him and there is hardly a member of his family or household whom Gill has not recorded at one time or another. The Joseph/Agnes portraits are especially poignant, Joseph in his craftsman's smock, bespectacled and serious, Agnes aged sixteen, unsophisticated, blooming. Gill, of course, could not resist her. A concurrent diary entry, recording a row with Mary *re* Agnes, in which Mary says he is 'too amiable', shows his early household habits dying hard.

The Johnstons had by this time arrived in Ditchling too. Edward Johnston had had his mind on Ditchling since the Gills had first arrived there. He had an instinctive love for the traditions of the country and the craftsman's respect for the proper way of doing things: the right way to lay the hedge, the best cure for a ham. The thought of an old Sussex wagon sent him into raptures: he saw it as 'A kind of Fairy Land Ship for beauty, with all its little stop-chamferred and painted banisters and beautiful time and craft shaped "parts".' (He added: 'I dare say it had a vocabulary of its own of anything from 50 to 100 words or more.') The early dreams of the Gill and Johnston families for building a house somewhere up under the Downs, where the men could work together and the wives could bake together, never quite worked out and the Johnstons had started Ditchling life in a rather ugly villa on the outskirts of the village. But their old intimacy had to some extent been recreated, and Gill had been involved with Johnston in the early stages of the sans serif design for the London Underground. Gill always acknowledged this project as a precursor of his own famous sans serif type design.

A little later the Peplers also came to Ditchling. Pepler, left in Hammersmith, had perhaps felt rather stranded and had written imploringly to Edward Johnston. 'Can't you think of any work that I can do at Ditchling? We want an excuse to follow the prophet (you) into the wilds.' Impulsively he more or less invented an excuse, gave up his job at the Department of Education and took over Sopers, the house in Ditchling village that the Gills had just moved out of. Pepler, who had an income of his own and a more cavalier approach to work than Gill, began to experiment with printing in the coach house where Gill had done his early carvings. With the kind of boyish zeal which Pepler generated well into middle age, he and Gill and Johnston resurrected the mood and the routines of Hammersmith a decade earlier. They held long late-night debates walking on the hills by moonlight, discussing deep questions of 'form' versus 'sense'. They studied Latin, a new enthusiasm. They formed a three-man Latin Club and played a home-made card game with a mass

12 *Hog and Wheatsheaf*. Wood-engraving, 1915.
The hog symbol was used in this form for paper bags
for the Hampshire House bakery and for the *Statement of Aim*.

121

of tiny cards all inscribed by Edward Johnston with the English word on one side and the Latin on the other.

Although their Hammersmith inheritance was strong, in their shared view of social purpose, in the habits of their friendship as well as in their shared obsession with lettering, one can at the same time detect a lightening of spirit, a sense of their relief. For Hammersmith was inevitably still a shrine to William Morris and still full of his disciples. Even the withdrawn and slow-moving Edward Johnston became more ebullient in the freedom of the countryside, and the playfulness about their life at Ditchling — the walks, bathes on the beaches, songs and hymns and whist drives — is reflected in the little magazine they started. It was a kind of tract, being concerned with social questions, art, industry, religion. It was also entertainment, eclectic and provoking both in its contents and its graphic quality. Typically of those years at Ditchling, with their conscious juvenilia, it was called *The Game*.

Games, particularly Latin games, appealed to Gill in his mood of going backwards. In a postcard to Jacques Raverat, one of those Gill postcards filled so neatly, edge to edge, with his philosophy of life, he explains that he is feeling it is totally essential to 'take sides' in this world, and that 'taking sides' necessitates being on the side of the poor or the rich, the grown-ups or the children: 'Upon which side does your heart beat?' Gill of course is on the side of childhood, and not just in theory but in the way he does things, makes things and most loves things:

I am just a letter cutter who has taken to 'sculpture' and so for me all things wonderful are 'primitive', elementary, clear, symmetrical, hieratic, ordered, smooth, serene, young, playful . . . other things are admirable but not beloved.

Gill identified himself with the simple things. In a new version of his list of loves, drawn up around this time, he puts on the one side:

Giotto etc.	Hair
Persian Rugs	Lines
Bricks & Iron Girders	String
Tools, Steam engines	Plaited Straw
Folk Song	Beer
Plain Song	& so on
Caligraphy [sic]	
Toys (not some few modern ones tho.)	
Animals	
Men and Women physically regarded	

These are the things he instinctively feels for, things he regards as actually a part of nature. On the other side he lists:

Velasquez
Rembrandt etc.

These are not a part of nature, they are commenting on nature. In this category Gill also includes 'most moderns'.

Animals, listed by Gill between toys and men and women, were a new interest. There had not been animals in Brighton or in Chichester, in his childhood years, and here at Ditchling in the farmyard he was fascinated by the natural activities surrounding him, the bees swarming, the goats kidding, the doe rabbits put to buck, the heifers to the bull. He was especially interested in the reproductive performances of animals and noted down their matings with an almost childlike avidity. One day, when the cow had been taken to the bull with no result, and had been prescribed some medicine to help her to conceive, Gill himself asked for the bottle, pulled the cork out, sniffed it, and gulped down the half-bottle which remained, complaining the next morning that the cow medicine had been useless. Another day he went so far as to examine and compare 'specimens of semen from self and spaniel dog under a microscope'. His attitude to animals, as to some extent to children, was that particularly Victorian combination of scientific curiosity mixed with high emotionalism. It is interesting to see the growing influence of farmyard images on Gill's work at this period. *Animals All*, one of his best-known engravings, made its original appearance as a woodcut, the

13 *Animals All*.
Wood-engraving, 1916.

14 *Hog in Triangle*.
Wood-engraving, 1916.
Device used in publications
of Hampshire House Workshops.

Gills' Christmas card for 1914. It is a recognizably Sussex farmyard grouping of ox and ass and cat.

But Gill's was no ordinary Sussex country scene. This was a sculptor's farmyard, not cosy and conventional but peculiar, alarming. The slight eeriness of landscape was described by Peter Anson, one of the young men who came hopefully to Ditchling in search of a new life, some sort of spiritual guidance:

Having reached the cross roads where the Common begins, I noticed an old purple-red brick farmhouse set in an orchard. From directions at the station I guessed this must be where the Gills lived. When I arrived at the gate, any uncertainty about this not being my goal was dispelled by the sight of big blocks of unhewn stone lying about in what had once been the farm-yard. There was also a large stone crucifix and an austere looking Madonna.

Stranger in a strange land? Which was the strange land, who the stranger? The Ditchling years saw Gill established as the famous oddity, the preacher of discomfort. He enjoyed his voice of doom.

Gill's working life as a sculptor at this period was dominated by the Stations of the Cross for Westminster Cathedral. This was a huge commission for fourteen five-foot panels carved in low relief, the ritual depiction of the episodes of Christ's last journey along the Via Dolorosa to the place of crucifixion and then to the burial, a surprisingly important job to be entrusted to a relatively inexperienced sculptor who had only very recently become a Catholic. Gill later jokingly described it as an act of last-minute desperation, the response to the threat of the then Archbishop of Westminster, Cardinal Bourne, to give the commission to the first Catholic he met in the street.

He started work swiftly, with that professional ease of concentration which those who worked with him found both impressive and demoralizing. He began his drawings in August 1913, starting with the very small initial design now in the British Museum, which compresses all the fourteen Stations into a drawing nine inches square, as glowing and precise as a medieval manuscript, and working up from these to a half-size cartoon. Gill himself was the model for the Christ in the Tenth Station, drawing his own portrait in the mirror for the purpose, as well as the model for the soldier in the Second, standing to the left below the cross.

The Stations, which now seem so well worn-in and so familiar, must in their time and setting have appeared startlingly raw, crude, primitive and in a very particular sense functional. They are very much the

sculpture of an architect. Gill said they should be seen less as works of art than 'furniture'. They are an early and an extreme example of his theories of coherence, his belief that in art and life 'it all goes together': the sculptures are simply the fittings for a building with a certain sort of purpose. He answered critics back with an enjoyable aggressiveness. To the man from the *Observer* who put it to him that he was self-consciously, unsuitably archaic he replied that he was not a learned antiquarian. He did things as he had to:

Practically I stand for a new beginning in stone carving. Most sculptors are modellers whose work is turned into stone under their direction by more or less mechanical means. I am not a modeller, but simply a stone carver. I am doing the work in what I consider to be demonstrably the right way. It follows, therefore, that if I do not do what other people consider to be pleasing to them it is my incompetence to please them. At the same time, perhaps, I should say that I am not out to please them exactly.

To the woman who came up to him in the cathedral to say she did not think they were nice carvings Gill replied politely that it was not a nice subject. He knew what he was doing. He was already definite. The Stations still seem the most satisfying of all his large-scale works. For such a young man they are astonishingly confident. David Jones always rated them the height of his achievement, something nobody but Gill could ever have arrived at. Gill himself, in his memoirs, echoes this opinion: 'I really was the boy for the job.'

As sculpture, the Stations have an unequivocal quality typical of Gill, especially at this period: the lettering relates so resolutely to the figures; the figures are subservient to development of narrative. The Stations of the Cross are there to tell a story and they have the clarity, the linear directness almost, of good signposting, the discipline in which Gill was already so well practised. They are very much the product of those years of born-againness; the years on Ditchling Common when Gill and his adherents saw themselves as being born anew on to the land 'to dig the earth, to plant and cultivate, to be shepherds and swineherds, hew wood and draw water, to build simple dwellings and simple places of prayer'. The conservative instincts within the Catholic faith, the glorification of the known, the tried, the childlike, inspired Gill in establishing the home routines of Ditchling and obviously influenced the Stations at Westminster.

But Gill could still make mischief. One of the most controversial aspects of his Stations was his proposal to introduce small touches of

colour: a blue lining and red borders to the Roman soldiers' tunics, green grass around the Deposition. This was part of his whole minor mania of the time for colouring in the details on his statues: gilding the extremities, painting in the eyeballs, putting necklaces around the necks of the Madonnas. (His clients sometimes found these additions irritating: 'Cribb to London to remove paint from nipples of young woman to please C.K.R.,' runs one entry in the diary.) One can look upon this sort of thing as just high spirits. Gill would always have his defences ready: jokes, treatises and theories on the right and proper naughtiness of life and his own consciousness of being the Lord's darling. A Catholic, he argued in a typically maddening passage in his memoirs, got preferential treatment: 'They say there are more Roman Catholics in gaol than any other kind of person; but, in a manner of speaking, they can afford to be.' Non-Catholics, Gill asserted, could not take such risks. But could things be so simple? Though Gill might like to claim so, in a bumptious mood in public, his diaries tell a different tale. There were increasing tensions between image and reality, the public life and private, the rules of work and worship and Gill's irresponsibility, his domestic tendernesses and his strange urge for the sordid – this at a time when Gill was gaining public recognition not just as Catholic artist but also, more and more, as Catholic father figure. Ironies accumulated as the Ditchling years progressed.

There are signs that his own sexual compulsions dismayed him. In March 1915, for example, he is entering his observation that it is possible to produce organism (*sic*) – 'by thought and concentration mental and muscular! Dangerous experiment.' Two days later, in London, after going to hear Belloc lecture on the war, he records with some alarm: 'Alas for me I gave a woman 2/- to feel her between the legs and she me. No connection, No orgasm. Am I mad!'

Gill was apt to claim that the religious framework was a necessary curb on the erotic appetite. Perhaps it was the sense that his erotic appetite needed more discipline than those of other people which made him fill his days with such vigorous activity, drove him on to make himself such an ascetic kind of life. It was a Victorian's prescription, like his father's cold baths. The diaries of the Ditchling days list out methodically a gruelling succession of tasks and obligations; and the regime then established, which lasted with few variations all his lifetime, was in a way to make the best of things. 'We cannot keep our thoughts secret from him – then let us share them with him. Fling them "on the rock which is Christ".'

In the Gills' living-room kitchen compline was sung nightly. It was a long low room. At one end two candles burned beside a crucifix on the mantelpiece; opposite in a stone niche was a small statue of the Madonna and Child, with another candle floating in a bowl beneath the holy figures. Visitors were conscious of lights and shadows flickering whilst, between these focal points, in two rows ranged down either side of the refectory table, the Gills, the workshop families, guests, friends, stood and worshipped. They formed a double choir. Eric would often act as cantor, or else his daughter Betty, whose voice was described by one of the regular attenders 'as plumb in the middle of the note, as English-sweet as her father's'. Later on, as the community grew, compline was chanted in one of the workshops and then in the Guild chapel which was built on Ditchling Common. But neither apparently ever quite recaptured the spontaneity and intimate absorption of compline in the Sussex cottage kitchen.

Life at Hopkins Crank was quite unlike that in any other household, wrote Peter Anson, who himself became a monk, expert on the history of church furnishing and eccentric monasticism:

There was a certain spartan simplicity about the domestic arrangements, and a complete lack of what are known as 'Modern conveniences' – of which at that period Eric strongly disapproved. He failed to see the necessity of a bathroom. Water was drawn from a pump. Meals, though the food was abundant, were somewhat erratic, because all cooking was done on an open fire which burned logs. More often than not the wood was damp. I have vivid recollections of one or other member of the family squatting on the kitchen floor, trying to get the fire going with the aid of a pair of bellows. The rest of us would be waiting for the meal, already conscious of hunger and wondering how long it would be before dinner or supper would be ready. Eric himself never bothered to leave his work until a bell was rung to announce that the food was actually on the table.

Though Gill was later to become more tolerant of modern inventions, at that time he was compulsively, even rather cruelly, derisive of what he saw in terms of spiritual temptation, pouring scorn on the typewriter which Anson had brought with him. He appeared quite delighted when, after a long railway strike, the lines in the cutting close to Ditchling were reported to be rusting. The rustier the better, since the railway was iniquitous. 'The rusty railway tracks', recalled Anson, with a slight groan, 'provided the theme for one of those long talks on the evil of modern industrialism which Eric could deliver with such devastating logic.'

The war seemed far away. When one thinks about Gill's passionate and controversial involvement in the PAX movement in the thirties his detachment from the First World War is rather puzzling. But when he was younger his view of things was narrower. Narrower and also in a way more arrogant: in later years he could not be so fiercely independent. But at Ditchling all his energies were centred inward, and his early references to the war are very cursory. 'We killed our first pig today!' Such news seems more important than reports of war in Europe. Perhaps it was a feature of his medievalization that news from the front reached him with all the lack of urgency of echoes from the battlefields of Agincourt and Crécy.

He was granted exemption from military service while he was working on the Stations of the Cross, though he joined the local Home Defence Brigade and bought a .22-bore rifle to practise shooting. He bought this in London and could not resist using it, finding a shooting gallery in Shaftesbury Avenue where he could try out his 'new little rifle'. On that same visit he noted:

> bt a flute 14/-!
> Haircut 8d.!
> Silk Tape 1/-!

The impulse buy was always an immense delight to Gill.

At Ditchling he collaborated more and more with Pepler. This was the beginning of the flowering of Gill's talent as wood engraver and typographer. Ditchling saw the development of his work in graphics, his most individual and enduring of achievements: his mastery of linear communication, his gift for the disposal of the image on the page. Gill had already worked with Pepler back in Hammersmith where Pepler, the amateur enthusiast, first started printing on a handpress which had once belonged to Morris. *The Devil's Devices*, a rousing anti-capitalist satire, the first book produced by Pepler at the Hampshire House Workshops, is illustrated with Gill's woodcuts and engravings. In his London days Pepler had also printed Cobbett's *Cottage Economy* of 1821, a book which ran into many editions in the nineteenth century and came into its own again as a real handbook, a guide to rural self-sufficiency at Ditchling, once Pepler had arrived with his single Stanhope handpress, two founts of Caslon Old Face and a supply of Batchelor's handmade paper. This was the start of the press known as St Dominic's, most idiosyncratic of the presses of its period.

These had been great days, of course, for the English private presses:

Kelmscott, Vale, Ashendene, Essex House, Eragny. But in important ways St Dominic's, the press established by Pepler first in Gill's vacated Ditchling village workshop and then in a purpose-designed building on the common, was very different from these distinguished predecessors. It was not so rarefied. It was much more homespun. It had a character of informality, alertness, so well summed up by Roderick Cave's description of St Dominic's as 'The most private and at the same time the most commercial (and certainly the most individual) of the English private presses of the present century.' This was partly because of the methods of working, the deliberately primitive use of ink made in the workshop from lamp-black, linseed oil and other time-honoured ingredients, applied to the type with home-made dabbers in the William Caxton manner: the effect was rather pleasingly irregular. It was also a question of ideology: the press was ready to tackle anything which came, a missal or a label for a jam pot. This policy, necessitating quick responses to wide-ranging demands, produced printing which could at its best be

15 Wood-engravings illustrating *Woodwork* by Romney Green, published by Douglas Pepler at Ditchling, 1918.

marvellously fluent. St Dominic's Press posters are especially successful. And perhaps more than anything the individuality, some might say the eccentricity, of St Dominic's has to be put down to the balance of the creative talents of its protagonists, Pepler and Gill, and the nature and the pleasure of their friendship. In the early years it was their joint creation; a statement of their joint beliefs, a *jeu d'esprit*.

Pepler has left the very best description of Eric Gill in action, dating back to those first days of St Dominic's:

The first thing which struck me as an observer of Gill at work was the sureness and steadiness of his hand at minute detail; the assurance and swiftness of a sweep line is one thing (and here he was a past master) but the hairs on an eyelash another – and he liked to play about with hair and rays which can hardly be distinguished with a magnifying glass (and easily tended to be filled with ink in printing.) Then he was always obliging. When I wanted a tail piece to end a chapter or an initial letter with which to begin one, he would tumble to the point at once, probably improve upon my suggestion, supply the block ready for the press within an hour, and come in to see it printed that same afternoon.

Pepler, clever, amiable, large, loose-limbed, expansive – once described as a steamroller beside Gill's firebrand – recognized and loved Gill's great efficiency, his tenseness and excitement, his professional commitment. Gill stimulated him and Gill's work moved him to great joyfulness. He wrote lyrically to Gill about the *fun* of printing from blocks like his which he loved for their own sake. 'I find them beautiful', wrote Pepler in a letter which has a fearful irony when one thinks ahead to the outcome of their friendship, 'in a way that I have not found other things beautiful – which is not only due to the fact that I have used them. It is rather splendid that we can as it were worship together in their use.'

Through the war years, once again, it was an all-in-all friendship. Gill and Pepler saw each other almost every day. It was an almost schoolboy friendship in their innocent high spirits and delight in one another's company as they worked on the press, planned the issues of *The Game* and roamed around the countryside delivering the headstones and the war memorials which were by now providing Gill with a quite steady source of income. Pepler always recollected one especial memorial, probably the Debenham stones delivered to Dorset in May 1917, which they carted half-way across the south of England in a wagon driven by a mutual friend of theirs, an expert poacher and a police dodger, behind two of Pepler's farm horses. They were well equipped with a barrel of home-brewed ale and a home-cured ham, which Mrs Gill provided. They slept rough in barns and stables and were suspected first as spies and then as escaped prisoners. A young man's escapade, described by Pepler in old age with a zest comparable to that of the contemporary account in Gill's own diary. They broke the journey in Winchester, where Gill went to confession. In a few months Pepler was to become a Catholic too.

Perhaps the daily company of Pepler, a rhymester in the open-road tradition, encouraged Gill to start writing his own verses. One day in his diary he follows 'Interview with the Cardinal at 11.0, very satisfactory'

16 *Actor on Stage*, a wood-cut design for Ditchling Dramatic Club, 1923.

with the triumphant little entry 'Wrote a sonnet!' The exclamation mark suggests it might have been his first. Of the few surviving examples of his poetry the most modestly convincing, and wistfully old-fashioned, is 'Caelum et Terra Transibunt', which was published in *The Game*:

> What is it to the Sussex shore
> That Alfred's bones lie hidden there?
> And how shall Egypt's parched sands
> Remember Cleopatra's hair?
>
> No memory indelible of man's frail life
> Can earth in earthly prison set.
> Even the pulsing of conjoined love
> Shall your own corpse forget.
>
> But coals of fire shall still be piled
> On earth's unheeding land;
> And men shall not forget the rounded hills
> Or leave deserted even desert sand.
>
> And oh! my Lover, when your grave shall give
> His long embrace, and all your parts disdain
> Love shall still keep our love imprisoned
> And bless your breast whereon my breast has lain.

Gill had moved into more precious literary circles since his conversion. For example he had made friends with André Raffalovich and John Gray, two of the most recondite figures of their period. Their transformation from dissolute youth in the London of the 1890s to Catholic middle age in suburban Edinburgh during the 1920s is recorded evocatively by Brocard Sewell in *Two Friends* and *In the Dorian Mode*. It is a story of peculiar extremes.

John Gray, who in the years which followed his conversion became a parish priest and finally a canon, had in his earlier days been regarded as a promising young poet in the Symbolist tradition. A delicate volume of his verses, *Silverpoints*, was published in 1893 by Elkin Mathews, designed in the art nouveau manner by Charles Ricketts. Raffalovich and Gray had been friends of Oscar Wilde and there were continuing rumours that the canon was the original of Wilde's Dorian Gray. Certainly, even by the time that Eric Gill made his first appearance in Gray's and Raffalovich's correct, subdued, sophisticated, pious Scottish households, there were still strong echoes of the heyday of the Symbolists. John Gray's must have been the only church in Edinburgh where prayers would be asked for the soul of Paul Verlaine.

Raffalovich praised Gill for his '*roominess* of mind', through which he had found he could move without knocking against misunderstanding. This was, he told Gill, a rare treat. (His own mind in comparison, he said, was like a curio shop where one could pick up some bargains if one could stand the things one did not want; whilst one dear friend of his was like a bare room 'with no furniture but a settee and an ashtray'.) Raffalovich's was an intelligent analysis. Gill did have roominess: a reservoir of creative skill and interest which encouraged him to work in so many different media, as well as an agility of spirit which allowed him access to so many different coteries. This spaciousness was one of Gill's attractive qualities.

His friendships were sometimes unexpected. For example, round about this period he had contact with another literary couple whose relationship, like that of Raffalovich and Gray, had a gentle aura of sexual ambiguity. Katherine Harris Bradley, known as 'Michael', and her niece Edith Emma Cooper, known as 'Henry', lived together at The Paragon in Richmond and produced poems and verse dramas under the pseudonym of 'Michael Field'. Michael, the aunt, wrote effusively to Gill, congratulating him on his conversion: 'Artist to artist, though stranger to stranger, I cannot write "Dear Sir" – Dear Mr. Gill.' Like Gill, the Michael Fields were also converts. Michael's tone, so educated,

17 *Toilet*, 1923. Wood-engraving based on drawing of Norval Gray,
John Gray's nephew who spent holidays at Ditchling.

18 *A Snake*, bookplate commissioned by
Canon John Gray for André Raffalovich.
Wood-engraving, 1925.

so fluent, is also slightly hectic. The new world in which Gill moved, that world of cultivated Catholics, had its own undercurrents of hyperbole.

It was at one of Raffalovich's famous Sunday luncheons, in June 1914, that Eric Gill first met Father Vincent. Raffalovich's social gatherings in Whitehouse Terrace were of an unusual elegance for the Scotland of that period. The *mise-en-scène*, as described by one *habitué*, suggested that one was acting in one of Oscar Wilde's plays produced by Cecil Beaton in slightly off-period costume. For both Eric Gill and Father Vincent the encounter at Raffalovich's table was momentous. Father Vincent McNabb, an influential priest in the order of Dominican Friars, later prior of the house at Hawkesyard, found in Gill and Ditchling the possibilities for the regeneration of the Catholic life in England, and a new focus for his quite extraordinary energies. For the next ten years he saw 'Ditchling' as a kind of blueprint for the founding of other Ditchlings, self-sufficient Catholic communities all over the country. The place dominated Father Vincent's thinking. 'You ask "Is Ditchling practicable?",' he once wrote. 'In the Irish fashion I answer by a further question "Is anything else practicable?".' For Gill himself the meeting was essential in establishing his links with the Dominicans, so strong until his death.

Why the Dominicans? They had been founded as an order of preachers and teachers and so they were very active. At the same time the order also had a strong tradition of the monastic and contemplative elements: it delighted in handing on the fruits of contemplation to others. This was a balance which Gill easily responded to. He already possessed, and kept, connections with several other orders: first with the Benedictines, and by now also with the Carthusians at Parkminster in Sussex. But, as Gill's friend Donald Attwater describes it, 'the association of Eric Gill with the Dominicans was providential'. Also, it must be said, the Dominicans were fashionable: not so fashionable then as they were to become later, when ageing Catholic intellectuals of the 1930s would write nostalgically of the Dominican leaven spreading through their generation, but already possessed of a high level of sophistication, particularly amongst the younger brethren. Gill himself, in his favourite role of man of no-nonsense, claims that his allegiance to the Dominicans was a question of truthfulness: the Order of St Dominic, being devoted to the truth, was therefore by necessity an order of preachers, since truth must be preached. For example, the forgotten truth that industrially based capitalism is *untrue* to the nature of man. With such spiritual joys and philosophical athletics, Gill threw his lot in whole-heartedly with

the Dominicans. His life had found an anchorage, he explained; and not only an anchorage but a port from which to sail and a port for his return.

This was one of Gill's attempts to achieve completeness: he came to see the force of Vincent McNabb's doctrine that there can be no mysticism without asceticism. *Strict* delight. This was his favourite slogan in those years. Another sort of yearning, for familial completeness, overtook the Gills on Ditchling Common in the wartime. Before and again after the birth of Joan in 1910 Mary had had miscarriages and it became obvious she could have no more children. Gill still wanted a son. So in the autumn of 1917 they set off to adopt one from the infants' home in Haywards Heath, arriving in the pony cart and evidently looking a little bit disreputable. Petra, by then eleven, went for the ride and remembered how the matron said 'We only have gentlemen's children here.' However, after some negotiation the Gills were permitted to take in an eight-month-old boy. The baby had been born illegitimate in Queen Charlotte's Hospital in London and sent to Sussex as an evacuee. He was never legally adopted. But he was always known as Gordian Gill and was brought up as the Gills' son.

Gill had long romantic memories of his own childhood: walking in his father's wake along the front at Brighton. This is reflected in his well-meaning but in the end inevitably thwarted attempt to raise Gordian in his own image. Gill's *Foster Father* carving, holy child and divine father, completed a few years after Gordian's adoption, is a poignant variation on the theme. The idea of succession, and male-to-male succession in particular, had an enormous hold on him. Again this was the missionary patriarch in ascendant. All his life Gill sought out sons, young men he could instruct and influence. Sometimes these were his apprentices, sometimes – and increasingly – they were intellectual and artistic Catholics, young men of independent means who came to Gill imagining he had the answers, who saw him as a guru, a protector. This happened all his life and in a way these were son substitutes. But, as his brother Cecil so astutely commented, the relationship could also be quite close to that of lovers. Of these son substitutes by far the most important was the charming, enigmatic and neurotic Desmond Chute.

'Dear Desmond, looking more like Christ than ever.' This, the description by Mrs Patrick Campbell, a friend of Desmond's mother, shows that even as a young man there was a spiritual quality about him. Also, not surprisingly, there was a certain stagyness. Cecil Gill later described him as an Aubrey Beardsley figure, tall, languid, aesthetic, often swathed around with scarves. His attitudinizing reflected his theatricality of

19 *St Joseph*. Wood-engraving, 1921.
After a drawing by Gill's daughter Betty.

background. Desmond Macready Chute came from a famous family of Bristol actor-managers; he was a collateral descendant of the great Victorian tragedian William Charles Macready. On the death of his father, his energetic mother, Mrs Abigail Chute, had taken on the management of the Princes Theatre in Bristol, and ruled it, as indeed she dominated Desmond, with great determination. Even Gill found Mrs Chute, *en grande dame* in her manner, rather difficult to cope with. The brilliant, spoilt, delicate Desmond was artistic and had been, briefly, a student at the Slade, but when war was declared he had returned to Bristol to help his mother with her war work. Early in 1918, when he first met Gill, he was a little rootless and unhappy, like many other followers of Gill, feeling at a crossroads, in need of an escape and searching for a purpose. He went up and introduced himself in Westminster Cathedral where Gill was working on the carving of the ninth of the Stations of the Cross.

They appreciated one another instantly, as is proved by the entry in Gill's diary for 5 April: 'St of X ix all day with interruptions. Desmond Chute came to see me in morn 12.0 and I talked with him till nearly 3.0.' Two days later Chute had been invited down to Ditchling. On 15 April there is an important entry, its significance stressed by Gill's own

emphasis 'Starting Chute with stone carving.' On 17 April, Chute was drawing Eric's portrait. He had already been accepted, drawn into the Gill household. So much so that by late May, when the Ditchling bees started swarming, Gill wrote, 'Desmond and Petra "took" the swarm unaided.'

The delight in new beginnings; the excitement of the strange yet already half-expected; something not unlike the lovers' relief in recognition: these emotions, experienced in some degree or other by many of Gill's pupils and assistants and disciples, were inherent in Desmond Chute's arrival, only more so. Chute was already a very devout Catholic, and a letter to the Lady Abbess of Syon shows how ecstatic was his discovery of the edifying Christian life of 'Franciscan simplicity' at Ditchling:

You will see from the above address that I have taken up new work. I was sent here by various little circumstances, and am now learning stone cutting and image-making under Eric Gill, maker of the Westminster Stations. He is a dear and holy man. We have an almost monastic life – Angelus rung – sung Compline followed by Rosary every night around a little Madonna of his making. The whole day is a round of praise, be it work or prayer; do you see my lines are fallen in a very pleasant and fruitful place, thank God.

He adds, perhaps a note of flattery to the recipient, that Eric's youngest child is especially delightful and since it is one of his dearest wishes that at least one of his daughters should become a nun, 'it is of her that we think in the habit of a Carmelite, a Poor Clare or a Bridgettine'.

Because he had arrived at dusk, Chute had not expected the impact of the view from his bedroom when he woke on his first morning on the common. He had of course a trained visual sense and his recollections of the scene many years later in an article in *Blackfriars* have an almost professional exactness: pigeons circling round a dovecote in the midst of a yard lined with workshops, the stonemasons' on the right, on the left the big black workshop where Eric did his carving, and the lower red-roofed workshop jutting out at right angles where he engraved and drew. It is a very painterly description: 'An opening between this and a similar shed marked JOSEPH CRIBB led the eye through a meadow to the top of Bull's Brow and thence across the hidden Weald to the Downs and open sky. Quince, apple and medlar bloomed in the orchard behind the house. Grey in the shadow of the workshops, sudden as a monolith on Easter Island, stood Gill's first colossal carved figure – MULIER.' The Gill–Chute relationship had great complexity but one of its main bases, one of the reasons why Gill was to describe Desmond Chute as the

only man with whom he had been able to talk without shame and without reserve, was the fact that this was a friendship between artists, a working relationship, casually intimate: they had a common language of visual perception, shared delight in the surprises of texture, tone, size, shape.

When Gill's exemption from war service was rescinded, once he had completed the Stations of the Cross, Desmond was left in charge at Ditchling in his absence. Gill sent him very long, intricate letters of instruction, addressing him as 'my dear and loving steward', and raising artistic questions, family and household details, and the day-to-day problems of the workshop such as the need for levying a sixpence per day charge on Albert the apprentice. This reminds one of how hard the times then were on Ditchling Common. In the same letter, with Gill's usual leaps of subject, with his knack of fusing inconsequential and shocking, there is a rather elaborate discussion of the pros and cons of using the word 'fuck' in the context of one of his recent wood-engravings depicting the sex act between man and wife. Already Gill's attitude to what he sees as sexual hypocrisy is notably defiant: 'We are still young', he tells Desmond, 'and adventurous and impatient with the respectable timidity of an adulterous and hypocritical generation.'

In September 1918 Gill was finally called up and allotted to the RAF Mechanical Transport Camp at Blandford in Dorset. On his way he called into Westminster Cathedral for high mass and made the Stations: his own newly finished Stations. On the train to Blandford he finished reading Penty's *Old Worlds for New*. The world he found at Blandford depressed him infinitely. It was a huge camp, spread over eight square miles, a receiving, testing and distribution centre for RAF technical equipment, 'an utterly unfriendly and unchristian place'. Not only unchristian but, an almost greater agony for anyone of Gill's energetic temperament, appallingly and deadeningly idle. Drilling, polishing buttons, listening to lectures on 'Morale and cultivating an offensive spirit', perhaps for the first time Eric Gill discovered apathy: he discovered how much work can be dodged when you know how. At least he had his rosary. He wrote to Desmond Chute in those first few homesick, desperately empty days at Blandford:

It is the greatest possible blessing having the office to say and so far I have found it quite easy to fit in. There is a terrible lot of waiting around in the army and as I don't talk to the other men much I find the beads very good.

Officially, Gill became an RAF driver. Privately he went to ground.

He was not, as he might have been, aggressive or defiant, except when a lecture from Sergeant Tribe on 'Cleanliness', which he regarded as obscene and irregular, prompted him to raise a storm. This was his only animation. Most of his months at Blandford were spent silently rebellious. Perhaps because he was in a camp so far away from the real lines of battle, at the tail end of the war, he never experienced the army camaraderie which his friend and fellow artist David Jones, for instance, found surprisingly pleasing, a long-lasting source of inspiration. Gill's life in the RAF was low-key, rather dank. He was ill with the influenza in hospital. The news of his brother Kenneth's death in France, in an aeroplane crash returning to his squadron after visiting Evan at Le Tréport Hospital, increased his great depression: 'a life just thrown away'. The moods of his diaries and letters of that period have little of his usual ebullience and hopefulness. He seemed only to live for weekends back at Ditchling or for leave days spent with Mary at the George in London. Once, in October, Mary came to meet him and 'It was like a marriage feast.'

Gill's attitude to the First World War has been much criticized. Graham Greene for instance, reviewing *Letters of Eric Gill* in 1948, attacked him for small-minded insensitivity, maintaining that his letters of that period, 'facetious, complacent, evasive, with an extraordinary tactlessness addressed as they often were to men enduring the five years' trench war, need to be read in company with Sassoon's poems or Blunden's *Undertones of War*'. The comparison presumably would not do Gill much good. And certainly the First World War did not bring out the best in him. It rather turned him back into the little man of pathos, an effect underlined by the loss of his beard, which army regulations had forced him to shave off. This made him the living proof of his own theory that a man needed a beard as a badge of masculinity. In uniform, and beardless, Gill seemed nondescript, suddenly verging on the impotent. He was finally discharged at the end of November in 1918. On his return to Ditchling Conrad Pepler failed to recognize him even though he stood in his own kitchen at the Crank.

On the common the intellectual level had been raised by the arrival of Philip Mairet, the writer, philosopher, pioneer ecologist and actor at Lilian Baylis's Old Vic. In one of the strange processes of casting or miscasting which happen in times of national crisis Mairet enrolled as a labourer on the farm which the Peplers had now bought on the edge of Ditchling Common. Cave, the cowman, took him out into the biggest of the far fields, gave him a brief lesson in the art of laying and trimming

a hedge, and then left him to carry on alone. Mairet was at this time a devotee of the swarthy and hypnotic Serbian intellectual Dmitri Mitrinović, an intimate friend of the sculptor Meštrović, and he brought Mitrinović to meet the Ditchling artists. The introduction to Gill was not successful: Gill had an instinctive suspicion of sages, particularly foreign ones. But Edward Johnston it appears was more receptive. He came upon Mitrinović standing in a cow byre looking rather lost and he asked if he wanted to be shown the way. 'No,' said Mitrinović, in a scene which sums up those years on Ditchling Common, 'I am only looking how noble an animal is the cow.'

Mairet's view of Ditchling is particularly interesting since he had been involved, as indeed had his wife Ethel, with Ashbee and the Guild of Handicraft in Chipping Campden. He stressed that in comparison Ashbee was easygoing. The community at Ditchling was a much more dedicated and comprehensive effort to revive and live by pre-industrial values. The agricultural commitment was much greater. Indeed it might be said to have verged on the fanatic. Mairet described how on Pepler's farm at Ditchling they not only mowed the hay with a scythe and cut the corn with the swophook but, when it came to the brewing of the harvest beer, Cave the cowman threshed the barley with a flail, winnowed it with a fan and malted the grain on a piece of sheet-iron over the slow fire. These were still the days when some of the old men on neighbouring farms wore smocks, as did the shepherds on the Downs, with their crooks, their dogs and somewhat incongruous umbrellas. 'It was meat and drink to us', wrote Mairet, 'to live in such an "unspoiled" rural economy, and we were sure that nothing could be more pleasing to God than to keep it so.'

This was of course the crux, the essential point of difference between the community on Ditchling Common and the other groupings of craft workshops of that time. The Arts and Crafts movement was in the main agnostic: it was fired by principles of humanism and democracy, artistic integrity, qualitative standards and a rather woolly sort of Art Workers' Guild nationalism. But catholicism suffused life and work at Ditchling. In Gill's eyes the practice of, for example, modelling things in clay for other workmen to copy in marble was worse than an offence against beauty or the Ruskinian doctrines of right-workmanship. His objections now had added moral force: it was a sin. Gill, 'God's darling', allowed himself a certain flexibility in creative areas as in others and he did in fact delegate work to a degree never quite admitted in his official writings. But he was always adamant about the theory of it. Artistic sins, like

others, might be interesting and profitable but they could only lead to hell.

After the war, the life on Ditchling Common was more emphatically, more demonstrably Catholic than it had been before. This was one of the main reasons why Edward Johnston, who had once been in the thick of the new plans for the community, and had even come to live near the Gills up on the common, very soon moved back into the village and then gradually rather faded from the scene. Johnston's wife Greta was coldly anti-Catholic and Johnston himself was perhaps a creature too solitary by temperament for organized religion and the family interchange which was so much a feature of the lives of the Gills and Peplers on the common. Evelyn Waugh's theory was that he was 'so good and holy and odd that he never felt the need of it'. His place in the intimate triumvirate at Ditchling was taken over to some extent by Desmond in the plans for the developing religious life.

Though Gill was by now thirty-six and Pepler forty they still had the young man's sense that anything was feasible. 'Those are pleasant days', wrote Gill, 'when young men and men in the prime of their life argue and debate about the divine mysteries and concoct great schemes for the building of new societies, and they were pleasant days for us.' Pepler, in old age, was equally nostalgic, explaining how his work with Gill, like his work earlier on in Hammersmith, was fired by what he called 'apostolic' urges. 'I saw visions (still do),' admitted Pepler in 1942.

What kind of visions were they? They were an extreme version of Distributist theories. Both Pepler and Gill had signed up for the beliefs propounded by Hilaire Belloc in *The Servile State*, a book written just before the First World War, a vigorous polemic in the English tradition of decentralist and moralist thinking. It had had quite an impact in its day. Gill's version of it was essentially the craftsman's version, as expressed in his famous essay *Slavery and Freedom* published four years after *The Servile State* appeared.

That state is a state of Slavery in which a man does what he likes to do in his spare time and in his working time does that which is required of him . . . The test of a man's freedom is his responsibility as a workman. Freedom is not incompatible with discipline; it is only incompatible with irresponsibility. He who is free is responsible for his work. He who is not responsible for his work is not free.

The *Servile State* argument was a sharply anti-collectivist argument: anti-capitalist and, just as caustically, anti-socialist. It held that the key

to the right life was *ownership*, proposing a scenario of back-to-small-scale agriculture away from state control, a return to private property in ownership of tools, workshops and land. The back-to-the-fields theories of Belloc and G. K. Chesterton had much in common with, say, the idealistic land-sharing proposals of the Chartists in the 1840s, or the New Life Carpenterianism of the 1880s. The difference lay of course in their catholicism. These were Catholic visions, arising from a very Catholic interpretation of English history. They were visions to which Gill and Pepler had responded immediately, instinctively, emotionally, soon becoming the willing, living demonstration of the Catholic version of 'three acres and a cow'.

The idea of Nazareth was also an important one. To Father Vincent McNabb, who was at this time the prime influence, the chief architect of the developing community at Ditchling, the emotional imagery of his Irish Catholic childhood was essential to the concept of Ditchling as he formed and propounded it, mingled with a more sophisticated reading of the teachings of St Thomas Aquinas. The cult of the Madonna; the cohesiveness of family; the dignity and holiness of lowly occupation: the image of the carpenter's shop was ever present in the imagination of Father Vincent on his many Ditchling visits, and in fact it is the subject of one of Gill's most lovely carvings on the font of the Catholic church at Pickering, one of his first commissions after his conversion.

The galvanic energy of Father Vincent, which virtually changed the whole identity of Ditchling, was described with awe by Bernard Wall, editor of *The Colosseum*, who claimed his holiness would have been recognized from China to Peru:

In his black and white Dominican habit and big boots in which he tramped around, he looked like the Saint Dominic in Fra Angelico's Crucifixion. He was ascetic and angular and, like Eric, made as little use as possible of any mechanical device. He preached religion and Distributism to crowds in Hyde Park and told them their life was mad, they must set themselves free, leave London and return to nature. If they asked, 'How?', he answered 'On foot'. He revived the ancient practice of kissing the foot of a host who entertained him. I remember the blush on Ronnie Knox's face when the black and white figure threw himself onto the floor at his feet after lunch.

Gill and Vincent McNabb in those days were very intimate and Gill has described the discovery of the Thomist doctrines, under Father Vincent's guidance, as 'no less than a revelation'. He was never himself an accomplished Thomist, said those who knew him well; he was not in

fact even very deeply read in St Thomas Aquinas's works at first hand; but he had the will and the speed of understanding to absorb the Thomist doctrine from McNabb and other Dominican friars. This, after all, was the traditional method. From St Thomas's works – in particular the *Summa contra Gentiles* and the *Summa Theologiae*, the classic system-atic exposition of theology – Gill found an explanation of the principles of God and man and holy living which confirmed and extended his critique of the modern industrial-political system, the set-up he and Pepler opposed with such derision. St Thomas became the leading light at Ditchling. The teaching of St Thomas seemed to Gill to have a vigour and a definiteness which answered, and justified, and in a way transfigured his craftsman's sense of the realities. As Coomaraswamy once did, now Father Vincent helped him to make sense of the concepts already evolving in his mind. Father Vincent loved the workshop life, and there are pictures in Gill's diary of the Father sitting near him in the workshop continuing the Thomist dialogue while Gill was cutting the West Wittering memorial slab. On another morning he was in Gill's workshop when a blouse manufacturer from Leeds came in to see him and Father Vincent had a 'great arguement' (*sic*) about the 'Eyes of needles'.

Since Gill was so unusually sexually active it seems pertinent to wonder why he chose to surround himself with so much celibacy. Did he welcome it as a palpable reminder of the rock which is Christ? Certainly during Gill's ten years on Ditchling Common his friendships with celibates were numerous and close, and it was a two-way traffic. Friars coming in to Ditchling, Gill and Pepler going outwards to see the friars at Hawkesyard, the house of studies at Rugeley in Staffordshire where McNabb was prior. Gill enjoyed himself at Hawkesyard, staying up late at night in the Fathers' Common Room, discussing human and divine love with Father Vincent, joining in the ritual life of the community. 'We received the Papal Blessing. Father Vincent also Blessed my Rosary.' The detail seemed important. A child's view of a new country.

It was at Hawkesyard that Pepler had been received into the Church by Father Vincent, and it was also at Hawkesyard, in January 1919, that Gill '*put on the habit*' for the first time, when they went into the choir for matins. Gill, carried away with the excitement of the moment, drew a little sketch of himself wearing the habit in the margin of the diary. Appearances entranced him. He wrote several books later on the psychology of dress. In addition to the habit, Gill later took to wearing 'the girdle of chastity', a symbolic cord worn by members of the

Confraternity of the Angelic Warfare, an offshoot of the Dominicans. The girdle had its origins in the pure white cord with which the two angels girded St Thomas Aquinas. The saint had just successfully repelled the advances of an importunate young lady, and the angels were to make sure he suffered no further temptations. The Angelic Warfare cord was ranked as sacramental: it was seen as a *sign* which did not bring grace *ex opere operato* but through the prayers of the Church and the devotion of the user. Gill was not a great self-critic and he wore the girdle gladly. 'Much good it did him,' remarked one of his friends.

Gill by now had embarked on joining the Third Order of St Dominic. This was a lay order. The orders of mendicant friars founded in the middle ages had developed a three-tier system: a first order of friars, a second order of nuns, and a third order of lay people. Desmond Chute, himself a member of the Third Order of St Francis, was able to explain the intricacies to Gill. It seemed an ideal system to be applied at Ditchling: Tertiaries were 'of the world' but were associated closely with the parent order, living in its spirit and taking on religious duties over and above those of ordinary Catholics. It contained an implication of having it all ways, of a life which was partly but not totally monastic, which appealed strongly to Gill's divided nature and set him on the road to the confusions, which delighted and disturbed him in almost equal measure, arising from his public image as 'the married monk'.

An unexpected witness of Gill's putting on the habit was the artist Stanley Spencer. Spencer was a Bristol friend of Desmond Chute's. They had met in somewhat histrionic circumstances, in the war hospital where Spencer had been posted as medical orderly. Spencer described the scene in terms of quasi-revelation with Chute as (once again) the Christ-like persona, the youth in a beautiful civilian suit walking towards him along the long stone passage with coloured glass windows all down one side. In these hot-house conditions their friendship had flourished and Chute had been largely instrumental in restoring Spencer's confidence in painting. It was Chute who brought Stanley Spencer into the Gill orbit, though they seem to have regarded one another with suspicion. Spencer certainly travelled unwillingly to Hawkesyard. Gill reported to Chute, who had had hopes of a conversion:

We are here and Stanley S. is with us having had a fearful wrestle – chiefly with himself. He met us at Euston on Saturday determined not to come at all – but we persuaded him and he came just as he was with his hands in his pockets and no luggage at all. What will be the upshot of it God only knows – he is in a curious mixed state of pride, prejudice and humility and reverence.

In the story of Gill's life one sometimes comes upon such figures, the sardonic spectator, the spectre at the feast. On the day of Gill's reception into the Church it had been 'the Wolves'. Now at Hawkesyard it was Stanley Spencer in the role of devil's advocate. 'Long arguments', Gill entered in the diary, 'with the Fathers and S. Spencer who said he was having a hell of a time.'

Back at Ditchling the religious life was very much expanding. It had been becoming more visible, more public. The purposefulness of it was reflected in new building plans, in ideas for making catholicism tangible. Gill's patron André Raffalovich in Edinburgh received this bulletin in summer 1920:

Five of us here are Dominican Tertiaries and we are trying to build a little chapel. We are also putting up a crucifix on a hill at the corner of the Common. We are also proposing to build our workshops in a group in one field and to form a little guild of Christian workmen. One workshop is already up and another begun.

The first five Tertiaries were Eric and Mary Gill, Desmond Chute, Douglas Pepler (from then on known as Hilary) and Herbert Shove, a retired naval commander related to the poet Fredegond Shove, a large flamboyant bearded pseudo-William Morris figure who farmed a small property at the south end of the common. Herbert Shove, though not very effective as a farmer, developed a considerable talent as a bee keeper. He too was a convert and a keen Distributist. His wife Rose also joined the order.

The mood of those days, the seriousness of endeavour mixed with high-spirited excitement at the novelty of things, almost a sense of daring, comes over very strongly in the minutes of the early Tertiary meetings, recorded so precisely in Gill's own lucid handwriting: discussions of the details of Ditchling workshop holidays on the days of obligation and days of devotion; plans for a school at Ditchling for the children of the order; the disposal of the male and female voices in the chapel. The religious nomenclature appears with a certain self-conscious picturesqueness: Sister Mary Ethel; Brother Desmond Bernardine; Brother Joseph Anthony (for Cribb, too, soon became a Tertiary). The tenor of the meetings was intimate but formal. Brother Eric Joseph TOSD was elected the first prior.

Gill himself designed the chapel. It was built by a local bricklayer, in the meadow behind Hopkins Crank, and formed the centre of the Ditchling workshop complex. This was consciously symbolic, a merging of work and worship, and the downing of tools and making for the chapel became part of the rhythm of Ditchling workshop life. 'We have',

wrote Gill, 'been trying to say the Office the really proper way. At present it is a great success. Prime and Meditation after the angelus at 6.0 a.m., Terce at 9.0 before starting work (which gets me to work punctually). Dinner at 11.15! Sext after the 12.0 angelus. None at 3.0 and then afternoon tea. Vespers and Rosary after the 6.0 angelus and Compline at 9.0. *And then we go straight home to bed*!'

20 *Spoil Bank Crucifix*. Wood-engraving, 1919.
The hilltop chapel was never built.

It was a self-consciously arduous programme. This saying of the office in public, systematically, by Tertiaries was in fact unusual. It has no equivalent in the history of the Dominicans in England. No one ever before, so far as one can see, lived a lay tertiary life with the commitment of Gill and Pepler's community at Ditchling. As in other Gill endeavours his embracing of religion had an exceptional quality of zealousness. To some people the zeal verged on the excessive. There were snide local complaints that when one visited the chapel one was likely to find Gill consecrating Pepler or Pepler ordaining Gill.

Much of Gill's work at this period was Guild work; community work in the building up of Ditchling and in the demonstration of its ideals to the world. Of this the most spectacular example was the Spoil Bank

cross, a great wooden calvary erected on the wooded hump above the railway line, overlooking the main road from Haywards Heath to Brighton, an admonition to the godless and/or capitalist traveller. Father Vincent blessed the cross, sprinkling it with holy water, and on his way back in the procession to the chapel was noticed reciting the *Te Deum* to himself. The calvary was also notably inspiring to Gill's sister Enid, herself a poet of some professional standing:

> There was a cross on Calvary –
> And stark against the sky,
> There hung the Christ of all the world:
> Men saw – and passed it by.

> There is a cross on the wide downs:
> High on a hill it stands: –
> And men have carved and placed it there,
> With love-inspired hands.

> They left Him dead on Calvary –
> But he is living still: –
> His cross against an English sky –
> Christ – on a Sussex hill.

The Spoil Bank crucifix was fifteen feet high. It was crudely dramatic. The figure of Christ was just carved timber, painted, the loincloth coloured blue, the eyes half-open: the effect was of a figure from a pantomime or fairground. Over the head was the lettered inscription: *Jesus Nazarenus Rex Judaeorum.*

The primitive and childlike, direct, nonchalant, untutored; muddy boots in the Guild chapel (which the chaplain of the neighbouring convent found distasteful, adding that the brethren were unshaven): in the years at Ditchling Gill created an affectation out of imperfection and it ran through his whole life there. If by accident he knocked the head off the figure he was carving in the workshop he would merely stick it on again. This was the reverse of his perfectionist craftsmanship, his orderliness, carefulness, control of smallest detail: in Gill the two tendencies somehow coexisted. His deliberate informality was also the converse of his childhood religion and its result. A little imperfection took him nearer to the real thing. And he liked surprising people. Grace Kauffer was astounded when, visiting Gill's workshop, she saw him light his pipe at the taper which was burning by his small shrine to the Virgin.

Alongside the religious order was the craft guild. The religious life and

handwork were seen as correlated. Gill's rejection of industrial methods of production and distribution – the camp *outside* which he stood, as he described it in no uncertain terms to the newly formed Design and Industries Association – was inextricably bound to what he saw as his rejection of modern worldly and irreligious values. Handwork was a condition of holy poverty, a concept which in its baldness and effrontery effectively put paid to all the complicated hand-or-machine arguments which troubled the consciences of craftsmen of that period. Handwork was the firm principle on which, in 1921, the Guild of SS Joseph and Dominic was founded. Because the members were supporting themselves and their families by the practice of a craft, it seemed logical to use St Joseph as their patron. The theory of the Guild distinguished it from other craft guilds of that time, making its operation both simpler and more agonized, given the forces of contemporary commerce. It held to the belief that all work is ordained by God and should be divine worship:

The love of God means that work must be done according to an absolute standard of reasonableness; the love of our neighbour means that work must be done to an absolute standard of serviceableness. Good quality is therefore twofold, work must be good in itself and good for use.

The members should, complying with Distributist tenets, own their own tools, their own workshops, and the product of their work. With solemn religious ritual the craftsmen were professed as brothers of the Guild in the chapel on the common. The new member would kneel down, at a signal from the prior, in the middle of the sanctuary, holding a lighted candle. One of the professed brothers would stand at his side holding the badge of membership. The novice would make profession of his willingness to live and work henceforth according to the rules and spirit of the Guild until death.

With the chapel completed, the Spoil Bank crucifix erected and the building of other cottages and workshops, the community acquired a more defined physical identity. It began to be a place which people came to, so that a count taken in 1922 revealed forty-one Catholics living and working on that particular corner of the common, not one of whom had been there at the beginning of 1913. Pepler had bought the field of seven acres on which the community buildings began to rise. Other building work was financed by the craftsmen themselves or with money borrowed on personal security or loans and gifts from friends. In 1921 it was decided to put the affairs of the fraternity upon what was described as 'a proper legal basis' and a small private company, the Spoil Bank

Association, was formed to own and administer the property on behalf of the Guild brethren. From the early days, when Eric, Mary and their daughters bought their own small four-square house and their two acres on the common, the idea of Ditchling had increased enormously in scope.

People came because the theories behind the life at Ditchling had begun to be expounded with great clarity and energy. Many would-be reformers, both before and after Gill, have discovered the importance of owning their own printing press, the quick and direct means of disseminating views. As the Essex House Press had printed C. R. Ashbee's message in the curious 'Endeavour' typeface he himself had designed, so Pepler and Gill with *The Game* and in a series of so-called Welfare Handbooks printed by St Dominic's sounded off on all their favourite topics of the moment: commerce, birth control, town planning. There are verses, comic dialogues, extracts from the wonderfully vivid, detailed diary kept by Eric Gill on his travels around Ireland with Pepler in 1919, engravings, country recipes, Cobbett's instructions for brewing beer. The mixture, holy, hearty, on the verge of *faux naïveté*, radiates the character of Ditchling at that period. One evocative issue was a *Catholic Gazette* reprint: 'Missions, or Sheepfolds and Shambles' by A. Sheep.

Both graphically and from the point of view of content *The Game* is anti-purist, very cheerfully eclectic. Even passionately so. Birth control and custard powder are equally derided, and for rather the same reasons: both are immoral not just because they interfere with nature but because of the wickedness of adulteration. Birth control and what Gill calls 'the blasphemy of Bird's Custard Powder' are both spoiling something which would otherwise be good.

This was Gill's great public propaganda period. Given a good cause, he had never minded making himself a bit ridiculous. In earlier days he and Pepler had enjoyed walking around London as sandwich-board men to publicize an exhibition. Now, with the same zest, he travelled around with a penny catechism in his pocket, hoping, if not looking, for inquirers. He and Chute and Pepler used to leave persuasive pamphlets lying around in trains and other public places for people to pick up: apparently the favourite was *Does the Catholic Church Protect Work People?*. This was a collection of extracts from the *Rerum Novarum* which the Catholic Social Guild had refused to publish and which the compiler, Father Vincent McNabb, had refused to water down. At one of Marie Stopes's pro-birth control meetings at the Queen's Hall in London Gill and Pepler sold fifty copies of their pamphlet against contraception, at 1/- each. Gill described the scene to Desmond in a letter:

The platform was filled with ladies and gentlemen in evening dress, Marie Stopes herself in the most diaphonous of low-neck dresses. Don't you think it remarkable that such a subject should be discussed in such a get-up?

He added that the hall was crowded 'and enthusiastically in favour of B.C.'.

For or against? 'On which side does your heart beat?' It was this quality of certainty, the one thing or the other, which drew so many people, from so many different backgrounds, to Ditchling at this period. Some were more or less sightseers, there for just an hour or two. But there were things about the atmosphere at Ditchling which made some of the craftsmen who arrived there stay for life.

What did they find there? In a sense they discovered what they wanted to discover. It was a place for the unloading of the private doubts and problems: Ditchling always had a strong attraction for the misfit. Partly this was because it was so close-knit a community; it was ready to receive and to enclose outsiders with the settled routines of its religious life and with the definite patterns and philosophies of craftsmanship. But it was also a question of leaders. 'But see how good are my leaders': the important truth he had discovered in his boyhood had in a way rebounded now that Gill had become leader in so emphatic a manner. Leadership, however, has its price, its special pressures. It was not to prove an entirely easy role.

That early post-war period on Ditchling Common was the time when Eric Gill was starting to become a little legend, and there are many accounts of first impressions he made on visitors. They are nearly always charming. Gill was warm, convivial, flatteringly serious even to the young. Tom Burns, the schoolboy arriving there from Stonyhurst with Augustus John's son Henry, was offered an overnight stay in the hay-loft at the end of a long Platonic dialogue: even with a schoolboy Gill liked drawing people out. Reginald Ginns, a young friar from Hawkesyard, who came to Ditchling for technical advice on operating the handpress on which they were printing the *Hawkesyard Review* got invaluable help and also had Gill's principles of art and workmanship drummed into his ears. It was a lasting lesson for him and for the other younger Hawkesyard brethren with whom Gill then came in contact: 'He taught us to see the beauty of line, shape and proportion enclosed within a surrounding frame.' An immediate, positive interest and welcome, leading into a discussion, an argument, a lecture, an hour or two of practical instruction, a sense of new departures, recreated

possibilities. This was often what visitors to Ditchling would experience, and it sometimes led to redirection of their life.

Some of the people who arrived at Ditchling were professional craftsmen, ready-made candidates for the Guild of SS Joseph and Dominic. One of these was George Maxwell, a coachbuilder from Birmingham, a Tertiary of St Dominic already and, as Gill described him, 'a very great Godsend'. (George's wife also passed muster: 'Mrs. Max', wrote Gill to Desmond, 'is also the right kind of Christian woman – no intellectual highbrowism about her.')

Another professional recruit to Ditchling Common – though he did not settle there for good till Gill had left – was Valentine KilBride, a handweaver from Bradford, steeped in the ideas of Chesterton and Belloc. He was originally sent to Ditchling by his parish priest, Father John O'Connor, mentor of Gill and Pepler as he was of G. K. Chesterton, and KilBride has left a graphic account of his first visit to the Ditchling community as it was by then: a conglomeration of six houses and a converted army hut all occupied by members or associates of the Guild dotted around an area of about twenty acres which bordered on the common. The workshops and chapel were in a central position and paths led to them from many points. He went on to describe his official application to Gill to join the Guild, arriving at the common one early summer evening:

The men were just coming out from Vespers in the Chapel when I arrived and I attached myself to Eric and we entered his workshop when I popped my question. It was received favourably, I thought. He said 'I am afraid we wouldn't be able to employ you', but I assured him that my intention was to be self-employed in my trade.

The self-employed, self-reliant tradesmen like KilBride were essential to any plans of Guild development. But it was the less professional, less rooted, solitary and anxious young men in their twenties who came to live at Ditchling who made the greatest impact on the Gills' own household. David Jones, Reginald Lawson, Denis Tegetmeier: these were young men suffering the effects of the Great War, all converts or on the brink of a conversion; all to some extent emotional casualties, all inhabitants, at one time or another, of the cottage in the paddock at the corner of a meadow with two pigsties and a cowshed. This house came to be known as 'The Sorrowful Mysteries' – an allusion to one of the three sequences of the rosary – since its residents, not surprisingly perhaps, tended towards gloom and introspection. Not even Ditchling

jokes, like the mare's milk served by Betty for tea one afternoon, could ever quite alleviate the atmosphere.

The surrounding sense of warmth and certainty provided by the Gill family, however, achieved something. David Jones, who arrived at Ditchling at a period of crisis in his development as an artist, was always lucid about his first impressions of Gill and the Gill household: Gill's affectionate manner; his extraordinary clarity; the Socratic method of his conversation, and his genius for clearing up a muddle, a physical or intellectual confusion, for pointing people in a sensible direction. He remembered very clearly the day he paid a visit to the workshop and Gill drew out three more or less three-sided figures: one open, one partly open, one completed. 'Which one is the triangle?' David Jones did not know, but said he liked one of them better than the others. Gill explained it had nothing to do with being better. Only one was in fact a triangle at all.

For such highly strung young men, the regime at Ditchling Common could be physically daunting. Desmond Chute had once fainted as he knelt on the unyielding coconut matting in prayer in the Gills' kitchen. Reginald Lawson, a refugee from the film industry in London, only recently recovered from a breakdown, had keeled over while assisting at the killing of a pig in the Gills' farmyard. The blood gushing from the animal's throat had been too much for him. But reactions were not always so dramatic, and it does seem likely that the physical demands of the regime, the emphasis on everyday ordinary labour which was so central to the form of life and worship which emerged on Ditchling Common, had a generally soothing effect on those who came there almost in a state of shell-shock, literal and metaphoric. On the whole the regular life, the rhythms of the seasons and the ceaseless demands of the natural economy seem to have worked, to some extent, a kind of healing. Reginald Lawson, who became a lay brother of the order and keeper of the shrine of St Dominic in Rome, wrote in his memoirs a kind of hymn of praise to the daily routines: the pruning and the clearing of the hedges and the ditches, wood to be brought in, barrels to be scoured, fodder for the pigs to be collected from the neighbours. David Jones, in a rush of enthusiasm, painted a panel, the entry to Jerusalem, *Floribus et Palmis*, on the newly whitewashed wall in The Sorrowful Mysteries. The panel is still there, recently restored, and it has the poignant feeling of a coming back to life.

For anybody coming to see Eric Gill at Ditchling, and in particular penetrating into that inner sanctum, the kitchen at the Crank, the visual

differences between life as the Gills lived it and life in the outside world were straight away apparent. There are many fond, and some over-fond, descriptions of the trim sash-windows, the 'stone-colour' paint, the wooden latches, the scrubbed refectory table, the Dutch brass chandelier, the pewter mugs and dishes, the wooden platters, the broad-rimmed pottery plates supplied by Gill's old friend Roger Fry's Omega Workshops. This cosy, demure scene became part of the Gill legend.

One of the most clear-headed analyses of Ditchling comes, interestingly enough, from Spike Hughes. His parents were Lillian, Gill's early Fabian mistress, and the first of her husbands, Howard Hughes the musicologist whose collected folk songs the Gill family sang loyally. In the Christmas holidays of 1919, Spike Hughes and his mother stayed at Hopkins Crank. He found the uncompromising atmosphere of catholicism slightly sinister, especially the 'considerable amount of splashing of holy water at the saying of grace before meals'. For his taste – and he later numbered Italian food and opera in his passions – the life-style at the Crank was a little bit too basic, with the water freezing in the basins, the home-made bread and butter eaten off the wooden plates, the family in their homespun, homewoven clothes. But although he found the attitudes verging on the phoney, he was in no doubt about the artistic standards:

It was a craftsman's home, with Gill carvings and shrines and woodcuts over every available mantelpiece, and doorway and in every corner. It was by usual standards a more than somewhat arty-crafty household and even I (who had had no great surfeit of physical comfort) found the domestic existence a little austere. But from a purely aesthetic point of view it was no ordinary arty-crafty collection of *objects* that decorated the Gill interior; it was a craftsman's home, but it was the home of a master-craftsman and it was no less a pleasure to live with a magnificently carved and lettered fireplace because it happened to have been done by the occupant of the house instead of by an outsider.

Maybe Hughes himself was not immune to the Gill influence, for only a year later he too turned towards catholicism.

Much of the impression, both visual and spiritual, derived from the sense of family. The three girls and the small boy – Betty, Petra, Joan and Gordian – were grouped dutifully, lovingly, around their devout parents. The unworldliness of the scene astonished most spectators. By ordinary standards the girls were quite uneducated. Gill did not believe in education for daughters. Indeed formal education for anyone was dubious. Although a school for Ditchling Common children was estab-

lished in a little wooden hut beside Spoil Bank its organization was always very random, and for enlightenment the children relied mainly on the goodwill of others in the community. Desmond Chute, for example, taught the Gill girls singing; Joseph Cribb, who was an expert on butterflies and beetles, gave occasional classes in zoology; Philip Mairet told them extraordinary stories of mice, men, philosophy, morality. But it never occurred to anyone to wonder if possibly they should be learning French.

Their unfashionable clothes, obeying their father's views of the right and proper dress for a virgin and a Catholic, inevitably set the Gills' daughters apart from their contemporaries. Even compared with the children of other notably unconventional artistic households – the Johns at Fryern, the Bell children growing up only a few miles away at Charleston – the Gill family seemed part of some separate existence, in some ways more ethereal, in other ways more rigorous than that of ordinary households. It was not an unhappy childhood, far from it. All accounts, from the Gill and Pepler children, the children of the Cribbs and the other Ditchling families, so closely interrelated through the life of the workshops and the life around the chapel, verge on the idyllic. Simple pleasures, intense friendships, great events – like the annual Ditchling Flower Show and the sports on Ditchling Common, with Father Vincent, as timekeeper, stopwatch in hand; followed by a giant Ditchling children's tea party. There were profound advantages in growing up at Ditchling. But the children always felt – this was the price of self-containment – that it was other people who were odd.

The sense of separateness could appear as a salvation, a source of inspiration to those who came to find it. For an extreme example, take the recollections of Reginald or (as he by then was) Brother David Lawson. In 1965, then in his seventies, he wrote:

In remembering Eric's and Hilary's households I cannot help thinking of Holbein's picture of St. Thomas More's family. The same grace and graciousness distinguished them, and in those early days at Ditchling it sometimes appeared even more strikingly. On one occasion I thought I saw a nimbus around Eric's head and shoulders. Wondering if it were a trick of light I moved around the table where he was sitting, but the nimbus remained. I am convinced of this.

Nor can one discount it. Gill's effect on some people was so lastingly powerful they went on believing the reality of nimbuses. But neither should one ignore less reverential commentaries: the glimpse in Ashbee's memoirs of the 'shrivelled, keen, cutting little man, scrubby and dusty'

who had pared off the rim of 'his apparently ordinary commercial felt hat, and tied up his muddy trousers with string to make himself look more like a poor Dominican lay brother – or as Richmond put it "Sir Gyrth the swine herd" '. There were things about Gill which Ashbee found a little suspect. The man struck him as being rather like his work: 'a piquant charm in its angularity but always something unpleasant'.

Serenity and sanctity? Pretension and aggression? Such polarities of view emphasize the contradictions in Gill's public personality. His unstated private conflicts, his unachieved hopes for integration, haunted him and were far from resolved in the years on Ditchling Common. Gill's own acquisition of man-of-wisdom status made things worse. He was, after all, supposed to know the answers. While his artistic reputation increased, his workload and responsibilities as an all-purpose sage and spiritual adviser also expanded and became quite onerous. Discussions would continue into the night and towards morning. Petra remembered him at times on the point of collapse from tiredness. He was resilient. He appeared to recover. But the diary, which shows clearly Gill's great sexual complexity, also betrays inroads of emotional strain.

His relations with Mary continued well and cheerfully. They always shared an amiable element of earthiness, which was perhaps accentuated by the Middle-English quality of life on Ditchling Common. Some of Gill's diary notes are positively Chaucerian in their feeling: references to rollings with Mary in a hay-rick, and the evening when Mary came down without her drawers on (the evening when Father Austin Barker came to supper). His accounts of sex with Mary have lost none of their old gleefulness. One entry – illustrated with one of his small drawings, a HE–SHE diagram – describes how he and Mary had 'a great time in bed' and actually discovered 'a new *façon de faire*!'. Gill's relations with Mary in themselves were very simple: they pleased each other and they went on pleasing one another as long as life continued. It is when it comes to Gill's relations outside his marriage and in particular, in the Ditchling years, to his relations with his daughters, that the scene becomes more complex and his own credibility in the Ditchling setting, as the venerated father of the ideal Catholic family, is less clear-cut.

The evidence in Gill's diary is that his sexual behaviour was, by conventional standards, extraordinary. Some of the entries have been obliterated but enough of them remain, almost clinical in the accuracy of their description. Visitors to Ditchling, even residents in the Gill household, must have been completely unaware of the undercurrents of family practice and feeling. For instance in July 1921, when Betty was

sixteen, Gill records how one afternoon while Mary and Joan were in Chichester he made her 'come', and she him, to watch the effect on the anus: '(1) Why should it', he queries, 'contract during the orgasm, and (2) why should a woman's do the same as a man's?' This is characteristic of Gill's quasi-scientific curiosity: his urge to know and prove. It is very much a part of the Gill family inheritance. (His doctor brother Cecil, in his memoirs, incidentally shows a comparable fascination with the anus.) It can be related to Gill's persona of domestic potentate, the notion of owning all the females in his household. It can even perhaps be seen as an imaginative overriding of taboos: the three Gill daughters all grew up, so far as one can see, to be contented and well-adjusted married women. Happy family photographs, thronging with small children, bear out their later record of fertility. But the fact remains, and it is a contradiction which Gill, with his discipline of logic, his antipathy for nonsense, must in his heart of hearts have been aware of, that his private behaviour was at war with his public image – confused it, undermined it. Things did *not* go together. There is a clear anxiety in his diary description of visiting one of the younger daughter's bedrooms: 'stayed ½ hour – put p. in her a/hole'. He ends almost on a note of panic, 'This must stop.'

During this period, Gill was producing that exquisite series of life drawings of his daughters: *Girl in Bath*, a portrait of Petra; *Hair Combing*, a complex image in which the cascade of hair both curtains and enhances the nearly nubile body; the solemn, latently erotic schoolgirl in *The Plait*. In few artists do the work and real life react so closely. The portraits of Gill's daughters, so exact yet sentimental, the artist-father seizing on a childhood almost vanished, are so very much a part of the years on Ditchling Common. Their sexual ambivalence – the iconography of child-bride and father-lover – and their meaning in the family stand as the most intense expression of that duality without which one cannot understand Gill's life.

In 1921 Betty was sent away to Gruyères for a year. Gill reported to his friend Father John O'Connor: 'she's been taken on as a domestic in a small hotel in Gruyères – help in house, learn French, Swiss cooking and La Vie Catholique – neither pay nor be paid. Desmond stayed there last winter and says Mme. Ruffieux is a very holy woman and leads v. holy life and all. We hope this will do her good and solve some problems.' Betty's dispatch to Gruyères has always been explained by Gill's view that his daughters should acquire domestic skills which complemented one another: Petra was by then learning to weave with Ethel Mairet, so

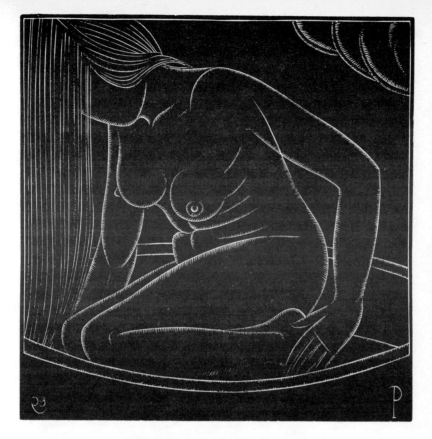

21 *Girl in Bath, II.* Wood-engraving, 1923.
Portrait of Petra, after a drawing from life.

Betty was sent off to make cheese and learn to cook. It was also understood that she had been sent away to distract her attention from David Pepler, Hilary's son, a childhood attachment which had by now developed into an unofficial engagement. Her father was known to disapprove of this on grounds of their youth. But there were evidently other passions involved. Gill's sexual feelings for his daughters explain the deep possessiveness with which he regarded their *amours* and their marriages. In Betty's case the situation was more complicated by the fact that his relationship with Pepler, which had started in such friendliness and comradeship, was by this time drifting towards a kind of rivalry, a growing opposition in their ideas of Ditchling which in the next few years developed towards a crisis.

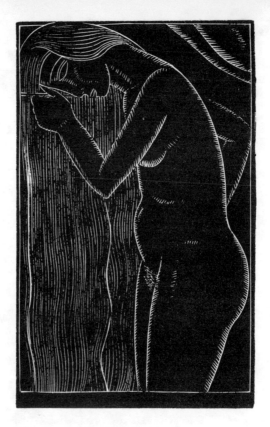

22 *Hair Combing.*
Portrait of Petra.
Wood-engraving, 1922.

One of the people Gill turned to at this juncture was Dame Laurentia McLachlan, the Benedictine nun and friend of Sydney Cockerell, at that time the sub-prioress of Stanbrook Abbey. It seems likely he had originally met her in connection with the printing press at Stanbrook. The hint of the rapport between Gill and Dame Laurentia, the enclosed nun with the unenclosed mind, as Bernard Shaw described her, makes one for once regret the laconic nature of Gill's diary entries. On 23 July 1921 he notes simply, 'Discussed question of Eliz. education with Dame L.' and that is that.

However, one senses how the problem was obsessing him by the very frequency with which he raises it. After Stanbrook he travelled on to Bradford, where Gill's emotional problems had another airing.

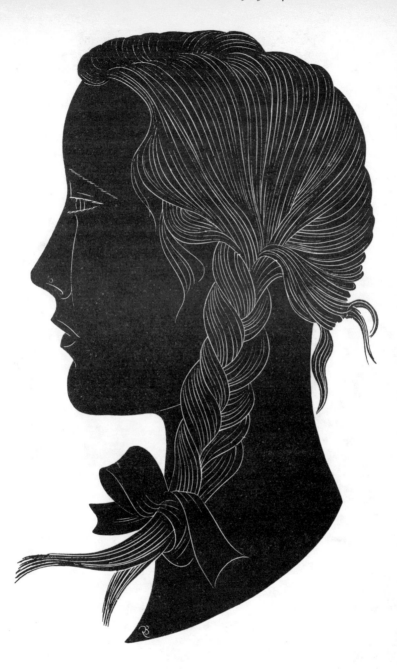

23 *The Plait*. Portrait of Petra, the artist's daughter.
Wood-engraving, 1922.

'Confession to Fr. O'Connor in eve and talk after supper re. Eliz. and my "affairs"!' John O'Connor was always, to Gill, a good confidant, sympathetic, robust. He once said Gill saw things *and* persons in the nude, and it was a tendency he shared. 'Began drawing of fucking for Fr. J. O'C,' runs one diary entry; then, five days later, 'Finished fucking drawings and diagrams for Fr. O'C.' But in the scale of confidants O'Connor then and always took second plate to Chute, and one of the great sadnesses, the bitterest of absences in another looming period of upheaval, was that Desmond had by this time made the decision to be ordained and was in the throes of leaving Ditchling.

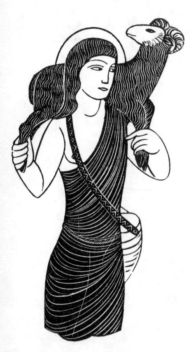

24 *The Good Shepherd* and
Chalice and Host,
ordination cards
for the Revd Desmond Chute, 1927.

It was a double departure towards Switzerland, the eldest Gill daughter and the 'good and faithful Servant', for Desmond was setting off for Fribourg, to study at the theological faculty at the Albertinum. The three of them travelled via Chartres, which Gill found more marvellous than ever and quite different in feeling since his first visit there with Lillian and his second with Mary. He rubbed his rosary on Notre Dame de Pilar and visited Notre Dame de Sous-Terre. He left Betty in Gruyères. He found Gruyères 'the most perfect little town'. It was a town of the right

scale for him. A place of great decorousness and bourgeois busyness which, as such small towns did, lulled him into forgetfulness of all his fulminations against capitalist values and conventional morality. He had, when it suited him, great liking for conventions and the subdued bourgeois pleasures. He returned to Gruyères with Mary the next summer for Elizabeth's birthday, and there is a lovely evocation in the diary of a family picnic by the gorge of l'Évi with Gill sitting in the sun beside the torrent working carefully on one of his small-scale boxwood carvings.

He had certainly not lost his capacity for doing several things simultaneously. Another of the sharpest of the scenes of this same period – which flicker through the diary like the pictures on the mirrorscope, for many years the centre of Gill family festivities – has Father O'Connor in Gill's workshop at Ditchling translating the book *Art et Scolastique*, Gill wielding the dictionary and carving *Divine Lovers* as the translation progresses. This book, better known in its later English version as *Art and Scholasticism*, was the work of the French philosopher Jacques Maritain, the great modern interpreter of St Thomas Aquinas. It was very much the handbook of that period at Ditchling, giving intellectual reinforcement to the life there, justifying the cult of the menial which prevailed. But though *Art and Scholasticism* was an inspiration to community thinking it was also, contemporary accounts suggest, a distraction from the actual output of the workshops. When St Dominic's Press was printing Father John's translation the brethren tended to congregate around the chapel soon after the nine o'clock sung office and would then discuss the finer points of Maritain all morning. After that they walked back home across the fields for lunch.

Art and Scholasticism; flesh and spirit; divine lovers. The last few years of Ditchling had a very definite flavour. It is not perhaps fantastical to relate the changing mood, maturer, more questioning, in some ways darker, to the increasing tensions of Gill's own inner life. His productivity was not in the least declining. In fact it was – as always with Gill – impressive, even amazing, in its volume and its sheer quality, inventiveness and exuberance. These were the years for instance of the enormous war memorial in New College chapel, Oxford; the Stations of the Cross at Bradford which Chute and Gill both worked on; one of Gill's most ebullient stone-carvings, *Splits*. But this period was also, for one reason or another (reasons very much bound up with his inward irresolution), a time when he began to invite and pursue controversy with a doggedness which strikes one as obsessive.

25 *Divine Lovers*,
second state.
Wood-engraving, 1922.

In the early 1920s Gill's concept of 'being fucked by Christ', a concept which bewildered and distressed so many people, first came into view. This idea Gill clung to defiantly, and he summed it up many years later in an explanation to the young Rayner Heppenstall of what it really means to be Catholic:

I wish I could get you to see the point about Xtianity – e.g. when we 'Marry' we don't say to a girl: madam you realise what we are is the embodiment of an idea (or do you?). We say: darling, we two persons are now one flesh – or words to that effect. It's a love affair first and last. Joining the Church is not like joining the I.L.P. or the 3rd International. It's like getting married and, speaking analogically, we are fucked by Christ, and bear children to him – or we don't. The Church is the whole body of Christians – the bride. Economic implications follow and are very numerous, but they *follow*. They are implications not explications.

The point is that the bride submits willingly to fucking. (Gill's view of female sex is fundamentally a passive one.)

To Gill the erect phallus came to have a particular symbolism as the image of God's own virility, the potency of holiness. It became the basis of a quite elaborate theory of human love being a participation in and

glorification of divine love. This was a theory Gill managed to believe in: he was not a hypocrite exactly. But like many other of his deeply held convictions, it had a certain very obvious convenience as the justification of his natural predilections, and perhaps he held on to it, argued it through with a zeal that sometimes looked like desperation, because it cast a blanket of righteousness over actions which otherwise seemed dubious – the adulteries, the incest. It was a theory which allowed a great permissiveness within the bounds of his domestic life and his religious discipline. It turned dark things to light.

Have you felt the smooth whiteness of the flesh between her thighs and the dividing roundness? Such thoughts are kindling to our fires. Hasten then to cast them on that Rock – and give thanks, give thanks, above all give thanks.

Interestingly enough, Gill's fascination with that knife-edge between the sacred and profane has echoes in the preoccupations of his family, and especially the most religious of his brothers. For example Romney, distant missionary brother, writing to Eric from Papua New Guinea:

As I passed out of our little Station Chapel two minutes ago, at the conclusion of Evensong, I passed kneeling just inside the doorway, one of the teachers' wives – a girl about twenty years old – her eyes were closed, her head slightly upraised, in prayer. Her garment, a skirt of fine grass, hung loosely from her hips. Her hands were pressed together, the fingers of each hand in perfect coincidence, but her thumbs crossed one above the other. Like a Priest at the Altar her joined hands pointed obliquely towards the floor.

Hard against her abdomen, and with those joined arms around his naked body, stood her little son – born nine months ago. Every action of his sturdy and perfectly proportioned body indicated eagerness and blissful enjoyment. His right foot, with heel slightly raised, was on the ground. His left, with toes and big toe separated, was trying to grip her just above the knee. His right hand had the outer side of her left breast gripped tightly and drawn down towards him. His left hand was extended upwards and outwards – fingers and thumb wide apart – trying to embrace her round the waist.

The scene has a good deal of Eric in it: the mixture of religiosity and sensuality, the sentimental reverence for the maternal image. And Cecil Gill, the doctor, the Church of England curate who became a Catholic, documented in his memoirs with a carefulness of detail very like his brother's love affairs, his own three including the approach to the seduction of a nun.

All this was far beyond the ken of Father Vincent. Gill's growing

26 *The Convert.*
Wood-engraving, 1925,
suggested by letter from
Gill's brother Romney.

sexual candour, as evidenced by his *Nuptials of God* wood-engraving, showing Christ on the cross in the unambiguously erotic embrace of the bride, the Roman Catholic Church, set some alarm bells ringing around Ditchling and the adherents of Ditchling. This provocative image, originally designed as the ordination card for the Revd Gerald Vann, was used in 1923 to illustrate *The Game*, although Hilary Pepler, with his earnest Quaker upbringing and rather bashful, boyish view of women, shared the general concern at what came to be seen as Gill's dangerous obsession with sex.

As 1923 went by there were many other signs of an impending power battle on the common. Gill and Pepler drew further apart daily. Pepler, with McNabb, was becoming more involved with plans for the enlargement of the Catholic community; Gill, more cautiously, saw the dangers of expansion. Pepler, the more gregarious, had more links with Ditchling village and the other craft families, the Johnstons, Mairets, Partridges. He had been appointed to the ancient office of Reeve of Ditchling Common, a job which appealed to his sense of tradition and his theatricality. Gill was now hardly ever seen down in the village. He did

27 *Nuptials of God.*
Wood-engraving, 1922.

28 *A Garden Enclosed.*
Wood-engraving, 1925.
Illustration for
The Song of Songs.

not mingle with that fraternity of craftsmen. More and more he was creating for himself, and his household, a sort of isolation.

Gill was becoming increasingly dependent on the people he felt were his own people. Pepler was his last attempt at equal partnership. The pattern was now changing into Eric Gill and entourage. The role of beloved disciple, son, supporter, brother-artist, vacated by Desmond Chute, was taken over to some extent by David Jones in those later years at Ditchling, and it is significant that his betrothal to Petra Gill, unlike David Pepler's to Betty, was not opposed. It was as if his daughters were considered as in the gift of Gill. David Jones was of Gill's circle and by this time a postulant of the Order of St Dominic. (Not, as his friend René Hague pointed out, because of any very deep conviction: he became a postulant because 'it was the drill'.) His place in the household was in fact already settled. The bestowing of Gill's daughter had its medieval overtones. There is a pretty picture in Gill's diary of an evening at Hopkins Crank with Petra sewing while David Jones reads *Twelfth Night* to her. Ditchling love was celebrated in David Jones's delectable small painting *The Garden Enclosed*, now in the Tate Gallery, with its

SUSSEX

domestic references to *The Song of Songs*: 'A Garden inclosed is my sister, my spouse.' Enclosed gardens, going back to the first small fenced-in spaces of his Brighton childhood, haunted Eric Gill as well.

Gill was inclined to defend his own spaces with some violence. His account of turning a settlement of gypsies off the common, 'very exciting and foolish', makes him sound as if he found such recklessness enjoyable. He certainly threw himself with great enthusiasm into the arguments and storms surrounding the war memorial for Leeds University. This became one of his most notorious commissions, first of all because of Gill's initial effrontery in proposing for a great commercial city a monument based on Christ turning the moneychangers from the Temple, and next because of the pugnacity with which he defended the finished work against its numerous detractors. It was Gill's first public controversy on this scale.

The original idea had come to him while sitting for his portrait to William Rothenstein. It had first been envisaged as a commission for the London County Council. As he reported in a letter to the artist, in an interesting reversal of the roles:

It will amuse and interest you to know that when you were drawing my portrait the other day I said to myself 'now what shall I think about while I'm sitting here?' And the choice was between thinking about women (in some detail) and thinking what I could do for the LCC Monument design. The former subject of cogitation seemed irresistible and I began on that, but somehow I got shunted on to the other subject and it suddenly occurred to me that the act of Jesus in turning out the buyers and sellers from the Temple when he did was really a most courageous act and very warlike.

How the *Moneychangers* would have been received by Londoners we will never know, but in Leeds the reaction was ferocious. The press reports and letters of reproach came piling in, filling Gill with an excitement one would come to recognize over the years in similar circumstances. In Ditchling, the St Dominic's Press produced a Welfare Handbook in explication and defence of the memorial, putting forward Gill's argument that the treatment was appropriate since modern war is in fact mainly about money. The artistic defence of the decision to carve the figures of the frieze fully-clothed, in contemporary money-makers' costume, is particularly Gill-like:

Nude models are mostly fools and can only stand in stereotyped attitudes and their bodies are covered with dimples and creases and lovely things you cannot

carve in stone and which only lead one astray and make you forget the beauty of stone in your admiration at the beauty of flesh.

Gill the unremitting tease. His behaviour in the Leeds war memorial episode was so blatantly annoying that in fact it seems hardly normal. His hunger for controversy had become excessive, almost perhaps a symptom of neurosis. So much so that the Vice-Chancellor, Sir Michael Sadler, who had at first supported Gill, in the end lost patience. 'A fine draughtsman, a vain poseur, a tiresome writer', he wrote in his diary when Gill died: 'He behaved like a vain, wilful child. The Memorial is a fine piece of work, but not nearly so good as it might have been. The mood is too obviously underlined.'

In retrospect one has to agree with this assessment. Gill's great gift for satire, so agile and so pointed on the small scale, as in the *Devil's Devices* woodcuts and engravings, translated less successfully into the very large-scale permanence of stone. The joke seems overblown. It seems a loss of judgement, though Gill tried to make the best of it in private as in public and wrote in his diary, when he went to inspect it a year after its erection, that it was 'very satisfactory to find it better than expected, though much more comic, and *beautifully* weathered'. It was an ambitious project, not just in its bulk and scope, its large-scale comic-strip techniques, but in Gill's experimental view of artistic possibilities, his optimistic concept of public art as the focus for debate. He was in fact proposing that a large-scale institutional sculpture could contain within itself a critique of society. For those disposed to attack it on Gill's own favourite 'functional' grounds – its sheer lack of effectiveness as a war memorial compared with, for example, the plainer and much grander memorial by Gill at New College, Oxford, the inscriptional roll-call of the 228 names – Gill would have an answer. He could always find an answer. The *Moneychangers* marks a new mood of obstinacy. The whole war memorial episode counts as one of those 'adventures in life'. He pursued such adventures with a temerity which if anything increased as he grew older. It was very much the product of those final Ditchling years.

In 1923 the Gills had a particularly lovely Ditchling Christmas. Home-made cards, family presents: Gill painted a tray for Mary. Carols in chapel after vespers, midnight mass and communion: and on Christmas Day what Gill described as 'a very happy feast at home'. Philip Mairet brought three of the actors from the Old Vic back with him to perform in *Four Shepherds*, a semi-professional production which was given two performances to 100 people in the large ironing room of the local

29 *Autumn Midnight*. Wood-engraving, 1923,
for the Poetry Bookshop edition of Frances Cornford's poems.
Title-page inscription to Jacques and Gwen Raverat from
Frances Cornford and Eric Gill.

laundry, the Gill and Pepler children joining in and, according to their
father, upstaging the professionals. Gill had carved the 'Bambino', the
Christ child, as the centrepiece. Mairet brought the actors in for lunch
at Hopkins Crank. But this was only a short lull. Just a few days later
Gill set off to Tenby, and then took a boat to Caldey Island, to visit the
community of Benedictines. He described this as an expedition of inquiry
into the affairs of the island to see if a marriage could be arranged
between the Tertiaries (spinsters) and the Benedictines who had been

30 *Safety First*, illustration for the *Labour Woman* periodical.
Wood-engraving, 1924. (reduced)

doing their own housekeeping and seemed to need a wife.

Gill's was an almost ceremonial visit. The prior, Dom Wilfrid Upson, with other Fathers, met him. He was shown around the farm, the priory and the island before attending compline at the abbey. It looked as if the Gills could soon be on the move again.

There was nothing new, of course, in the idea of moving. Gill loved the settled life, the details and the emblems of domesticity. But no one was more eager with plans for grand upheaval: the Stonehenge scheme

with Epstein; more recently the schemes for Plumpton Mills in Sussex with Edward Johnston and the Peplers, a romantic rural place of willow banks and fishponds, for which detailed architectural plans had been drawn up. Most recently of all, and most serious, had been the plans to move to Ireland, to Crappa Island off the coast of Galway. The Tertiaries at Ditchling had discussed this officially at their Tertiary meeting. It was recorded in the minutes that 'Bro. Eric thought he would be able to shake off the "middle class" life and become a mere peasant.' Ireland appealed to him very much, as one can see from his 'Diary in Ireland': he liked what he saw as its primitive simplicity, its feeling of reality, the small scale and the sweetness mixed with the extraordinary crudenesses and uglinesses. Gill saw, and revered, Ireland as the place of all the contrasts and a country where the Ditchling ideals could be transplanted. Encouraged by Father Vincent there had even been at one stage a scheme for affiliating Ditchling with Sinn Fein. But in the end the plans for colonizing Crappa had not proved practicable, and Gill exchanged his vision of the peasant life of Ireland for the very different peasant life of Wales.

He had heard of Caldey from Donald Attwater, a stranger who arrived on the off-chance, like so many. He had vaguely heard about the craft community at Ditchling and as usual he had been welcomed into the Gills' kitchen and immediately engaged in a lively conversation which went on well past midnight. (Donald Attwater, not untypically of those casual visitors, stayed to write his book on Gill, *A Cell of Good Living*, and eventually married the daughter of Gill's poetic sister Enid: the Gills having received him made the utmost use of him.)

Attwater, on that early visit, described the Benedictine community on Caldey, which had only ten years earlier changed from an Anglican monastic community into a Roman one, and the deserted monastery buildings, of more direct interest to Gill, at Capel-y-ffin in the Llanthony Valley up in the Black Mountains. Through the rest of the year, as Ditchling discontents accumulated, the idea of Capel-y-ffin as the possible place of salvation seems to have lodged itself more firmly in Gill's mind. Capel! The name with its associations of escape, exoticism, wish-fulfilment, set up reverberations as once Ajanta had. Like a small child Gill could be intoxicated by a resonance.

The original idea was that the whole community should move from Ditchling Common to the mountains. The Benedictines at times appeared to be mounting a take-over bid for the Dominican Tertiaries: at least, they actively encouraged the removal. Dom Wilfrid Upson and a deputation of monks visited Ditchling to discuss the possibilities; Gill

recorded a great deal of talking and walking and the prior held a conference in the chapel. Some of the Ditchling craftsmen were more responsive than others: Joseph Cribb, for example, settled in Sussex with his family and workshop, was dubious of upheaval. Eric took him to view the prospects at Llanthony but Cribb wrote in his diary, 'Jolly glad to get back home.' Pepler himself, the archetypal liberal enthusiast, the signer-up for causes, was enthusiastic enough to start negotiating for the purchase of a farm in the Welsh mountains. But as the weeks went by there were emerging complications, immediate differences and the dredging-up of conflicts of past years, conflicts up to then unstated, some of them not even recognized. Father Vincent McNabb, for many different reasons, predictably enough strongly disapproved of the idea of removing the community so far away beyond his jurisdiction, and his distraught interventions heightened the sense of drama. In June 1924 McNabb presided over a meeting at St Dominic's Priory in north London at which Gill read aloud his denunciation of Hilary Pepler. (He had composed this paper on the train.) Though the meeting had ended in the kiss of peace, Father Vincent's hopes for resurrecting Ditchling were doomed to disappointment.

Only a few days later Gill wrote to Desmond Chute:

I expect you have heard from Hilary, but I don't know if he has warned you of the fact that, owing to financial difficulties and, as I think, financial crookedness, on the one hand, and attempts of some members to enlarge the scope of the Guild to include responsibility for family affairs as well as workshop affairs there is a serious dead lock and a break up of the whole thing seems inevitable. I hope you need not be worried by it all – I hope you will not see the sepulchre through the whitewash. You are well out of it anyway.
 Love from us all – your affectionate brother in St. Dom.
 Eric P. J. G. o.s.d.

It was ironic in that year of the *Moneychangers* that one of the main reasons for the split was a financial one. The Ditchling finances had always been chaotic, in spite of Gill's own obsessiveness with his account books. Gill had not been much involved with the more general Guild finances for the very simple reason he had little money. His fees were not high: they were workman's not artist's charges. By far the largest sum in the Ditchling job books had been £765 for the Westminster Stations, entered in 1914, and even in the middle 1920s his standard rate was a modest £2 a day.

31 *Hound of St Dominic*, symbol of St Dominic's Press, Ditchling.
Woodcut for poster, 1923. (reduced)

Gill's only contribution to the Guild central fund was £500 borrowed
from Lord Howard de Walden. Financial control, though in theory a
shared responsibility, was in reality put in the hands of Pepler, the only
Guild member who was reasonably prosperous. Gill resented this. His
resentment bubbled over into some notes he wrote as the background
to the quarrel, by this time becoming more public and embittered. Pepler's
education and background of relative affluence had, Gill maintained, left
him with 'a sort of Manicheism' with regard to money: because he
considered it intrinsically evil all care and method in financial affairs
seemed to him unnecessary, even despicable. Gill summed up Pepler's
attitude with a rather startling venom:

Everyone loves HP but *hates* his finance
 & hates his brutal methods
 his dictatorial manner
 his minding other people's business

He accused Pepler bitterly of always rushing into new projects and
leaving the consolidation undetermined.

There was of course a great deal more to it than that. It was not a
simple conflict of the rich man versus the poor man, a question of the
person who called the tune financially, although there was certainly a
little of this in it. It was more a confrontation of methods and personality.

Pepler was fundamentally outgoing, seeking opportunities to expand the craft community, to extend the boundaries from the common to the village. Gill, in spite of his talent for publicity (all the more acute the more deliberately denied), was essentially reclusive and was becoming more so.

The emotional tensions of the last few years, intensified by his resentment of Pepler and of Betty's continuing love for Pepler's son David, made their continuing partnership impossible. Gill had become temperamentally unsuited to a partnership. As Philip Hagreen, wood engraver, a new arrival at Ditchling, put it so succinctly: 'Eric had to be the Abbot.' He had begun to panic at the thought of being answerable. He could no longer tolerate the prospect of the challenges of those on his own level. He was out of sympathy with the idea of Ditchling. From now on, his mind was set on the need to be the master, and be seen to be the master, in his own house.

Gill's own official reason for pulling out of Ditchling was the publicity surrounding him and the community: his need to get away, and get his family away, from the endless stream of visitors, reporters and inquirers which had increased in volume, and in nuisance value, since the *Money-changers* controversy. It was certainly quite true that Hopkins Crank attracted visitors out of all proportion to its modest facilities for dealing with the public: Desmond Chute, in his Ditchling days, had shared with Mary the task of entertaining and distracting visitors until Gill was ready to receive them. But, like many of the versions of the truth which Gill put forward, this too was far from the whole story. There was something in Gill's nature which demanded the publicity, and this as much as anything was what he needed to escape from. Pepler, who understood him well, saw his deep-rooted and infuriating contradictions: the urge for space for peace of mind and contemplation which so bizarrely coexisted with the 'non-contemplative streak', his 'exhibitionist twist'. In one of the most penetrating passages which anyone has written about Gill he suggests 'It was that twist, which he perhaps did not fully allow for, which made him apprehensive of the publicity he unfailingly created.' It was one of Gill's great errors that in quarrelling with Pepler he rejected the one person who could see him as he was.

On 22 July 1924 Eric Gill wrote formally resigning from the Guild of SS Joseph and Dominic. It was a sadly businesslike letter:

My reasons for this are of course obvious and I think you will agree that no other solution is possible as we have lost confidence in one another. You will no

doubt let me have at your convenience a statement of what the Guild deems to be my obligations as tenant of my workshop etc. and I will make out a statement of the Guild's obligations to me. Meanwhile I have handed the £25 gold and the chapel account book, balanced to date, to Joseph.

I remain your affectionate brother in St. Dominic

Eric Gill o.s.d.

Hilary, Joseph Cribb and George Maxwell wrote back, on the day of St Mary Magdalen:

Our dear Brother, some things which are lost are found again, we ask you simply to defer the matter until we have had the opportunity for a conference with Dr. Flood in the chair. He will be here for the Feast of S. Dominic, what better day for arriving not only at the truth but at concord?

But Gill, with that streak of obduracy which was one of his less attractive qualities, gave the brethren few grounds for hope. He wrote to Pepler:

Dear H. I thank you for yr. joint note and for its obviously charitable intent. My decision is however unaffected by it. Certainly I hope to have some conversation with Dr. Flood and if you like to invite me to your meeting I will come but I cannot promise to take part in discussion . . . There is no need for discord but only for a reasonable settling up.

The situation was by then beyond repair.

There is no doubt, on the evidence of the contemporary Guild minute books and the correspondence in the Prinknash Archive, that Gill behaved badly in this episode. He had his private reasons for needing to escape from Ditchling, but the manner of his leaving showed the same insensitivity as his escape from Chichester or his cursory farewell to his one-time friends in Clapham. His departure still had the gaucheness of his youth. He had been underhand with his own brethren, negotiating privately with the Prior of Caldey for the leasing of the Grange, one of the buildings up at Capel. He later put the winding-up of the finances in the hands of lawyers. The feeling against him in the Guild ran very deep. At the actual moment of departure in mid-August there were brave attempts at reconciliation, even a mass picnic on the downlands when the sun shone, one of those scenes which made Ditchling seem idyllic. But the breach between Gill and the Peplers, and between the craftsmen left at Ditchling, was never really healed. He was never quite forgiven. The rumblings of disaffection were still audible when the author first visited Ditchling in 1966.

Ditchling, as originally envisaged, was now over. With a sinking heart David Jones, left behind, watched the last few odds and ends leaving the

Crank, in old Evans' Vans of Ditchling. Others had their own regrets. Father Vincent McNabb, the Prior of Hawkesyard, recollecting the unforgettable time when 'Ditchling' was as music to his ear, wrote with a great nostalgia to Pepler some years later:

Your gift of Whitsun cream was more than welcome! It was, of course, one of the best things that even Ditchling could give. But it had memories in its gift; and they were even better than milk and honey. How irresistibly it brought back the Ditchling I first knew, and loved with the intensity of a first love.

To Desmond Chute looking back on it from the more rarefied setting of Rapallo, where he spent his life once he had joined the priesthood:

Ditchling was rather crude: we were too self-sufficient and insufficiently self-supporting. But will anything ever have the vigour and freshness of that first spirit?

To Pepler, who stayed on the common till he died, memories of those first years, what he called 'the great ten years', were overcast with a huge sadness. He missed most intensely Gill's musical companionship: 'I think', he wrote, 'his singing of the solo parts of *Media Vita* in our chapel the most beautiful sound I have ever heard.'

For Gill, Ditchling became a kind of symbol of lost innocence. He dreamed about Ditchling with a sentimentality which would be embarrassing if it were not so tragic. He records one of those dreams in his memoirs:

I was walking in heaven with Mary and the children. We came upon our Lord . . . And I said to him: 'This is Betty . . . and this is Petra . . . and this is Joanna . . . and this is Gordian,' and he shook hands with them all. And then I said: 'And this is Mary.' And he said: 'Oh, Mary and I are old friends.' It was a green open hill-side with paths and bushes and a blowy sort of sky with Downland clouds.

WELSH MOUNTAINS AND PYRENEES

CAPEL-Y-FFIN

1924–8

A few days before departure in mid-August 1924 Gill dispatched another of his change-of-address missives, this time to G. K. Chesterton. Its method of approach was the familiar full-frontal, its references characteristically wide-ranging:

I do think you make a bit of a bloomer in (1) supporting Orpenism as against Byzantinism and (2) in thinking that the art of painting *began* with Giotto – whereas Giotto was really much more the end. We are leaving Ditchling Common and after this week my address will be *Capel-y-ffin, nr. Abergavenny, S. Wales.*'

Of all his destinations Capel-y-ffin, quite literally *cappella ad finem*, was by far the furthest off, the most remote, the wildest. It was in fact fourteen miles from Abergavenny, closed in by mountain walls rising 2,000 feet high on both sides of the valley and at the head. The only outlet led south down the valley. The nearest railway station was ten miles away. The postman, who came once a day, arrived on horseback. The doctor, also horse-borne, came from Hay-on-Wye weekly. Capel-y-ffin may not have quite fulfilled Gill's wishes, expressed so vehemently in the crowded days at Ditchling, to move his workshops out into the wilds of central Africa, with fifteen lions chained up outside to deter visitors; but in some respects South Wales struck Gill as even better. There was daily mass at hand. There were sheep running on the mountains and stone galore, both for carving and for building, with the bonus, which appealed to Gill's inherent streak of stinginess, that the stone was for the taking, '*at no extra charge*'.

Looking back on the actual mechanics of the move, Gill decided that the exodus of his own large family from Brighton to Chichester had been as nothing compared with the performance of shifting out three families

– three fathers, three mothers, seven children aged between five and nineteen, one pony, chickens, cats, dogs, goats, ducks, geese, two magpies and the luggage – from Ditchling and settling them in at Capel. They travelled first of all by train, getting out at Pandy, the nearest station at which the pony could be detrained. Then people and animals piled into a large lorry which took them up the rough and narrow mountain lane. At one point the route became impassable. A tree had to be felled to allow the lorry through.

Petra Gill had stayed behind at Ditchling to complete her training as a weaver in Ethel Mairet's workshop. But Betty and Joan both came to Capel with their parents: the pony was Betty's and she was the person chiefly in charge of the rest of the menagerie, a job which rather suited her philosophic temperament. (Her father found animals desperately wayward.) The rest of the lorry-load consisted of the Brennans, Dan Brennan having been a farm labourer at Ditchling, and Philip Hagreen, the engraver, with his family. Hagreen, sixty years later, could remember all too vividly the acute discomforts of that journey, as the lorry lurched on towards Capel in a downpour. He had the feeling it always rained at Capel, and indeed the annual rainfall level, on average as high as 63 inches, is unusual. He remembered the sound of the streams swishing down the mountainside. He also recalled with lasting horror the pervasive smell of goat.

On their way up the mountains they passed the ruined abbey at Llanthony, the picturesque remnants of a twelfth-century priory of Augustinian canons, built on a valley site of extraordinary beauty. Gill had at one time had his own eye on Llanthony, and Mary, with that tactfulness and loyalty which in some ways made her the perfect wife for him, was sometimes heard telling people around Ditchling that his mission in life was to restore Llanthony Abbey. But that plan had fallen through, and in the end the Gills had settled for a building four miles further up the mountains, the large and faintly sinister one-time monastery which belonged to the Caldey Island Benedictines. For Gill it was a choice in some ways suitable, in other ways, like many of his choices, problematic.

The monastery had a background of spiritual history even more unusual than that of Gill himself. It had been built towards the end of the last century by the curious, indeed notorious self-styled Father Ignatius of Llanthony, evangelistic Anglican deacon who believed he had been called to revive the Benedictine monastic life within the Church of England. He was a charismatic figure, an obsessive publicist, a

formidable quarreller with church authorities. What he lacked was staying power and the breakaway community of Benedictine monks which he ruled at Llanthony gradually dwindled. When Father Ignatius died in 1908 only three of the original community remained. The story is a haunting one, a tale of hopelessly misdirected fervour, a hymn to English amateurism and eccentricity. Its hold on literary imagination survives as the subject of Arthur Calder-Marshall's *The Enthusiast* and the intriguing side plot in A. N. Wilson's novel *Gentlemen in England*. It is notable that Gill, with his dislike of competition and his instinctive lack of interest in history, always underplayed the Ignatius connection, and indeed went so far as to dismantle Father Ignatius's reredos when he found it in the church.

This strange building had by then been unoccupied for years. Its idiosyncrasies were itemized, with feeling, by Donald Attwater who had arrived to live there not long before the Gills:

In 1923 the Monastery stood empty and dilapidated. The buildings were of local sandstone, built at various times round a small central grass garth, in an emphatic but elementary pseudo-gothic. Time and neglect made them look more uninhabitable than they in fact were. Diamond panes of windows had been pushed in by an exuberant growth of ivy (originating from a cutting taken at the grave in Margate of Father Ignatius's mother); overhanging branches of trees swept the western roof. Holes gaped in the roof of the low north side; all around was a mess of rusty metal fittings, tangled with nettles, brambles and fallen stones; a wooden outside stair sagged precariously. Inside, the rooms had been arranged with a masterly eye to inconvenience; they were dark and depressing, and a film of muddy dust lay everywhere. To crown all, in the garth near a broken iron fountain stood a decayed wooden cross, marking the burial place of a nun from the convent which once adjoined the main building. When Eric Gill first visited the place, he saw all this, and more – for example, that these buildings stood on the side of the valley that enjoyed the least sun. But he also saw further; he saw the possibilities of the place and the house.

It was once again a case of the diametric opposite: the rolling Sussex downlands exchanged for the Black Mountains, the 'neat toy' of a house on Ditchling Common for a building which had, at its worst, such overtones of Gothick horror, a Castle of Otranto, a 'Monk' Lewis resurrection. It was not a place to encourage casual trippers. Its potential for peacefulness much appealed to Mary in her role as Gill's protector. She saw Ditchling drive him frantic. 'I used to feel I must pick Eric up and run off to the mountains – there to let him work in peace – and live a life of prayer and contemplation.' Now she had.

The arrival at Capel was, like all the Gill arrivals, a scene of merriment, confusion, new hopes and new excitements. That most surprising vision of the lorry drawing up in the courtyard and disgorging its cargo of people, birds and animals, was watched with delight by René Hague, a young man tentatively attached to the Caldey monks, who happened to be out on the hillside cutting sticks. He came dashing down to greet them. It was one of those encounters, like Desmond Chute's first meeting with Gill beside the Stations of the Cross in Westminster Cathedral, which had repercussions which lasted all Gill's life. René Hague eventually married Joan, Gill's youngest daughter. In the late afternoon the Gills finally unpacked themselves and took possession of the monastery. The house was swept and dusted and the Attwaters had brought in great masses of late foxgloves. There was a sense of festival, the end of a long pilgrimage. Gill notes: 'Everyone most kind and gave us a fine welcome. Tea and fire ready. Put up beds pro. tem.'

The Attwaters were already in residence in the west wing of the building. The Gills and Hagreens settled into the east and south wings, sharing the only lavatory and bathroom with the Attwaters. The heritage of Father Ignatius remained in two long rows of monastic cells along the upper floors of the east and north wing. These cubicles, just big enough to take a narrow bed, a chair and a small table, divided from one another with partitions seven feet high and open to the roof, came into their own in later years to house the children of the prolific Gill families and friends. But Father Ignatius's church, which the Gills had assumed ready and waiting to be worshipped in, was not to prove so useful. It turned out to be simply the choir of a large church which had never been completed, like others of Ignatius's grand projects. The carved wooden choir stalls were still in place but the vaulting was in dreadful disrepair. Stones had showered down from on high and were now littering the founder's grave in the centre of the choir. Gill decided to abandon it, and a much less grandiose and more domestic chapel was made in the north wing, after a little rearrangement. This agreed conveniently with all Gill's integration theories. He approved of the idea of the chapel in the house.

The religious life at Capel got going very quickly. The idea of Gill changing his allegiance and becoming a Benedictine oblate had not been pursued further. Perhaps a very kindly and understanding letter, more or less giving the switch-over his blessing, from the Prior of the English Dominicans, Bede Jarrett, had had some influence: Gill liked to go into reverse. In the end he decided to remain with the Dominicans, arguing with characteristic agility that the mission of St Dominic had after all as

its earthly objective the bringing back of the world, collectively and individually, to St Benedict. This was a diplomatic let-out in what might have become a rather tricky situation, and throughout their Capel period the Gills' links with the Caldey Benedictines were friendly, near-familial. The prior, Dom Wilfrid Upson, the subject of one of Gill's strongest and most imposing portraits, was a frequent visitor at Capel where he entertained the families with card tricks and conjuring, at which he was an expert. And it was a Caldey monk, Father Joseph Woodford, then living up at Capel recovering his health, who was allocated to saying mass in the Gills' chapel. This again was integration. It became the pattern. From then on the Gill households almost always had their priest.

The bulletins started going out from Capel and in those early weeks they were energetic, full of happy fervour. They described a set-up which, if not quite as absolutely basic as the Robinson Crusoedom of Ditchling Common, was still extremely primitive.

Well – [wrote Philip Hagreen to Desmond Chute] we are all settling down here rapidly and all goes well with us all. Difficulties are many and various, but you can imagine the way in which Eric tackles them all. What a man! I feel bewildered that Heaven should have sent me as his companion.

Mary Gill, too, wrote to Desmond, in a fever of activity:

The days are all too short – for there is much to be done. Betty and Joan are very good and helpful, and we look forward to Petra coming with her loom. We want as much as possible to make all our own clothes – and grow what food we are able.

But she adds on a note of realism: 'I think it is going to be uphill work.'

The move to Capel seems to have released in Gill himself a surge of creative energy. In the early weeks he had already set about completing an unfinished carving he had brought with him from Ditchling, the black marble torso of Christ known as *Deposition*, now at King's School, Canterbury. It is generally regarded as one of his finest sculptures, and Gill described it later as 'about the only carving of mine I'm not sorry about'. In the somewhat chaotic circumstances of arrival he began on the carving in the coal cellar at Capel, a location which afterwards struck him as peculiarly well suited to the subject. That evening, in one of those scenes of rather solemn domesticity which linger in the minds of many visitors to Capel, he gathered his family around him after supper and read them *Alcestis*. At its best the life of Capel had a sweetness, a containment, an end-of-the-road feeling so high up amongst the

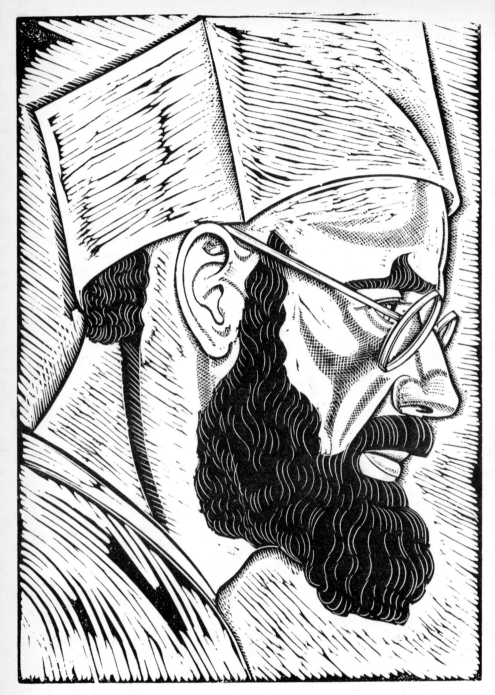

33 Self-portrait. Wood-engraving, 1927. A version was used as frontispiece for
Douglas Cleverdon's *Engravings by Eric Gill*.

mountains. '*Montes in circuitu eius et Dominus in circuitu populi eius,*' Eric Gill would assert serenely if self-consciously. But at Capel there was also a feeling of last chances, of being up against it, almost a sense of urgency. If the cell of good living could not be achieved at Capel was it likely to be feasible anywhere at all?

By the time he got to Capel, Eric Gill was forty-two. To René Hague, then just nineteen, he looked like an old greybeard, a Noah in the Ark. The portraits of this period show he was becoming slightly grizzled in appearance; his youthful look of edginess, his whipper-snapper wiriness, had been overtaken by a more ascetic quality, what sometimes seems almost like an abstraction of expression. By this time he was looking older, wiser and more weathered. This is not at all to say that Eric Gill had become pompous. Philip Hagreen describes how, finishing the *Deposition*, he and Gill sat for days, one on either side of it, rubbing and rubbing it with carborundum to give it a nice shine before they took it off to sell it, finally being reduced to giving it a coat of French polish. He quite liked to play the charlatan. But he had an acquired depth of experience, a refinement which shows clearly in the major works of sculpture done at Capel, the *Deposition* and the carving which he started not long afterwards, *The Sleeping Christ*, the stone head of Christ recumbent. This is now in Manchester City Art Gallery.

These two carvings have an agelessness, a *trouvé* quality. In a curious way they seem to belong nowhere, as if recently unearthed from some ancient burial mound or discovered in the ruins of a medieval cathedral. David Jones used to say that the most successful of Gill's works were his unconsidered artefacts, the little crucifixes on the forgotten gravestones, the holy-water stoups, small things done for realistic purposes. Things normal and right and as though of a tradition. Some of his inscribed stones, as Jones so clearly understood it, seemed to express 'the anony-mous and inevitable quality we associate with the works of the great civilisations, where an almost frightening technical skill for a rare moment is the free instrument of the highest sensitivity'. This still seems a true judgement. Gill's particular sense of the *necessity* of art, its relation to the sanctity of everyday activities, and his perception of himself not as the abstract artist but as part of a long line of artist-*factors*, came to be defined more clearly in the years at Capel. The bricklayer, the pastrycook, the hedger, the house painter, the sacrificing priest, the portrait painter, the architect. As a sculptor, Gill believed that he was part of this succession.

It was part of this philosophy to be broadminded. Perhaps if he had

been more ruthlessly ambitious he would have come to justify the rather gushing local welcome-to-Wales articles which described him as the greatest English sculptor of all time. But his theory that nothing was too lowly for attention, and his liking for variety, excitement at the deadline, encouraged him to do an awful lot of things at once. The London art establishment, the 'Art-nonsense' adherents, would have thought this was a pity. But in fact, as his defenders always pointed out, this was Gill's nature. It was just the way he saw things. This was Gill's conviviality. His inscriptional work, the basis of his carving, had always been carried on alongside sculpture, and the more routine activities – the 'Tombstones, Tombstones, Tombstones' – were to him a source of great delight and reassurance as well as the provider of a fairly steady income. He was glad, he once said, to have 'the fly-wheel and the safety valve of letter cutting' to hearten him 'when sculpture and the modern world seemed equally bloody'. More recently, engravings had fulfilled much the same function, more specific, shorter-term and much less chancy than the sculpture.

He loved the new idea of working on his own, far away from Ditchling and from Pepler. In the spring of 1925 he wrote to Desmond: 'Doing my own printing is great sport and I've got a large and a small printing press here and a copper plate press too. Copper engraving is a great game.' What he liked so much was, first, the control of the whole process which he had never experienced at Ditchling. He enjoyed the experimenting. He realized at Capel that his wood-engravings could be printed like copper plates, the ink being rubbed into the engraved line, and the surface wiped clean, and this was a method he adopted. He responded to the definiteness of engraving, the directness of printing one's own image, the relation of lettering to illustration. Like a printed letter, a wood-engraving, he insisted, was a *thing*, not the representation of a thing. This made it the more satisfying, the more godly. The other difference, and this was also an important one, was that at Capel he began collaborating with a client in some ways as demanding, as expert and pernickety, as amusing and exuberant as Gill himself was.

This was Robert Gibbings. He and his wife Moira had taken over the Golden Cockerel Press at Waltham St Lawrence near Twyford in Berkshire only a few months before the Gills arrived in Capel. Gibbings was himself an artist as well as an entrepreneur, a founder member of the Society of Wood Engravers at a time when wood-engraving was on the verge of a considerable revival. At the beginning of his new enterprise Gibbings had contacted several engravers whose work he admired. Gill

had been the only one to turn him down, chiefly on the grounds, mystifying to the Gibbingses, that the Golden Cockerel was not run by a Catholic. However, family loyalty proved stronger than religious scruple, and when it was suggested that Eric should provide a series of engravings for a little book of poems by his sister Enid, her *Sonnets and Verses*, which the Golden Cockerel proposed to publish, he agreed to do so, and stayed on to become Gibbings's chief collaborator over the next decade. The *Song of Songs* of 1925; the *Troilus and Criseyde* of 1927; then the *Canterbury Tales*; and above all *The Four Gospels*: it was a collaboration which resulted in some of the classic examples of specialist book production of that period. Gibbings employed other well-known artists: John Farleigh, Blair Hughes-Stanton, John Nash, Eric Ravilious, as well as David Jones. But it was the books and later on the typeface designed for him by Gill which made the reputation of the Golden Cockerel. They have a forcefulness and clarity which still excites one: in comparison the Nonesuch Press books seem rather winsome. They also have that 'air of mild between-the-wars eroticism', as Colin Franklin puts it so politely. For a while the Golden Cockerel *was* Eric Gill.

It is strange in a way that Gill's short period at Capel, years of so ostentatious a retreat, brought him not just one but two important patrons. It was an example of the rule of the reversal: the world literally beating a path up the Welsh mountains. The second of these clients was Stanley Morison, Typographic Adviser to the Monotype Corporation. The typefaces Gill designed for Monotype under Morison's aegis – Perpetua in 1925, Gill Sans-serif from 1927 onwards, Solus in 1929 – remain Gill's greatest claim to fame, the full flowering of his talent for producing what he called 'absolutely legible-to-the-last-degree letters'. It was Morison's perceptiveness and powers of persuasion which redirected Gill's skill at lettering, essentially a craft skill, into a new channel of design for machine production. Gill Sans is still, after over half a century, a valid modern typeface, in constant use.

Morison's own views on Gill's achievements, although obviously somewhat biased, are worth quoting as they emphasize the *newness*, the high originality, of Gill's designs for Monotype. Of Perpetua and its italic version:

They are creations. There never was anything of that kind before Gill did this, and never has been anything since. The capitals that he did, I think, will be immortal. They'll be used as long as the Roman alphabet is ever used anywhere. And probably those Perpetua capitals – the titling, so-called – I suppose are the

THE
GOLDEN
COCKEREL
PRESS
SPRING
1930

34 Gill's Golden Cockerel lettering, in its engraved form, used on the cover of the Spring
List of the Press, 1930.
The face was designed as a special or display type.

188

finest capitals ever done since Sixtus the Fifth – 1589. They're far better than the classic Trajan and Augustus pattern – far better.

Their genius lay, as Morison argued convincingly, in the fact that they had evolved so directly from the work of a letter *cutter*. They were unselfconscious design. For years before he became a type designer Gill had been perfecting these same letter-forms on stone.

Because Gill believed in work as a most serious part of life, without which any cell of good living lacked its centre, it is perhaps worth looking more precisely at his working relationships with Gibbings and with Morison. They were first of all *reliable* relationships, intensely professional, and this was perhaps one of the good reasons why they both lasted so long and so productively. 'Those were idyllic days,' wrote Gibbings later, yearningly, remembering how punctual Gill was:

He was tremendously conscientious about delivery, and when he gave me a date for a block I could answer the postman's knock on that particular morning with the assurance that there would be put into my hand a parcel addressed in Eric's precise calligraphy.

But it was not only a question of parcels, importantly though a well-packed parcel (like a nicely written postcard) ranked in the Eric Gill scale of priorities. His relationship with clients was a business one, and businesslike: Gill's invoices continued to be models of explicitness. But there were other things; if other things were not forthcoming then Gill tended to think the client not worth having. His criteria for long-term clients were exacting. It was not all the normal designer–client framework. He gave more to them, and he expected much more from them. Almost with the hopes with which one enters a new love affair he expected them to share his tastes and to extend them. Gill's working relationships were yet another facet of his mania for adventuring in life.

Gibbings and Morison were both then in their mid-thirties; opposite in style, yet each in his way complementary to Gill. Gibbings, agnostic, socially confident, large, picturesquely bearded, Irish, flexible, romantic, the roamer in the country, the frequenter of *louche* night-clubs; Morison the convert, high-principled, strong-minded, always dressed in black and looking like a Jesuit, emphatic in his manner, slapping his thigh with an alarming shriek of laughter, a man's man, a London clubman fastidious in taste. These were not exactly Gill's bad and good angels: it was not so clear-cut. But they reflected, and to some extent developed, his opposing tendencies.

Hand and machine; craft and mass production: two of those pairs of

opposites so much revelled in by Gill in his theories and writings. They reached an apotheosis in his work for Gibbings at the Golden Cockerel and his designs for Morison and Monotype. These two collaborations went on simultaneously through the later twenties and on into the thirties. Both gave Gill great latitude. On the one hand at the Golden Cockerel he developed his natural affection for the handpress, for the specialist edition, with its built-in possibilities for endless variation, the well-judged self-indulgences which Gill enjoyed so much. On the other side at Monotype he was enabled to push to its far limit his liking for and preoccupation with the regular, the tidiness inherent in design for mass production. Though he resented the use that had been made of machines and the effect on machine-minders, he had kept his childhood delight in sheer mechanics, in inventions and machinery *per se*.

Gill rejected the whole concept of leisure as a separate activity. The 'Leisure State' was horror. It was therefore important that the people for whom he worked were suitable companions outside work as well, so that work and leisure could flow pleasantly together. Gill found Gibbings and Morison were very much compatible, and again in their differing ways they answered the opposite needs within Gill's personality. Apart from the presswork, on their many expeditions and in their rather recherché extra-mural pleasures, Gibbings would encourage Gill's sense of curiosity, the tendency for dissipation in his nature. Morison was never dissolute and never wasted time, and he and Gill agreed that they detested all vulgarity, particularly that created by the capitalists, as they agreed in their clear and direct faith, while sharing a distrust of the Catholic authorities (those 'macaroni merchants', as Morison once called them). Gibbings was a folk-song man; Morison liked mainly plainchant. With his great elasticity Gill managed to love both.

He also loved their women. This again was a departure from the usual formalities of clients and designers, an example of how Gill challenged sexual conventions in a way which less adventurous people of his period considered much too much. In the easygoing, sexually uninhibited household of the Gibbingses it was quite predictable that, with the positive blessing of her husband, who said he would not trust any other man to enjoy such intimacy, Gill made quick advances on the lavish, lovely Moira. The triangular relationship had always much excited him: in the British Museum there is a small lewd drawing, done in Cairo, of two men entering one woman. Accounts in the diary of visits to the Gibbingses record cheerfully nude drawing, kissing, fondling. One night in late November 1925: 'Bath after supper and dancing (nude). R & M

fucked one another after, M. holding me the while.' The liaison with Moira was casual, unconsidered; it had a kind of innocence, an accidental quality. What was more surprising, and for Gill of more significance, was his later annexation of the lady friend of Morison, the woman well described as 'the First Lady of Typography', the sparkling and the formidable Mrs Beatrice Warde.

During his time at Capel Gill spent many of his weekends in Berkshire with the Gibbingses. It was one of those homes from home which he relied on: a contrast to, and sharpening of, his everyday existence. In their Thames-side home the Gibbingses led a comfortably Bohemian existence in a style which a contemporary feature in the *Graphic* called 'Arcady in Berkshire', with pictures of the family naked round the swimming pool and Gibbings himself in a large flamboyant sunhat, working on a carving in the garden. Gill fitted himself easily into this new mood of things. These were working weekends: Gill standing in the press room in his home-made smock with a home-rolled cigarette in his hand, arguing the technicalities of the new typeface for the Golden Cockerel. Such scenes were well described by Gibbings in his *Memories of Eric Gill*. They were also weekends of intensive entertainment, and more than entertainment, sexual experiment which went on through the evenings and long into the night. For example, the entry in Gill's diary for 22 June 1927:

A man's penis and balls are very beautiful things and the power to see this beauty is not confined to the opposite sex. The shape of the head of a man's erect penis is very excellent in the mouth. There is no doubt about this. I have often wondered – now I know.

It is noticeable that the entries in Gill's diaries, normally so workmanlike, in the form of notes or jottings, sometimes flow more freely – as in the above passage – when he is describing experiences at Waltham. There was something about Gibbings which released Gill's latent urges. He threw off all restraint: even the stern eye of his father. He allowed Gibbings to influence him towards a kind of life which, if the opposite of Capel, was even more remarkably the opposite of Brighton.

Gill had cherished a taste for what he called 'high jinks'. But his sort of hedonism differed from Gibbings's in that for him it was not simply entertainment. He wanted to absorb it, to make it part of the familiar. Only part of him was anarchist. One of the most explicitly erotic of Gill's drawings, which can be dated from the diaries to a weekend at Waltham St Lawrence in 1928, is *KL on Sofa*. The sofa is significant,

the homeliest of furnishings. He needed to domesticate eroticism. A sheet showing a set of four drawings of male organs (which Douglas Cleverdon produced for the perusal of the author one tea-time in Islington in 1986) has that fusion of the sexual and cosy. Each item is affectionately labelled 'self', 'Douglas', 'Joseph', 'Leslie'. 'Douglas' is Cleverdon, one of Gill's favourite male models until Cleverdon's possessive mistress put a stop to it. 'Joseph' is Joseph Cribb, for whom nude posing had become, over the years, almost a way of life. 'Leslie' is Leslie French, the actor, Gill's model for Ariel on his BBC carving of *Prospero and Ariel*. The drawings are precise, beautiful, and somehow sweet-natured: the genitalia of Eric Gill and friends.

Douglas Cleverdon's Bristol bookshop was another of the outposts much frequented by Gill at his Capel-y-ffin period. Cleverdon was a young antiquarian bookseller, a friend of Desmond Chute's who had first introduced him to the Gills. He already had ambitions to be a publisher, and Gill took him on to help him with the distribution of his essay *Id Quod Visum Placet* (too Thomistic a work for the Golden Cockerel). Cleverdon then himself published Gill's *Art and Love*. Cleverdon was also a protégé of Morison's, and Cleverdon's bookshop, in a turning off Park Street which runs up from Bristol to Clifton, has a special place in typographic history. The fascia board DOUGLAS CLEVERDON, hand-painted by Eric Gill in 1927, is often pointed out as the first example of Gill's sans serif lettering. This is not wholly accurate, since Gill had used sans serif for various hand-painted notices round Capel, most notably the MEN and WOMEN signs made for the chapel, to show which sex stood where. Nor was it correct to see it as the starting point of the collaboration between Eric Gill and Morison: Gill had been working for Monotype, on the design for Perpetua, since 1925. But it does seem certain that the idea of commissioning a new sans serif type-face occurred to Stanley Morison at the time of his own visit to Bristol in 1927. He was staying with Cleverdon, in the studio flat above the bookshop, and he saw the newly completed fascia board and the collection of alphabets which Gill had written out for Cleverdon as a diversion while recovering from flu. When one looks at them closely, very few of Gill's commissions were in fact straightforward commercial transactions. This one, his most famous, was a typical amalgam of friendships, personalities, circumstance and place.

The atmosphere of Cleverdon's Bristol suited Gill. Again, it was a place complementary to Capel. He enjoyed the contact with the young Bristol intellectual circle of which the Cleverdon bookshop was the

focus. It was a talking-shop with some of the vigour of the old days of Orage's *New Age*. On the first floor of the building, the Clifton Arts Club met. The beautiful large studio on the top two floors was shared by Cleverdon with Methven Brownlee, a professional photographer, a lady of great character, adored by Gill and Cleverdon, and several other friends, both male and female. It was a floating population: this easy, open, clever and idealistic ménage, which takes one forward to the fluid, mixed-sex households of the 1960s, was a new experience and a delight to Gill.

Besides Gibbings and Morison, Gill was again working for his original great patron, Count Kessler. Gill had wondered about Kessler in the wartime: 'No – I don't know where Count Kessler is,' he had written in a letter to his brother Evan, 'I think he must be pretty sick. I know he belonged to the anti-Kaiser party and had no love for Potsdam – but now I suppose it's a case of "my country right or wrong" for him and so he's fixed up and helping God to punish England. It'll be interesting to meet him après la guerre – if he's not killed and I'm not either.'

But Kessler had survived the war, as Gill had guessed he would, having seen in the count some of his own demonic energy. He shared Gill's passion for adventuring, took risks. The printing of the Cranach Press edition of *The Eclogues and Georgics of Vergil*, with woodcuts by Maillol, for which Gill had cut the headline of the title page in 1914, had now been resumed. It was in connection with the Virgil lettering that, on 20 January 1925, Count Kessler made the journey up to Capel.

The account of that visit, which appears in Kessler's *Diaries of a Cosmopolitan*, is worth reading in full for its account of Capel as seen by the eyes of a sophisticated foreigner. There was a certain crossing of the wires:

Midday left for Abergavenny to visit Gill and discuss with him the *Georgics* commission. His address had been given me as Capelyffin (pronounced Chapel-y-fin, signifying capella ad finem) near Llanvihangel. At Abergavenny nobody had ever heard of it. I therefore took a car and drove first to Llanvihangel on the assumption that Gill's home must be quite nearby because he answered my wire from there. My driver had never heard of Capelyffin either. At Llanvihangel we were told it was another twelve miles away, high up in the Black Mountains. The driver grumbled that he could not guarantee our getting there because the roads are so bad and narrow. He himself had never been beyond the monastery of Anthony [*sic*] at the foot of the mountains.

We drove between meadows and hedges along a narrow road through a beautiful lonely valley which did indeed appear to lead into the wilds. I was

reminded of my journey a year ago up the Rio Grande. Past the ruins of Anthóny, a medieval monastery, the road became ever narrower and my driver more despairing. We arrived at a steep slope. A local told us that Gill lived in another monastery higher up, founded by Father Ignatius.

Proceeding between more hedges and meadows and finally climbing a steep path, I reached a dilapidated monastic building, passed along a cloister passage under repair, marched through an ante-room to where I could hear voices, and suddenly stood in a medium-sized room where a number of women and girls and two very dignified-looking monks were sitting in front of a large log-fire.

One of the women stepped forward. I recognized her as Mrs. Gill. Had I not met her husband on the road? He left a couple of hours ago to meet me, but we must have missed each other. Then she introduced the two monks. One of them, a handsome middle-aged man of grave though friendly appearance, is the prior of an island monastery and was about to return to his sea-girt home because of some celebration there tomorrow.

I sent my car back to look for Gill. He arrived about an hour later, a Tolstoy-like figure in a smock and cloak, half monk, half peasant. He was accompanied by his son-in-law, a young sculptor and draughtsman.

There was nothing dramatic about this re-encounter after the war years, but we were both moved. Later Gill said that for him and his friends, and evidently for me too, art has now taken second place to achieving a regeneration of life. Pre-war life was too superficial. That is why they are here, 'trying hard to be good', though it is not always easy. Yet he must go on working, even if only in order not to starve. In fact he is very busy. He showed me some fine small box-wood carvings and reliefs made by himself and his son-in-law, numerous woodcuts and copper-engravings, depictions of saints and the Crucifixion, portraits and so on. They are all of a high standard.

He and his wife as well as the children (which is more surprising) profess themselves well in this monkish seclusion. Ditchling had been too petit bourgeois, leaving them only a choice between London and the wilds. They decided to give first preference to the wilds and up to now the experiment has proved successful. They have no sort of help, do everything themselves, cook over an open fire, (like we did when we bivouacked during the war), lead a squatter existence four hours from London, and are happy and completely content.

It is obvious from this, and other similarly highly coloured references to Gill, that Kessler had a rather simplistic view of Gill as the Church Father in the desert, the voice crying in the wilderness, the 'mendicant friar' with bloodshot eyes and unkempt hair, missing the more human quality of cosiness which coexisted with his prophetic urges in such an interesting and such an English way. He was unaware of Gill's peculiar combination of crudenesses and subtleties. He did not understand his very English sense of humour, the McGill in Gill, the English seaside postcard

smuttiness which made him find it so amusing to spy on courting couples in Hyde Park (while working on the lettering for Epstein's *Rima* carving). When Gill, in reply to Kessler's cross-examination about the exact contents of a proposed edition of an Indian love treatise, *Ananga-Ranga*, described this as 'well, in reality, thirty-four ways of doing it', Count Kessler evidently found this rather shocking. Nor did he comprehend Gill's English visionary quality. He thought Gill was like Van Gogh. But this was surely a misreading. He was a much more local prophet, more in the tradition of William Blake or Stanley Spencer. Gill was not a wild man. He saw niceties in life.

For a more level-headed description, written later by a lifelong friend who first visited Capel a few months after Kessler, we should return to Cleverdon. After a traumatic journey, Cleverdon arrived at Capel in the afternoon one Saturday. To him Gill had seemed immediately prepossessing: not farouche but reasonable, dignified, quite shrewd.

He was rather short in stature, with twinkling eyes behind strong glasses, very friendly and good-humoured and responsive. By contrast with Morison's sombre clothes, he always wore a roughly-woven knee-length tunic or smock, usually belted at the waist, with golfing stockings turned down at the knee. It was a very sensible garment for his way of life as a sculptor and engraver. In his engraved self-portrait he wears the stone-mason's square folded-paper hat, designed to keep the stonedust out of the hair, and easily replaced by simply folding another sheet of paper. The hand-woven cloth he wore was in no way a hair-shirt, as he wore next to his skin a feminine shift or camisole, with intermediate garments that could be added or removed according to the weather. At a time when a gentleman's suit required at least 24 buttons, it really was a very rational garment. If held slightly forward, of course, it ensured both modesty and freedom of movement when nature called.

The debate about whether Gill was an eccentric or the soul of unselfconscious common sense is a debate without a resolution. It is an argument which still continues heatedly, as the author has recently discovered, and it is a question which largely depends on the person's relationship with Gill: the closer and more loyal being the most likely to defend his sartorial idiosyncrasy as normal working garb. (Walter Shewring, for example, in an article in *Blackfriars*, explained his square paper cap as the traditional protection against chips and dust, as worn by Tenniel's Carpenter in *Alice in Wonderland*; Beatrice Warde claimed that the typesetters at Monotype accepted Eric Gill as just another tradesman.) What does seem to unite almost everyone who met him, and certainly everyone who struggled up to Capel, was a sense of

delight in his company. He amused them and intrigued them, somehow bringing out the best in them. It was true that, as Stanley Morison expressed it, Gill could very easily have been a 'personality', if he had chosen to. He had all the equipment: 'Gill knew quite well that if he chose to be a West End artist we could be lunching down there at the Savoy.'

It was this charisma, Gill's unfailing high performance, which made the life at Capel appear so reassuring. It was why Robert Gibbings thought it worth surviving the midwinter dinners by candle-light at the long refectory table at which everyone wore overcoats or shawls: 'if the stone floors were cold, hearts were warm,' wrote Gibbings; 'Eric was as lovable a man as you could meet.'

The presence of Mary Gill was also essential to the welcome of the household. She never seemed obtrusive, but her comfortable ways, like her habit of giving the tea-cosy a small pat when she put it on the table, gave Capel its feeling of receptiveness and calm. The household in Wales seemed as serene and all-embracing as the one at Hopkins Crank. Mary was good with waifs and strays: injured animals, odd people. Capel soon had its own quotient of neurotics and semi-residents.

If scything had been the great activity at Ditchling, at Capel it was knitting. This was partly because of the preponderance of sheep; like stone, fleece was for free, and the garments the Gills wore were inevitably sheep-coloured, greyish, brownish, merging nicely with the mountainous surroundings. The counterpart of scything, men's activity, knitting was an emphatically female occupation. It had for Gill a very deep symbolic meaning. It became his perfect image for the nurturing, protective, domestic, peaceful woman, blameless in her occupation; interminably busy, like his mother back in Brighton. Knitting seemed a thing of holiness. At Ditchling he had done the design for an engraving *Madonna Knitting* showing the Madonna, undeterred by Child and angel, decorously plaining and purling. This was printed on a rhyme sheet to accompany the carol 'Mary sat A-Working'. At Capel Gill drew his own Mary with her needles, *Mary Gill Knitting*, the epitome of homeliness. With his intense reverence for the domestic arts as opposed to the official art forms, Gill took knitting seriously as a creative activity. He wrote: 'I view all "art work" as I do house building or knitting.' He was not a feminist, in many ways he was indeed an anti-feminist, in his glorification of the passive, homely woman. But his championing and transforming of the significance of traditional feminine activities anticipates most

recent feminist thinking on the subject in a very curious and interesting way.

Such things were discussed at Capel *ad infinitum*. Its atmosphere was maybe the ultimate example of John Ruskin's ideal state where the workman is a thinker and the thinker is also much involved in manual labour. Donald Attwater, officially Gill's secretary and intellectual factotum in the early years at Capel, was a man of many talents, editor of abstruse dictionaries and commentator on the Uniat Eastern Churches. He was also in charge of renovating windows. There were plenty of these, smashed, decayed, in appalling disrepair, and the task involved not only the replacing of the diamond panes with rectangular ones, but long discussions about the teleology of windows: was the primary purpose to let light in or to encourage looking out? Eric, not too keen on vistas, was determined that their primary function was to let in light.

Gill had a way of looking, and a manner of expression, which was very influential on those who knew and lived with him. He set a kind of style, an intellectual directness, practical, quizzical, verging on the *risqué*, of which one still hears echoes in conversation with the now ageing survivors from Gill's circle. It is unlike, indeed in many ways opposed to, the Bloomsbury manner: more robust and less malicious, less consciously cultured or maybe one should say more consciously uncultured. Gill tried to be plain, unaffected and accessible, and even if in this he was not completely successful (since in some ways his households of cultivated plainness were just as idiosyncratic and fantastical as any of the complicated ménages of Bloomsbury), Gill's optimism and generosity were patent.

What he managed, at Capel as at Ditchling, was to give other people a sense of their identity. Desmond Chute once wrote, of his time with Gill at Ditchling, that those years brought him something nothing else could have brought: experience, not any special experience, but just the ordinary life of man. He went on:

At last I feel that I have somehow come to live not as an onlooker, nor as a man at my particular job, but as a man among men. A simple thing, not worth chronicling – but a thing uniquely difficult to me.

René Hague, in these days in the Black Mountains, was exactly the same age as Desmond Chute had been when he went to live at Ditchling, in a similar position of irresolution, a Catholic drifting on the verges of monasticism. He too was received into the Gill household, enclosed by it, cocooned by it, and for him as well it was in a way his saving.

Eric's attitude was so absolutely different from anything in his earlier experience that it seemed to him a kind of revelation, and suddenly the world began to have some meaning. He too left his account, the nostalgia of the cerebral:

Just as in retrospect, all winters brought great drifts of snow, skating and sledging, and all summers seem to have included long tramps over dusty roads in a blaze of sun, so those days at Capel-y-ffin appear as endless talking, in particular about Maritain and the philosophy of art.

Other services were given: there is a diverting little entry in Gill's diary, 'cut René H.'s hair.'

If the regime at Capel helped people to discover what they were, to effect an integration, it also had the openness, the flexibility, to carry out the task, in some ways much more difficult, of letting them discover the things that they were not. At Ditchling David Jones had worked rather in Gill's shadow in the role of the apprentice. Gill had been intent on tidying his methods, making him more 'workmanlike': an uphill struggle. (His entreaties that Jones should clear the clutter off his work table, and treat it with respect, as the Lord's altar, were useless; David Jones felt much securer in a muddle.) It was really only after 1924 when David Jones arrived at Capel, that, building on fundamental principles of Gill's, he found his own direction. The Welsh countryside, what he saw as 'the strong hill-rhythms and the bright counter-rhythms of the "*afonydd dyfroedd*" ', the bright sparkling little brooks, stimulated a whole series of his finest landscape paintings, some done out of doors, in his tightly lashed trenchcoat, in the course of a particularly hard Welsh mountain winter. His days at Capel gave him that perception of his Welshness which emerges after that time in his painting and his poetry. Out of the basic simplicities of life there, the routines, the companionship, the family acceptances, he found – paradoxically – confidence in his very individual self-expression, developing those traits, those crookednesses, those intangibles which lifted his work to a quite different plane of genius from Gill's, as Gill most readily conceded. It was, for both of them, an essential relationship, and not without its ironies. Jones's inscriptional lettering, which at certain periods poured out in such profusion, has its aspects of Eric Gill gone mad.

The nuances of that particular relationship were caught well by John Rothenstein. John was now in his twenties, having recently left Oxford. He had been encouraged by Gill to become a Catholic, and Gill was his

godfather. He went to stay at Capel for a week or two in the summer of 1926:

A few moments after my arrival there came into the sitting-room a small man who, though I now know that he was thirty-one, looked not more than twenty-four. 'Well goodbye, Eric,' he said, 'I'm going now.' In my mind's eye I can still see the two of them shaking hands. Eric Gill keen-glancing, energetic in gesture, his pedantic aggressiveness softened by a frank and unassuming smile, and wearing his black biretta, rough black cassock gathered in at the waist, black stockings cross-gartered and sandals. David Jones: pale face surmounted by a thick ingenuous fringe; languid figure, speaking of a pervasive quiet. I have said that he looked younger than his years, and this was so save in one respect: his flesh was of that delicate, tired texture generally found in old age. The dark eyes, large and mild, had in their depths a little touch of fanaticism quite absent, for all his aggressiveness, from Gill's. His clothes were anonymous. The contrast between the two men was not more apparent than the friendly understanding between them. David Jones and I were introduced, shook hands (his grip was soft and shyly friendly), and he went.

Gill had hoped in vain for Joseph Cribb to move to Capel. But in April 1925 his brother Laurie, who had also worked with Gill at Ditchling and had become a Catholic soon after his arrival there, came to help with a particular project in the workshop. He liked Wales and he stayed there. He went on with Gill to Pigotts where he became Gill's chief assistant in the workshop. He was with Gill virtually all his working life. Laurie, described by Gill as 'my noble pupil' and 'too good to live by a long way', was a tremendous asset in the somewhat nerve-racking conditions of Capel, sweet-natured and adaptable, amenable to helping Mary with the fire-lighting. David Jones idolized Laurie as the perfect British workman, and though David Jones had that romantic view of workmen one is apt to find in artistic intellectuals reared in the London suburbs, Laurie Cribb had some qualities which justified that title. He was not intellectual but neither was he deferential. He had the crafts-man's confidence in his abilities, for he was a virtuoso letter cutter, more skilful than Gill and even better than his brother. Whereas during his first few years Gill would draw out the lettering on to the stone for Cribb to cut the letters, he gradually delegated more and more so that Cribb often drew the letters out as well as cutting them. It was true collaboration to such an extent that Cribb's inscriptions from the late 1920s onwards are not easily distinguishable from those of Gill. Gill trusted Cribb, and gave him the opportunities which formed him. He became perhaps the finest British letter cutter of this century.

Later on at Pigotts Gill's workshop was much larger, more of an atelier. But at Capel the organization was more modest: it was still more or less the one-man-and-a-boy set-up. This was the way Gill liked it. It allowed him to experiment, as with the set of alphabets he worked out while at Capel for the Army and Navy Stores – an exercise in house style for their notices and signs. It was a job he enjoyed doing, based on simple block letters which he tried out for effect. 'It's rather fun', he wrote, 'cutting out great big letters out of white paper and sticking them on big black sheets – they don't half stare at you – fine test for astigmatism.' The Ditchling *Game* was over, but some of that mood was kept.

Much of the time at Capel Gill was very happy. He made love a lot when happy. At some periods in the diary the Gill symbol for love-making, the cross with four small dots (or without, for variation), appears every single day. Love was a celebration, the way he and Mary marked the especially memorable occasion: the homecoming, the birthday, Gordian's first communion. It could also be a whim, a sudden inspiration, like the time when walking back from Hay over the mountain they decided to make love in the wood on the way. The variety of life at Capel gave him pleasure. The sort of programme then appearing in his diary was: sorting and signing prints in morning; killing and skinning Billy goat all afternoon; then beginning the design for the £1 note in evening (a commission from the Mint arrived at Capel). The next day in the morning he was cleaning out the coal cellar, before moving on to the *Troilus and Criseyde* engraving which occupied the afternoon and evening. One entry is simply 'Enjoying life all day.'

Gill came to describe the life at Capel as beauteous, in a way only Gill could:

And we bathed naked [he tells us in his memoirs] all together in the mountain pools and under the waterfalls. And we had heavenly picnics by the Nant-y-buch in little sunny secluded paradises, or climbed the green mountains and smelt the smell of a world untouched by men of business.

But how perfect was it really? One comes to mistrust the golden haze of memory in Gill's *Autobiography*. On some aspects of Capel there is a sharper picture in Gill's more honest, detailed contemporary letters. His two main confidants of the time were Desmond Chute, corresponding with him from Rapallo, still addressing Gill as his 'beloved Master'; and Father Austin Barker, the Dominican who had now replaced Father Vincent as his spiritual touchstone. His letters to them both expose a

different view of Capel. The diaries, too, suggest that it was not quite so paradisal. Several things about Capel had not been working out.

First of all, Gill was disappointed he had not been able to establish a guild or confraternity in the Black Mountains, as he had done at Ditchling. This seems odd in view of the past few years of crises: guild life was exactly what he needed to escape from. But Gill never ceases to surprise one with his resilience and his depth of contradiction. He still clung to the vision of male bonding, the peaceful, productive, enclosed masculine community, as he had glimpsed it long ago at Lincoln's Inn and more recently, to some extent, at Cambridge. He found the female quality of Capel very irksome: 'You can't discuss with women,' he wrote to Desmond, sadly. Also, from the point of view of his religion, he was very isolated. The area round Capel was predominantly Baptist. There was even a Baptist chapel alongside the monastery. This impelled Gill to make Capel a more formal Catholic stronghold.

He had got to the point of drafting out a constitution, asking René Hague, a classicist, to put it into Latin. The rules of the new guild had been amended so as to avoid the mistakes of Ditchling. After supper one night in Wales he read out his proposals to Philip Hagreen, David Jones and Dom Theodore Bailey, Benedictine monk and artist and another long-term visitor. Hagreen and David Jones rejected the idea, and Gill, hurt and angry, in one of his rare rages, turned on them and said, 'The Guild is founded and Dom Theodore and I are the members,' before stamping out in frustration: Dom Theodore, notes Hagreen, had never been consulted. The subject of the Capel guild was not raised again.

Gill's relationship with Hagreen, which had started so propitiously, had after a few months become a little acrimonious. Hagreen admired Gill, but he had views of his own and he was never Gill's disciple. His father had been the drawing master at Wellington; his grandfather had been an architect. He had been one of the founders of the Society of Wood Engravers. He was an artistic figure, so to speak, in his own right and, significantly, he had not signed up for Capel. Gill became increasingly disheartened with the Hagreens, complaining that Philip's ill health prevented him from carrying on a conversation with the cut-and-thrust and vigour to which Gill had been accustomed, and finding Hagreen's wife almost impossible to deal with: 'she's suffering', he wrote to Austin Barker, 'from the strain of motherhood on top of the strain of a university education'. She had left Bedford College with a first-class degree in Philosophy. He also disapproved because she wore a coloured dress, maintaining that good Catholic matrons must wear black (though

none of this prevented him from propositioning the gaudily clad, over-intellectual Aileen Hagreen). After seven months there the Hagreens had left Capel. Philip's later view of life there was that Gill's cell of good living had become 'a kingdom in which his fads were law'.

Gill's tendency to faddishness and laying down the law certainly increased in the time he was at Capel. This was partly the result of the loneliness he wrote of in letters to his friends, the lack of anybody at all on his own level with the weight either to challenge or properly to support him. Anonymity, of course, had been the thing which he had hoped for, the shedding of his label as 'The well-known sculptor who did the Stations of the X at Westminster Cathedral', and all that entailed, but there was a certain price to pay for isolation. Gill also seems to have felt more anxious and more threatened as the Ditchling residue of disagreements rumbled on and on.

'The finance of Ditchling is still round my neck like a halter,' he told Father Austin in his early days at Capel. The technical disputes, over debentures and property and who owned the blocks for Gill's engravings for St Dominic's Press, had gone on from then right up to 1927 when a legal form was arrived at which allowed Gill's action against Pepler to be withdrawn. At one point Stanley Morison had been called in as an arbiter, but this was a dispute beyond the powers even of Morison, for the confrontation involved not only tools of the trade, methodology of craftsmanship, philosophy of ownership, ideals of good-fellowship, but also, most of all, a background of emotional and sexual involvements more complex than most people ever dreamed of. There was too much at stake.

There are certain rows, particularly common it seems in the partner-ships of the arts and crafts in Britain, which acquire a kind of legendary status out of all proportion to many of the issues, feeding on their orig-inal relatively minor causes until a point of no return is reached. One obvious example is the heart-rending quarrel between Ernest Barnsley and Ernest Gimson, living for years in total non-communication in Sapperton in Gloucestershire, the remote village to which they had escaped from the London of the early 1890s. Another classic quarrel was the melancholy rift between Gill and Pepler's one-time Hammersmith neighbours, T. J. Cobden-Sanderson and Emery Walker, which ended in Cobden-Sanderson's destruction of the Doves Press type. This he cast into the Thames from Hammersmith Bridge, sheet after sheet, evening after evening, the craftsman's perfectionism in reverse, beginning by breaking up the matrices. Gill's blocks did not end up at the bottom of

the river: in fact in the end Douglas Cleverdon acquired them, returning them to Gill. But in the obstinacy of its long-drawn-out drama the Gill and Pepler feud was remarkably the same.

'I cannot remember Hilary complaining of your faults, not even when you appeared in church with bare legs.' This was the sort of accusation, in a long, reproachful, letter from Clare Pepler, which was still pursuing Eric Gill at Capel. For Pepler, who lacked Gill's self-saving streak of realism, the quarrel between them had been almost devastating. He had had so many of his hopes invested in the close relationship of their workshops and their families, and he had trusted absolutely in Gill's judgement. His son Conrad, in later years, came upon the draft of a will which made over to Gill everything he possessed for Eric to use in the interests of Pepler's children as he thought best. Pepler's reactions, which had always been emotional, became so exaggerated by the tensions of the quarrel that the arrival of a rather scrawly Christmas greeting from Eric Gill at Capel a few months after the parting had reduced him to tears. His feelings for Eric had something of the female. With Gill he had a kind of seventh sense. Once travelling from Bristol to London, in the years when Eric was at Capel, he had a sudden feeling Eric was on the train. This was in fact quite feasible as the journey to London from Capel-y-ffin involved catching the train at Abergavenny and changing on to the main line at Newport. Pepler roamed along the corridors until he discovered Gill, a discovery he later came to attribute to the intervention of the Holy Spirit and the divine wish for reconciliation. Gill still resisted peacemaking. He still suspected Pepler. But they talked until the train got into Paddington.

The impossibility of reconciliation rested, for Gill, partly on Betty's long determination to marry David Pepler. Gill had refused to recognize an engagement between them before Betty was twenty-one. By the time she was twenty-two, and still insisting, he had to be forced to drop his opposition; but he did it with poor grace.

At that time there were extenuating circumstances. Petra had decided to break off her engagement to David Jones (which her family had sanctioned, and which had indeed been blessed in the chapel at Ditchling) and to marry Denis Tegetmeier; for the Gills this had entailed commiserations and anxieties. Gill was also very worried about René Hague's developing devotion to Joan, dating back to that first day when she alighted from the lorry: Gill mistrusted the idea of René Hague as son-in-law, no doubt by this time sensing Hague's innate rebelliousness. Perhaps he felt that all three daughters had abandoned him, that his

jurisdiction as father was being called in question. Challenge to his authority always induced paranoia. Even Donald Attwater, Gill's most trusted of disciples, his amanuensis, was berated for defending Betty's determination to make her own decision about the man she married. He described with some amazement Eric Gill turning upon him with a sudden venom: ' "And you call yourself my friend." '

There is no sign from Gill's diaries for this period that his sexual experimentation with his daughters had continued. It was an attraction, it seems, attached to early puberty, a fascination with evolving sexuality. But for some reason the obsessiveness Gill showed with his two eldest daughters in the years at Ditchling was never refocused upon Joan, the youngest daughter, who was at that same age when the Gills arrived at Capel. It may have been that Joan was a more independent spirit: her father in those Capel years exclaims in desperation about her intransigence, especially her swearing. But it seems obvious from entries in the diary that Gill's sexual preoccupations were changing and were becoming less private, less familial. Abetted by the Gibbingses, Gill's sexual activities were now more ordinary. They were lustier and cruder. But Gill was still inclined to give Betty, before marriage, detailed advice and instructions about love-making. 'Instr. to B. re. "first night" ': his diary records a bombardment of solicitude as her marriage approaches. There is paternal fondness. And again, there is more than a trace of the voyeur.

The wedding day itself was very difficult for Gill. It was a joint wedding, for at the same time Laurie Cribb was being married to Teslin O'Donnell. It took place in the Catholic church at Brecon. There was a technical hitch: the clearance certificate had been sent not to Brecon in Wales but to Brechin in Scotland and this caused some panic and delay. But this problem was nothing compared with the trauma of the meeting between the Gill and Pepler factions. The photographs of Gill at the wedding, all in black, with a large black hat, make him look a bit bedraggled, scarecrow-like and almost furtive. He was anything but robust in spirit, asking Donald Attwater to come and sit beside him at the wedding breakfast if it looked as if he and Pepler might be left alone. This element of cowardice in Gill is unexpected if one only knows him from his writings, which have such a ring of confidence and invulnerability. But the cocksure stance had always been a little misleading. Gill had a deep-rooted fear of embarrassment which Attwater, quite rightly, traces back to his fearful embarrassments of childhood, the terror of his over-sentimental father making an exhibition

of himself. His nervousness of Pepler, and his rejection of what he now saw as the 'outwardness' of Ditchling was undoubtedly a part of that whole ancient inhibition. Ditchling now made him feel 'all overish' with shyness.

The personal chronology which emerges from Gill's work has, when examined closely, two levels of significance. The official: the bookplates, the change-of-address cards, maps, devices, announcements of marriage, ordination cards and so on, for particular people on particular occasions. Also the unstated: the dozens, even hundreds, of images which can be related, once you know Gill's history, to his concurrent perceptions of places, times and people. There is the official invitation to Betty and David Pepler's wedding, an engraving also used for *Troilus and Criseyde*, which shows two enclasped lovers, a simple, gentle image. There is another *Troilus and Criseyde* design, quite similar, but showing a small Cupid looking down upon the lovers from a vantage point high up on the tree top. This is an example of more intimate subversiveness. From the Capel period too comes one of Gill's most wistful pictures, *The Chinese Maidservant*, the maid with the bare bottom, a beguiling invocation of what Gill understood as the extreme delights of illicit household sex.

At Capel-y-ffin there was no apparent dalliance with maids. There was no occasion for it: Mary and the girls between them managed all the housework. But Elizabeth Bill, Gill's secretary there from mid-1925 onwards, had some unconventional duties: 'Talked to Eliz. B. re size and shape of penis. She measured mine with a footrule – down and up.' The behaviour of his organ, the oddnesses which had dawned so wonderfully upon him in his boyhood, went on fascinating Gill, still more so as he grew older. His 'Studies of Parts', now kept strictly locked away in the safe of the British Museum, include dozens of these quasi-scientific penis studies, accurately drawn and annotated carefully ('6½" to 7" up, 3½" or 4" to 4½" down'; and, more unbelievably, '12" up, 9½" down'). They have a *joie de vivre* which makes it hard to feel much shocked by them, and many of them date from the years in the Black Mountains.

At Capel some definite patterns of Gill's ménage were established. First the resident priest, now the resident mistress. Elizabeth Bill came to Capel from London where she had been working. She was a woman of independent outlook, with an illegitimate son, René Ansted: a background very similar to Eric's sister Enid. Her attraction for Eric was this very independence. She had a private income; she had decided tastes, including a liking for faintly pornographic books. She was also

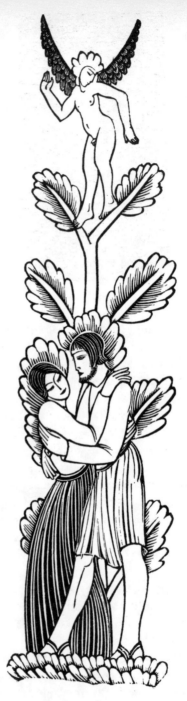

35 *Cupid Looking Down on Lovers.*
Wood-engraving for *Troilus and Criseyde*, 1926.

36 *The Chinese Maidservant.* Wood-engraving, 1929.

knowledgeable about antique furniture, bringing a selection of antiques with her to Capel. Her son René came as well and was apprenticed in the workshop. To the Gill daughters Miss Bill seemed cosmopolitan. She had an exoticism alluringly out of place in the Black Mountains, and she spoke fluent French. She was very enterprising, with a disposition one might now describe as sparky, going off with Laurie Cribb one Sunday to Swansea to see the Wales versus Ireland rugby match. For Christmas 1925 she joined the Gill party, with Eric and Mary and Donald Attwater, on a 'holy year' visit to Rome, a cut-price pilgrim's outing which involved train travel across Europe and third-class lodging in the hostel of St Martha, adjoining St Peter's. The primitive simplicity of this appealed to Eric: high airy rooms, bare wooden tables, white curtains round the beds.

Adventurous women, the reverse of his own Mary, always stimulated Gill. There is a whole succession, going back to Lillian Meacham and the well-publicized escapade in Chartres. Gill responded to their sharpnesses, and women of this style liked the way that Gill set out to shock and surprise them. His full-frontal technique pleased them. Clever women like effrontery, as Gill discovered early. This was the approach which had so enraptured Frances Cornford back in 1910 when she wrote to tell Gill of her 'dim feeling' that in earlier days he would have burned her at the stake. His remarkable knack of sexual provocation delighted

Beatrice Warde, who many years later described Gill's ability to pull the carpet out from under you. His reversal of expected attitudes confused, disarmed and finally won over. Gill gave Miss Bill lessons in stone-carving at Capel, as he had once taught lettering to Lillian. After Holy Hour one day he dictated letters, then showed her slides of semen under the microscope. Two days after she had noted the dimensions of his penis, Gill was making her a rosary. She was soon to become a Tertiary of the Third Order of St Dominic. Encroaching middle age had not diminished Gill's facility for the reconciliation of the fleshly and sublime.

Gill's resident mistresses – Elizabeth Bill, and later, at Pigotts, May Reeves and Daisy Hawkins – were also his main models. He had come quite late to life drawing. He put forward the endearing theory, in the introduction to *Twenty-Five Nudes*, that one could not embark on life drawing any earlier because one did not really know enough of life. One needs to reach a stage when 'the experience of living has filled the mind and given a deeper, a more sensual as well as a more spiritual meaning to material things'. It was a case of love and friendship. Perhaps the artistic usefulness of Eric's female friendships and loves helped Mary to accept them, even so much on her doorstep. She did complain about them: Petra could well remember some heated conversations taking place between her parents behind the bedroom door. But Mary's public loyalty was always invulnerable. She genuinely saw Eric Gill as the great artist, not bound by the same rules as more ordinary people. Late in the 1920s, when she was almost fifty, she still wrote with a girlish devotion to her husband, 'I am simply bubbling all over with pride at the thought of being your wife.'

Capel had its long periods of calm, giving Gill more space for contemplation than he had ever had before, or was indeed to have again. In his monastic fortress, in the shadow of the Tump, the high ridge immediately beyond the monastery, he gave his undisturbed attention to the subject which of all subjects he found the most intriguing. These were what he called 'the psycho-physical problems', the physical relationship of man to woman, and he came to the conclusion, put forward in his memoirs with the force of revelation, that sex is in truth the main thing anybody thinks of:

How many times a day do men think, perhaps only momentarily, of the shape and attributes of human flesh? How many tiny interstices are thus filled? How often and how vehemently do we look forward to going to bed – but not to sleep? . . . I can only confess that, judging from my own experience and having no reason to think that others are different from me, the thought or memory of

that activity of our bodies, which is only openly acknowledged between lovers (or alas! when illness gives doctors a polite entry into our too secret life) and which reaches its fulfilment in physical union and orgasm, does in fact occupy, in greater or lesser degree, very many of the interstices of our waking lives and thus colour and inform and perfect or, it may be, mar our doings.

The theory of the interstices shows Gill in action at his most character-istic: his most marvellously, mischievously, frighteningly truthful. Gill was putting into words the inherently unsayable, just as he was at that same period preoccupied with visual images regarded as undrawable, or anyway not suitable for general consumption. Capel was retreat in some ways. But in fact the Capel period was the time of Gill's most controversial re-engagement, four years of great activity and growing notoriety.

'There is no such thing as impropriety when it comes to saving souls': this, one of the usefully self-justifying aphorisms Gill had such a good stock of, was good enough for devotees like Donald Attwater. But the sexual high spirits and explicitness of some of his graphic work of the middle 1920s daunted and dismayed a number of his earlier supporters, especially the priestly and monastic ones. In particular the Golden Cockerel edition of *The Song of Songs*, with Gill's blatantly, effusively erotic wood engravings, and his later illustrations for E. Powys Mathers's rather dubious *Procreant Hymn*, aroused suspicions that Gill was merely 'gloating', being naughty, and that his deliberately provocative behaviour would bring his Dominican affiliations into disrepute.

The point was that Gill's subject matter had now altered and came closer to the everyday erotic, the collectors' pornographic. From the 'nuptials of God' days, with the erotic content justified by Gill as an expression of sanctity, his images now veered more obviously towards human sensuality. One engraving in *Procreant Hymn*, *Earth Receiving*, has the hand of God upraised as if in blessing, over a most athletic scene of human copulation. This sort of transposition might well confuse the eye of the beholder. At the same time, Gill's whole audience had enlarged. The subscribers to the rather esoteric publications of the Golden Cockerel were by no means the people on St Dominic's Press's mailing list, the friends of Gill's and Pepler's who had once been sent *The Game*. (For example, going through the records of the Golden Cockerel in California, I came upon an order for *Procreant Hymn* from my own great-uncle, a bibliophile and art collector, not a Catholic, who as far as I know had no connections with Gill's circle.)

37 *Earth Receiving*. Wood-engraving for *Procreant Hymn*, 1926.

Gill could quite well claim that this increase in circulation for his work was beneficial on grounds of sexual honesty and that its popularity in fact proved the whole truth of his interstices theory: it only goes to show. But this was not the way his priestly colleagues saw it. It was not the way, perhaps, they could afford to see it even if they wanted to. Even Gill's friend Desmond, who had once himself contributed some very unequivocal verses to *The Game* and who still, to judge from their exchange of letters, to some extent shared Gill's preoccupation with the erotic, sounded anxious at *The Song of Songs* and counselled caution.

He suggested diplomatically that Eric's talents really lay much more with stone.

Over the next few years the complaints came pouring in. Gill had always been an enthusiastic letter writer, but on this complex topic the exchange of correspondence reached a record level and the archives are bulging with the arguments between Gill and the brethren. It is an extraordinary episode which tells one a great deal not only about Gill but about the narrowness of view and the defensiveness of the Catholic Church in England at that time. There was even intervention over *Procreant Hymn* from Father Bede Jarrett, Prior of the Dominicans, a letter written in a tone of some authority even though he had not seen the book in question. Gill sent him a print of the offending picture, but in answer to his request to suppress the edition told him that by this time all the copies had been sold.

Gill combated the arguments amassed against him spiritedly. They ranged widely, from anxious prophecies of the possible effects of Gill's scenes of uninhibited sexual enjoyment upon national morality in general (Father Austin Barker had seen three teenage girls sniggering over *The Song of Songs* in Birmingham), to more recondite references back to the Catholic artistic tradition of avoiding the depiction of the act of intercourse. The name of Marie Stopes is often called in question. Gill resisted his accusers with a strong defence of his own judgement and an assertion of the righteousness of candour in his treatment of the sex act, challenging decisively the Catholic inheritance of dualism, the division of spirit and matter, spirit being sacrosanct and matter being suspect. Gill argues very passionately, solemnly and startlingly for his own long-held view that *both* are good and *both* are valid. Many of Gill's arguments had much more recent echoes in the Vatican II upheavals and reversals.

Here is Gill in full flight in reply to Father Austin Barker in 1926, an outpouring prompted by Father Austin's comments on Gill's essay *Id Quod Visum Placet*. This was Gill's controversial exposition of his theory that 'a beautiful thing is that which pleases being seen'. Gill writes in some despair:

It is becoming clearer and clearer that arguing about it won't help anyone (except the author) and least of all will it help priests and those who, like priests, are 'invincibly convinced' of the unimportance of the subject – they won't approach the business except in the mood of half amused tolerance or half bored intolerance. Like the rest of the world they are only interested in getting and spending, keeping an eye meanwhile on their heavenly home and a sort of list of things no fellow should do – I mean that while their only real interest is in

getting and spending (at what pains they are to prove that Catholics are just as good at 'science' as non Catholics and that Catholics are just as 'progressive' as anyone else!) they, remembering that they've got to die some day, take care not to infringe against the rules. For the rest, talking about 'art' or 'beauty' is just, for them, so much nonsense – and as for the things themselves (as distinct from *talking*), well, they regard them as just so much museum stuff – nothing to do with life except to titivate the drawing room or the church (make the altar look pretty). The state of modern Europe – the masses of people totally engrossed in getting and spending – is apparently what they approve. Their only complaint is that so many things that no fellow should do are done! Be an absolutely bloody fool, make a vast fortune out of potted meat, live at the Ritz or at Tooting, have a season ticket to Brighton – you're welcome, nay you're worshipful – but don't, oh don't steal more than a penny, don't use swear words, don't ever get drunk, and above all don't, oh I beg you, don't ever even so much as think of any other girls's legs! Love God? Ah yes – of course – but remember that life here below is like being in the W.C. (quite pleasant, not necessarily sinful but only a dirty function). Such is the apparent attitude of our spiritual fathers!

One thing the Fathers found particularly baffling was Gill's jocularity in sexual matters. They could not easily agree with him that sex is funny: and how could they know, as Gill quite often pointed out? Yet a sense of comedy was at the basis of his attitude, as in the sort of scene which Philip Hagreen recollected at the time of the *Deposition* carving, a very Gill-like knockabout argument on whether the Lord should be uncircumcised or circumcised. He felt almost proprietorial about Christ's genitals, in a way which allowed him to treat them irreverently, and this assumption of a special privilege, as if Gill had some sort of hot-line to the Godhead, was something easily resented by the more conventionally devout. Gill enjoyed, and made the most of, this irritation factor: 'God won't split,' he liked to say; 'me and the Pope are pals.'

Perhaps Gill's sense of comedy acted as a safeguard. In point of fact, he had a sure instinct for what, artistically, constituted the indecent and how close he sometimes sailed to it. Once, at the time of *Procreant Hymn*, he and David Jones paid a visit to its author, E. Powys Mathers, a big fat man with a taste for true pornography. Besides being the original Torquemada in the *Observer* Mathers had translated the *Arabian Nights* and other erotic Eastern writings. The walls of his flat in Lincoln's Inn Fields were almost papered over with pornographic postcards. At the sight of these Gill turned to David Jones saying, 'If I were not a Catholic, I should have been like this.'

Amongst the priests, the only one who really understood Gill's attitude

to sex was Father John O'Connor, the 'unique parish priest' of St Cuthbert's church in Bradford. In real life he had that same quirky imperturbability which made him one of this century's most popular fictional heroes: he had inspired the Father Brown of G. K. Chesterton. In 1937 he became a privy chamberlain to Pope Pius XI and was thus designated Monsignor. O'Connor was an oddity. His obituary in the Tablet sums up someone in his way as original as Gill was, with the same sort of curiosity and humour:

He was simple at heart; whimsical, original and subtle of mind – a curious blend of childlike faith and sceptical questionings, of delicate sensibility and shocking frankness. Regardless of persons on occasions, he would flout puritanical prudery by 'calling a spade a spade' or retailing the scandals of Popes and Cardinals. His knowledge of such things, as well as of the more reputable affairs of men, was like Sam Weller's knowledge of London, 'extensive and peculiar'.

He and Eric Gill were obviously soulmates. Gill in fact lists him as one of the great influences of his life, and O'Connor left behind a most memorable description of Eric's husky voice, resembling Greta Garbo's, and his 'very short, very ready' laugh.

He understood the way Gill's mind worked, and defended it incessantly. At the time of scandal over *The Song of Songs* he allowed it to be said that the engravings were approved by 'a responsible priest': this was Father O'Connor, who had also edited (with his own amendments) the text for the Golden Cockerel edition. O'Connor maintained stalwartly that the reactions of the Church to Gill's eroticism had an innate hypocrisy. He had his answer for the 'so-called pious persons'. This was the somewhat brutal argument that people who cultivate the sheltered life are not entitled to pronounce on nudity. O'Connor himself was in a different category, asserting that although he had never been in love, he had always worshipped Woman. More than many 'pious persons' he could see the thing as Gill did. He had the highest admiration for Eric Gill's precision, for his longing to be certain:

He wasn't going to label a bottle till he had ascertained the vintage. He was the child at the Hans Andersen coronation who pointed out: 'He's got nothing on!' When he saw a photograph of strenuous action, e.g. Suzanne Lenglen making an impossible return, he undressed it at once in drawing. This he made a work of piety.

With defenders like this, who needs the hierarchy? Yet perhaps there was a sense in which Gill's championing by a priest as peculiar as Father John O'Connor itself caused some suspicion. It was certainly now clear

that the Dominicans were having their misgivings about Gill, misgivings which increased over the next decade. This was Church politics in action. They had cultivated Gill, indeed to some extent they had made him what he was, so they stood to be embarrassed if, as now seemed likely, he posed a formal challenge to the Church authority, at a time when his own public reputation had burgeoned.

Gill was perverse about authority. He sought it with such longing, then felt driven to oppose it, to test it out, to tease it, as he had done with whole successions of authorities from his own father onwards. What made Gill such a difficult and slippery opponent was the way he shifted ground and altered mood and played defiance:

The right and proper Naughtiness of life, as God made it, is classed by the police with mere filthiness. I think it well to go ahead doing what seems good – however naughty it be.

Gill at his worst was the street urchin, the tormentor who rings all the doorbells then runs rapidly away.

Did Gill have a sense of evil? People close to him have doubted it. David Jones told the tale that Gill was furious with anyone who talked about bad apples: to him all apples were good apples. René Hague's considered judgement was that Gill did not accept that anything could be intrinsically evil; this explained why he was taken by surprise and finally so undermined by the evidence of evil undeniably confronting him at the beginning of the Second World War. His awareness or otherwise of evil was a question Father Bernard Delaney put to Eric Gill in relation to sex, and it is a crucial question. Was Gill honestly entitled to the privilege of innocence? Had he really been unaffected by the Fall?

SALIES-DE-BÉARN
1926—8

In Eric Gill's life, more than that of many artists whose work is more strictly topographical, the shifting sense of place is at times quite overpowering. This was one of the main paradoxes in his nature: the need for contemplation and the urge for constant movement. We see this most acutely in his period at Capel, when at times his life resembles his own perpetual-motion machine, a strange contraption he invented in his early days at Ditchling. He spent many hours perfecting this, finally reporting: 'have reason after experiment to believe it will WORK!'

Gill himself could never keep still for very long. The quiet reclusive months in the Welsh mountains were broken into frequently by travels, small adventures, change of mood and change of place. The cell of good living always had to have its opposite. Gill had a basic need for the alternative, the outpost. From Capel, there was Waltham St Lawrence, there was Bristol, and – the furthest and most foreign of the outposts of this period – there was Salies-de-Béarn, a small spa town in the foothills of the Pyrenees.

Gill had a huge affection for Salies, which he rated in his list of perfect places as higher even than Lincoln's Inn or Chichester. The Gill family went to stay at Salies, off and on, all through the Capel years and they were still going there at the beginning of their period at Pigotts. Sometimes they went for just a few weeks at a time. Once they spent a whole winter out at Salies, autumn to spring 1926–7, when Gill produced about sixty of the engravings for the Golden Cockerel *Troilus and Criseyde*, working in a room he hired above a chemist's shop. Gordian Gill was even sent to school there for a year, learning to speak French with a Basque accent. He was fetched back to Capel for the holidays. Gill thought it would be good for him to learn about French life, and to hear accounts of Waterloo which did not mention Wellington.

38 *More's Utopian Alphabet.* Wood-engraving, 1929.

Eric Gill has come to be associated so closely with rural communities it is easy to forget how immersed he was as well in the notion of the ideal city. But he had, after all, been trained as an architect in an urban office. He had spent a good deal of his early life in towns. He always remained haunted by the idea of the truly civilized small city where the life was plain and regular. Sir Thomas More's *Utopia* was a book which Gill knew well: one of his very earliest commissions in lettering had been for the title page of the Ashendene edition, and over twenty years later he designed a new *Utopia* for the Golden Cockerel which included his proposals for More's Utopian alphabet ('*Utopiensium alphabetum*'). With his obsessive interest in new systems of living Gill seized on Salies-de-Béarn as an example of Utopia in action. He saw it as the sort of town which no longer existed in England, a memory of what, say, Beaconsfield or Amersham might have been once. He praised the fact that Salies was

so static, thriving on its ancient trades of salt distilling and sandal-making. He liked it for its holiness, its modesty, its sense of people living an honourable life of honourable work. Another of its attractions, which one must not underestimate, is that Salies seemed so very far removed from the Welsh mountains.

Gill set out on his first trip there in May 1926, in a mood of holiday. He had a very simple – and Victorian – sense of pleasure in the onset of a spree, stopping off in Paris on his way to meet the Gibbingses. So lighthearted was his mood that he left a portfolio of prints of the Stations of the Cross in a taxi after a performance at the casino in the rue de la Gaîté: the sculptor Ossip Zadkine retrieved them for him later. With the Gibbingses he went on random pilgrimages around town, not unlike the Bohemian artists' routs Gill always claimed that he detested: visits to casinos and night-clubs. At one of them, 'a strange place' which Robert Gibbings had been given the address of, they saw 'some girls nude posturing in a lascivious manner'. They went to the Folies to watch Josephine Baker. As described in one of his neat postcards back to Mary, a visit to a music hall had also been great fun: he was especially impressed by a fine mulatto dancer who performed on 'a great circular *mirror* suspended from the roof and let down right in front of the stage'.

The pleasures of the Golden Calf were not forgotten. There was something in the razzmatazz of public entertainments which made him very happy. His response was childlike. Music halls seemed to encourage Gill's worst gestures of defiance, as in his limerick:

> There was a young lady with balls
> Who said 'I will dance on the halls'
> But the manager said,
> 'Mrs. G. will see red,
> Just think of the view from the stalls!'

For an artist and designer of such rigour and discernment Gill could be quite blatantly and astonishingly tasteless. For him the tastelessness, one feels, was part of the enjoyment. On another evening in Paris, in a Faustian scene of subversion of talent, Gill helped prepare the Gibbingses for a dance at Juliana's, painting Robert with a colossal face all over his chest and stomach, with nipples for eyes, his navel for a mouth. Compared with this the diversions up at Capel – the walks up the Tump, the bathes in the sheep-dip – seem straitlaced.

The set-up in Salies itself was not straightforward. The house had been bought by Elizabeth Bill, Gill's secretary-mistress, with the intention

that the family should share it. The Gills provided the furniture, bought locally (except for the beds, ordered specially from Paris). The situation was further complicated by the fact that Miss Bill's elderly lover Mr Ansted, the father of her child, whom she was soon to marry, was also on the scene. Joan, the first to meet him, reported to her parents that Mr Ansted was 'rather old and dodery [*sic*], but very good fun, and very fond of Elizabeth'. Apparently he never stopped calling her 'My dear'. But Joan also pointed out that he was 'very touchey, and it might be quite awkward'. In a scene replete with irony, since Elizabeth had typed the original manuscript of *Id Quod* up at Capel, her fiancé had asked to see the newly published version in its nice blue binding. According to Joan 'he saw the first picture and passed it back to Elizabeth without looking any further!' The jealous husband syndrome was, to Gill, a new experience. Not perhaps without amusements, for he liked the tightrope life.

The Bill-Gill house at Salies could not have been more different in scale and style from Capel. Joan described it as 'a perfectly topping little villa' and Gill, in a letter to Desmond, depicted it as 'quite a solid little place', an eight-roomed house in several acres of land, some of which were vineyards. But neither of these descriptions quite does justice to the reality of Villa Les Palmiers which was, and still is, a very elegant and formal bourgeois residence on the suburban heights above Gill's holy city, Salies. Was it in fact so different from the house Gill once rejected on his visit to Maillol in Marly? The sight of it pulls one up with quite a jolt, reminding one how deeply ingrained was the bourgeois in Gill.

Life in France was unlike that at Capel. Less strenuous, much calmer. Gill was lyrical about his routine of early-morning mass at the parish church, then what he called 'Little Breakfast' at the café, a morning of work, lunch up at the villa, work again till dusk, then back to the church for benediction. Joan or Petra often came down to meet him after work. Then home again to supper. In the evenings back to town for talk and the local liqueurs in the café in the *place* or the Café de la Terrasse beside the little river. 'Day after day passed thus,' wrote Gill in sentimental memory: life resembled a good clock, reliable and regular:

On feast-days we had holidays and we made expeditions – to Sauveterre with its terrace café a hundred feet above the rushing Gave, to St. Engrace, right up in the pass, to Bellocq, to Oloron Ste Marie where there is one of the best and most vehement sculptures in the world, but especially to Sauveterre because it was within walking distance and after a day by the river it was nice to walk the five miles home (with a good swill of red wine, sitting on the bench outside the Estaminet at the top of the hill) in the cool of the evening singing songs along

the road. (I haven't told you this: singing songs was one of their special things; they knew simply hundreds of songs and sang them in trio – if we were at home I used to play accompaniments, not always too successfully, on the tin whistle – songs of England and Scotland, the Highlands, the Hebrides, of Ireland and France, a never-ending succession, one reminding of and leading to another and what one didn't remember another would. Did ever anyone ever before have three such daughters?)

Gill's accounts of his travels always have great springiness. One of his charms is his total contradiction of the British cultural tradition of the laid-back and laconic. His response to novelty is immediate and personal, not inhibited, not weighed down by inherited experience. New rhythms of life; new sights of art and architecture; the strange game of *pelote*, a kind of Pyrenean squash; unaccustomed food and drink like the 'black coffee in bowels' laced with *prunelle* which Joan Gill, with her Daisy Ashford spelling, describes as being served at Salies in mid-morning: such things stimulated Gill in a quite unusual manner. The drawings he did around the town in Salies, like some of the sketches he did later in Jerusalem, have a spontaneity one rarely finds in other Gill drawings. These are holiday sketches in a rather special sense.

If Salies had its built-in tensions Gill forgot them. The accounts of those visits in his memoirs are euphoric, a masterly example of his technique for remembering only the side of things he chooses to remember. His daughters' descriptions of the Pyrenees are different: relations between the Gills and Ansteds grew embittered. The Ansteds moved into a separate establishment. They did not speak on meeting one another in the street. But one senses none of this in Gill's emotional descriptions of Salies-de-Béarn as 'that heavenly Jerusalem in which men unite to praise God and love one another'. Gill managed to deceive even himself with great efficiency.

By autumn 1927 holidays were over. Gill had returned from Salies, via Paris where he and Gordian visited the Eiffel Tower. For the next few months he was more or less marooned in Glebe Place, Chelsea, working in a studio lent by Lord Howard de Walden, a good friend and patron to Gill over the years. For Gill, the connoisseur of holy cities, the contrast between Salies and London was dramatic. From the professional point of view London was the most necessary of his outposts, and partly for that reason was the one he most resented. Of all cities London seemed to him most irreligious: 'There's nothing holy here – nothing,' he told Middleton Murry, as they once sat eating in a London hotel restaurant. But more and more it was the city he could not escape from, provider of

the income which he needed to support the kind of holy life he had evolved.

By this time Eric Gill, the despiser of Art-nonsense, had had to join the London gallery circuit. He was on the books of the Goupil Gallery in Burlington Gardens, off Bond Street. It had dawned on him at Capel there was no other way of surviving. He had reserves of realism and he had accepted the inevitable rather as at this same period he had lulled himself into acceptance of working for Monotype, the capitalist industry he once derided. By now he was resigned to some extent to making the best of things, still seeming jaunty, giving them his philosophical 'What ho!'

The large carving which was occupying Gill in London was intended for a major exhibition at the Goupil. The stone was too unwieldy to be carted up to Capel: a practical problem Gill perhaps had not foreseen. Gill's youngest sister Angela modelled for this giant kneeling torso of a woman which was first known as *Humanity*, then renamed *Mankind*. The sculpture is now in the Tate Gallery, after enjoying the curious distinction of being rejected for the zoo at Whipsnade. (Were the zoologists, wondered one contemporary commentator, so obsessed with animals as to be blind to human beauty?)

Mankind is one of Gill's most assured, impressive carvings, in the classical tradition. Critics at the time compared it with Maillol and Meštrović, and even Phidias. P. G. Konody, one of Gill's most sympathetic interpreters, wrote in the *Observer*:

This magnificent torso has much of the majestic dignity, but neither the frontality nor the immobility of Egyptian sculpture. It also has much in common with Greek sculpture of the best period – the proportions are classic and the relations of part to part conform with the best Hellenic tradition – though simplification of form is carried beyond the point permitted by the Greek sculptors' leaning towards realism. The rhythmic flow of the silhouette is maintained from every point from which the torso is viewed; and the sculptor's taste and technical skills have extracted from the Hoptonwood stone all the beauty of surface and texture which that material can possibly yield.

Even Gill's most hated paper, the *Daily Mail*, was enthusiastic about *Mankind*, maintaining that 'the pefect formal relations' achieved by the artist in carving 'this wonderful torso' allayed any regret about the absence of head and arms and legs. There was general acclaim. But looking at *Mankind* now, in the context of Gill's work, one is struck most of all by its unusual anonymity. It is not for instance nearly so

immediately, obviously recognizable as the work of Gill as its earlier counterpart, the *Mulier* of 1914. It is less radical, more abstract. Not so much the known, maternal figure, more the generalized woman. This prepares one for the relative conventionality, even the blandnesses that one finds from time to time in Gill's work from then onwards, and suggests a kind of winding down, a mood of middle age.

Gill, after all, by this time was about to be a grandfather: Betty had her first child, a boy, in March 1928. And the correspondence between Gill in London and Mary still in Capel through the long weeks of their enforced separation had its elements of pathos. It is the correspondence of two rather weary people. 'I can't think what I'm doing half the time,' he tells her wanly, 'and I feel all hurried and flurried and worried.' His routines are all awry: one day he lunched off bread and butter, potted meat, whisky and water, and an olive and a fig. A few days later he reports to Mary: 'It's now 7.30 and I've written 22 letters I think.' Even his sexual fantasies are not quite what they were, they are rather desolate and sweet domestic yearnings:

I'm dying for a scrap with you. I suppose I must wait till after March 1st but Oh! dear! just think, if you were here now, and you were down below playing the clavichord while I wrote letters and then, when you called, I came down to tea (and when you pulled your skirt up you have those nice black combinations on!) and then we could have the evening together. Well, Well, it's nice to imagine it anyway.

In May 1928 there is a quite significant entry in the diary: 'To Pimlico with MEG – house hunting!' This is the first sign we have that Gill is contemplating pulling out of Capel. It is also the first revelation of his willingness to contemplate a place in which the spiritual resonances are so feeble. Pimlico! Compared with Capel (or Ajanta) Gill must have realized that the place lacked inspiration. The Gills' search for a house first in Pimlico, then Kilburn, suggests an altered state of mind.

Gill gave several reasons in his *Autobiography* for his sudden decision to leave the monastery, of which the one that his wife and the girls wanted it is perhaps the least convincing. Certainly with Betty's marriage and the imminent departure of Petra the household at Capel was becoming most impracticable. Father Joseph Woodford, the sick monk on loan from Caldey, had been sent away to Switzerland for further treatment, and the nearest Catholic church was many miles away. But such minor inconvenience was not the sort of reason to which Gill paid attention in planning his life. One senses, in fact, from his perpetual

dependence on diversions, trips and travels, that the actual life of Capel had failed to satisfy him, that moving to the wilds had been an act of defiance not successfully sustained.

Had Capel itself proved too far-flung an outpost? Had its foreignness, which Gill at first had so much welcomed, become unsympathetic? Did Capel now seem alien: too uncivilized, too swarthy, too rugged and too *Baptist*? Desmond Chute, writing from that other, sunnier, outpost of Rapallo, sent an epitaph of comfort, telling Eric that Capel-y-ffin was out of character: 'A splendid place, yet somehow not you. Wales is not you, nor mountains you.' Gill was so English he required an English context, to be judged with Purcell's music and with Hepplewhite chairs.

HOME COUNTIES

39 *Mulberry Tree*, letterheading for Cicely Marchant,
owner of the Goupil Gallery. Wood-engraving, 1934.

PIGOTTS

1928–40

On 11 October 1928 the Gills left Capel at 8 o'clock in the morning, arriving in High Wycombe at 6 o'clock that evening. They had made the journey in Charles Smith's lorry. It was a scene of *déjà vu* which Graham Greene alighted on as an example of Eric Gill's great oddnesses, the super-eccentricity which set him apart from a tradition in itself as eccentric as that of Roman catholicism in the England of the later 1920s:

Eric Gill, with his beard and his biretta, his enormous outspokenness, his amorous gusto, trailing his family across the breadth of England with his children, cats, dogs, goats, ducks, and geese, belonged only distantly to this untraditional tradition; he was an intruder – a disturbing intruder among the eccentrics.

He was not part of the Catholic aristocracy, the tradition romanticized in *Brideshead Revisited*. Gill had not, as Greene commented, the baroque internationalism of a great Catholic school behind him; nor had he been brought up with the 'tag end of peasant beliefs picked up in saints' lives'. He was odder than the odd in his idea of work as worship. He was also set apart by his philosophy of homeliness. To sophisticated Catholics the Gill ménage could by this time appear dauntingly peculiar, arty-crafty, *middle-class*.

Pigotts, in the Chilterns, in the heart of the Home Counties, could hardly have been a more English destination: a collection of local red-brick buildings set around a central farmhouse, with a pigsty in the middle. (When the Gills bought it the place was known as Piggots, but they felt that Pigotts was easier to write and more in line with the name as pronounced locally; it also appeared on ancient maps as Pycotts.) Pigotts was a pleasingly formal group of buildings, in the quadrangular pattern Gill had been so fond of since his days at Lincoln's Inn. It lay

five miles from High Wycombe along the road to Speen, in a clearing on a plateau at the top of a hill approached up a steep lane. All around are beech woods, a permanent reminder of the commerce of the neighbourhood. High Wycombe was the centre of the furniture industry, and this was the timber on which it based its trade.

Gill had financed the purchase of the property with the proceeds of *Mankind*. By selling the carving quite profitably he had been able to put down £500 immediately and borrow the remainder from the bank. He paid £1,750 for the farmhouse and its buildings, with a one-acre orchard and sixteen acres of grass. He was marvellously pleased with the purchase and the scope it gave him to reorganize his life and reassemble his dependants. As with each new move, the move to Pigotts seemed the answer: Desmond wrote agreeing that Pigotts looked like 'IT!' Gill's work as a sculptor, which had been in danger of dwindling away during the years at Capel, seemed likely to revive in the more practical conditions of High Wycombe, a short train journey from London. The Goupil Gallery planned another exhibition of his work in 1930: this now seemed much more feasible. 'If this isn't providential,' wrote Gill, 'what, oh, what is?'

The Gills arrived at Pigotts rather like explorers reaching a new settlement. The buildings round the quadrangle were allocated. On one side was the farmhouse, from then on known as 'the Big House', where the Gills themselves lived. On another was the building, once a stable and a threshing barn, which became Gill's workshop: the stable was converted for his drawing and engraving and the barn was turned into his stone shop. The third side of the quadrangle was mainly taken up by a one-storeyed building. This became the premises for Hague and Gill, the printing press that Gill started with René Hague, his future son-in-law. On the fourth side was the cottage and studio where Gill's other son-in-law, Denis Tegetmeier, came to live after his marriage to Petra early in 1930. Abutting on to that another little cottage housed Joan and René Hague once they too were married. Here David Jones would stay, sometimes for months at a time: his Pigotts paintings sum up the intimate and beautiful, confused, congested, intellectual-agricultural scene. The marriages of Petra and Joan, the two remaining daughters, within the first two years of the settlement at Pigotts created a new pattern. Unlike Capel, which had operated as a single household, Pigotts formed a series of small households, almost a colony.

The chapel was still central. As at Capel, as at Ditchling, it was felt to be important that the chapel should both become and be seen to be

accessible from workshops and domestic areas alike. By a feat of ingenuity a chapel was created at Pigotts from a rather improbable cramped corner which joined the farmhouse to Gill's workshop, with one door leading one way, another door the other way and a third door opening straight on to the meadows. The chapel was both conspicuous and very private ('what a luxury', wrote René Hague much later, 'to look back on in these days of vernacular prayer-meetings'). An open screen partitioned it off from the main household. A small stone altar was constructed in the centre. Six months later, the Gills' chapel was licensed for mass.

The first few months at Pigotts were occupied enjoyably with the domestic tasks of settling in and settling down. Gill was always keen on notifying changes of location, as if needing to publicize his own hopes for a fresh start. He drew a meticulous map out for his visitors, as if they were about to embark on a vast journey instead of setting out for a day trip to the Chilterns. He also designed a little 'Naphill 42' layout, for the number of the telephone the Gills had had installed. (The first person Gill telephoned was G. K. Chesterton, then living only a few miles away in Beaconsfield.) Gill's own hand-lettered signboard, leading up the hill to PIGOTTS, was the cause of an acrimonious correspondence with the Bucks county surveyor but is still to be seen, a rather touching small memorial to Gill's early hopes in colonizing Pigotts and indeed a demonstration of a whole artistic outlook. Like the artefacts of the Shakers, with whom Gill shared his spiritual seriousness and his discontent with worldliness (if not his flagrant sexuality), much of his best work has the decorum of necessity. It is family art, design for the community. Its conviction arises from immediate, real needs.

Eric Gill in his mid-forties still saw himself as the iconoclast, the outcast. But in fact by the time he arrived at Pigotts his worldly reputation stood high. His show at the Goupil in 1928 had gone far to consolidate his artistic reputation, and Gill received the approbation with some embarrassment: 'the blooming show is an absurd success – monstrous. Approbation galore and you know what absurd things critics say when they try and in the mundane sphere.' Books were being written about him. A comprehensive illustrated volume on his sculpture, assembled by John Rothenstein, had been published by Ernest Benn in 1927. Gill did not approve of his protégé's Introduction and dispatched one of his caustic letters saying he had found it very disappointing. ('You'd somehow got a lot of minor facts wrong and the journalese seems to me . . . a pity': close ties of affection did not preclude Gill's rudeness – *au*

40 *Naphill* 42.
Wood-engraving of
Pigotts number for
Gill's letterheading,
1929.

41 *Pigotts Roads*, 1928.
Wood-engraving of
surrounding area
showing bus route and
two local pubs,
The Gate and The Harrow.

contraire.) But the publication had enhanced Gill's reputation and it was followed in 1929 by another substantial book on Gill by Joseph Thorp, with a 'critical monograph' by Charles Marriott. That same year an important essay on his work by Stanley Casson was included in *Some Modern Sculptors*. Here he was being viewed alongside Rodin, Maillol, Meštrović, Gaudier-Brzeska. In spite of the fact that his output had been meagre in the recent years in Capel, Gill was by now established as a leading British sculptor, a sculptor considered on an international level. When Charles Holden – perhaps the most visible architect in London between the wars – came to choose the sculptors for the outside of the new London Underground headquarters above St James's Park Station, Eric Gill would have seemed an obvious choice.

This was one of the jobs which was occupying Gill in the first few months at Pigotts. 'Started Holden sculpture job,' he entered in the diary

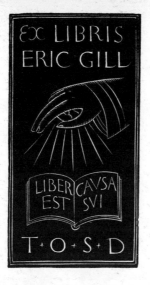

42 *Hand and Book.*
Wood-engraving for Gill's
own bookplate, 1928.

for 13 October 1928, 'Shifting stones all day long.' On 16 November:
'Holden Sculpture models all day (did a love picture in eve).' Four days
later he had started work on site on the new building at St James's.
Epstein had the major part in the commission, carving the two figures
Day and *Night* over the entrance. The old tensions and rivalries were by
no means forgotten and there was an 'irate and emotional' scene between
the two star sculptors in the office of the clerk of works. Gill was in
charge of a team of five more sculptors, including Henry Moore, working
on the carvings of a series of figures representing Winds, high up on the
building on the seventh floor. He himself carved a pugnacious North
Wind, a languorous and very female South Wind and an energetic and
slightly comic East Wind, a sculpture which has an obvious affinity with
the gargoyles of the Gothic churches and cathedrals. The medieval
concept of the team of working sculptors in the heart of the city had its
obvious appeal, as did the value to the Pigotts workshops of such a large-
scale and profitable piece of work. But Gill had many doubts, both moral
and artistic, about the whole idea of surface decoration on a building.
His old ideas were in fact by now quite fashionable, and many of the
more progressive architects of that period shared Gill's basic conviction
that a large and public building should be *plain*. His mixed feelings –
and his view of the sacredness of work in relation to the centrality of sex
– emerge from a discontented letter to Graham Carey in America, a
letter almost literally from the scaffold:

I am at present doing some big but unimportant sculptures on a building in London – architectural fal-lals merely but a valuable experience. We are working against time – horrible clanging and noise and mess all round – revolting contrast between our (there are 5 sculptors on the job) attempts at 'love-making' and the attitude of mind of the 1000 'hands' around us. The building is good and plain – iron with plain stone facing – we are quite out of place.

Gill reacted against the *mindlessness* of sculpture on a building which was otherwise so rational. In one of the most likeable and most persuasive of his writings of the period, the Introduction to the collected *Engravings*

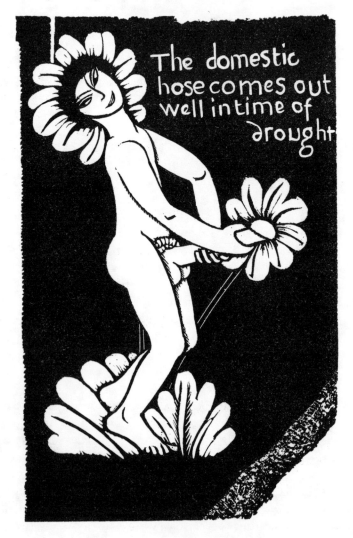

43 *The Domestic Hose.* Woodcut, 1929.

published in 1929 by Douglas Cleverdon, he emphasizes his aim to rid his work of the merely idiosyncratic and eccentric and traces his love of clarity, his yearning for the tangible, explicable, and solid, back to his original apprenticeship in architecture. He explains that the only thing he ever went in for with complete and undiluted enthusiasm is 'the making of a collation': the putting of things in their right and proper place.

Gill's essay ends with one of those familiar lists of favoured objects: familiar except that this one is in Latin, translated from Gill's original, and is rather more erotic in content than its predecessors:

Idem ego amo omnes res creatas, uiros et feminas et omnia, siue animantur siue minus, siue cohaerent in se siue minus, et maxime uirorum pectora et lumbos et culleos, feminarum papillas et nates, amo uentris rotunditatem solidamque molem femorum et minutas illas subtilitates umbilici et oculorum et huiuesce-mode omnium. haec amo, ideoque cum licet mihi, ni alia obstiterint, ea fingo quae sint rotunda . . .

The translator of the passage, Walter Shewring, was a classics master at Ampleforth College, having recently left Oxford with both the Craven Prize and the Chancellor's Prize for Latin prose. At Pigotts, he was one of the essential people, as Desmond Chute had been, as David Jones still was. His presence was accepted, and his talents were made use of. In a sense, Walter Shewring was another son-substitute, as well as the resident intellectual. Gill came to rely on his mental vigour and composed a clerihew about it:

> Walter Shewring
> Was nothing: if not enduring.
> And for general enlightment, something that is more than
> a coronet, and incredible learning
> He left us all worms –
> Turning

To which Shewring retaliated:

> Eric Gill
> Said 'Art is just skill';
> Herbert Read replied 'Lumme!
> I thought it reflected the goings-on in my tummy.'

Clerihews were a favourite Pigotts game – like quoits.

Walter Shewring's range of interests was wider than Gill's own, more

like Desmond Chute's in its inclusion of the modernists: Picasso, Schoenberg, Pound. Shrewring's role as an interpreter of Gill became important. His essay, 'Considerations on Eric Gill', remains the most illuminating commentary on Gill's philosophy of art and workmanship.

In 1929 Gill's own *Art-Nonsense* was published. This was the first of whole series of editions of Gill's collected essays. These, appearing almost annually through his Pigotts period, established him as the man of views, the licensed social critic. The public became familiar with Gill's special tone of voice. That tone was somewhat bullying. In normal conversation Gill's manner was quite different: he was gentle, watchful, patient, drawing people out. A conversation with Gill was rather like a chess game. But his prose style, in contrast, is peremptory, impatient. Epstein called it doggerel. Shewring, more sympathetically, likened it to Dickens. At its best it does have some of Dickens's clarity and urgency, but its repetitiousness can certainly be tedious. (René Hague, his son-in-law, in fact stopped going to Gill's lectures because he knew them by heart before he got there.) Gill himself defended his method of approach not on literary grounds but as a functional necessity, claiming there were many readers only capable of remembering a point which is repeated frequently; a missionary-preacher's technique.

Art-Nonsense is set in Eric Gill's Perpetua, the first public use of the typeface. The engraving on the frontispiece is *Belle Sauvage*, in one of several versions: the naked woman emerging from the thicket, which is one of Gill's best-known and most beautiful of images of his mature period. Again it shows his personal preoccupations, the game he played, the juggling of the real and imagined. The model for *Belle Sauvage* was Beatrice Warde, the woman who was, apart from Mary, for several years the most important in Gill's life.

The history of Gill's *amours* is a succession of opposites, alternatives, attractions to the foreign, and of all his mistresses Beatrice Warde is the most extreme example of that tendency: most opposite to Mary, most contradictory to Gill's formal theories of ideal womanhood. Beatrice Warde was, first of all, quite literally foreign. She was the professional lady from New York who had first arrived in England with her husband, Frederick Warde, in 1925. By the time Gill encountered her she had left her husband, had become publicity manager for Monotype and had begun an amorous professional relationship with Morison which continued all his life. In many respects Beatrice Warde personified the feminist woman Gill so frequently derided: living on her own in a

ART-NONSENSE

AND OTHER ESSAYS

BY ERIC GILL

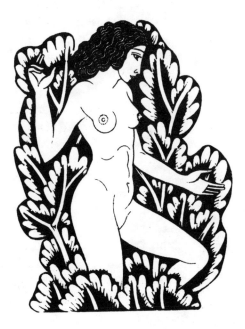

LONDON

CASSELL & CO., LTD. & FRANCIS WALTERSON

1929

44 *Art-Nonsense* frontispiece incorporating a version of *Belle Sauvage* wood-engraving.
This was the first commercial use of Gill's Perpetua.

45 *Belle Sauvage III.*
Wood-engraving, 1929.
The model was
Beatrice Warde.

situation of conventionally dubious morality; making her own way in a professional world, the predominantly male world of typography. She even assumed for professional purposes a male pseudonym, and as 'Paul Beaujon' she contributed long and rather dauntingly learned articles to typographical journals. All this Eric Gill found, in reality, most piquant. His relationship with Beaujon, as she was known familiarly in typographic circles, was wonderfully, stimulatingly, perverse.

Douglas Cleverdon, another of her lovers, described the mobility which men found so unusual:

At one moment she would be bubbling over with gaiety and wit; at another you would find her absorbed in hard intellectual argument, or forcibly putting her publicity across to a bunch of printing executives. She was a first-rate printing historian. And she was very beautiful. One might describe her as a mingling of Venus and Athena: Venus rather than Aphrodite, Athena rather than Minerva.

In temperament she was, once again, not unlike Lillian. In another generation she too would have read Nietzsche and gone to Fabian meetings. Her spirit appealed to Gill as did her body, her 'fine American carcase' as he called it. He drew many portraits of her. She was one of the main models for his *Twenty-Five Nudes*, an expert in holding the acrobatic pose.

46 145 Pimlico Wharf, map to Beatrice Warde's house. Wood-engraving, 1935.

47 Bookplate for Mrs Beatrice Warde in her *nom-de-plume*, Paul Beaujon, 1927.

In analysing the Beatrice Warde attraction, one must not forget the competition element. Gill was to some extent a predator. In all his close relationships with married couples he compulsively, inevitably sought the wife. He was childishly jealous of other people's women, not even allowing his apprentices at Pigotts to bring their girl-friends into the workshops. He liked to feel all women in the world belonged to him. Beatrice Warde had no official ties with Morison: his wife was still alive, although they did not live together. It seems unlikely, on the evidence of friends close to them both, that Morison's relationship with Beatrice was physical. He was a strict Catholic, still playing by the rules. But their obvious affection and dependence had made them a couple of a kind, and the triangular relationship, as we have seen before, was irresistible to Gill. Something of the nature of it, and the ease of Eric Gill's relationship with Beaujon, a friendship based on admiration and companionship as much as physical excitement, comes over in an entry in Gill's diary: 'To BW in eve – sup with her. SM came later and I drew his hands and drew BW after. Slept with BW and she with me . . . but did *not* commit adultery – we really slept.'

It is interesting, not to say ironic, that one of the things both Morison and Beatrice Warde appreciated most about Gill was his domestic setting, the closeness of his family, the peacefulness of Pigotts. Morison envied

235

this deeply, though he did not like the country; he had never had a family life and he still craved one. Beatrice Warde would sometimes travel down to Pigotts on a Sunday when Mary would be polite to her, though not enthusiastic. Members of the family recall her at the tea table looking rather *outré* in her London weekend garments, a bird of a different feather, vivacious, conversational, laying down the law.

In the year of *Art-Nonsense* Gill's mother lay dying in Sussex: the apparently indomitable, energetic Rose. She was once said to have gone about for weeks with concussion after cracking her head on the chimneypiece, because she had no time to call the doctor. Some of this unusual will-power had been handed on to Eric. Past clashes of religion, as well as personality, were forgotten in the emotion of visiting her in the nursing home at Chichester. Enid, Cecil, Angela, Max, Evan, all assembled at her bedside: it was one of those clan gatherings the Gills went in for. Shortly before she died she went over all the names of her children, one after another, a sad and lengthy ritual. She said she had loved each of them. Mary arrived in Sussex and went across to Brighton with Eric to arrange about the grave for Mrs Gill in the Extra-Mural Cemetery. It was a wet day. There was a strong sense of time passing. The next day, before the funeral, Eric took the opportunity to talk to the Archdeacon of Chichester about his father's retirement from his parish at West Wittering. Though Eric makes little direct reference to his feelings on the passing of his mother there is a revealing depth of emotion in the letter he wrote to Desmond two years later, on the death of Mrs Chute:

I dare say that you will feel your mother's going very poignantly, there were many bonds between you and, considering the difference of view and interest, her patience and generosity, in the presence of what, to her, must have been your strange enthusiasms, were very great and tender. If you need consolation, may we help to console.

Up to now Gill's own health had given no cause for alarm. True, he had never been especially robust, and his late nights and the pressures of his work had sometimes had their consequences. One sometimes comes across such entries in the diary as 'Very tired. Up 1.30. Slept 14 hours!' He drove himself hard. After a day of illness, in bed with a chill on the stomach, he got himself up and travelled off to London for a meeting at the office of Eno's Fruit Salts (of all places), then returned to Pigotts and got straight back into bed again. But he had never had a serious illness, and a fairly thorough overhaul by the doctor just before he had left

Capel revealed nothing more fundamentally alarming than an incipient weakness in one ear. So the breakdown Gill suffered in the year after his mother died was shocking and mysterious. Perhaps it was related. The causes of this breakdown can only be surmised from the views of those who saw it and the evidence contained in his diaries of the period. It was an event which affected the remainder of Gill's years at Pigotts; after this, he was never really well again.

It came upon him suddenly, a bolt from the blue after a fine summer of excursions and reunions. This was summer 1930, the year he went to stay at Weimar with Count Kessler. Here he met Maillol, by then an old, gnarled man of seventy. The re-encounter was amiable, but hampered by the language problem. (Gill had still not learned much French.) In the course of this visit, Gill drew the portraits of Kessler, Maillol, and Nietzsche's sister Frau Foester-Nietzsche. He also successfully shocked Kessler and his household by getting out his sketchbook and showing a series of nude drawings of a girl with a fine figure in poses which John Rothenstein, who was also staying with Kessler, described as 'of a startling impropriety'. The model, Gill asserted, was the Deputy Librarian at High Wycombe. (It was not, apparently, another young librarian, Elizabeth Coles, better known as the novelist Elizabeth Taylor, who also came into the Gills' orbit at this period and later wrote a book, *The Wedding Group* (1968), in which the view of Pigotts is somewhat less than flattering. She had a love affair with Gill's assistant Donald Potter.)

After Weimar Gill had travelled on to Salies, where the small-town routine had, as always, delighted him. He had gone to the circus. He had finished writing *Clothes*. He travelled back via Paris and Chartres Cathedral, which still seemed to Gill the most heavenly of buildings. He had returned to Pigotts early in August. He and Mary celebrated their twenty-sixth wedding anniversary: Petra and Denis, the newly married couple, came round for a glass of wine with them that evening. Plans were made for Joan and René's wedding in November. There was nothing to prepare the Gills for the alarms and upheavals of the next few months.

Then one day at the end of September Petra found her father wandering in the quadrangle. He had lost his memory. The form this amnesia took was particularly frightening in someone whose normal state of mind was so very accurate: he could not remember who he was or where he was. He was put to bed at Pigotts. He was given drastic treatment; leeches were applied. Five days later he was taken off by ambulance to the St John and St Elizabeth Hospital in St John's Wood. Father John O'Connor

wrote to Mary asking what the chances were for his recovery. It seemed as bad as that.

Emotion ran high around what might have been his deathbed. 'MEG came to see me *every day*,' Gill wrote in the diary, which he filled in retrospectively after his recovery. Desmond Chute soon arrived and gave Gill holy communion; '*confession to him*' is underlined by Gill significantly. Father Vincent McNabb, after years of embitterment, came to make his peace with Gill not once but twice. Pepler arrived with Joseph Cribb from Ditchling but Gill claimed to be too unwell to see him. Betty came, and David Jones, and Tom Burns, the editor of *Order*, who as a schoolboy had first made the pilgrimage to visit Gill at Hopkins Crank. His brother, Dr Charles Burns, a specialist in nervous diseases, also cast his professional eye on Gill.

One bizarre feature of Gill's mysterious illness was that during the first two days of his intensest headaches the only thing he could bear to contemplate was a copy of Lutyens's plans for the Roman Catholic cathedral in Liverpool. 'Nice chap, Lutyens,' as Gill once said all those years ago. The illness was a catching-up of things he thought were past.

As he recovered Gill enjoyed himself in hospital. It suited his need to be the centre of attention. Towards the end of his three weeks there he was holding court not unlike the eastern potentate giving or withholding audiences. He was intrigued by the patient–nurse relationship, especially since the nurses were all nuns; as he reported to Romney, still in Papua New Guinea and the brother who came closest to his esoteric interests, it certainly

seemed strange at first to have a nun administering the enema and with delicate fingers separating the cheeks of the arse – my doctor said they were damned inefficient but, as he said, amply made up for it, and more, by being very good nurses – certainly the holiness which radiated from them was enough to make you happy and if you're happy what else matters?

By the end of October Eric Gill was back at home.

But what had caused his illness? What made him so unwilling to dwell upon it later? (It is not even referred to in the memoirs.) Was this simply an evasion of so fearful an experience, an attack on his whole being, the negation of identity? I think one has to see it in the context of a person who had always needed to put his personal mark on things: the artist who signed his work; the Tertiary who firmly, even rather ostentatiously, put o.s.d. (for Third Order of St Dominic) after his signature on letters to his friends. Was it also pride of memory? Gill's memoirs themselves

proved how important this was to him: 'The only real enjoyment of life is in the memory.' In this sense it was his testing ground, his way of self-control.

Gill had a strong consciousness of his persona: his standing as an artist, his man-of-wisdom image, and his domestic role of *paterfamilias*, the ultimate authority. But in the years which led up to his breakdown this persona had in fact been threatened in some most important ways. His artistic identity was being called in question by the national effects of the Depression as well as by the economy of Pigotts, with its new accumulations of dependants: times were hard for artists, and the doubtful feasibility of spreading his talents in so many varied areas must surely have occurred to him. Was he mainly a sculptor? An engraver? A typographer? His domestic identity was also being questioned. Joan, the last of his daughters, was about to be married in circumstances which, if they did not reach the intense anguish occasioned by Betty's marriage to David Pepler, had still, as we have seen, caused anger and anxiety. Gill had warned Joan about René Hague's shortcomings as a husband. 'I don't think he realizes that at present he is more of a luxury than an "economic unit",' he had told her cruelly, 'and you know yourself how "happy go lucky" he is and how impossible and unreliable and unstable – and then how "awfully sorry" he is – for about 5 minutes . . .' But Joan, like Betty, had chosen to defy him. Gill's own sudden, serious breakdown in the month before the wedding must surely have been triggered by a build-up of frustration.

His public life and sexual life had never really tallied. They became more opposite during the years at Pigotts. In the months before the breakdown the diary shows, for instance, that he had resumed the old relationship with Gladys. His sister was now thirty-nine, remarried and divorced since the first of her husbands, Ernest Laughton, had been killed in the First World War at the Battle of the Somme. Gladys now lived on her own with her small daughter in a coastguard's cottage at West Wittering close to her father's parish. Here Gill sometimes went to visit her. 'Bath and slept with Gladys,' runs one entry in the diary. Such Gill family intimacies seem routine, a habit. A few weeks later there are more surprising entries: 'Expt. with dog in eve' (the rest has been obliterated). Then, five days later, 'Bath. Continued experiment with dog after and discovered that a dog will join with a man.'

To dismiss such incidents as simple aberration is, in Gill's case, much too easy. They have their comic aspects perhaps, but in arriving at any true assessment of Gill they must, I think, be seen to have a very serious

UNEMPLOYMENT

¶IT IS absolutely necessary to have principles, that is things that come first, the foundations of the house. What we want to know is: what principles of common sense are relevant to the matter of human work.

a

I

48 Title page for *Unemployment*, pamphlet printed by Hague and Gill and published by Faber and Faber, 1933.
The wood-engraving is entitled *The Leisure State*;
the pamphlet is set in a combination of Perpetua and Joanna.

relevance. The urge to try things out, to push experience to limits, was part of his nature and part of his importance as a social and religious commentator and an artist. The idea of aiming at the true, the known, the proven was at the very basis of Gill's creative energy. His concept of holy beauty involved tangibility. Gill was of course as much a craftsman and an architect as what is conventionally thought of as an artist. The integration principle which Gill tried to arrive at was a question of mechanics, the way things work together. Junctions, connections: this was part of his obsessiveness, his ambition for the fusion of religion, art and sex.

In hospital Gill had started writing a new book, *An Essay on Typography*. When he got back to Pigotts, he carried on dictating it to Mary and to René Hague. On 19 November René and Joan were married: the nuptial mass was followed by a wedding breakfast at the Red Lion in High Wycombe and a reception for sixty back at Pigotts. Two days later a mass of thanksgiving for Eric's recovery was held. In a gesture of generosity towards the marriage as much as for the further-ance of his own ambitions as a printer, Gill had set up a printing press at Pigotts under the name of Hague and Gill. (He did however make the typical proviso that his son-in-law should call him Master.) Two years later the press was officially made over to René. But Gill himself remained very much involved in the decisions about what the press would publish. *Typography* was one of the early publications, and so was *Park*, a strange and brilliant little novel, a Kafkaesque fantasy of loss of identity, by Gill's friend and Oscar Wilde's, the enigmatic Canon Gray.

Gill was on the edge of a new and forthright theory: his customer-is-right phase. If this seems an unlikely position for Gill, perfectionist and moralist, to have arrived at, it had a certain logic as the absolute antithesis of artists' self-indulgence, the art-for-art's-sake attitude. The press at Pigotts was in line with this new mood. It was not a 'private press', Gill spent some energy explaining: it had nothing to do with the Hammer-smith ideals, the worlds of Cobden-Sanderson and St John Hornby.

the real distinction between such a press and others is not in the typographical enthusiasm of its proprietors, but simply in the fact that a 'private' press prints solely what it chooses to print, whereas a 'public' press prints what its customers demand of it . . .

I think it would be good if we could all agree that the distinction between private and public is what the words themselves suggest, and has nothing whatever to do with the use of machinery, whether hand-driven or otherwise, or with questions of the artistic quality of the product.

49 An illustration from *An Essay on Typography*.

50 *Tree and Dog*. Wood-engraving, 1931.
The dog is a reconstructed version of the Hound of St Dominic.

51 Monogram ER, signifying Eric/René. Woodcut, 1930.

In some ways Hague and Gill was close in ethos to St Dominic's. The best of its production achieves a comparable spontaneity, vivacity. But it was not, and was not intended to be, purist as purity was understood on Ditchling Common. It was not so Catholic and not so missionizing: it was there to print what its customers asked for. It was also less emphatically a *hand* press. As well as an Albion, Hague and Gill possessed a motorized platen press. Gill's attitude towards machine production had softened since Ditchling. Influenced by Monotype – and by financial necessities – he was now coming round to a more easy view.

Gill was working with great vigour in those first few years at Pigotts. The illness seemed in some ways more stimulus than setback. As one of his pupils once commented so rightly, Gill's *work* was the engine which drove him, and in the months immediately before and after his collapse Gill drew on his reserves of almost superhuman energy to produce three of the designs, in three very different areas, which show him at the height of his artistic expertise.

The first of these was the Joanna typeface. This type, named in honour of Gill's daughter Joan, was designed originally for Hague and Gill: it was family typography in action, and it was not until 1939 that the Monotype Corporation made a version for machine composition for Dent's. The idea of producing his own type for his own press had an obvious appeal to Gill, and Hague described his 'delight and enthusiasm' as they first proofed Joanna, 'the type which was the first to be made entirely on his own account and to satisfy his own idea'. Though never as widely used as it deserved, Joanna has always had its passionate supporters amongst specialists. Its balance of clarity and individuality has made it the choice of the experts, the typographers' typeface. Robert Harling, for example, has maintained that of all Gill's type designs Joanna, in its italic version, remains 'the most individual and successful'. The letter-forms, he says 'have character and beauty, discipline and gaiety'; all these, of course, in Gill's eyes, being prime domestic virtues.

The second of Gill's major projects of this period was the design for *The Four Gospels*, the culmination of his work for the Golden Cockerel Press and again the example which experts and collectors in that field have always viewed as the height of his achievement. To describe it as a series of engraved initial letters for the Bible text, though strictly correct, gives little idea of the richness and complexity of Gill's own contribution. The decorative letters do not just embellish the text, they play upon it and develop it, to the point at which distinctions are blurred. Are they lettered illustrations? Or illustrated letters? The two things flow together

ALPHA

PERPETUA

abcdefghijklmnopqrstuvwxyz

ABCDEFGHIJKLMNOPQRSTUVWXYZ

1234567890

Look after truth and goodness,
and beauty will look after herself.

abcdefghijklmnopqrsttivwxyz

ABCDEFGHIJKLMNOPQRSTUVWXYZ

First I think, and then I draw my think.

JOANNA

abcdefghijklmnopqrstuvwxyz

ABCDEFGHIJKLMNOPQRSTUVWXYZ

Man is matter and spirit,
both real and both good.

abcdefghijklmnopqrstuvwxyz

ABCDEFGHIJKLMNOPQRSTUVWXYZ

Artists are no more immoral than stockbrokers.

GILL SANS

abcdefghijklmnopqrstuvwxyz

ABCDEFGHIJKLMNOPQRSTUVWXYZ

We are to be children in heart, not in intellect.

abcdefghijklmnopqrstuvwxyz

ABCDEFGHIJKLMNOPQRSTUVWXYZ

Magnificat anima mea Dominum

52 Sample sheet of Gill typefaces:
Perpetua for Monotype, 1925;
Joanna for Hague and Gill, 1930,
later modified for Monotype;
Gill Sans-serif for Monotype,
1926 onwards.

OMEGA

with a rhythm, a control and an exhilaration which brings one back inevitably to Gill's own definition of creative energy: the exuberance of nature, the urine of the stallion, the spiritual field.

Gill's other main preoccupation in the early 1930s was *Prospero and Ariel*, best known of all his carvings, over the entrance of Broadcasting House in Langham Place. The diaries tell us that talks about the sculptures had begun only a few days after Gill returned from hospital, and work continued, much of it on site in central London on the scaffold, until well into 1932. It was a complex commission, involving not just the provision of the central Prospero and Ariel/Father and Son figures, but also three relief panels showing Ariel being carried up by angels, Ariel accompanied by Gaiety and Wisdom, and Ariel piping to a group of children (an obvious reference to Children's Hour). For the foyer, Gill provided another large male figure: *The Sower* (or *The Broadcaster*), a back-to-the-land figure distributing corn. Gill himself was very discontented with the carvings, and it is possible to criticize in detail, but taken as a whole one surely has to rate them as Gill's most successful foray into public art. They have, and have had for many years, a direct impact on the passing public which derives from their simplicity, their *story-telling* quality. They are childlike in a way which reminds one of Gill's Westminster and Bradford Stations of the Cross.

Simplicity, clarity, directness: these are obvious in all Gill's major projects of the early 1930s. But one also finds complexity, absurdity, aggression: in Gill there is always the rule of the reverse. The BBC carvings are tortuous in metaphor, the work of the man who will not listen to the radio. ('Who are Prospero and Ariel,' asks Gill in desperation, 'and why are they appropriate to the BBC?' Was it some sort of pun on Ariel and aerial?) *The Four Gospels*, with their elaboration of design, are a blatant contradiction of Gill's own strict rules of plainness. The special, pleasing quality of the Joanna typeface is its domestic quirkiness, so well described by Harling: 'We would have to go back', he says, 'to the Fell typefaces to find a type so wayward in design and yet so easy on the eye.' In all three of these designs Gill's waywardness is crucial. It is his genius of perversity. We are back to strict delight and his own partial view of licence. The latitudes he gives himself – in art, in sex, in marriage – have their basis in his view of that primary relationship of God to man, as of giver to receiver; a masculine concept. As Gill elaborates it: 'the proper speech of man to God, as of woman to man, wife to husband, mistress to lover, is "do with me what thou wilt" '.

While Gill was carving *Prospero and Ariel* real fame overtook him.

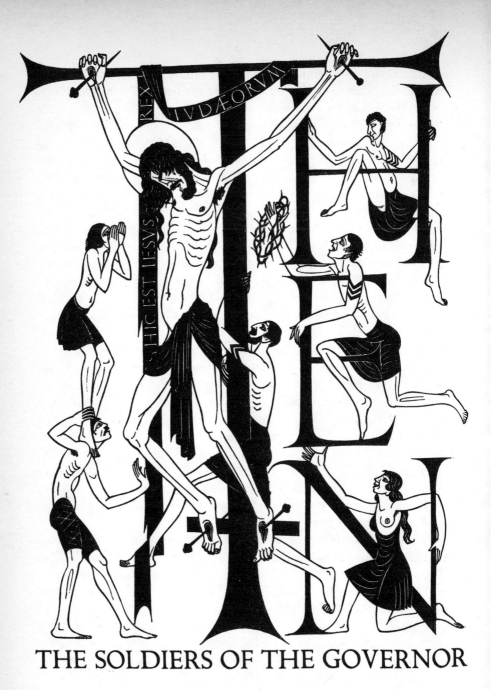

THE SOLDIERS OF THE GOVERNOR

53 A page from *The Four Gospels*.
Gill's own Golden Cockerel alphabet was used in
combination with his decorative wood-engraving for the initial letters.
Golden Cockerel Press, 1931.

He became a public figure on the *Daily Express* level. Even this had its ironies, for in his insistence on working out of doors on the scaffold in all weathers, with a zeal in fact not strictly necessary, he was asserting the craftsman's anonymity. He wanted the conditions of the ordinary stonemason. But the spectacle of Gill in his belted smock and knee socks appealed deeply to that instinct for nostalgia and regression so deep in the English character. Besides this there was the contrast between his monkish garments and his growing notoriety. He played up to this sense of ribaldry. He encouraged the rumour that he wore no underpants by shouting down jocularly from the scaffold to a passing friend, 'It's all balls, you know!' He became the 'Married Monk', in the language of the tabloids. Public fascination with what was perceived as Gill's moral ambiguity was fuelled by the scandal of Ariel's pudenda: the governors of the BBC, after a preview of the carving behind a tarpaulin, asked Gill to make the organs more diminutive. In one mood Eric Gill enjoyed such scenes immensely – and there were more to come, involving for example the reduction in size of the buttocks of the angels supporting the shield over the gateway at Jesus College, Cambridge; the banning of Gill's *Ck. and Balls* carving in the showroom of Shanks Bathroom Fittings in Bond Street (Gill obligingly carved a floral spray instead); even, after Gill's death, the controversial disappearance at the command of the then archbishop of the monkey from his carving of St Thomas More in Westminster Cathedral. Gill liked to shock the bourgeoisie and saw it as his business. Also, in a way, he needed the publicity. But Beatrice Warde, who knew about publicity as well as understanding how Gill's mind worked, maintained that his dependence on public recognition was a source of agony to him.

Gill's main model for Ariel was Leslie French, the actor. He was then playing the real Shakespearian Ariel in the Old Vic production of *The Tempest* at Sadler's Wells. Gill wrote to him to ask if he would let him make some drawings from his 'beautiful figure': 'Beautiful men', Gill added, 'are not common.' Gill made great friends with him, and encouraged him to draw. Mary too was very fond of him, soothing and protective when he went to sit to Eric at Pigotts:

It was nearly always very cold, I remember, and as I was posing in the nude Mary used to see there was a good fire burning in the studio. I think it was a stove. At first I was rather embarrassed at standing about so long in the altogether. Mary used to come in to the studio during the sittings bearing a tray with hot soup and since she was the perfect mother figure I was never for one moment embarrassed.

In any study of the wives of artists Mary should have her chapter. She was the perfect oiler of the wheels.

The true model for Ariel, the model in Gill's mind, was not of course Leslie French at all but Gill's adopted son Gordian. *Prospero and Ariel* is a larger-scale, maturer version of *The Foster Father*: the father hieratic, wise, protective, optimistic, closer to a Gill self-portrait than the Prospero of Shakespeare; the son nervy, tense and eager but bound closely to his father. This was still Gill's hopeful, vulnerable vision of Gordian, by then in his mid-teens. Gill had hopes that Gordian would be a printer. There is a touching diary entry: 'Printing "label" with Gordian in eve. Our first piece of letterpress printing.' When he went to see the Fanfare Press Gordian went with him. The father-and-son image was still greatly on his mind. But it was already clear to other members of the family that Gordian would never be the son Gill had envisaged. His erratic education – first the local school at Salies, then the boarding school attached to the Benedictine monastery at the Abbey of St André near Bruges in Belgium – had left him bemused and without much sense of purpose. Though later in life Gordian joined René Hague in the press at Pigotts, and worked as a sales representative for Dent, his connections with the printing trade were always fairly tenuous. At one point he even worked as a porter at Asprey's on Bond Street: that emporium of luxury which Gill, in his heyday, had scorned as the epitome of capitalist evil. Gordian lacked the vigour, and the talent, of his father. One of the sadnesses of the Pigotts period was the way this gradually dawned on Gill himself.

First the London Underground; now the BBC: by the early 1930s Gill had definitely moved into the world of the big sculptural commission. From then on his workshop enlarged accordingly. The first of a long line of new recruits was Donald Potter, summoned to see Gill in London on the scaffolding outside Broadcasting House, and taken on at Pigotts a week later (Gill was always quick at implementing his decisions). This was in September 1931.

With the arrival of Potter, a carver of some experience then in his early thirties, Gill's carving shop began to alter in character. Over the next few years another nine young carvers – Anthony Foster, David Kindersley, Hew Lorimer, Angus McDougall, Michael Richey, Walter Ritchie, Ralph Beyer, John Sharpe, John Skelton – came to work at Pigotts. There were normally three or four apprentices working there at any one time, along with Laurie Cribb, Gill's permanent assistant. This made it a very different set-up from Gill's workshop as it had been at Ditchling or at Capel. It was not just a question of increased delegation:

Gill, in spite of a theoretic belief in one man, one job, had in fact been delegating since the early days at Ditchling (the idea of the master and apprentice had always had its somewhat contradictory appeal to him). But the workshop structure at Pigotts was much looser, less domestic. The apprentices lived out in lodgings in the neighbourhood. Some were working on a weekly rate of pay, around £2 according to experience. One or two had come on grants from local county councils. Some were paid by Gill on a piecework basis while continuing to carry out their own commissions in Gill's workshop. Donald Potter, a protégé of Baden-Powell's, brought a large Boy Scout totem pole to complete at Pigotts. This stood out incongruously in the workshop surrounded by the Catholic iconography.

The social and cultural mix in the Pigotts workshops in the thirties was an interesting one. Some of Gill's new apprentices were public-school boys. David Kindersley's father was actually a stockbroker. Hew Lorimer's father was Sir Robert Lorimer, the most distinguished Scottish architect of his generation, friend of Raffalovich and Gray. Angus McDougall, son of the psychologist William McDougall, that advocate of the idealistic outlook, was far from being Gill's most brilliant apprentice but he is still remembered for the *élan* of his graffiti decoration of the Pigotts downstairs lavatory. Several of Gill's apprentices were not even Catholic. The religious life did not dominate the workshop as it had done at Ditchling, with the routine exodus from the workshops to the chapel. At Pigotts the religion was less obligatory. When the Angelus bell rang, work stopped for a few minutes and those who were inclined would say the prayer.

Donald Potter has described the mood and the routines of Pigotts at that period:

We started work about nine and Gill would usually come over to us an hour later after dictating his letters for Mary to write out in her neat script. He would look at our progress and pass comments, giving advice or allocating fresh work. After that he would retire either to his engraving room or to his carving workshop and unless we were helping him, we wouldn't see much of him until teatime when we would gather together in his workshop and eat Mary's wonderful home-made bread baked in a primitive oven. Tea finished, out would come his old Oxo tin full of tobacco, with EG engraved on the lid, and he would roll himself a cigarette and chat for a while, then we would return to work until about six o'clock.

Gill's relationship with pupils could be charmingly forthcoming: he

would sometimes invite Potter to come round in the evening with his cello, and together the master and apprentice would play Corelli sonatas, Gill on his tinkling spinet. But it had its backbone of authoritarianism. Gill had evolved a system, which he employed with pleasure, of summoning apprentices across the yard at Pigotts by means of a tin can with a string, a home-made bell pull: the number of pulls indicated whom he wanted. When addressing his apprentices Gill would use their Christian names but he expected them to stand up when he entered the room and call him 'Sir'.

The marvellous qualities of Gill as teacher are corroborated by Potter and by others. He taught more by example than words ('although', Potter adds sharply, 'we got plenty of those as well'). Gill taught just by knowing so well what he was doing:

We learnt to respect the nature of our materials and impart to our sculpture that firm, crisp, stone-like quality seen in the best periods of carving down the ages: he frequently quoted the carvings on Chartres Cathedral. He believed that art should be for a definite purpose – not just art for art's sake. He was also contemptuous of art schools, favouring rather the idea of students working in a Master's studio as in medieval and renaissance times. We, his pupils, were to copy and learn all he had to show us and then improve on it, or take what we needed.

Taking what they needed: this was the point of Pigotts. Although it is quite easy to accuse Gill of exploiting his pupils, this was not the way they saw it. There were few who did not feel they had gained inestimably from their time at Pigotts. Not just from the point of view of techniques but of ideas: the conversation flowing, the upturning of assumptions. For most of Gill's young pupils it was a crucial period of learning, of unravelling – their university.

Gill had another pupil, on and off, at Pigotts in the early 1930s. Prudence Pelham is the only female included in the long official list of Gill's 'Apprentices, Pupils or Assistants' compiled after his death by his devoted brother Evan. Gill was in theory opposed to the idea of women carving: he saw women more as weavers, like his daughter Petra. But he made an exception for Prudence Pelham. This was not so much because Lady Prudence was the daughter of the Earl of Chichester, though Eric was enough his father's son to have a touch of snobbery. Gill found Lady Prudence – whom he first encountered when he and Laurie went to Stanmer Park in Sussex to cut the joint memorial stone for her father and brother – stimulating and provocative as well as beautiful. She was

then eighteen. He encouraged her interest in art, sending her his essay 'The Future of Sculpture' (at this point she had just been making her first cast). He indoctrinated her into the mysteries of male anatomy; Eric Gill's was the first penis she had ever seen. She was a frequent visitor at the Pigotts of this period, sometimes staying for a week or two, working in the workshop alongside Gill's other pupils. They liked her and accepted her. She had that English aristocrat's informality. She responded easily to the unknown situation. This was one of the things Gill appreciated in her. He dedicated *Clothes* to her. Again there was an element of yearning in the contrast between Prudence Pelham, highly strung, witty and elegant, young woman of the workshop, and the much more solid, sensible and fertile women of Gill's domestic ménage. David Jones, who came to love her, has left a portrait of her which captures her elusive quality: the woman beautiful and barren. She touched extremes in Gill, and he felt protective towards her. In the last of her letters to Gill, written shortly before his death in 1940, she said: 'you've disentangled more muddles more humanly for me than anyone I know'. Prudence Pelham later married Guy Branch, who was killed in the war. She subsequently lived with the painter, Robert Buhler, changing her name by deed poll. She died young, leaving little work behind her. One has the impression she was one of the few women who, though fond of Gill, resisted him, and this was an attraction.

In 1932 Eric Gill went for the greatest train ride of his life: he went for a journey on the *Flying Scotsman*. He had lettered the name plate for the engine and after he had gone to King's Cross to affix it he was taken on a ride in the driver's cab, travelling as far as Grantham. The good child's reward indeed. Gill wrote an account of the journey for the *London and North Eastern Railway Magazine*. This must rate as one of his best pieces of writing: he always wrote best when least conscious of impressing, as in the more extended of his diary entries and his more informal and unconsidered letters. He was a born reporter, with his grasp of the essentials and his interest in detail, and travel stimulated him in much the way that sex did. He regarded both as wonderful extensions of experience, appreciating both the mechanics and the mindlessness, the way in which the spirit took over from the flesh. Gill's account of his train ride has the same great joyfulness as the account he sent to Mary of his first flight in an aeroplane (with Petra) from Hendon airfield a few years earlier:

It was glorious . . . bumping gently along the ground and then gradually getting

up speed and then rushing at a vast speed and then at last leaving the ground and flying is very much like fucking. xx

Gill was preoccupied around this time with another well-known traveller, Odysseus. He was carving a fifteen-foot bas-relief panel, *Odysseus Welcomed from the Sea by Nausicaa* for the lounge of the Midland in Morecambe, a hotel then owned by the London, Midland, & Scottish Railway. The commission came through Gill's friend, the architect Oliver Hill. The panel shows the (bearded) Odysseus being received by Nausicaa, while three female attendants stand behind her proffering a robe and wine and fruit. Underneath this festive scene is an inscription, 'There is hope thou may'st see thy friends'. Past critics have been caustic about this panel, and certainly it did not survive its transformation into a decorative motif used on the menu for the LMS dining cars. But with the recent revised appreciation of 1930s decor the panel has undergone a reassessment, and was indeed chosen as one of the key exhibits in the Hayward Gallery *Thirties* exhibition. It is, I think, Gill at his best: assured, lighthearted, very supple. And it shows him much in tune with the spirit of his age.

The Odysseus frieze raises the whole interesting question of Gill and modernism. How modernist *was* Gill? It is in some ways quite surprising to discover how many of his contacts of this period – Serge Chermayeff, Eric Mendelsohn, Maxwell Fry, for instance – belonged with that close-knit group of architect-designers considered at the time to be alarmingly progressive. In the early thirties Gill was at least partly in the avant-garde. The diary records that in 1933 he went to watch the Boat Race from Maxwell Fry's house in Hammersmith: the distance he had travelled from Cobden-Sanderson's Hammersmith to Maxwell Fry's is striking. That same year, on one of his frequent trips to Cambridge, he visited Finella, the house designed by Raymond McGrath for Mansfield Forbes, a young history don at Clare. Of all the new architecture of the period this building was the ultimate in rationality: a modern glass house. It made a strong impression on Gill, as Gill endeared himself to Mansfield Forbes:

He dresses in a long alpaca gown and looks exactly like a Tibetan priest. But he is so natural and whimsical despite the togs. Our ideas of glass sculpture, ie. tombs of warriors, with themselves laid out on top, excited him quite a lot.

Eric Gill visits Finella! It seems such a contradiction, the negation of so much that he believed in. And yet should one be surprised? He was after all one of the oldest of the rationalists. He had for long had his own

theories of reductionalism, functionalism, rational building, many of the deep-felt tenets of the modern movement. His whole idea of churches being places which chaps prayed in was not so far removed from the Le Corbusier concept of the house as a machine for living in. One might quite well claim that Gill had got there first – except that the Puritans anticipated *him*.

Chermayeff attempted to involve Gill in grand plans for an Académie Européenne Méditerranée, a sort of seaside Bauhaus on a site above a bay formed by Cap Nègre and the Pointe du Rossignol, half-way between Cannes and Marseilles. It was to be a school dedicated to the 'modern' (the quotation marks come from the prospectus). The directors were key names in 'modernity': H. Th. Wijdeveld and Eric Mendelsohn the architects; Amédée Ozenfant the painter. Paul Hindemith was to be in charge of music; Chermayeff interiors; and Gill typography. Gill designed the graphics for the leaflet on the school and he was no doubt disappointed when it foundered. He would certainly have found intoxicating prospects in the idea of a new and intellectually stimulating outpost, so many miles from Pigotts. Its ideas of the daily life for staff and students being 'regularly ordered and in common' were related to, if not suggested by, Gill's own ideas of artistic education; and there are Gill-like traces in the official justification of the choice of site. This was not just a question of nice weather. Says the AEM prospectus: 'the Mediterranean seaboard is the historical cradle and home of the principles of faith, law and order which are necessary for the evolution of a new classical unity'.

And yet Gill was too English – and probably too Catholic – for outright modernism. His approach to rationality was hedged around with tolerance, with quirkiness, with wistfulness, with humour, with inherited experience. He had this much in common with another much younger but equally English artist he encountered at this period. Eric Ravilious was also working on the Morecambe commission. There was an immediate compatibility. Ravilious shared Gill's delight in curiosities, the idiosyncratic passing scene, the small-town oddities, as well as his devotion to lettering: one thinks of Ravilious's Alphabet and Coronation mugs for Wedgwood. They had a common background, not perhaps co-incidental, of strict Nonconformist parents, and both had been brought up on the south coast, beside the pier. Ravilious's father kept his own young Eric, growing up in Eastbourne, in a state of constant terror in case he asked his friends on their visits to the household if they had been saved or if they cared to say a prayer with him. He seems to have gone

54 *Map of Europe* with lines radiating out from Le Lavandou. Wood-engraving, 1933, for prospectus of Académie Européenne Méditerranée.

further even than Arthur Tidman, having GOD IS LOVE written inside his hat.

While Gill was working on the frieze at Morecambe his own father was showing signs of dying. He had spent his past few years, after retiring from West Wittering, in an old men's home called Dormansland. Here he had been quite happy. There was built-in entertainment, for the home adjoined a racecourse: he went to the races while venting disapproval, enjoying himself doubly. His wife used to tell him he only really wanted to get to heaven to see the angels naked. One hopes he did.

Gill was at the Midland Hotel, working on the decoration of the staircase ceiling, the day he had the news of his father's death. He

travelled down to Brighton. His father, like his mother, was buried in the Extra-Mural Cemetery. The funeral was followed by the usual massive family tea party, this time in Brighton Pavilion Creamery. Eric's brother Max was there. These were the two brothers who had inherited most obviously their father's artistic gifts: MacDonald's career had in a way developed parallel to that of his more famous brother, since the days they had both lived in Lincoln's Inn. He too had a reputation as a letterer, had been a member of the War Graves Commission Committee and designed the standard headstone for the British Army dead of the First World War. He had specialized in decorative graphics. MacDonald Gill was the designer of the 'Wunderground' map for London Underground, and also later the painter of the murals in the dining saloons of the *Queen Mary* and the *Queen Elizabeth* transatlantic liners. Compared with Eric he operated on the artistic middle ground. He was the sort of artist his father understood. Moreover, he was married (though not happily) to the daughter of a canon, whom he left eventually for the daughter of Edward Johnston. Eric's father made it clear, from early days, that he would like it if Eric could be more ordinary, more like Max.

After the funeral, Gill hurried back to Morecambe. His life there was becoming more than usually *mouvementé*. He had met the woman who for the next few years was to fill the role vacated by Miss Bill, that of resident mistress, the lover in the house (or, as it turned out, the lover in the caravan down the garden at Pigotts). This was May Reeves. On the face of it Miss Reeves was a little unexpected both in background and appearance. She was the sister of a well-known Dominican, Father John-Baptist Reeves, a friend of Gill's since Ditchling and later editor of the *Catholic Herald*. She was in her thirties, presumed to be a virgin, a large woman with knock knees, very buxom, with nice trim ankles and neat slim waist. Gill of course enjoyed a contrast, and it has been suggested he responded to the challenge of her strictness of manner and her somewhat uncompromising countenance. He must have seen some hidden voluptuousness in her. With his connoisseur's eye he could appreciate the contours defined by the tightly-buttoned high-necked twinsets May Reeves wore habitually: she became one of his models for *Twenty-Five Nudes*. In the diary accounts of his visits while at Morecambe to the Reeves family home at Garstang, near Lancaster, he quickly switched attention from May's sister Annie, a less formidable character, to May herself. It was, the diary tells us, very largely a car courtship. 'To Garstang for night. May R. came in car to fetch me . . .' The car, for so long the object of Gill's invective, suddenly acquired a

much more rosy image. It was possibly the car rides with May Reeves which encouraged him, a couple of years later, to invest in a car of his own, a Ford four-seater, and even to design a car: Gill once designed the bodywork for a three-wheel vehicle for BSA.

From the middle of 1933, May Reeves became one of the fixtures of Gill's household. First of all she came and went at Pigotts, theoretically helping Gill to sort out all the woodblocks which had arrived at Pigotts from Waltham St Lawrence. (The Golden Cockerel by this time had been sold.) After that she was found employment up at Capel: the Gills kept on the monastery, which they had now purchased with a legacy from Mary's family, for holidays. May Reeves, who had trained as a teacher, opened a boarding school there with Betty, the Gills' daughter, as the matron. Eric Gill is himself listed in the prospectus as drawing instructor, while Petra offered tuition in spinning and weaving, and Father Bernard McElligott, the chaplain at Pigotts, gave classes in plainchant. The clothes list reflected Gill's own tastes in specifying four pairs of brown stockings ('red tops'), one black beret, one short velvet cord jacket (without collar), and three holland tunics with red belts.

When the Capel school closed down, having attracted too few pupils, May Reeves moved back to Pigotts and there she ran a day school for the children of the family and friends and neighbours. It was at this point that she moved into the caravan alongside the Gills' farmhouse. Her position in the household was then permanent, almost defined. She was known as 'Auntie May', and she was accepted rather in the manner of the old-time governess or nanny: on the outskirts of the family, the expert in her sphere. Her sexual role *vis-à-vis* Gill was also accepted by the family and by his inner circle. The rule of the harem in that stronghold of catholicism? Gill had by then manoeuvred himself into such a position of impregnability that no one, it seems, dared to put that question to him directly. His own need for, or at least his enjoyment of, two women on the premises, sometimes both in the same day or night, comes over graphically in his diary entries with their sexual sign language: one x for Mary, xx for May.

In 1933 Gill was corresponding with Frieda Lawrence, widow of D. H. Lawrence, who had died three years before. Gill had been a great admirer of Lawrence's. So much so that the day after his death mass had been offered for him in Pigotts chapel. Gill had made two wood-engravings based on *Lady Chatterley's Lover*, using himself as the model for Mellors. His own copy of the book has many annotations, and he generously lent it out to his apprentices. (Walter Ritchie, being handed

what purported to be a copy of *Grimm's Fairy Tales* discovered – with mixed feelings – that it was the unexpurgated *Lady Chatterley*.) Gill was impressed by Lawrence's formidable honesty, while deprecating his irreligion, and very early on in his period at Pigotts he had written a few pages of a pseudo-D. H. Lawrence novel of his own. He had introduced it with the statement:

This is not a novel in which a story is told or a dramatic situation developed or analysed. It is simply a putting into words of what is usually represented by asterisks.

It is notable that Gill and D. H. Lawrence, both such intrepid challengers of the conventions in the sphere of the sexual relations, were also both courageous, one might even say foolhardy, in their attempt to break through the boundaries between verbal and visual expressiveness: Lawrence, the writer, also took to painting as medium of expression; Gill, the artist-craftsman, also saw himself from time to time as the creative writer. Gill's judgement of Lawrence's art is not recorded, but Lawrence's view of Gill as writer was not flattering. His review of *Art-Nonsense* could hardly have been ruder:

Mr. Gill is not a born writer: he is crude and crass. Still less is he a born thinker, in the reasoning and argumentative sense of the word. He is again a crude and crass amateur: crass is the only word, maddening, like a tiresome uneducated workman arguing in a pub – 'argefying' would describe it better – and banging his fist.

This review, published posthumously, was the subject of the correspondence between Gill and Mrs Lawrence. Gill took Lawrence's criticisms humbly: 'I think he is probably right in most of his strictures. I am indeed an inept and amateurish preacher.' But he was glad that at least Lawrence had agreed with his basic proposition, which was the idea of the sacredness of *workmanship*: the perception that 'happy intense absorption' in any work, brought as near to perfection as possible, is a state of being with God. In their different ways, Lawrence and Gill both saw this. Workmanship was a truth they both knew well, from their experience. 'The men', wrote Lawrence, 'who have not known it have missed life itself.'

'The *men* who have not known it'; Gill and Lawrence of course shared another passionate idea, and this was the concept of *man* as the creator. Their Congregationalist background is important. Springing from their common upbringing in strata of society in which male/female roles were

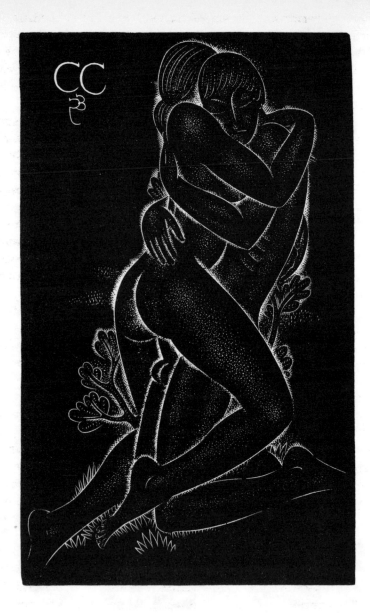

55 *Lady C.*, illustration (unused)
for D. H. Lawrence's book *Lady Chatterley's Lover*.
Wood-engraving, second state, 1931.

so definite and settled, their view of creativity tended to be phallic. In Gill such notions had been overlaid and also strengthened by accretions of catholicism, so that by middle life, conveniently dismissing his own wife's early training and practice in the crafts, he could arrogantly say, 'women have rarely been even mediocre artists'. For Gill, artists to be reckoned with were always male.

Gill's view of male and female, as advanced in *Clothes* and other writings of this period, was in some ways very set, authoritarian and traditionalist. He liked women to dress decorously, preferably in uniform: his ideal examples being nuns and nurses. (One notes from the diary that he and Mary saw the film *Mädchen in Uniform* in summer 1932.) Gill was very disapproving of provocative accessories: 'scents, paint, closely clothed hips and croups, a swaying walk, immense care of the face and hair, short skirts in the street, diaphanous clinging drapes in the evening, bare backs and chests'. In theory at least, Eric Gill went in for plainness in women. Men he allowed more licence. Whereas vanity in women was castigated as vicious – 'a sign of degredation [sic], a proof of departure from the divine plan, the fruit of irreligion and sexual abnormality and abandon' – Gill argued that vanity in men was to be much encouraged. With Gill, one subject always spills out into another, and his essays on dress (like his writings about chisels, like his diatribes on architecture, sunbathing and custard) tend to contain an entire Eric Gill philosophy. His little book called *Trousers and the Most Precious Ornament* is in fact a grand defence of male supremacy, a plea for the reconsideration of the penis, tucked away into men's trousers, 'all sideways, dishonoured, neglected, ridiculed and ridiculous – no longer the virile member'. The dishonoured penis was a terrible indictment of the world's lost potency, the onset of commercialization and destructiveness. In their craziness and funniness Gill's penis-power writings remind one of the cunt-power movement of the 1970s. This is Eric Gill in pursuit of Germaine Greer.

In *Clothes*, Eric Gill says what he thinks of contraception. He describes it as 'simply masturbation *à deux*'. He argues rather fiercely that when 'by means of contraceptive contrivances, a man and woman seek the same gratifications they make themselves homosexual and earn the same condemnation'. Homosexuality is 'the ultimate disrespect both to the human body and to human love'. It is a condemnation one might have expected to issue from the lips of Arthur Tidman Gill. All the more surprising then to find Gill at this period ensconced in an exchange of views and friendly interchanges – lunches and teas are recorded in the

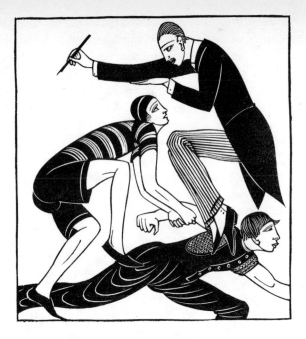

56 Wood-engravings for Eric Gill's *Clothes*, 1930.

diary – with one of the great pioneers of contraception, Marie Stopes's successor Dr Helena Wright.

In her day Helena Wright was a very famous figure, the author of *The Sex Factor in Marriage*, the doctor all progressive people went to in that period of earnestly experimental sex. She appears impressively, for instance, in Juliette Huxley's autobiography *Leaves of the Tulip Tree* dispensing good advice: 'Take a lover, and I will give you the contraceptive.' She was a remarkable woman in her early advocacy of the uses of sex therapy and in her insistence that her patients had a proper working knowledge of the male and female organs. In this dissemination of knowledge Eric Gill had, perhaps unknown to himself, assisted. Above her examination couch hung a Gill drawing, for demonstration purposes, showing the penis from the lateral view.

Gill met Dr Wright through her friend, and Gill's patron, Oliver Hill. Their arguments seem to have started instantaneously. 'All artists are self-centred,' wrote Helena Wright later, 'so he wasn't interested in my work – not very, but I was interested in him.' Their arguments were mainly about catholicism, virgin birth and papal supremacy. Gill's point of view, Dr Wright maintained, was emotionally biased and she felt that

Eric failed centrally in logic (a judgement his Dominican friends would have agreed with). Gill and Helena Wright had a good deal in common besides their shared interest in human sexuality: Dr Wright and her husband had been missionaries in China, so Gill's missionary background would have held no mysteries. But there were some very fundamental differences. They agreed quickly as friends that they would never agree.

How far was Gill's view of birth control affected by his faith, in particular by the worship of the Blessed Virgin Mary (or the BVM, as Gill and Father John O'Connor liked describing her)? What form of birth control did he himself espouse in practice? Some of the answers to these problematic questions are suggested in an interesting letter Gill wrote to Dr Wright in 1933, accusing her of having 'a rather exclusively hospital nurse point of view' of sex. Perhaps, he suggests wickedly, this is inevitable:

You don't seem to see or appreciate the essentially Rabelaisian quality of life. You're romantic. You don't sufficiently appreciate the difference between the psychology of the sex act in men and women.

You don't appreciate that sex act with contraception is the same as homosexuality. You don't seem to be aware that the control of *contraception by the woman* is essentially Matriarchy. If you are aware of this you don't say so. (Ask Mussolini!) Matriarchy is the (probably) inevitable conclusion of our Industrialised Commercialism. The two things (Industrialised Commercialism and Birth Control by the woman) are complementary. You are entitled to believe in and work for a matriarchal state. Men are equally entitled to resist it.

I believe in birth control by the man by means of:–
(1) Karetza.
(2) Abstinence from intercourse.
(3) Withdrawal before ejaculation.
(4) French letters.
I don't think 3 and 4 are good. I don't think abstinence from orgasm is necessarily a bad thing. It depends on the state of mind and states of mind can be cultivated. (Anyway there's no point in ejaculating seed into a woman who doesn't welcome it – they can jolly well go without, if they don't want our spunk they needn't have it.)

Let us talk about Matriarchy next time – and Commercialism.

It was, as one can see, a stimulating confrontation. And in spite of accusations and counter-accusations – Dr Wright in her turn infuriating Gill by suggesting he lacked technical knowledge in such areas – there was a point at which the two agreed significantly. This was in the view,

at the time extremely radical, that sex could be different things to different people, that sex was a means of increasing possibilities within a relationship not necessarily binding or long-lasting, and that this could be both beneficial and delightful. In a way Helena Wright made Gill's own behaviour respectable: she gave a kind of seal of approval to his dalliance, his instinctive liking for love without commitment. Gill failed to follow this through to its conclusion in that he could not envisage for his wife the sort of freedoms he himself was seeking. But in the diary one finds Gill acting out the tenets which Helena Wright would have so tenderly defended: a lightness and affection of sexual behaviour. One sees this for example when Gill stays with his agent, Cicely Marchant of the Goupil Gallery ('such a dear charming woman', Mary described her gallantly): Gill goes to her bed 'for a little while'. Gill would defend such moments as God's gift, so to be cherished. This mood of his comes over at its most specific in the diary description of a morning spent at Pigotts with Clare Leighton, sister of Ronald Leighton (lost fiancé of Vera Brittain) and herself a wood engraver:

Clare Leighton came in m. and I drew her portrait. We talked a lot about fucking and agreed how much we loved it. Afterwards we fondled one another a little and I put my penis between her legs. She then arranged herself so that when I pushed a little it went into her. I pushed it in about 6 times and then we kissed and went into lunch.

Gill was endlessly inquisitive about a woman's body. He spent a substantial proportion of his hours looking at the female form and drawing it. As he admitted freely, a little ostentatiously, sex was very often, almost always, on his mind. How was it then that Gill had so vague a comprehension of woman's sexuality? This was one of the traits Dr Wright found so dementing. Gill could and did look hard at women; but he could not make that leap of the imagination. In this, he could not get even as far as D. H. Lawrence: a deep instinctive shyness always seemed to hold him back. For Gill this inner reticence was, I think, the influence of the hell-fire sermons and the *double entendres* of his Nonconformist upbringing as much as, more recently, the BVM.

There is a revealing little passage in his memoirs, the childhood recollection of being taken on a visit to Aunt Sophie, a friend of his father's who lived somewhere near Blackheath. Gill remembered sitting up in Aunt Sophie's bed one morning while she had a bath in a hip bath in the middle of the room. He could remember everything 'except what she looked like'. There is that other passage, in which Gill so engagingly

acknowledges the influence of the unacknowledged: the secret thoughts of sex which punctuate the day's activities. 'Is it', he asks, 'the same with women, or are they mostly cold as fishes and as unconcerned and incurious, or only concerned as victims . . .?' At his age, with his experience, how did he fail to *know*?

In 1934, Eric Gill travelled to Jerusalem. He was by this time fifty-two, and this was the last of his revelation places. He claimed that it confirmed and enfolded all the others. Chichester, Lincoln's Inn, Salies-de-Béarn: all these had had their influence on Gill. But the influence of Gill's two short visits to the Holy Land in 1934 and 1937 was in a way profounder. There were things he absorbed from his visits to Jerusalem which altered his whole outlook. So much so that Gill's life can almost be divided into pre- and post-Jerusalem phases. Post-Jerusalem was characterized by an increasing sense of desperation with the world as man had made it, and a growing perception of himself as the Lord's chosen which induced a kind of carelessness in ordinary dealings. In Jerusalem, as he described it in histrionic terms, the language of his father, Eric Gill had seen 'as it were eye to eye, the sweating face of Christ'.

He had gone in the first place to Jerusalem to carry out carvings of a series of panels for the New Archaeological Museum. This commission came through his friend, Eric Mendelsohn, the architect, who practised in Jerusalem as well as London. The carvings have a ponderously academic emphasis, representing the various civilizations which have formed the cultures of the land of Palestine, from Canaan and Egypt to the Crusades. Gill, however, set out in his usual mood of holiday, travelling with Laurie Cribb on the SS *Rajputana*. They shared a cabin, described with Gill's habitual exactness:

Very nice little cabins. 2 bunks; L.C. on top. 2 wardrobes, 2 chests of drawers. Washing basin (cold only); lamps over bunks for reading, also little shelf for books, etc; electric heating stove.

The details of that visit are wonderfully vivid in *The Jerusalem Diary*, a series of extracts from Gill's letters edited by Mary and published in a small edition a few years after his death. The scenes of liner life. The train ride between Lydda and Jerusalem. The sights so achingly familiar to those who knew their Bible: the actual place where David killed Goliath! the birthplace of Samson on that hillside to the north! The sense of a homecoming in coming into Palestine is described by Gill most movingly. His language is that of the artist-as-reporter:

We are in Palestine – very near Jerusalem. It is as you would expect – two extremes meeting. Camels and mules and donkeys . . . And ancient and young men and women and children exactly as all the Bible pictures, and palms and orchards of orange and lemon and hedges made of cactus; and alongside, railways, electric power-stations, soldiers in khaki etc. At this moment passing men and camels ploughing field with lots of big stones in it dotted all over. But it is not a field, it is a whole countryside, no hedges or enclosure. Low bright green mountains beyond – higher brown ones behind.

He was so excited he burst out singing 'Jerusalem the Golden' in the train.

Gill found Jerusalem poignant in a way that nowhere had been before. This was partly a very simple childlike wonder that he too was walking where Christ had once walked. He felt this in a way which was immediate and intimate. It sharpened his own sense of past experience. The wilderness of Judaea, for example, took him back with a lurch of nostalgia to the barren heights around Capel-y-ffin. But the experience was also very positive. The sight of such extremes as could only be encountered in the holiest of cities – the sense of inner sanctity surrounded by crass commerce – made a highly emotional impact upon Gill. From now on he saw himself with a new conviction as on the side of the pure in heart, the peasants.

In Jerusalem he took to wearing Arab dress: a black and gold striped *galabea*, the long robe, which he wore with the traditional head cloth and black girdle. 'The head thing (*caphia*) is splendid for the sun – keeps it off your neck,' he told Mary, enclosing an explanatory snapshot. Coming upon a beggar woman near St Stephen's Gate, the gateway which leads out towards the Mount of Olives, Eric Gill was moved to kiss the ulcerated stump of the arm she was holding out beseechingly towards him. David Jones, who saw the scene from a distance, was impressed by this reaction to a bodily deformity from someone so preoccupied with physical perfection. The scene itself seemed biblical, anachronistic, marvellous. In 1934 chaps just did not behave like that.

For Gill, it was a time of more domestic afflictions. Mary had come out to Jerusalem to meet him, but the last two weeks of sightseeing were ruined by a raging toothache which first came upon him at the Mount of the Beatitudes, on a trip to Galilee. The tooth was removed but a painful abscess developed. He had to be given morphine on board ship. His first stop back in London was a visit to the dentist. Gill noted, 'excruciating scraping operation. Arr. home quite unnerved.'

There was much worse to come. David Pepler, Betty's husband, who

had been unwell when the Gills left for Jerusalem, was when they returned quite obviously dying. He had had cancer of the throat for several years: the warning sign had been his apparent mysterious allergy to Brazil nuts. It was partly because of his delicate health that he had been encouraged into farming. A few weeks after the Gills returned to England David Pepler died in hospital in Oxford. Gill travelled back to Pigotts in a lorry with the body. Father Bernard McElligott, the chaplain, met them at the chapel. There David's body was laid out.

After mass and requiem Eric Gill spent the next morning drawing David's portrait. It was a strange experience, coming so close on his visit to Jerusalem with its extremes of contrast between the new and old worlds, conservation and decay. In a throbbingly emotional yet physically precise passage in his memoirs Gill describes these hours he spent by David's body, capturing the likeness before it altered, vanished. It was, he wrote, a race between corruption and revelation:

On the one hand his spiritual form became more visible as its fleshly shape became more attenuate – on the other the disintegration which death of the body more precisely is became more and more woefully and nauseatingly imminent. I was not horrified, I was not even astonished; but it was difficult, thinking of the lips she had kissed, to keep back my tears.

Post-Jerusalem, from the mid-1930s onwards, there was a very obvious change of mood at Pigotts. Gill had come back from the Holy Land less optimistic than ever in his life. He had decided the only thing to do was to take up a position even more antagonistic to his contemporaries than that of 'a mere critic of the mechanistic system'. He realised he had to oppose the *very basis* of their civilization; and that this aggressiveness would have the effect of making him appear antagonistic even to the Church itself. It was a serious realization, which was bound to have its repercussions on Gill's cell of good living, on his home, his hearth, his family. There were still of course the scenes of Gill-like comedy, high spirits. Only a few days after the death of David Pepler, Gill encountered Evelyn Waugh at a conference in Laxton where the Dominican Fathers ran a boarding school. They shared a dormitory. Evelyn Waugh expressed amazement at the night clothes Gill appeared in. Such teasings would continue. But one has to see Gill's last few years at Pigotts against a background of deepening despair.

Despair took many forms. One was, paradoxically, an increase in home comforts. Gill sold out more and more to ordinary bourgeois values in a way which reminds one of that other English prophet of the

New Life, Edward Carpenter, living his last peaceful years in Guildford, Surrey. Compared with the 'bed full of fleas' which had been Capel, Pigotts was by the mid-thirties the lap of luxury. Those who had known the Gill regime at Ditchling were even more astonished by the Buckinghamshire scene. The garden was quite formal, up to good Home Counties standards: Mary Gill and her gardener went to the Chelsea Flower Show ('quite the proper thing,' wrote Eric, 'all the duchesses do it'). Charlie, the odd-job man, now also the chauffeur, would appear from time to time wearing a chauffeur's cap. For Peter Anson, whose typewriter had been so ridiculed at Ditchling, it was a little galling to arrive at Pigotts and find that Gill no longer looked askance at type-writers: 'an ever-growing correspondence', wrote Anson, 'had made it necessary for him to engage a private secretary and one heard her typing on the keys of "a writing machine" all day long'. As he described it, it was almost a production line: 'not only were there letters to be written or answered – there were books and articles and lectures waiting to be typed'. He was quite overcome by the glories of the bathroom with its black marble bath and its chrome-plated taps. (This bath, installed in 1932, is still in use at Pigotts. On the day of its arrival, the Gills took a joint bath in it. Eric liked the effect of white limbs on a black background.) Gill's old friends, needless to say, viewed these changes with mixed feelings. The response of the Dominican Tertiaries at Ditchling was particularly bitter. There, Eric was regarded very much as a Lost Leader: he had sold out to the Mammon of Unrighteousness.

It would be a mistake to see the middle years at Pigotts as a time of unrelenting gloom and tension. Much of the time it seemed a fresh and joyful period in which many of Gill's visions of the cell of good living – the overlap of bed and board, farm and workshop, home and school – came their closest to fruition. For the small Gill grandchildren growing up at Pigotts it was an almost ideal childhood: healthy, free, companionable. For Gill's pupils and apprentices it was a liberation. The cheerfulness of mood is perhaps epitomized by Anthony Foster singing 'Green grow the rushes-o!' and flinging his own urine, collected in a jam jar, from the window of his lodgings to fertilize his mushrooms. The urine of the stallion? Where else but at Pigotts? The memories of those who were with Gill at Pigotts are still almost overflowing with just this sort of scene.

The industriousness, the purposefulness, the central sense of holiness: all this deeply impressed the many visitors to Pigotts, visitors who came thronging up the hill on Sundays. (Mary would have to ring the bell for dinner to disperse them.) People came to regard Pigotts, as Ditchling had

been seen, as a place of refuge, a source of inspiration. The household of the Gills was still being compared with that of St Thomas More at Chelsea. It still appeared a haven of order and serenity. In the mid-1930s more than ever it seemed like a good deed in a terrifying world. The liturgical pattern of the seasons had a great immediacy in that gentle rural setting. In the beech woods, in one of the trees, Gill hung a crucifix, a wooden cross carved for him by Donald Potter. Around it arose a little Pigotts ritual: Gill would set out for a walk to it each day.

The Master by now had a new group of young men, semi-disciples. These were the *Order* boys, the radical small circle of young Thomists who contributed to *Order*, the occasional – and waspish – Catholic critical review which Tom Burns had founded. They were friends of René Hague's and belonged to his generation. They were the intellectual Catholic public-school boys, the more questing of the spirits produced by Stonyhurst, Ampleforth and Downside in the early 1920s, now on the edge of middle age.

Burns himself in particular and Harman Grisewood spent much time at Pigotts in this period. Gill's attraction for them was as a Catholic of stature, of an older generation, who was yet not afraid to question the Catholic autocracy: a rare combination in the Britain of the time. In the heated debates of the middle 1930s about whether Catholics should 'muck in' or withdraw from the political world to till their gardens, Gill's stance was of course particularly relevant: he was both an inspired mucker-in and mucker-out. They admired Gill's definiteness. His cast of mind, his breadth of viewpoint, his almost machine-gun logic: Eric Gill struck them as much more Continental than English in his attitude. Tom Burns and his friends allowed him to pontificate in the way which Gill enjoyed and indeed came to depend on. At Pigotts and at Blackfriars in Oxford, where Gill also had a number of admirers among the young Dominicans, the days were, once again, vigorous with argument. As it had been at Ditchling it was a two-way traffic: Pigotts to the Dominicans, Dominicans to Pigotts. In another of those beautiful and clear-cut Pigotts visions, Walter Ritchie, a new apprentice in the workshop, not a Catholic, remembers his amazement at twenty monks arriving from Blackfriars on bicycles one summer afternoon.

And yet there were anxieties. There were so many children growing up at Pigotts. Growing up so 'sweet and good', as their proud grandfather described them: 'Petra's four are truly lovely, and Joanie's two.' After David Pepler died, Betty went to live at Capel. Her daughters too resided at Pigotts in the term-time, swelling the ranks of Gill descendants in the

May Reeves schoolroom. By the end of the decade Gill had eleven grandchildren. The RAB – for Ragged Arse Brigade – René Hague called them. Additional children would come over from next door where another Catholic artist-craftsman, Joseph Nuttgens, lived and made stained glass (which Gill did not approve of). He too had a large family. To visitors the place seemed overrun with children. It became almost a cliché in every description of Pigotts at this period: the fruit trees were in blossom; lambs frolicked in the orchard; 'little naked children' tumbled about the lawn.

There was an irony in so much visible fecundity. Gill, in his memoirs, described the strong impression left on his imagination by being present at the birth of Petra. He had understood the pain that follows on from pleasure: the agony of childbirth from the wonder of the sex act. 'No one', he wrote, 'who has not witnessed the almost unbelievable transformation which parturition causes, and witnessed it with seeing eye, can know the truth about human love and sex.' At that time of Petra's birth he had been conscious of seeing, with the shock of revelation, the counterbalance of man's desire: 'It was not horrible; it was simply astonishing – that a thing so loved could be thus transformed.'

The extended, and still extending, family at Pigotts had this same ambivalence: it was both lovely and grotesque. If it was the ultimate and living demonstration of so many of Gill's theories of joyfulness and rightness, it had come to be a limitation on his freedom. These were all mouths to feed, families to be supported. The economies of all the households in the compound depended on the work which Eric Gill brought into it. 'Where are you going?' Adam Tegetmeier asked his grandfather one morning. He remembered the reply, 'To earn your bread and butter.' It was very hand-to-mouth: Gill's net profit for 1934 had been £1,124: for 1935, £921. In 1936, a year much improved by payments for the League of Nations sculpture in Geneva, it rose to £2,035. (These figures must be seen against the background of a time when an industrial worker's earnings averaged £150 per annum, and a three-bedroomed semi-detached house cost about £650.) By 1937 it was back to £933. It was not impossible, but there was very little leeway. The finances of the press were even more precarious, and Hague had to be bailed out by his father-in-law frequently. Gill did this generously, but financial dependence made a very uneasy situation for two sons-in-law who both, in their own right, had developed considerable talents: Hague as a subtle and scholarly translator (his translations of Teilhard de Chardin are especially impressive), Tegetmeier as a letterer, engraver

and cartoonist. Both were caught in a trap which had its comforts and convenience but which, from time to time, they both bitterly resented. Tegetmeier, in particular, made moves to get away and set up on his own, realizing that much of the work he did at Pigotts was run-of-the-mill. Petra encouraged a departure. But the force of Gill's personality was such that it tended to dominate all those around him. People lost their power to make decisions of their own.

The set-up at Pigotts had a certain claustrophobia. This is a theme developed by Elizabeth Taylor in her novel *The Wedding Group*, so clearly based on Pigotts. The conflict is between paternal authority and daughterly dependence: only one out of three daughters breaks away, and at some cost. The real-life scene *en famille* was described by Rayner Heppenstall, at that time a young man in search of a religion, whom Gill invited for a weekend at Pigotts in the spring of 1936. He arrived on the Saturday:

Tea was in the studio, at the back, beyond it the high shed. There were bedrooms above the studio. Mrs. Gill, a small, frail woman with spectacles atilt upon her nose, had briefly appeared and presently withdrawn. A girl brought in a tray. She, too, was small and wore spectacles. She was a happy smiler.

The next member of the community I met was Gordian, Gill's adopted son, a silent heavily built youth, on fire with pimples. Two Gill daughters lived with their husbands in the two cottages. They were Joan and Petra. Their husbands were René Hague and Denis Tegetmeier. Hague seemed to be in charge of the printing. Tegetmeier was a cartoonist. Hague and Joan were coming to dinner. Tegetmeier and Petra would look in afterwards.

There was also Father Bernard. Father Bernard had come from some monastery in the north, by way of a nervous breakdown and a sort of Catholic psychoanalyst. It was convenient for Gill, because it gave him a chaplain. Father Bernard was an authority on plainsong.

In the shed beyond the studio, an outsize Virgin and Child stood roughed out in stone. It had the familiar long, straight Gill lines, the naïve and tender gesticulation of hands and repose of feet, the medieval innocence of feature, the stylised folds of drapery, the suggestion of mere relief in what was nevertheless fully dimensioned sculpture.

'Man's proudest adornment,' said Gill, and touched part of the standing Christ-child above the Virgin's elongated hand on his thigh. 'After all, since in his physical nature he was every inch a man, Jesus must have had proper genitals.'

Reminded that he too was a man, my host led me out by a side door of the shed, to make water, as he said, in the broad light of day and to the greater glory of God. To perform this operation, Gill, wearing the short grey habit he judged appropriate to his membership of the Third Order of St. Dominic, had no fly-

buttons to deal with. Women, he considered, were unlucky. They had to squat down. At Ditchling, however, one old woman was said to be able to pee over the church wall. Gill had never seen her perform this feat, but had asked a local tradesman how she did it.

'Oh,' the tradesman had said, 'she has a trick of pinching herself like this.'

And my host demonstrated.

We returned through the studio proper, which was also the library and where the apparatus for wood engraving was laid out on a large, low table. It was dusk when we came to the chapel. This looked new. Everything was very plain and white. The only statue and the crucifix were already covered with pieces of purple cloth, it being the Saturday before Passion Sunday. The girl was standing on tip-toe, trimming, then lighting, the lamp. This would burn all night, a bubble of flame adrift upon a little sea of oil, which as the glass was pink, itself appeared rosily flushed.

We returned to the studio and were brought a jug of ale and three pewter tankards. Just before dinner, René Hague joined us, Joan having stayed in the dining-room with her mother. Hague was a tall, handsome, pale young man, with spectacles and wild black hair. He spoke rapidly and with vehemence.

At dinner, his vehemence was principally directed against Father Bernard, a white-haired but not at all aged priest, whose air was one of great benignity. René Hague's views were strongly anti-clerical. Indeed, he seemed to be rather against religion altogether. There was some talk of birth-control, a subject with which I had found young Catholics to be generally obsessed.

Joan was a small, fair, intelligent, attractive young woman, but she too wore spectacles. That made six people with spectacles, both the senior Gills, Father Bernard, Hague, Joan and the busy girl who now waited at table. The weakness of their eyesight was perhaps due to lamplight and wood smoke. Father Bernard said grace. Gordian, who did not wear spectacles, read aloud from what I suppose was Butler's *Lives of the Saints*.

Tegetmeier and Petra came in as the girl was serving coffee. Neither of these two wore spectacles. Nobody seemed much worried by Hague's vehemence. Every now and then, as it betrayed him into blasphemy or coarseness, he would stop and apologise.

'Sorry, Bernard,' he would snarl. 'Cloth and all that.' The Tegetmeiers did not stay long. As each of his daughters left him, Gill made a sign of the cross on her forehead with his thumb.

This somewhat malicious account has to be seen in its context as the retrospective work of a novelist and critic notoriously lacking in the milk of human kindness. (He was lacking in charity even towards himself: his journals, published recently under the title *The Master Eccentric*, reveal that he kept a phial of poison in his study, ready for an instant suicide when the mood took him.) His retrospective view of Pigotts was

affected by a deterioration of his friendship with the Gills once he had decided he would not become a Catholic: that, as he put it, his conversion was 'off'. Even so, it is revealing as an outsider's account of a family in which the cross-currents of relationship are certainly unusual. There is also the suggestion that Gill's once-so-shocking sexiness – the 'penis treatment' visitors to Pigotts came to call it – was by this time verging on the boring, the banal. Indeed the sight of Gill's male member, all too obviously visible to his young niece seeing him from floor level as he sprawled in his chair in the sitting room at Pigotts, put her off the whole idea of marriage.

In some ways Gill was suddenly becoming like an old man. In the way of old men he had come round to accepting, with only a token show of disapproval, the honours which once he would have swept aside. He was elected an Honorary Associate of the Institute of British Architects in 1935 and two years later became an Associate of a body he had scorned as that prime repository of Art-nonsense, the Royal Academy. Even more ironic was his inclusion in the list of the first eleven industrial designers to be awarded the Royal Society of Arts' insignia of Royal Designer for Industry – Eric Gill, who had once reviled both industry and monarchy. (Not that this had ever stopped him, one should perhaps remember, from designing coins and £1 notes and postage stamps. 'Plenty biz. no do!' he once told David Kindersley; 'No biz DO!' This was a rule he himself stuck to.) His election to the Royal Designers had a double irony since these were just the people he had jeered at since those old days at the Central School: the followers of Lethaby, the fuddy-duddies, tweedies, the boys who did not drink, the English gentleman designers. The early RDIs were Gill's old Arts and Crafts connections: J. H. Mason, Harold Stabler, the aged C. F. A. Voysey, Douglas Cockerell. Amongst the Royal Designers Gill only met his match in Edward Gordon Craig, the visionary stage designer: that other man of temperament, genius and tiresomeness, and indeed another worshipper of Isadora Duncan.

There is a wonderfully graphic illustration of the temperamental difference between Eric Gill and the designers of the mainstream English typographical tradition. This is the account by Reynolds Stone, the letterer and wood engraver, later almost the archetypal Royal Designer, of his first encounter with Eric Gill as a young man. They met in a train travelling to Cambridge. Stone had recently left the university and had become an unpaid trainee at Cambridge University Press. He much admired Gill's work and indeed had in his baggage four large sheets,

reproductions of Gill lettering, which he had just purchased at the Victoria and Albert Museum. Sitting opposite the Master, he unrolled these in the carriage. Gill was, not surprisingly, immediately friendly and they talked together all the way to Cambridge, mostly on the subject of Stanley Morison, described by Gill as perhaps his greatest friend. Reynolds Stone then spent a fortnight working with Gill at Pigotts. Gill's attitude to lettering excited and impressed him: one can see its influence on much of Stone's work later. Its precision, its composure, its *English-ness* is Gill-like. In many ways one thinks of Stone as Gill's closest disciple, in that English tradition of typographic reticence. It is symptomatic that they both excelled at bookplates. But their points of divergence are interesting too. There was something about Pigotts which Stone balked at. 'The atmosphere of work and worship', he wrote later, 'was very powerful and impressive and made the outside world seem banal and vulgar, but I know that I would have had to escape if anyone had asked me to stay.' He had glimpsed Gill's solemnity, and it had alarmed him. Gill seemed to Reynolds Stone a kind of Ancient Mariner, incredibly loquacious. Other Royal Designers felt a similar discomfort. They resented his impatience. They distrusted the abstractions, the religious-ness, the sex.

AIBA, ARA, RDI: did it matter? After the return from that first visit to Jerusalem, some things Gill used to think so important seemed irrelevant. He was much more careless about questions of consistency. Even Gill was less concerned about the dotting of the *i*s. He had altered his whole view about political activity. Where once he had argued, in a letter to Father Bede Jarrett dated 1926, that an artist 'is not a propagan-dist', he had come full circle to claim, nine years later, in his essay 'All Art is Propaganda', that no painter can paint a picture without being a propagandist for something. He maintained that 'no decent Catholic painter could paint a picture whose effect was to add another buttress to the bourgeois'. From the middle 1930s we find Gill heavily involved with the pacifist and left-wing arts groups: PAX, the Peace Pledge Union, the Artists' International, the Christian Arts Left Group. His name appears habitually, almost *ad infinitum*, in the lists of left-wing signa-tories to the protest letters in the correspondence columns. And increas-ingly, inevitably, one might almost say compulsively, Gill moved into more direct confrontation with the Church.

It was partly a habit of mind with him, of course. As Gill had always been interested in love so he had always been interested in the left. But perhaps these natural inclinations had been sharpened by his meetings

in Cambridge in the early thirties with the Russian physicist, Peter Kapitsa, protégé of Lord Rutherford, whose remarkable balancing act in carrying out his atomic experiments in Cambridge and conveying the results openly back home to Russia is so revealing of the mood prevailing in the England and especially the Cambridge of those years. Kapitsa was, as C. P. Snow described him, just the sort of personality that Eric Gill responded to: the star of the Cavendish, with a distinct touch of genius and also in those days, before life sobered him, 'a touch of the inspired Russian clown'. Kapitsa was Gill's contact for his carving of the seven-foot crocodile on the outside of the Mond Laboratory building. His name appears often in Gill's diary for that period. Gill stayed with him in Cambridge and went to the Zoo in London on Kapitsa's behalf to draw the real reptiles. The crocodile itself was Russian in its symbolism: 'the great unknown' in created things. Gill's own comment, in a letter to Douglas Cleverdon, was, 'What shd. we know of reptiles who only reptiles know?'

Whether or not publicity was agony, Gill was an unmissable figure on the leftist platforms of the thirties. Where the protestors congregated there was Gill, 'speaking in a light voice, with a dry wit, above his Biblical beard'. The mood of those gatherings is well suggested in a report in the *Catholic Herald*, 11 December 1936, under the heading 'Three-Cornered Debate: Gill v. Read v. West':

Catholic Craftsman Eric Gill; Surrealist and Critic Herbert Read, and Marxist Intellectual Alick West got together on the subject of Art and the Revolution at a meeting held last week by the Christian Arts Left Group in Watney Street, E. The meeting was held in Watney Street presumably to attract local inhabitants, but Bloomsbury and S.W.1 conspicuously filled the hall.

Although the speakers were not agreed upon what Art is, or upon what form revolution should take, they were unanimous in declaring that some revolution (nature decided by views of speaker) is not only necessary, but certain.

With three such brilliant dialectics, the atmosphere soon became (so to speak) thick with wit. Epigrammatic phrases poured out before the assembly: Gill taking out his anti-industrial theory for its daily exercise: Read, the most studied intellectual of the three, decrying the intellectual idea as the directing force of art and preaching the doctrine of natural expression, and Alick West working hard to forget his bourgeois upbringing in an effort to assimilate truly the Marxian theory, all made for an evening full of stimulating ideas of a highly controversial nature.

Here are some statements that alternatively aroused applause and objection from the critical gathering.

Eric Gill:

Art is another word for human work. Industry is the business of making things that other people want and are prepared to pay for.

The difference between art and industry lies in the fact that industry is interested in things made and art is interested in the making of things.

An artist is not a special kind of man, but every man is a special kind of artist.

For an artist, work is the end and pay just enables him to go on working. For a factory-hand, pay is the end and work just enables him to go on being paid.

Machines displace human labour rather than help it. They reduce the labourer to conditions of sub-human irresponsibility. They cause workmen to be workers.

I want to throw over these sub-human conditions, not for the sake of beauty (beauty can take care of herself) but for the sake of humanity.

Christianity is the only movement that endeavours to stop this landslide into servility.

After this Herbert Read weighed in with the comment 'I feel like a lion in a den of Christians', and a member of the audience, Mr Michael Trappes-Lomax, expressed his conviction that painted on the walls of every art school in the country should be the statement 'Beauty is rather a bore'.

The Catholic Church was once again in a dilemma. In his role of Catholic Artist, the Church saw Gill as a good thing, someone to be nurtured. He was a point of contact between the Romish minority in Britain and more mainstream art and culture, and his influence on younger Catholics was profound. But as a Catholic Artist in the company of Marxists, he was now becoming an increasing liability. Gill's support of the Republicans against Franco in the Spanish Civil War was not so controversial: it was a view shared by quite a number, though by no means a majority, of Catholics in Britain. But there were other issues on which Gill's views were opposed, often quite blatantly, to Catholic authority: in his support for outright pacifism, and in his scenario for workers' control of the means of production, which brought him very close to a Communist position. (It is notable that Gill's friend and client Stanley Morison was with him on the one issue, against him on the other: their exchange of correspondence, energetic and affectionate, in the late 1930s would merit publication by itself.)

The complaints came pouring in, as they had done before, at the time of the *Nuptials of God* furore. Only this time, they came from authorities still higher: even from the Archbishop of Westminster himself. Cardinal Hinsley's first communication was indirect, a tactful word of warning conveyed through his secretary, Monsignor Valentine Elwes, to Gill's

66 Y *Twympa, Nant Honduu* by David Jones. View up the Tump from Capel.
Pencil and watercolour, 1926.

67 Capel-y-ffin, the Gothic monastery and the ruins of Father Ignatius's church.

68 The family chapel at Capel-y-ffin, where Father Joseph Woodford celebrated mass.

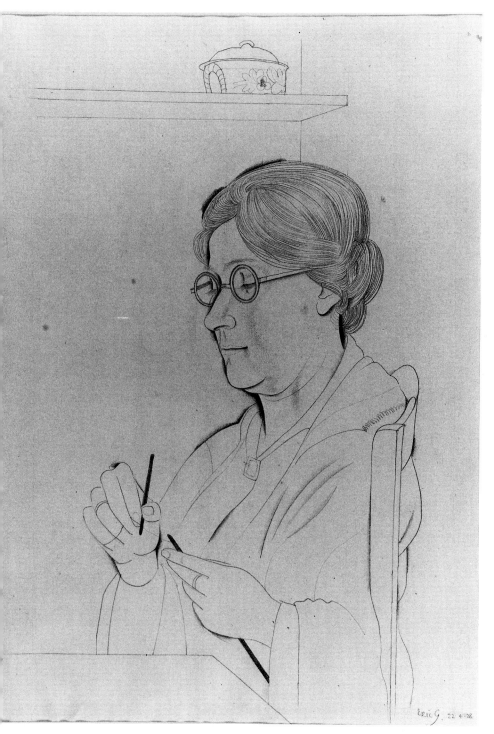

69 *Mary Gill Knitting*. Pencil drawing, 1928.

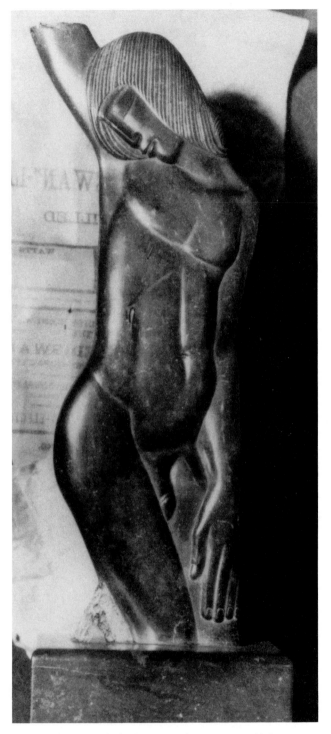

70 *Deposition*. Black Hoptonwood stone, 76 cm high, 1924.
Now at King's School, Canterbury.

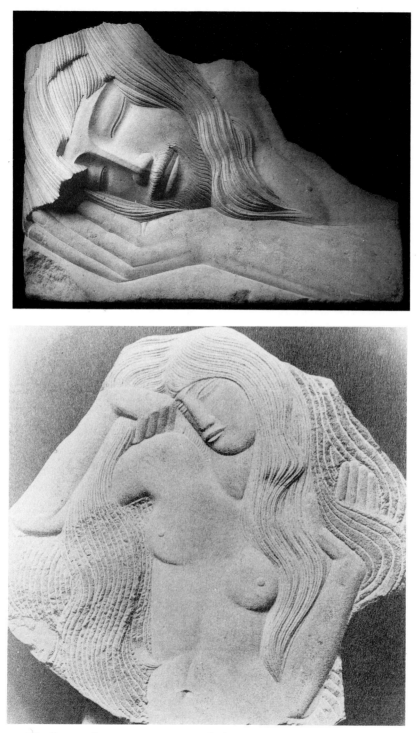

71 *The Sleeping Christ*. Caen stone, 30 cm high, 1925. Manchester City Art Galleries.

72 Carving of Girl. Capel-y-ffin stone, 15 cm high, 1925.

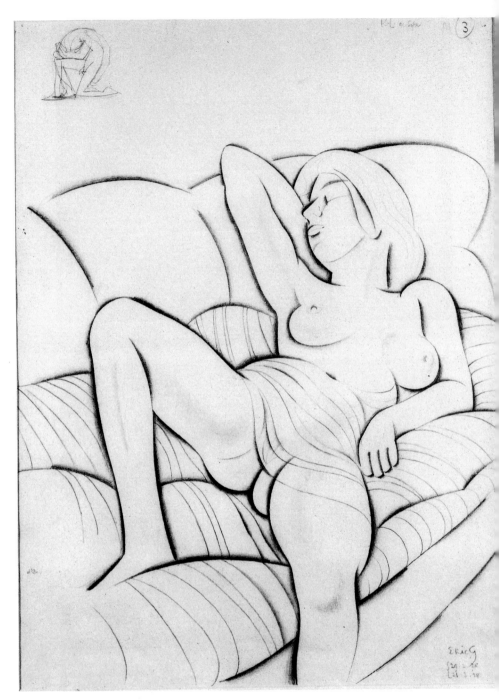

73 *K. L. on Sofa*. Pencil drawing, 1925–8.

74 *Douglas Cleverdon*, portrait by Methven Brownlee, 1924.

75 *Stanley Morison*, a detail of a portrait by William Rothenstein, reproduced in *Fleuron*.

76 Beatrice Warde in the early 1920s, shortly before her arrival in England from New York.

77 Robert Gibbings in the 'Library' of the Golden Cockerel Press at Waltham St Lawrence.

78 Fascia board painted for Douglas Cleverdon's bookshop
off Park Street in Bristol, 1926.

79 & 80 Gill Sans typeface for Monotype. Capitals alphabet, dated 1927,
lower-case alphabet, 1928, brush and ink.

81 Portrait of Eric Gill engraving, by Howard Coster, 1928.

82 Eric Gill in his workroom at Capel-y-ffin with Joseph Thorp, author of one of the first books on his sculpture. Photograph by Howard Coster.

16 To London, 9.5 fr. Chi. arr. 11.0
to Goupil Gallery. Lunch with W.M.
Met H.J.C. in n & saw him off at Victoria
To Enid's for the night at Wanstead.
Walk with Cecil after supper.

17 To London 9.0 to Goupil Gallery.
To Geo Friend re Copper pl. proofs.
to "G.K's" re shares etc. Bucks re Tools.
To Aston Webb's re Ballard's angels ✳
To B & O & Bumpus.
To Gray & Davison n Capel-y-ffin organ
To Newport 7.55 fr. Padd. (supper at Padd)
Slept at the Shaftesbury.

18 to Llanvihangel 9.50 S.T. fr N'port.
& walked thence to C-y-ff. arr. 2.30 off.
✳ (& Nfy took her dr. off....) Letters etc. till supper.
Confession 6.0

19 8 Mass & Comm" 8.0
Talking with 8.f. & R.H. & Nfy & reading.
Wrote out accomp.t for Asperges.
✳ Comp. & Ben" T.0

20 Up late.
Letters all m with dim Bill
X Carving Tr. Gray figure all n & on till 9.0

Note ✳ = face to face (on top)
 ✗ = sideways - generally from back.

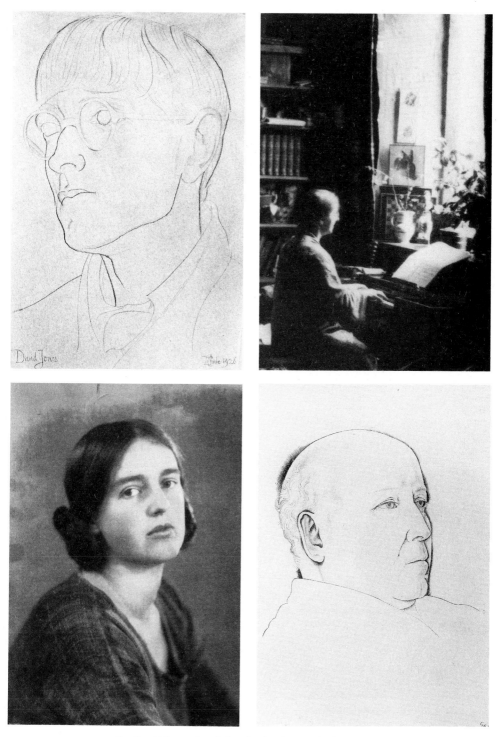

84 *David Jones*. Pencil drawing by Desmond Chute, 1926.

85 Mary Gill playing the clavichord in the sitting room at Capel.

86 *Petra*, portrait by Methven Brownlee, *c.* 1928.

87 *Father John O'Connor*. Pencil drawing, 1929.

88 The Gills in the garden at Capel-y-ffin. *l. to r. back:* David Jones; Petra; Teslin Cribb; Mary Gill; René Ansted, son of Elizabeth Bill, Gill's secretary; Eric Gill; René Hague. *front:* Joan, Gordian, Tommy Waters, Betty, Mary Gill's sister Vi Waters.

89 The Gills on the hillside at Capel-y-ffin. *left group* includes Betty, Mary Gill, Teslin Cribb, Joan. *Centre:* Eric Gill. *right group:* Petra, Gordian, David Jones.

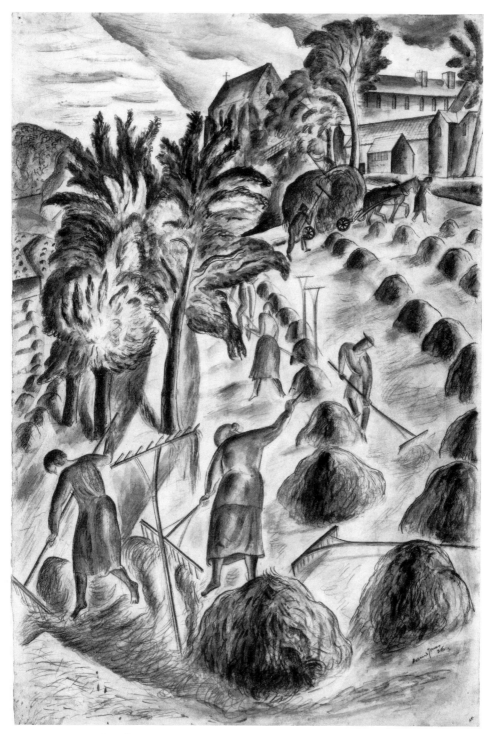

90 *Mr Gill's Hay Harvest* by David Jones, 1926. Watercolour and pencil.

91 Eric Gill with David Pepler and his daughter Betty, after their wedding in Brecon, 1927.

92 Eric Gill and Donald Attwater at Betty's wedding. Attwater is wearing a version of
the male attire recommended in Gill's *Clothes*.

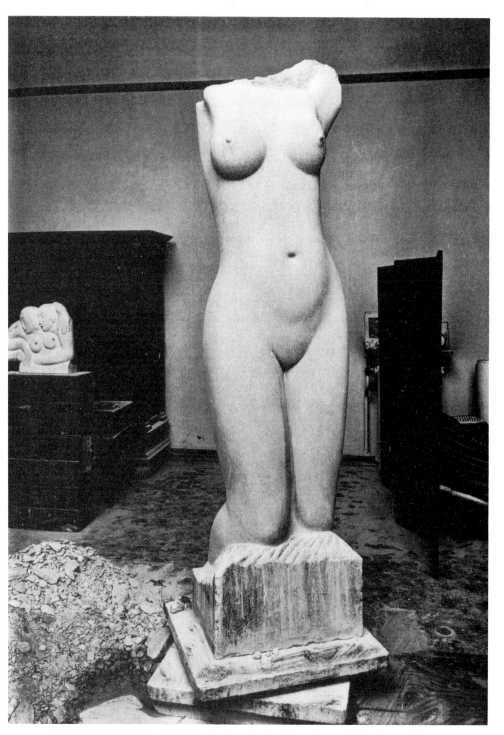

93 *Mankind in the Making*: Gill's *Mankind* carving in the studio in Glebe Place, Chelsea, 1928.
This photograph appeared in Joseph Thorp's book on Gill's sculpture.

94 View of Salies-de-Béarn.

95 Eric Gill as seen by a fellow-student in the life class, Paris, summer 1926.

96 *At Loustau's Salies-de-Béarn*. Pencil drawing, 1928.

97 *Villa Les Palmiers at Salies-de-Béarn*. Ink drawing, 1926.

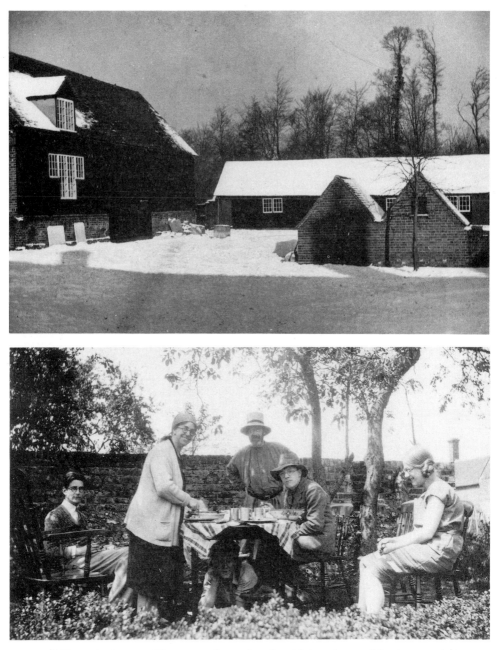

98 Pigotts in the snow. View across the quadrangle, with large barn to left, pig sty to right.

99 Tea in the garden at Pigotts, early 1930s. *l. to r.*: René Hague, Mary Gill, Eric Gill, David Jones, Joan Hague.

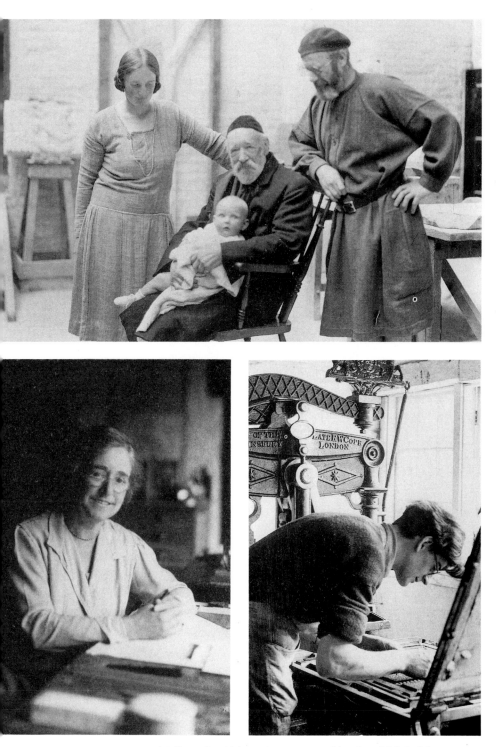

100 Four generations of Gills: Arthur Tidman, Eric, Petra and her first child, Judith Tegetmeier. Arthur Tidman was then in his mid eighties. He died in 1933.

101 Mary Gill at Pigotts, *c.* 1930.

102 René Hague at the Hague and Gill Press, late 1930s. Photograph by Howard Coster.

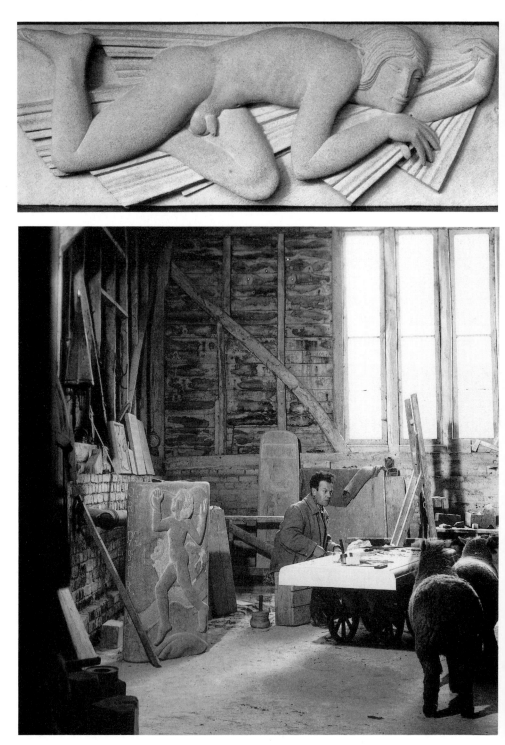

103 *The East Wind*. Portland stone, 25 x 30 cm, 1928.
Model for carving on west wing of St James's Park Underground Station. Tate Gallery.

104 Laurie Cribb with sheep, in the stone shop. Laurie, brother of Joseph, was Gill's
chief assistant at the Pigotts period. The carving on the left is by Walter Ritchie.

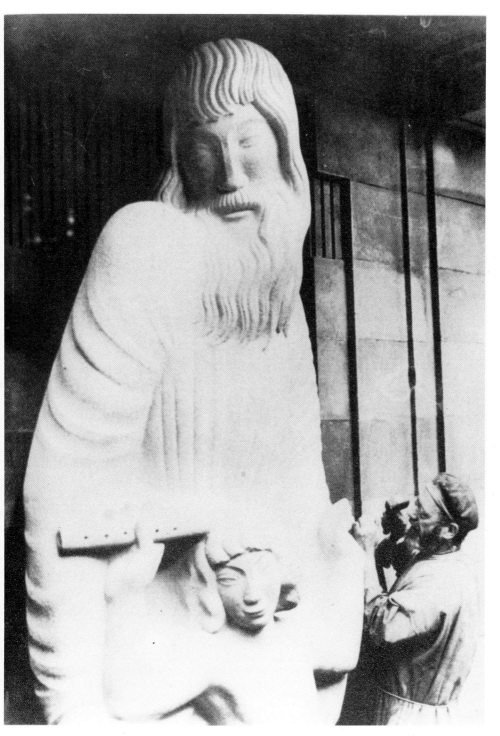

105 Gill working on the *Prospero and Ariel* carving at Broadcasting House, 1931.

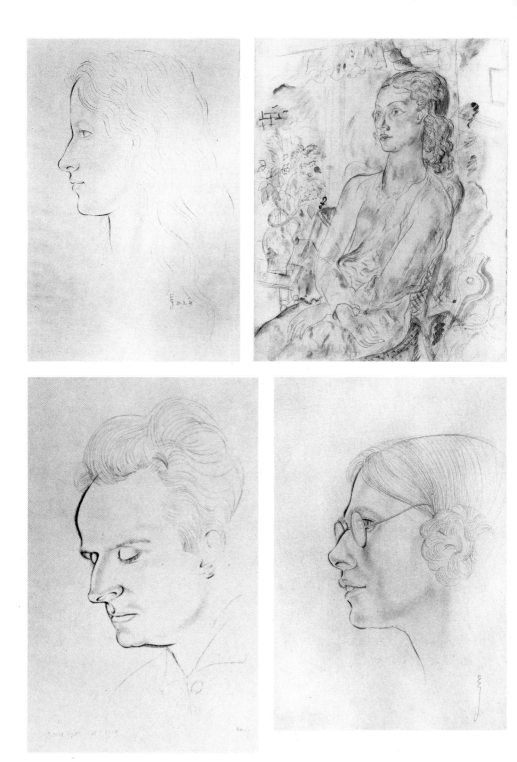

106 & 107 *Lady Prudence Pelham*. Pencil drawing by Eric Gill, 1938. Pencil and watercolour portrait by David Jones, 1930, at the time she was a pupil of Eric Gill's.

108 *David Pepler*, pencil drawing at his death, September 1934.

109 *Betty*, the artist's daughter, in 1939. Pencil drawing.

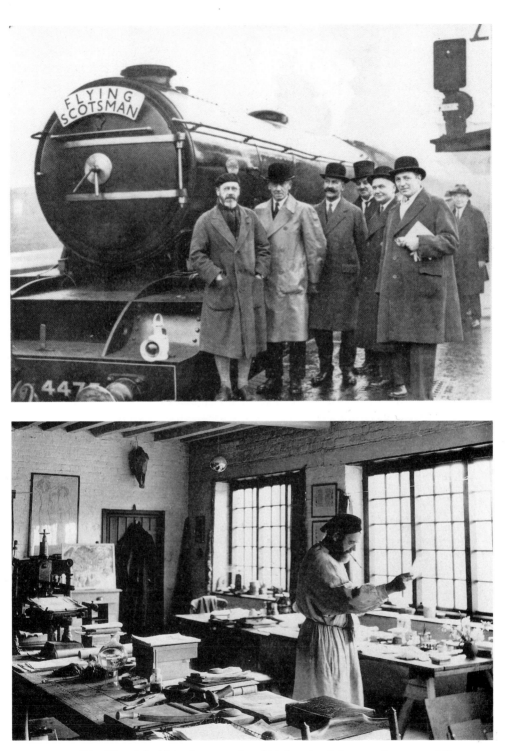

110 Eric Gill and the *Flying Scotsman*, for which he painted the nameplate, 1932. Gill Sans was adopted as the standard typeface for the London and North Eastern Railway.

111 Gill in the engraving shop at Pigotts, *c.* 1940. Photograph by Howard Coster.

112 May Reeves, the Pigotts schoolmistress, with her charges. These were mainly Gill grandchildren and children of Gill's neighbour, the stained-glass artist Joseph Nuttgens. Eric and Mary Gill to right of picture.

113 Family group at Pigotts. *back, l. to r.*: Joan, Betty, Gordian, Petra, Mary Gill with Charlotte Tegetmeier, nursemaid holding her own baby. *front:* second girl helper with six more Gill grandchildren.

24 . 9 . 37

Thank you very much for your picture card
too many irons in the fire — sculpturing, designs
I am most awfully jolly glad that you and
wanted for new stamps for postcards, lectures & god
the blessed infants are all enjoying yourselves
knows what all. And bills, bills, bills to pay.
so much and specially glad that young Rich'd
and the Secretary is away on holiday. a few more
likes the sea so much. All well here but
years shall roll a few more seasons pass......
am completely flummoxed with work — too
much love to you and all.
 E. G .

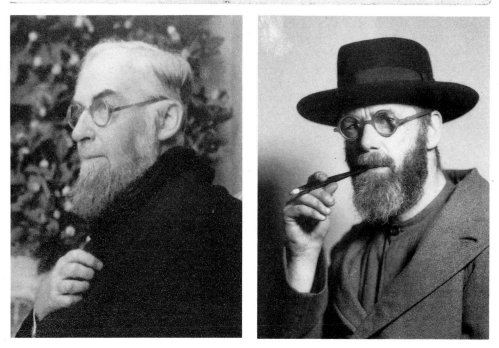

114 Distraught postcard to Joanna Hague from her father, September 1937.

115 Il Reverendo Desmond Chute in his Rapallo period.

116 Eric Gill in a black hat: another portrait by his friend Howard Coster.

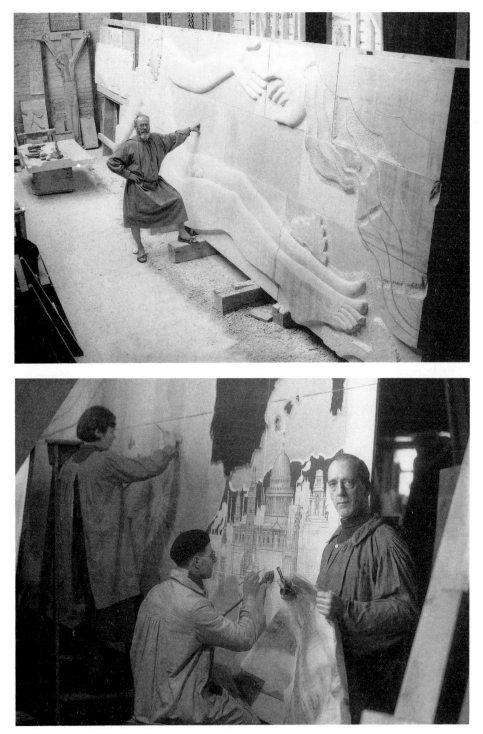

117 Gill's *Creation* sculpture for the League of Nations Building in Geneva, nearing completion in the Pigotts stone shop. Photograph by Howard Coster, 1937.

118 MacDonald Gill, Eric's brother, photographed in his studio by Howard Coster, 1930.

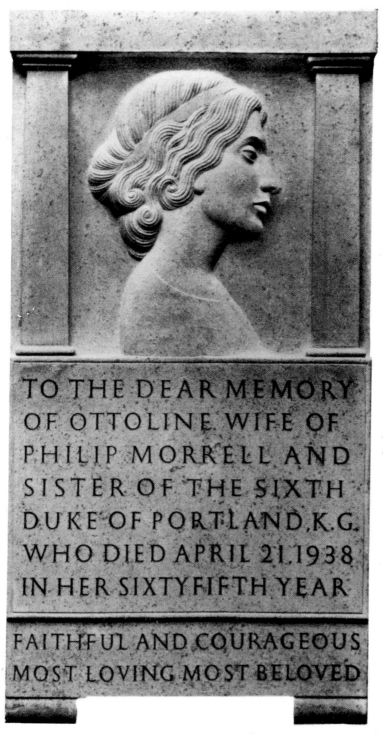

TO THE DEAR MEMORY
OF OTTOLINE WIFE OF
PHILIP MORRELL AND
SISTER OF THE SIXTH
DUKE OF PORTLAND K.G.
WHO DIED APRIL 21 1938
IN HER SIXTYFIFTH YEAR

FAITHFUL AND COURAGEOUS
MOST LOVING MOST BELOVED

119 Memorial tablet for Lady Ottoline Morrell. Hoptonwood stone, 1939.

120, 121 & 122 The church of St Peter the Apostle at Gorleston-on-Sea, Norfolk. Architect's drawing view from the south west. Pencil and watercolour, 1938. Interior showing Gill's proposal for the central altar. Pen and ink drawing, 1939. The interior photographed around 1970.

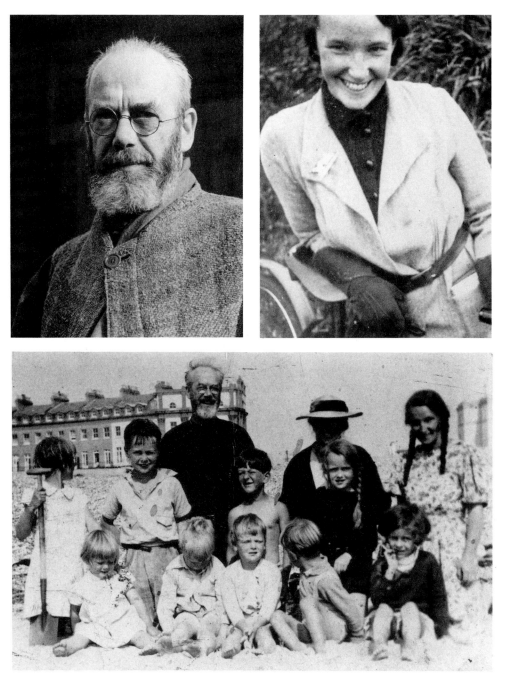

123 Eric Gill photographed at Pigotts by Claire Loewenthal in 1938.

124 Daisy Monica Hawkins at Pigotts in 1937, when she was twenty.

125 The Gills with their grandchildren, Hayling Island, September 1938. Daisy Hawkins, with plaits, on the far right of the picture.

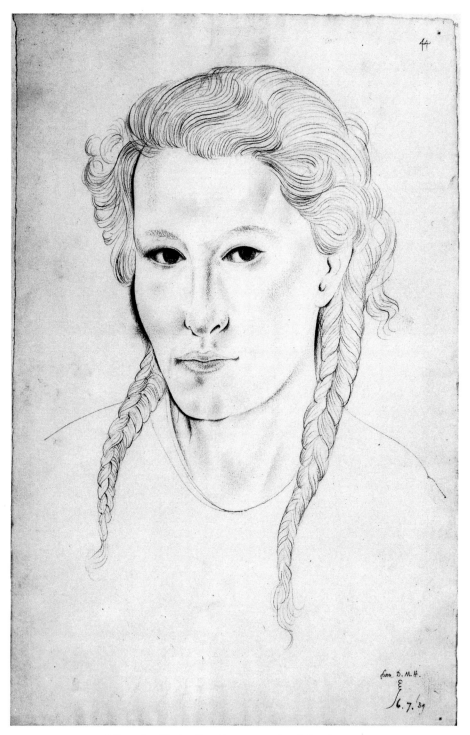

126 Portrait of *Daisy Hawkins*, no. 44. Pencil drawing, 1939.

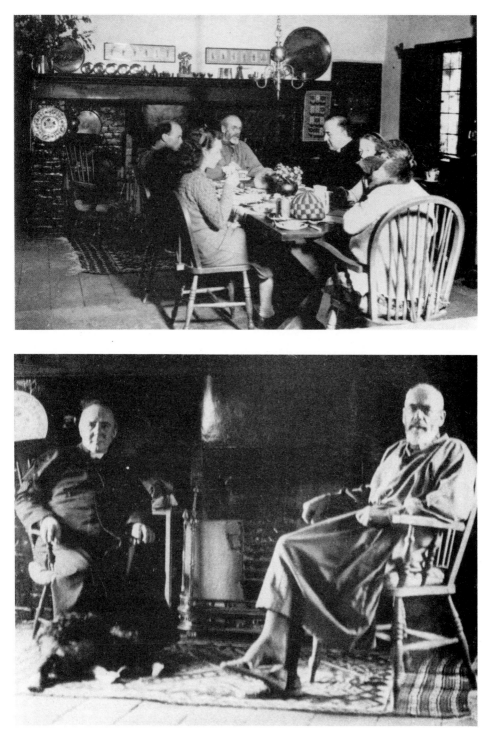

127 Tea in the kitchen at Pigotts. *l. to r.*: Hugo Yardley, Clemency Geddes, Eric Gill, Dr Flood the chaplain, Joan Hague, Mary Gill with cat.

128 Eric Gill and Dr Flood photographed for an article in the *Bystander*, 30 October 1940. The picture is captioned: 'Priest and sculptor sit in the warm afternoon sunlight in a setting whose cheerful simplicity and shining exact cleanliness are reminiscent of a Dutch-interior painting'.

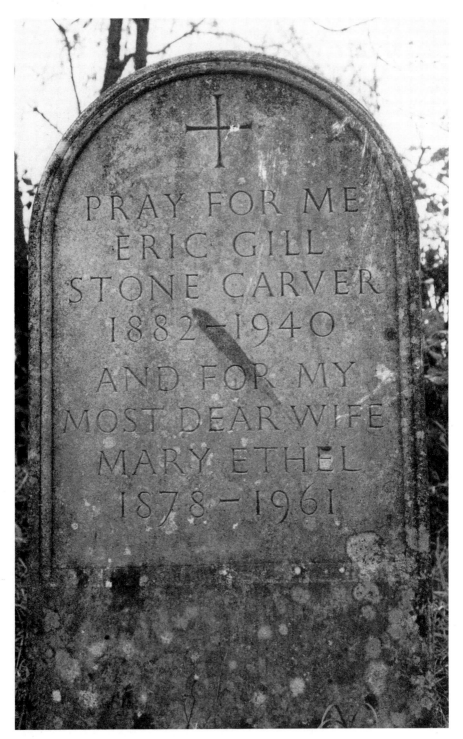

PRAY FOR ME
ERIC GILL
STONE CARVER
1882–1940
AND FOR MY
MOST DEAR WIFE
MARY ETHEL
1878–1961

129 Eric and Mary Gill's gravestone in the cemetery at Speen, 1940 and completed 1961. Gill designed the inscription himself and it was cut by Laurie Cribb.

chaplain, Father Bernard. He expressed his dismay that Gill's name was included in publicity for an exhibition of the leftist British Artists' Congress. He was 'very much shocked and distressed to find the name of as well known and highly esteemed Catholic as he on the title page of such a publication'. Gill pretended he was going to toe the line, but did not. Indeed, a petition of protest addressed to the archbishop two years later, against the bombing of Barcelona, is signed not just by Eric Gill but Mary too.

What especially infuriated Gill in the correspondence with Westminster was its conspiracy of superiority: the implication that Gill, a sophisticated person, should know better. The argument that it was dangerous to tamper with the faith of simple people was to Gill, by then, anathema. Since his return from Jerusalem Gill felt more convinced than ever that the weaker brethren were the very people one *ought* to influence.

In the middle and late thirties, through his all-art-is-propaganda period, Gill was working on the largest commission of his life: three huge panels in seventeen sections for the League of Nations building in Geneva, the British Government's gift to this great enterprise. The *Moneychangers* image was still much on his mind, and Gill had intended to provide an international, enlarged version of his Leeds carving. After all, as he insisted to the secretary-general, the League of Nations' primary function was 'the ridding of Europe and the World of the stranglehold of finance, both national and international'. When one American financial delegate objected that the installation of a *Moneychangers* sculpture would in fact represent the last and greatest hypocrisy of the British Empire, Gill changed tack with his usual agility. He wrote off to Anthony Eden, then Minister of State without Portfolio for League of Nations affairs, with the following (equally political) proposal:

Imagine the centre panel 28 ft. long and 7 ft. high, practically entirely filled with a naked figure of a man reclining (rather as in the picture of the Adam by Michael Angelo) a vast and grand figure of Man with hand outstretched and the tip of his finger touching the tip of the finger of God which is coming down from above, and in fine letters on the background, in Latin because it is a universal statement and not specially an English one, the words, 'AD IMAGINEM DEI CREAVIT ILLUM'. Because *that* is the point, Man was created in the image of God and it is *that* image which is being defaced and befouled.

The British consul in Geneva, Ronald Armstrong, wrote to tell Gill that Eden had been delighted with the scheme: 'He dined with us the day of the new King's succession and he spent a long time after dinner looking

at a pleasant quarto volume which I found at Bumpus' shop dealing with you and your work with some good illustrations.' One cannot help thinking how Rose Gill would have been pleased.

The *Creation* panels have all the faults of Gill's large-scale public sculptures. They are overwrought and ponderous, they have a certain deadness. In a way they make one long for Gill's very small-scale, domestic carvings: the Madonnas, crucifixes and the little Divine Lovers of the Ditchling period; the spontaneous, intimate, almost toy-like sculptures such as the tiny sea-maiden Gill once carved at Capel. But seen as a public sculpture, in the context of the general run of monumental murals in the Europe of the thirties, one feels more than ever grateful for Gill's quality of *seriousness*. Was he also being serious when, at a cocktail party given by the consul in Geneva to inaugurate the building, he knelt down on the carpet and said quietly, 'I thank God for the delicious gin'?

Gill's life at this time was what in later days would be defined as stressful. It was not just a question of the volume of his work, though even this could well have been daunting to a man a great deal stronger. It was also the division of his concentration, the switching of his mind from one thing to another: the letters, the speeches, the meetings; all the travelling. More work than ever was being done on the train. Gill's London case (now in the Gill collection at Chichester) was kept ready packed, like a doctor's bag, at Pigotts: in it would be such things as a comb, a pair of scissors, a reader's ticket for the British Museum, a long appointments list and job list for the metropolis as well as his ticket to Marylebone Station.

Sometimes days were too crowded to include the things which mattered. In 1935 Elizabeth Bill (as Eric Gill still called her) died of a perforated duodenal ulcer. Gill hurried up to London after a busy morning in Oxford spent fixing John Galsworthy's memorial tablet in the cloisters at New College. His train got in to Paddington at 1.47. But, as he noted sadly in the diary, 'too late to go to Eliz. B's funeral'.

He was far from well himself. In autumn 1936 he was ill off and on for six weeks with bronchitis and congestion of the lung. When Post Office officials came to discuss designs for the stamps for George VI's coronation, Gill received them in his bed. It was only gradually that he was able to get downstairs for tea or a small wander round the workshops. Even after he was back to full-time work, he continued to be chesty. A contemporary photograph by Howard Coster shows him wearing a protective scarf, which Petra wove him. He was in that vicious circle, too worried to get better. Anxieties dominated his letters of this period

to friends and relations. Worries about his workload; worries about money. Though still in his mid-fifties he was now appearing older. He was more aware than ever how the edifice of Pigotts – family, farm, workshops – depended on his health.

In December of that year, he and Mary spent a few weeks in Rapallo, staying with Desmond Chute. Walter Shewring joined them there. This was a total change of scene, exactly what Gill needed. 'Arr. Rapallo 3.15.' he entered in the diary, 'lunch in train at Turin. Found Desmond well and comfortable in charming Villa San Raffaele. Slept early and well.'

In an article entitled 'Il Reverendo Desmond Chute e la Rapallo culturale di anteguerra', a local acquaintance, Professor Pietro Berri, gives an account of the singular regime at San Raffaele. It was very unlike Pigotts:

To be seen lately at Rapallo was the figure of a priest, tall, but of wan complexion, with a beard at one time golden, but gradually streaked with grey, always sporting dark glasses for the greater protection of his sight, or an eyeshade . . . and invariably with a purse in his hand . . . For some years a painful illness – which did not in any way dim his intellect – confined him to his house, except for occasional car-trips in the neighbourhood of Rapallo. He spent most of his time in his comfortable villa, which was filled with books and musical scores, the piano always open, lavish with fine furniture and valuable works of art, in a permanent state of semi-darkness, striving to protect his weak eyes from the least reflection of sunlight . . .

His distinguished manners, his elegant style of speech, his refinement of dress and person, the gentlemanly ease with which he moved in eclectic cosmopolitan circles, the style and discernment of his conversation, his unfailing interest in all things musical, his wide knowledge of things intellectual – all these call to mind the salon of the Abbé Liszt; he too had his bevies of adoring ladies, and his ever-worshipping disciples. These, his art, and especially his music, fully occupied those parts of his days not dedicated to his priestly duties or to his charitable undertakings. He was an aesthete in the purest sense of the word, whose every gesture revealed a rare fastidiousness, not always concealed behind an unexpected shyness.

Unlike Pigotts in some ways; yet there was rapport between them. There was a sense in which the rarefied life of Rapallo – only partly exaggerated by the professor – supplied some of the elements absent, and missed, at Pigotts, much as Desmond Chute, most beloved of Gill's friends, might also be regarded as his kind of *alter ego*. What Rapallo supplied were things beyond the bounds of possibility in the domestic and workshop

hurly-burly of Pigotts. Desmond had arrived at a condition Gill still envied: an isolation, a remoteness, a repose. But then Desmond was single; and also single-minded. His life had a decisiveness which Gill would never emulate. The celibate? The patriarch? The eremite? The publicist? Gill still kept the options open for his preferred extremes of living, at whatever cost.

In Gill's last few years that visit to Rapallo appears like a little interval of bliss. The party took walks up from the town to Portofino Vetta, enjoying the double view to Genoa and to La Spezia. A few days before Christmas, Gill was reading G. K. Chesterton's *Autobiography*, sitting in a café on the front. Desmond introduced him to Ezra Pound: a meeting which was stimulating, if not an absolute success, since Pound had drawn the inference that Gill's belief in monetary reform made him a Fascist. Gill in vain tried to explain that this was not the case. Pound's mistress, Olga Rudge, came down to San Raffaele to play the violin. With Desmond Chute at the piano, there was Mozart and Pergolesi in the evenings. Eric Gill and Mary did a lot of love-making (once Gill had recovered from a slight recurrence of his illness). They travelled back to England via Paris where Gill undertook a programme all too reminiscent of the visits to Paris in the twenties with the Gibbingses. He deposited Mary at their hotel, went to 'a dance place called the Sphinx which would be exactly like "a pub in Paradise" if it were not for original sin', and stayed up very late drinking and talking with two 'nice girls'. He arrived back in London the next day at 4 p.m., discovering to his horror that the lecture he had thought he was giving at 4.30 had in fact been two hours earlier. 'The bulk of the audience', he wrote with satisfaction, 'had done me the honour to wait! Well, well, some weekend,' he writes with happiness to Desmond. He was home feeling quite well again. Pigotts once more seemed idyllic: 'All well here and the children blooming like a Perkins rambler *in lateribus*.'

But Gill was becoming accident-prone. He had only been back at Pigotts a few weeks when he fell off the trestle, working on the League of Nations carving, and broke the tenth rib on his left side. Again, he was restored by a holiday abroad, an interlude in Palestine and Egypt, financed by Graham Carey, his American supporter. A visit to the Pyramids particularly thrilled him:

I did go and see the great Pyramid! and went up and into its middle! Nought but exclamation marks will convey to you its amazing and marvellous mad grandeur! Did you like the Pyramids? Not half!

But although Gill again seemed to make a reasonable recovery, from then on various symptoms occur at frequent intervals. In the May of the next year Gill noted he had lost his memory for an hour and a half one evening.

For years past he had been preoccupied with thoughts of death. In 1936, with a terrifying echo of *The Duchess of Malfi* ('And thou com'st to make my tombe?'), Gill had even gone so far as to design himself a gravestone. Donald Potter carved the lettering, and it was included in a London exhibition. The stone conveyed the message:

REMEMBER ME

ERIC GILL

LAPIDARI

Then the bleak words HEU MIHI: 'Woe is me'. The inscription implied that he would die at fifty-four. Gill later laughed it off: 'About that tombstone in memory of e.g. aged 54 – don't worry,' he wrote to Graham Carey. He explained that he was asked to do a specimen tombstone so he did one for himself: 'it might come in useful one day and the age can be altered'. His reason, he said, for choosing fifty-four was that it seemed a very good age to die at. He did not, as it turned out, die at fifty-four. But the portraits of Gill at this period remind one of how frail he was, how aged. He does, at times, look almost deathlike, an impression most marked in the many Pigotts pictures of the Gills *en famille*, crowded out with healthy children.

But Gill always surprises. Late in life, ill, at his least resilient, he embarked on two important episodes which might have daunted a person ten years younger. The first was a building of his own design which was in effect his début as an architect: St Peter's Church at Gorleston-on-Sea in Norfolk. The second was the love affair with Daisy Hawkins, which was the most consuming of Gill's several loves.

It seems most surprising that Gill was in his fifties before he had the chance to design an actual building. So many of his theories were theories of building. Moreover, as he wrote to tell the Bishop of Northampton, defending his decision to design the building around a central altar, he had been 'a working builder' for one and a half years. (This presumably referred to his works on Ditchling Common.) This very belated architectural commission reached Gill through his neighbour, Joseph Nuttgens, a friend of the priest at Gorleston. Gill seized on the project as a long-awaited opportunity to put into practice a multitude of related ideas

about building, preaching, singing, church history, world politics, all burgeoning out from the elementary question, 'What *is* a church?'

Gill had in fact answered that question already with his statement that a church is merely a canopy over an altar. He elaborated it in relation to Gorleston by claiming that the mass is not a Queen's Hall concert. Gill's essay 'Mass for the Masses', published in the year that Gorleston was finished, emphasizes his view of the crucial importance of bringing 'the reality of the Mass' back to the people.

He reiterated his ideas in a long letter to the priest at Gorleston which accompanied his drawings for the building. Gill argued that the 'mysterious' side of religious practice had perhaps been exaggerated at the expense of the evangelical or apostolic side: 'It is of course actually impossible to exaggerate the mysteriousness, but it is easily possible to under-do the evangelical; and one of the ways in which the loss of contact is most apparent is the tradition which has grown up and placed the altar away from the people at the East end of the church.' His proposal was to resite the altar in the *middle* of the building, so that not only during the celebration but also during communion the people would gather round the communal table. It is interesting to see Gill in action exerting his utmost powers of persuasion on the slightly nervous Father Thomas Walker, telling him that by agreeing to Gill's schemes for the centralization of the altar he will be taking part in 'a great movement for the re-evangelisation of the people'.

This was a radical theory in its day, though already implemented by Father John O'Connor in the new church of the First Martyrs in Bradford. It was a belief which had obvious connections with Gill's current workers'-control principles, and it is a striking anticipation of more modern arguments for the resiting of the altar – views now familiar through Vatican II, Catholic biblicism, the *laos*, ecumenism even. Gill had put his theories into practice before Gorleston, in his redesign of the chapel at Blundell's School in Tiverton. Here the boys shifted the altar to the middle of the chancel and, under his direction, carved the four stone sides of it with their own designs, set in concentric circles. The headmaster, Neville Gorton, wrote of Gill that it was because he was profoundly orthodox that he was fundamentally revolutionary: 'Because he loved the ecclesia he believed in axes and hammers in the House of God.'

The church at Gorleston makes one wish that Gill had had more opportunities in architecture. A plain and rather countrified brick building rises arched and barn-like around the central altar. The interior

is painted white. The art is the antithesis of the pompous, complicated 'repository art' Gill so much hated: it is direct, naïve, childlike, like the Ditchling Spoil Bank cross. Denis Tegetmeier painted the large crucifix and also the later Stations of the Cross which are hung round the walls like nursery pictures. As with so much of Gill's work, St Peter's Church at Gorleston is stylistically difficult to categorize. It lies somewhere between Arts and Crafts and rationalist. The nearest parallels are perhaps the visionary-ruralist church by W. R. Lethaby, All Saints', Brockhampton, in Herefordshire; or the Scandinavian-modern churches of the 1950s.

His old mentor Lethaby would indeed have had much sympathy with Gill's view of the Gothic, as expressed in a long postscript to the priest at Gorleston:

Many people rightly think it is absurd to build in the Gothic manner in the 20th century, but this opinion is only right in so much as it refers to imitation mediaeval ornaments; for as a method of building construction – apart from ornaments – nothing is more rational and scientific than Gothic. The pointed arch actually is stronger than the rounded one, unless you go in for iron girders or ferro-concrete.

With Gill's view of modern Gothic it is tempting to speculate about what he might have built in 1910 or 1920.

Perhaps one has to see Gill as the classic late developer, coming late in life to love as to architectural practice. It is certainly bizarre to find the man whose views on morals had been in public circulation for a decade behaving, when well into his fifties, as if he had never been in love before. The affair with Daisy Hawkins, coming as it did at the end of his life, was somehow that much more intense. It was the culmination of so much of Gill's past history. The emotion which surrounded it poured out not just into Gill's diaries and other writings of the period, but into a whole new and vivid sequence of drawings of the female figure. These were later published in two volumes, *Twenty-Five Nudes* and *Drawings from Life*.

Daisy had almost always been a part of the Gill ménage. She and her mother had first known the Gills at Ditchling, where Mrs Hawkins took in village dressmaking. She and Daisy had been gradually absorbed into the household. Mrs Hawkins – known as Hawkie – seemed most strait-laced and conventional, but Daisy in fact was illegitimate. Mrs Hawkins liked to claim that Daisy's father had been killed in the war. He had been killed in wartime, as he strolled down Piccadilly. Daisy, the only child,

had been sent to school in Brighton. She went to a convent, perhaps through the Gills' influence. Her mother was not Catholic, but Daisy was received into the Catholic Church when she was twelve. When the Gills moved to Pigotts, Daisy and Mrs Hawkins moved with them. They lived in the Big House and were in a way considered a part of the family, as is made clear in an affectionate message sent back home to Pigotts from Eric in Jerusalem: 'give my love to J, P, B, G, R, D, DJ, J, P, M, Mrs. H, D, CF, and Donald P'. At the same time they were servants: Mrs Hawkins and her daughter waited on the Gills at table. To Gill, this ambiguity was part of her attractiveness.

The image of the servant girl had always been a favourite. After Lizzie in Hammersmith there had been the Ditchling nursemaids: first Mabel Cherriman, then Agnes Weller. Gill had drawn these teenage girls with some of the same tenderness which he had lavished on the drawings of his daughters at a comparable stage. Daisy was sixteen when she first went to live at Pigotts. Her status in the household, a delicate mixture of the skivvy and the daughter, was tremendously appealing. Gill's feelings on the subject are suggested in another little passage from the *Jerusalem Diary*. He describes a visit to an Arab household near the Holy Sepulchre:

All very clean and tidy and beautiful and fresh and cool and comfortable. We sat down on a long settee against one wall and had cigarettes and presently one of the sisters came in with a tray and glasses of lemonade. Nice girl about 15, dressed as nuns dress girls in blue serge with white collar and two plaits of hair.

The plaits, the semi-uniform, the attitude of service: the sister in Jerusalem had been a Daisy too.

Daisy seems to have been more than usually attractive. At Pigotts she had had a number of proposals, although she used to joke that she only had to start to knit a pullover for the current boy-friend to call the whole thing off. (Later on she would refuse to knit jerseys for her husband.) She had lost her virginity to someone in Gill's workshop. She refused to say to whom, but it seems likely from the evidence of those at Pigotts at the time to have been John Sharpe, the boy from Borstal whom Gill had so misguidedly taken on as an apprentice in 1936. Gill, when told, had been roused to a proprietorial fury. This may have been what moved him to assert his rights in Daisy. On 11 January 1937 there is a startling entry in Gill's diary: 'made promise with DH in chapel'. It seems to have been a kind of betrothal. Sanctified. Secret. By now Daisy was nineteen.

Gill's affair with Daisy Hawkins continued for two years. It is

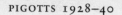

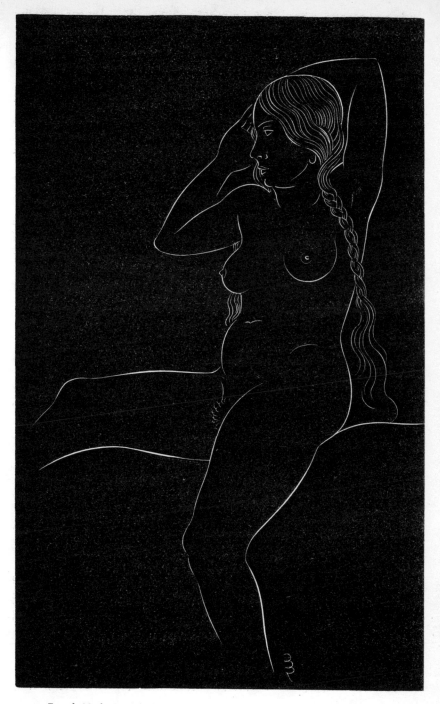

57 *Female Nude, Seated*. Wood-engraving, 1937, intended for *Twenty-Five Nudes*.
(reduced)

documented very clearly in the diaries, standing out from the background of professional and local activities – carvings for Geneva, drawings for the Post Office, Arabic type, haymaking at Pigotts – making these look routine and boring in comparison. It was an affair of greatly concentrated energy. Through 1937 to 1939, Gill was drawing Daisy constantly, sometimes even daily. He drew her and made love to her. For Gill, as he came to rationalize it, the making of the love was an essential of the drawing. (As ever, he found the theory to justify his actions.) The places they made love were of extreme importance to him. He would note these systematically, whether in his studio, in Gordian's room, in Dr Flood the priest's room, on the landing or in the bathroom. This was part of his obsessiveness, the way that Daisy Hawkins practically took him over. He recorded, almost desperately, the details of his love-making. These records suggest that it was oral and not phallic.

Their affair has its memorial not just in the diaries and not just in the many drawings of Daisy – Daisy standing, Daisy sitting, Daisy dancing, Daisy plaited – which Gill left behind him. There is also that most passionate essay he wrote to accompany the *Drawings from Life* published in 1940. It is an essay on attitudes to love and to love in relation to art: conclusions towards which he had been working all his life and which his relationship with Daisy had now clarified. Gill writes:

heaven forbid that I should seem to preach an erotic mysticism. We know what we have seen and touched, both with the body and with the mind – and that these things are inseparable; for it is the man, the whole man, body and soul, who enjoys and not his eye or his hand merely or his mind alone – we know the unnerving loveliness, heart-breaking, tear-bringing, which sometimes, however rarely, shakes the soul of the man and of the draughtsman. We know the sense of contact with God Himself which such moments seem to bring – as though a sort of arrow pierced our heart. We know the pang of thankfulness which then overwhelms the mind.

The *Drawings from Life* were reminiscent altogether. The Introduction to the book had been supplied by Desmond Chute though not attributed to him: it purported to be from the 'private letter of Priest to penitent'. It made the romantic assertion that nakedness was 'the only nobility left to the vast majority of men'. It continued, in a kind of hymn to holy poverty:

Apart from their vulgarity when new, how often does one not see a godlike torso emerging from filthy n^{th} hand garments, almost radiant with the visible touch

58 *Female Nude, Standing.* Wood-engraving, 1937, used in *Twenty-Five Nudes.*
(reduced)

of the creator. If naked bodies conceal a hell-hunger of lust, they can and do kindle a hunger for heaven. May God bring us thither.

Some of Gill's monastic contacts, by this time ever-watchful, thought these words supported homosexuality.

By the spring of 1939 Gill's affair with Daisy was reaching a crisis. Mary was showing signs of putting her foot down, for the one time in her life. She was practical: perhaps she saw the whole domestic–workshop framework being imperilled by Gill's male-menopausal recklessness. Perhaps she wanted to reassert the balance of a marriage in which, after all, at one time she had been superior. One must not forget that in the early days of courtship it was Mary who had been the more sexually experienced.

May Reeves was also very definitely on the warpath. She was being made increasingly neurotic by the strains of what had now become a quadruple relationship, with Gill's two middle-aged-to-elderly dependants (May was in her forties, Mary now over sixty) competing with Daisy for his sexual attentions. 'MR made me x,' runs one of the entries in Gill's diary during the affair with Daisy: next day May Reeves left for Cornwall. May's desperation was understandable. Her emotional and sexual dependence upon Gill, late arouser of her passions, was intense. She was not of an age or an appearance to find substitutes. She could expect no comfort from Mary, who disliked her. Gill's judgement in entrusting the school at Pigotts to her – indeed setting up the school to give May her *raison d'être* – looked less and less convincing as May, not a patient teacher, took to beating the children about the head with rulers.

On 5 May Daisy was proposed to by Alex O'Hanlon, a young farmworker from Glasgow brought in by Dr Patrick Flood, the new chaplain at Pigotts. (Dr Flood, a friend since Ditchling days, had had a Glasgow parish.) Gill disposed of Alex O'Hanlon most efficiently, taking him for a discouraging walk through the beech woods. Soon after, O'Hanlon returned back home to Scotland. But the incident had side effects: it forced a confrontation.

On 13 May Daisy Hawkins went to confession at High Wycombe. (Gill spent the evening cutting the tennis court with the Atco. This he described as 'hell'.) Three days later Gill himself confessed 're DMH' at Westminster Cathedral. He got back home from Ireland, from a Peace Pledge Union conference, on 23 May to find 'all well – but full of difficulties . . .' He added more exactly: 'MEG well anyway.' On 28

May he wrote to Daisy's mother at Capel-y-ffin where she was staying, helping Betty.

The next day he and Daisy took tea with Dr Flood. Gill does not describe the conversation in detail, but its gist is suggested by the events which followed. On 30 May Gill had an afternoon of drawing: 'DMH No. 41.' There was a supper party, a sad supper held in Daisy's honour in the evening. Then the next morning, after mass and communion, Gill went with Daisy to High Wycombe to the bus station where he put her on the bus to Capel-y-ffin. On the way home he stopped to have a haircut. He spent the afternoon drawing No. 4 of his Oxford Stations of the Cross.

Effectively, Daisy Hawkins was now banished. Gill of course went up to Capel after her. He could not stay away, and in an awful parody of days at Pigotts, he pursued her around the rooms and corridors at Capel, making love to Daisy in Betty's room, the schoolroom, wherever he could find her. She would sometimes come and meet him on the hillside, as once Mary did. For Gill Capel was now truly *capella ad finem*. Running after Daisy he became the ageing satyr: occupational hazard for a pioneer of sex.

Would Gill have ever contemplated leaving Mary for the sake of Daisy Hawkins? It does not seem very likely. He loved Mary too. His final view of Christian marriage was expressed concisely in a letter to Romney on the subject of MacDonald, their brother, who was leaving his own wife after many years of marriage. Gill regarded this as irresponsible, absurd:

brother Max is so *virtuous* by nature and so *stupid* and muddle-headed (also by nature and he always has been an impossible person to argue with) that he prefers to cast M. adrift and break up the home (thus depriving his children of all that home implies) rather than have a love affair to go to confession about.

In his last few years we see Gill growing more despondent. He seemed somehow to have shrunk in size. Described by John Betjeman, who once encountered Gill on 'the moving stairway' at Paddington Station, he appears a toy eccentric, a peculiar teddy bear. By the late 1930s, Gill no longer seemed alarming. He was over-exposed. He had to some extent been absorbed into the system, almost like the fool at court. Graham Greene was partly right when he pointed out that Gill had in the end been taken over, rendered impotent, by that overpowering Catholic tradition of eccentricity, to the point at which even his most outrageous anti-clerical utterances 'caused only a knowing smile on the face of the

faithful'. Gill himself realized this, and it very much annoyed him. He became extremely querulous. He took up the stance of the prophet without honour. 'They don't believe in my prophecies,' he wailed.

Pigotts could by then appear a place of some absurdity. With a madness reminiscent of *Cold Comfort Farm*, visitors would be sent out to look for hens' eggs in the nettles. Pigotts agriculture was always unconvincing: in the early days a haystack had been made but thatched so inexpertly that, when the rain got in, spontaneous combustion turned it into a huge bonfire. The diversion of workshop labour on to farmwork was a source of amazement to David Kindersley, the apprentice in the workshop, who would sometimes be sent out at Mary's desperate request to fetch the cows back from distant fields, or to drive a cow to bull and waste valuable working hours holding a cow's tail while the vet would search her like a penny dip.

Nor did the religious life ring true completely. The considerable problems of Father Bernard, the first chaplain, rightly defined by Heppenstall as a neurotic, were eclipsed by the more public faults of his successor. Where McElligott's flaw was amorousness (he had had an affair with a girl while at Pigotts), Dr Flood's was inebriation. He would go on drinking bouts with the High Wycombe parish priest. One of the next-door children, Patrick Nuttgens, served the daily mass of Dr Flood for several years before realizing that the reason he was so difficult to get out of his bed in the morning was that he had an acute hangover. Sometimes Dr Flood would disappear for days on end and a search party would have to be dispatched to fetch him. There was a disarray at Pigotts, not immediately obvious, but once perceived – in such a setting – disconcerting. One has a vivid sense of the familiar Shakespearian themes of comedy and tragedy: the sense of dislocation, nothing is but what is not.

As war came, the cell of good living took on attributes of nightmare. Gordian only discovered when his call-up papers came and he joined the RASC that he had been adopted: perhaps he had half-known he was not part of the Gill family, but the definite proof brought appalling dismay and relations with Gill never properly recovered. René Hague, whose stance was further left even than Gill's, had been conducting increasingly ferocious arguments with his father-in-law over the political tensions of the thirties: 'René came in after lunch and told me about Marxism,' Gill entered in some irritation in his diary. Their relationship deteriorated further when Hague decided to join the RAF. There was a final scene of irony when Walter Ritchie, a fairly new apprentice in Gill's workshop

and a conscientious objector (but not a Catholic) was asked by Mary Gill to leave Pigotts. She told him they could not do with trouble from the police.

So much that Gill had dreaded was now going on around him. The first harbinger of war had been Ralph Beyer, an apprentice in the workshop, a refugee from Nazi Germany; when he arrived he spoke not a word of English. Pigotts also received evacuees from wartime London: three small girls and a baby boy from a Marylebone slum (the older children were enrolled in May Reeves's schoolroom). Gill was still attending PAX meetings up and down the country. In a small act of more localized defiance he refused to use the gas mask handed out at the beginning of the war to all British citizens, pacifist or otherwise: with a Gill-like kind of logic he maintained the regulations only stipulated gas-mask boxes, not the gas masks. So he carried his gas-mask container around empty. But by this time he was ill, and there was not much fight left in him.

In his last years Gill was working on a series of commissions for Guildford Cathedral, at the instigation of his friend the architect Edward Maufe. (Prudence Maufe commissioned a paper hat from him: as usual his friendship was the closest with the wife.) But from the end of 1939 through into 1940 Gill's work was interrupted by a succession of colds, sore throats, attacks of flu; and then in April 1940 he contracted German measles which made him feel 'completely rotten', and from this developed congestion of the lung. Working on his carvings wearied him increasingly and he became nervous about inhaling stone-dust. He spent much of the summer either in bed or out in the garden, 'more or less stuck in a deck chair' with a rug around him. ('Old age coming on I guess.') In June there was a visit from his Fabian love, Lillian, now the wife of the Professor of Egyptology at Oxford; but he felt too ill to see her. He was lost in anxiety, depression and a strange kind of visionary, almost surreal, clarity. Harman Grisewood went to see him in the autumn.

We talked about the visual effect of the bombed ruins. I remember his saying that a ruined state gives dignity to a building which before had been hidden by the banality of the environment, rather as the wounds of battle give dignity to a man's body. I confirmed this later when some of the shops in Oxford Street were hit and bits of Victorian 'classical' lay about the thoroughfares.

Eric Gill, perhaps forgetting the lettering he did there, expressed the hope that a bomb would fall on Selfridge's, as a symbol of the civilization he detested, rather as John Betjeman would pray for bombs on Slough.

Gill's visual perceptions and sense of his past history had no doubt been heightened by the writing of his *Autobiography* which occupied that final summer, between his bouts of illness. It is an extraordinary work for someone ailing: a vivid summing-up of past scenes and past experience. The writing is impressionistic, emotional, tricky; both characteristically open and concealing. The words of the frontispiece refer to the communion: '*quod ore sumpsimus*', that which we take into our mouth.

In the *Autobiography* he does not mention Daisy. Perhaps Dr Flood, who typed the book and acted as Gill's theological adviser, ruled that she must be left out. But the sense of her is ever present in the intimacy and deep feeling of his writings about sex, in particular in a passage which is really a rewording of his Introduction to *Drawings from Life*. Here he argues, gently, amusingly, alarmingly, that our sex organs are our flowers. They are, Gill maintains, quite literally flowers:

What are those lovely creatures which we delight to fill our gardens with and to display on our tables? What are they indeed but the sex organs of the plants they adorn. So that it is neither fantastic nor even an exaggeration to say that while from one point of view the country hedgerow is filled with savage creatures armed to the teeth – with poison and thorns and spikes and every sort of offensive and defensive weapon (in this respect perfect models for all modern nations), so from another, it is nothing but an uproarious exhibition of desire for fruitfulness and multiplication. And having thus become enlightened as to the nature of the flowers in the field, does one then turn round and say: O hell! what a filthy world it is? I can't imagine that such would be the result. Rather, it seems to me, we should turn round on all our previous pruderies and think of ourselves as being adorned, as indeed we are, with precious ornaments. And thus a great burden of puzzlement is taken from the mind. And, what is more to the point; a great wave of cheerfulness breaks over us, and of confidence and that is to say confidingness.

As a love letter to Daisy it is jubilant, articulate: Daisy whose sex organs Gill delineated passionately. As a hymn to the eroticism of the familiar it is touching and imaginative, lunatic and maddening; an astonishing performance for a man quite near to death.

Gill did not give up easily. He still had curiosity. He wrote, of his *Autobiography*, 'Really it amounts to a search for the City of God.' And even at the end of it one can still see Gill searching. In his last few months he was still busily discussing plans for emigrating to America with his family, to join Graham Carey in the founding of another cell of good

living, this time in New England. Was this the last example of what Father Martin D'Arcy called Gill's 'fallacy of perfectionism'?

In summer 1940, Gill took on a new secretary, Colette Yardley. She was surprised to find her typewriter converted to type Arabic. Her husband, Hugo Yardley, was a conscientious objector, set to work on Pigotts farm. Mrs Yardley's duties sound familiar. She was greeted every morning with a kiss and the sign of the cross upon her forehead. On 28 August Gill entered in the diary: 'Letters with Colette Y in m. x. Conversations re. amorousness etc.'

In September he still felt full enough of energy to enter into an ebullient correspondence in the *Catholic Herald* about army prostitutes, a swansong for Gill's ambivalence and impudence. He was not convinced by the argument that the potential profits of wartime prostitution put unfair pressure on girls with weak moral resistance. In a letter to the Association for Moral and Social Hygiene he expanded on his view:

I think it is a mistake to suppose that all the desire and therefore demand is on one side. On the contrary in a normal society women want men as much as men want women. Although of course the instinct to take the initiative is more on one side than the other.

Shortly before Gill died he took on a new apprentice. This was his nephew John Skelton, son of his sister Angela, the model for *Mankind*. John Skelton was immediately adept in the workshop, almost a replacement for the son Gill always wanted. When Gill went into hospital he left John with a job list, much as he had left instructions with Desmond all those years ago, when he left Ditchling Common for the army camp. His directions were still most scrupulously clear.

In October 1940 Gill had been taken into hospital at High Wycombe for an X-ray. He had made a surreptitious copy of the notes on his medical chart. These he submitted to his doctor brother Cecil when he got back home to Pigotts. Cecil described the scene: 'As he rolled a cigarette, sitting in his workshop, I told him that his trouble was indeed a fatal disease of the lung. It was impossible, even if desirable, which I don't believe, to deny him the truth. He was that kind of person.'

A serious operation to remove the cancerous growth in his lung had been proposed. But Gill resisted the idea of pneumonectomy: such bodily mutilation seemed impious. He preferred to die. Once he thought he would be dying Cecil describes him as being 'quite gay and lighthearted', almost as if planning a heavenly holiday. On 31 October Gill read Wilenski's *Ruskin*, adding a footnote about it to his *Autobiography*. He

cleared up the workshop ready to go to hospital. On 4 November he was taken into Harefield House hospital in Middlesex, to which the Brompton Chest Hospital had been evacuated. There had now been a suggestion of a minor operation to cut out a small portion of the diseased lung. Gill told the surgeon he would be quite glad to die: he hated the prospect of growing old like Rodin, 'carving ladies' bottoms with great technique and no inspiration'. But he was persuaded to be operated on. In bed he kept busy translating the Psalms and beginning the illustrations for a book of Chinese cautionary tales, *Glue and Lacquer*, translated by Harold Acton and Lee Yi-Hsieh for the newly reconstituted Golden Cockerel. He continued diary entries, though the handwriting is shaky, still indicating the hours of work to charge for. He kept up his correspondence. He wrote to Colette Yardley, signing his letter E with the elongated tail stretching right down the page, which was a sign for special fondness. He sent a little postcard to Father Conrad Pepler, the son of Hilary. It bore a cryptic message, beautifully written, the dictum of St Anthony of the Desert: 'One never rises so high as when one does not know where one is going.'

The minor operation on his lung was carried out, and he seemed to be recovering; but then suddenly he worsened. Eric Gill died in the middle of a very heavy air raid, just before 5 o'clock in the morning of Sunday 17 November (as he would have certainly recorded in his diary). Mary was with him. He was fifty-eight. Shortly before he died Monsignor Sutton, chaplain at the hospital, had heard his confession, given him the holy viaticum and anointed him. He had answered all the prayers himself, in Latin. They said some more prayers in English, together. The chaplain wrote:

There was a beautiful serene expression on his face as I left. I can truthfully say I have never, in my 45 years as a priest, seen a more beautiful death.

One might say that Eric's sanctification had begun.

The death certificate described Eric Gill as a sculptor (his marriage certificate had called him a calligrapher). His body was brought back to Pigotts and, like David's, was laid out in the chapel in its coffin. Remembering that Eric had always had a horror of being buried alive, his brother Cecil got out a scalpel and professionally severed an artery in his left forearm.

There was a large gathering at Pigotts for the funeral on 21 November. People crowded the small chapel, spilling out into the hall and on to the half-landing between chapel and workshop and up the steep stairs

leading from the stone shop to the upper studio where Eric had done his drawings from life. The coffin remained open through the requiem mass, which was said according to the Roman rites. It might have been expected that as a Tertiary Gill would have been buried in the Dominican habit, but for one reason or another he was not. Father Lockyer, the parish priest of High Wycombe, celebrated the mass; and Cecil Gill and Gordian assisted him as servers. The family 'choir', which had practised 'In Paradisum' the previous evening, consisted of Betty, Petra, Joan and May Reeves with Denis Tegetmeier (to provide a deeper voice) and the grandchildren. Most of the close relations were there, and Gill's apprentices. Walter Ritchie, the apprentice who had been summarily dismissed from Pigotts, bicycled over from war-ravaged Coventry, arriving just in time.

At the end of the service, before the body was removed, Mary went up to the head of the coffin, and with her finger transmitted a kiss from her lips to the dead lips of her husband.

It was a fine clear gusty day which turned to sunlight as the coffin, in a farm cart, resting on a bed of straw, was taken down the hill from Pigotts through the beech woods. The English country scene reminds one so acutely of the funeral of that other English artist-craftsman-prophet William Morris, forty years before across the hills at Kelmscott. Immediately behind the cart, surrounded by the grandchildren – several of them grandchildren of his and Gill's in common – walked Hilary Pepler, carrying the cross. Behind in the procession walked Mary, the three daughters, Dr Flood, the Pigotts chaplain, and three Dominican Fathers in white habits. 'In Paradisum' was repeated on the journey. The local builder, a great friend of Eric's, led the horse the mile and a half between Pigotts and Speen, where in the Baptist churchyard – a not-quite-incongruous last resting place – Eric was buried. There was one hymn at his graveside: 'Jerusalem the Golden'.

He had left exact instructions for his grave, the real one. The inscription was to read:

PRAY FOR ME
ERIC GILL
STONE CARVER
1882–1940

It was carved by Laurie Cribb, leaving space, as Gill had asked, for more lines of lettering recording the name and dates of his 'darling and most dear wife Mary Ethel'. He had also asked permission for a small stone,

with the letters 'E.G.', to be let into the floor at Westminster Cathedral, near the Fourteenth Station of the Cross. He had had to be deterred from his original proposal for his right hand to be severed and placed beneath the Station: the histrionic tendency was with him to the end.

Mary Gill was the sole executor of Gill's will. Apart from land and property descending to his daughters there were special beneficiaries. Among them, Gordian was left £500: a sum which increased his bitterness against Gill and the family. In a codicil dated 1937 Gill bequeathed to May Reeves 'the drawing by me of herself (nude, front view) made at Pigotts on December 31, 1933'. Gill left Daisy Hawkins all the original drawings reproduced in the book called *Life Drawings by Eric Gill*, if they were still unsold at his death. The day after the will was read, one of Gill's assistants noticed Daisy arriving at Pigotts surreptitiously and walking across the yard towards Gill's office to make sure of her inheritance. She was, he remembers, wearing a red coat.

There was also a curious bequest to brother Cecil. Gill left him the parcel of drawings labelled 'Studies of Parts', with the proviso that if he did not wish to keep them they should be presented to the museum of the Royal College of Surgeons in London. As it turned out, the Royal College rejected them when they were offered in 1948 as 'not showing any pathological condition', which is why they are now in the British Museum (Private Case).

One way and another, Gill left so much behind him: over 100 figures or reliefs in stone; over 750 pieces of inscriptional lettering; half a dozen typefaces; 1,000 engravings; 300 pamphlets, articles and books. He made wonderful things. But in some ways one remembers him most for his impression on the minds of other people. Gill was a most extraordinary person, and it is very strange how his immediacy lingers.

Only the day before I finished this biography I heard from Philip Hagreen, Gill's companion at Capel, now aged ninety-seven. Eric Gill, he wrote to tell me, was not a star or a planet, he was a comet. A comet has a tail.

SOURCES

INTRODUCTION

'cell of good living' Gill, *Autobiography*, p. 282

'It All Goes Together' Gill essay first published in *The Cross and Plough*, vol. III, no. 2, Christmas 1936; reprinted in *In a Strange Land*, 1944, and used as title of American edition, *It All Goes Together*, 1944

'He would sit on the bed all night' John O'Connor, review of *Last Essays, Blackfriars*, February 1943

'let 'em all come' Gill, *Autobiography*, p. 132

'spiritual fathers' Eric Gill to Father Austin Barker, 15 March 1926. English Dominican Archive Carisbrooke

'I very much doubt' Eric Gill to G. Wren Howard, 2 May 1933. Jonathan Cape Archive, University of Reading

'It is thus' Gill, *Autobiography*, p. 248

SOUTH COAST

Eric Gill's own *Autobiography* is the chief source for the two early chapters, in conjunction with Eric Gill's diaries, William Andrews Clark Memorial Library, UCLA. The diaries end 1897–8, early on in the Chichester period.

Additional information from *Awara*, the unpublished memoirs of Cecil Gill; typescripts of talks by Cecil Gill given at the Clark Library, UCLA, in 1949 and 1969 and an interview with Cecil and Vernon Gill in 1967; typescript of BBC interview with Evan Gill in 1961; lectures by and conversations with John and Christopher Skelton and in particular John Skelton's account *Eric Gill and Chichester*, Chichester Cathedral, 1975; family scrapbooks and childhood memorabilia in the Gill collection at the Clark Memorial Library and the West Sussex County Record Office in Chichester and in the collection of Yvonne Ayres and Julia Hasler; author's interviews with Rosemary Stewart-Jones, Petra Tegetmeier, Margaret Breitenbach, David Gill.

CHAPTER ONE: BRIGHTON 1882–97

'a treasure-house' Rayner Heppenstall, *Four Absentees*, 1964

'The very first thing I can remember' Gill, *Autobiography*, p. 15

'When I first saw Eric Gill' René Hague, 'A Personal Memoir', *Blackfriars*, February 1941

'I look back then to my childhood' Gill, *Autobiography*, p. 58.

'taking things for granted' *ibid.*, p. 59.

'Whilst he was employed' anon., *The Life and Times of Selina Countess of Huntingdon*, William Edward Painter, 1839
'truthful, ingenious, quick' Frederic W. Farrar, *Eric, or Little by Little*, 1858
'a beautiful black-haired young woman' Gill, *Autobiography*, p. 42
'Mother has not got' Eric Gill to Helena Hall, 26 October 1893. Ayres/Hasler
'rushing hiss' Gill, *Autobiography*, p. 20
'three-quarters of the chaps in the *DNB*' David Jones, BBC radio interview, 9 April 1961
'with much splashing' Cecil Gill, *Awara*, unpublished typescript. David Gill
'If the inspection' Henry Willett, Introduction to Chalk Fossil catalogue, 1871. Booth Museum, Brighton
'from a high-brow point of view' *ibid.*, p. 45
'the grey light and my impotence' Gill, *Autobiography*, p. 22
'the lay-out of the figures' *ibid.*, p. 29
'a quite ordinary person' Eric Gill to Richard de la Mare, 17 October 1935. Clark
'a daze of exultation and pride' Gill, *Autobiography*, p. 34*n*.
'We have only played' Eric Gill to Helena Hall, 26 October 1893. Ayres/Hasler
'Even now' Gill, *Autobiography*, p. 31
'learning things out of little books' *ibid.*, p. 26
'stuff of which martyrs are made' *ibid.*, p. 34
'How extraordinary' Eric Gill to Everard Meynell, 14 February 1911. Ayres/Hasler
'so easily led' Gill, *Autobiography*, p. 23
'they continued naked' Philip Hagreen to the author, 27 January 1987
'when I consider those friendships' Gill, *Autobiography*, p. 37
'He had his foibles' Cecil Gill, *Awara*, unpublished typescript. David Gill
'my mother built up in our minds' Gill, *Autobiography.*, p. 44
'quite a lot in sharpening pencils' *ibid.*, p. 45
'jingo imperialism' *ibid.*, p. 258
'intensely patriotic' Cecil Gill, *Awara*, unpublished typescript. David Gill
'the bookworm of the family' *ibid.*
'I had not known death' Gill, *Autobiography*, p. 79
'But how shall I ever forget' *ibid.*, p. 53

CHAPTER TWO: CHICHESTER 1897–1900
'little squashy house' Gill, *Autobiography*, p. 123
'to make a cell of good living' *ibid.*, p. 282
'not big and grand' *ibid.*, p. 81*n*.
'embrace a career of art' *ibid.*, p. 85
'smoking a cigarette in a holder' quoted Donald Attwater, *A Cell of Good Living*, 1969
'to the publisher' Gill diary, 17 January 1898. Clark
'constitutionally incapable' Desmond Chute, 'Eric Gill: The Man and the Maker', *Good Work*, vol. XXVII, 1964
'Mr. Catt the Art Master' Gill diary, December 1897. Clark
'working while conducting a hard conversation' David Jones, 'Eric Gill: An Appreciation', *Tablet*, 30 November 1960
' "mad" on lettering' Gill, *Autobiography*, p. 91
'alphabet from Domesday Book' Gill diary, 28 October 1898. Clark
'a delightful fellow' Cecil Gill, interview by David Kindersley, 20 April 1967. Clark
'I go in for bell ringing here' Gill diary, December 1897. Clark
'through it with a toothcomb' Cecil Gill, interview by David Kindersley, 20 April 1967. Clark

'building made by "chaps" to pray in' Bernard Wall, *Headlong into Change*, Harvill Press, 1969

'a well-worn, well-loved, comfortable fireside chair' Ian Nairn and Nikolaus Pevsner, *The Buildings of England: Sussex*, Penguin Books, Harmondsworth, 1965

'just what I wanted to emulate' Henry Moore, 'The Romanesque Carvings', *Chichester 900*, Chichester Cathedral, 1975

'I have seen those stones' Philip Hagreen to the author, 28 January 1987

'mentally bursting like a bud' Gill, *Autobiography*, p. 83

'Up Cathedral all day' Gill diary, 4 May 1899. Clark

'always been interested in love' Cecil Gill, Clark Library Symposium on Eric Gill, 1967

'Introduced to Mrs. Johnson' Gill diary, 19 November 1898. Clark

'My dear Miss Johnson' Eric Gill to Winifred Johnson, 8 January 1898. Texas

'he sat just behind us' Mary Gill, *He and She*, 1913. Clark

'like a French woman' David Jones, BBC radio interview, 1961

'lovely, lovely, lovely' Gill diary, October 1898. Clark

'Mr. Catt say nuffin" Gill diary, 27 February 1900. Clark

'no abiding city' Gill, *Autobiography*, p. 92

'little house – four square' *ibid.*

LONDON

Information for these chapters is drawn mainly from Eric Gill's diaries and job books (from 1902 onwards) and his early lectures, in the Clark Library, UCLA; Gill's *Autobiography*, informative on the early years in London, more enigmatic about Hammersmith; Gill family correspondence in the Gleeson Library at the University of San Francisco, and in the collection of Yvonne Ayres and Julia Hasler.

On Johnston and Pepler: Priscilla Johnston's biography of her father, *Edward Johnston*, Faber and Faber, 1959; Edward Johnston, *Formal Penmanship and other papers*, edited by Heather Child, Lund Humphries, 1971; Hilary Pepler, *The Hand Press*, St Dominic's Press, Ditchling, 1934; Hilary Pepler, 'Hampshire House Workshops', article in *Blackfriars*, February 1950; chapter on Pepler in *Like Black Swans: Some People and Themes* by Brocard Sewell, Tabb House, Padstow, 1982.

On Hammersmith Arts and Crafts in general: *The Journals of Thomas James Cobden-Sanderson*, London, 1926; John Brandon-Jones, 'Memories of William Morris in London', *Country Life*, 14 May 1964; Dorothy Harrap, *Sir Emery Walker*, Nine Elms Press, 1986.

Records of the Arts and Crafts Exhibition Society, National Art and Design Archive, London; records of the Fabian Society, Nuffield College, Oxford; W. H. Smith Archive, Abingdon. Gill's correspondence with H. G. Wells in the Wells Collection, University of Illinois at Urbana-Champaign.

Conversations with Father Conrad Pepler and Father Brocard Sewell.

CHAPTER THREE: CLAPHAM 1900–2

'what could be more surprisingly wonderful?' Gill, *Autobiography*, p. 106

'only he who loves Pimlico' Gill to *GK's Weekly*, 4 June 1927

'too kind to be true' Gill diary, 16 March 1900. Clark

' "big gun" Gill to Robert Heaps, 9 June 1900. Chichester

'I AM WRITING THIS LETTER IN PRINTING' Gill to Evan Gill, 24 April 1900; quoted Shewring (ed.), *Letters of Eric Gill*, 1947

'circus boy' Gill to Gladys Gill, 24 June 1900; *ibid.*

'some beautiful things' Gill diary, 24 April 1900. Clark

George Christopher Carter information from records of RIBA
'a revelation' Gill, *Autobiography*, p. 101
'It all goes together' Gill essay first published in *The Cross and Plough*, Christmas 1936
'George Carter, the integral man!' Gill, *Autobiography*, p. 157
'only daily-work art is worth a button' quoted Priscilla Johnston, *Edward Johnston*, 1959
'to make *living letters*' Edward Johnston to Sir Sydney Cockerell, *ibid.*
'the first time I saw him writing' Gill, *Autobiography*, p. 119
'lassitude, of physical strength drained right out' quoted Priscilla Johnston, *Edward Johnston*, 1959
'*Writing & Illuminating*' quoted Priscilla Johnston, *Edward Johnston*, 1959
'letters are things' Gill, *Autobiography*, p. 120
'chisels must be of the right temper' Edward Johnston, *Writing & Illuminating, & Lettering*, John Hogg, London, 1911
'exceedingly amateurish' Gill, *Autobiography*, p. 116
'It either flows forward' *ibid.*, p. 123
'filled all the nooks and crannies' *ibid.*, p. 85
'I have been thinking about a plan' quoted Priscilla Johnston, *Edward Johnston*, 1959

CHAPTER FOUR: LINCOLN'S INN 1902–4
'It is the most lovely clear, cold, starry dark' quoted Priscilla Johnston, *Edward Johnston*, 1959
' "Light's abode, celestial Salem" ' Gill, *Autobiography*, p. 126
'We don't get on very well now somehow' Gill diary 18 April 1900. Clark
'I believe his coming is a good thing' quoted Priscilla Johnston, *Edward Johnston*, 1959
'I shall have to go to that' Eric Gill to Evan Gill, 16 June 1903; quoted Shrewring (ed.), *Letters of Eric Gill*, 1947
'that men themselves may have more life' Edward Johnston, quoted Priscilla Johnston, Foreword to *Formal Penmanship and other papers*, 1971
'I was so moved, excited, all of a tremble' quoted Priscilla Johnston, *Edward Johnston*, 1959
'a priviledge' Gill diary, 16 October 1903. Clark
'Then for the first time' Eric Gill, *He and She*, April 1913. Clark
'Writing out beautiful Zion' Gill job book, 1903. Clark
'It is a beautiful place' Gill diary, 26 October 1903. Clark
'instead of art' E. S. Prior, *A History of Gothic Art in England*, George Bell and Sons, 1900
'first public work' Eric Gill to Louisa Prior, Edward Prior's widow, 29 October 1932. Information provided by Lynne Walker
'I do not mean' St John Hornby to Eric Gill, 20 September 1905. W. H. Smith Archives
'So one job led to another' Gill, *Autobiography*, p. 118
'Gill shall have the sofa' quoted Priscilla Johnston, *Edward Johnston*, 1959
'Double bed try in Walworth R' Gill diary, start of 1904. Clark

CHAPTER FIVE: BATTERSEA 1904–5
'enchanted garden of Christian marriage' Gill, *Autobiography*, p. 131
'The roundness and largeness' Eric Gill, *He and She*, 1913. Clark
'windows looking out to the south and west' Eric Gill to Rose Gill, 18 December 1904. Clark
'I start the year' Gill diary, 1 January 1905. Clark
'Woman' G. K. Chesterton article, *Illustrated London News*, 24 March 1906
'Moreover it seems clear' Eric Gill, *Typography*, 1931. (I am indebted to Christopher Skelton for first pointing out this key passage.)

CHAPTER SIX: HAMMERSMITH 1905–7

'I can still see Eric' Cecil Gill, 'My Brother, Eric Gill', typsecript of talk, 18 November 1949. Clark

'All day, and for many days' T. J. Cobden-Sanderson, *Journals*, 17 January 1900

'having the advantages of country' quoted Priscilla Johnston, *Edward Johnston*, 1959

'Mr. A. E. R. Gill and Mr. H. L. Christie' undated card recorded in catalogue of Gill ephemera, G. F. Sims, Summer 1967. Clark

'Bought a Kodak' Gill diary, 13 March 1906. Clark

'Tried Wood Engraving,' Gill diary, 20 November 1906. Clark

'I want to become a monk' T. J. Cobden-Sanderson, *Journals*, 30 April 1901

'EJ read Plato' Gill diary, 3 July 1906. Clark

'men and women were not just rabbits' Gill, *Autobiography*, p. 125

'to discover the needs of man' Housemakers' Society records. Clark

'Your noble behaviour' quoted Priscilla Johnston, *Edward Johnston*, 1959

'silent figure in a shabby mackintosh' John Middleton Murry, *Blackfriars*, February 1941

'The drawing and cutting of the Roman letter' René Hague, *David Jones*, Welsh Arts Council, 1975

'I have the eye of an E. Gill' John Skelton, in interview with the author, 11 October 1986

'Mr. Gill's work is made the more valuable' Edward Johnston to LCC Paddington Institute, 26 July 1905. Clark

'There will be no artist craftsmen' Eric Gill, 'Society and the Arts and Crafts', lecture reprinted in *Swallow*, 1907. Clark

'a dear, comical sort of man' Eric Gill, review of *Tradition and Modernism in Politics* in *Blackfriars*, July 1937

'He is to be remembered' Eric Gill, 'John Ruskin', centenary address to the English Speaking Union, London, 8 February 1934, reprinted in *In a Strange Land*. Clark

'still floundering in the Benthamite bog' Eric Gill, 'Socialism and the Arts and Crafts', lecture at Essex Hall, London, 31 May 1907

'an organisation of craftsmen' Eric Gill, 'The Failure of the Arts and Crafts Movement', article in *Socialist Review*, December 1909. Clark

'had talk about A & C' Gill diary, 3 July 1907. Clark

'Report of Spec. Com.' *ibid.*, 7 December 1906. Clark

'the block seems on the whole a good one' Eric Gill to Edward Pease, 30 October 1908. Nuffield

'there is so much really excellent type' *ibid.*, 1 April 1909

'Webb got in!' Gill diary, 2 March 1907. Clark

'We are for the PLEBS' Hilary (Douglas) Pepler and David Jones, *Libellus Lapidum*, St Dominic's Press, Ditchling, 1924

farmers' wives and housemaids Philip Hagreen to the author, 28 January 1987

'Lillian's 1st writing lesson' Gill diary, 9 February 1907. Clark

'Oh taste and see' Gill, *Autobiography*, p. 265

'Doesn't the Cathedral look splendid' Eric Gill to Ethel Gill, April 1907. Gleeson

'a very shabby silent little fellow' Katharine Adams, quoted Wilfred Blunt, *S. C. Cockerell*, Hamish Hamilton, 1964

'Gill was a more remarkable creature' Sydney Cockerell to Katharine Adams, 1941, quoted *ibid.*

' "Oh Hell!" I said' Gill, *Autobiography*, p. 134

'a very decent success' Gill diary, 10 August 1907. Clark

SUSSEX

Main sources: Eric Gill's diary and job books and Gill correspondence in the Clark Library, UCLA; the Gill–Chute correspondence in the Gleeson Library at the University of San Francisco; the records of the Guild of SS Joseph and Dominic in the English Dominican Archive at Carisbrooke, Isle of Wight, and the Gill correspondence with the Prior of Caldey in the Prinknash Archives. Also Eric Gill's *Autobiography* and *Letters of Eric Gill*, ed. Walter Shrewring, Jonathan Cape, 1947. Typescripts of BBC radio interviews for the 1961 Gill profile, with Donald Attwater, Joan and René Hague, David Jones, Father Conrad Pepler, Petra and Denis Tegetmeier. Author's interviews with Petra Tegetmeier, Philip Hagreen, Cecilia and Jenny KilBride, Margaret Breitenbach, Rosemary Stewart-Jones, Father Conrad Pepler, Tom Burns, Peter Cribb. Author's correspondence with Father Reginald Ginns.

For Gill, Pepler and the Guild at Ditchling: Desmond Chute, 'Eric Gill: a Retrospect', series of articles in *Blackfriars*, from December 1950; Father Conrad Pepler, 'Ditchling, a Community of Craftsmen', article in *Dublin Review*, no. 482, Winter 1959–60; Hilary Pepler, *The Hand Press*, Ditchling, 1934; Brocard Sewell, *Like Black Swans: Some People and Themes*, Tabb House, Padstow, 1982 and 'Aspects of Eric Gill', article in *Chesterton Review*, vol. VIII, no. 4, November 1982; *Aylesford Review*, issue on 'Hilary Pepler and The Saint Dominic's Press', vol. VII, Spring 1955; Brocard Sewell, chapter on 'St. Dominic's Press' in *Three Private Presses*, Christopher Skelton, 1979; Valentine KilBride, unpublished fragment of autobiography, by kind permission of Jenny KilBride; Joseph Cribb, unpublished diaries and job lists in possession of Peter Cribb; Brother David Lawson and John Ginger, *A Brother's Life*, typescript extract of book in preparation.

For Ditchling in general: Priscilla Johnston, *Edward Johnston*, Faber and Faber, 1959; Philip Mairet, *Autobiographical and other papers*, Carcanet Press, Manchester, 1981; Margot Coatts, *A Weaver's Life*, Crafts Council, 1983.

On Gill and the Dominicans: Father Bede Jarrett, *The English Dominicans*, Burns Oates and Washbourne, 1921; Father Ferdinand Valentine, *Father Vincent McNabb: A Portrait of a Great Dominican*, Burns and Oates, 1955; 'Father Vincent McNabb O.P.', special issue of *Blackfriars*, vol. XXXIV, no. 281, August 1943; Angela Cunningham, 'Father Vincent McNabb and Distributism', paper given at Spode House, 1979; *In the Dorian Mode: A Life of John Gray* by Brocard Sewell, Padstow, Tabb House, 1983.

Accounts of visits to Gill in Ditchling in: Peter Anson, *A Roving Recluse*, Mercier Press, Cork, 1946; C. R. Ashbee, unpublished journals, entry for November 1923, King's College Library, Cambridge; Spike Hughes, *Opening Bars: Beginnings of an Autobiography*, Pilot Press, 1946; Geoffrey Keynes, *The Gates of Memory*, Oxford University Press, 1981.

For Gill and Desmond Chute: Walter Shrewring, 'Desmond Chute, 1895–1962', article in *Blackfriars*, vol. XLIV, January 1963; Brocard Sewell, 'Desmond Chute: Aesthete and Churchman', paper given at Spode House conference, 1980, reprinted in the *Antigonish Review*, no. 62 and 63, 1985. On Chute and Stanley Spencer: Richard Carline, *Stanley Spencer at War*, Faber and Faber, 1978. On Chute in Rapallo: Mary de Rachewiltz, *Discretions*, Faber and Faber, 1971. Biographical material in Stanley Spencer Gallery, Cookham.

For Gill and David Jones: René Hague, *David Jones*, University of Wales Press for the Welsh Arts Council, 1975; Introduction by René Hague, *Dai Greatcoat: a self-portrait of David Jones in his letters*, Faber and Faber, 1980; David Blamires, *David Jones, Artist and Writer*, Manchester University Press, 1971; Paul Hills, 'The Art of David Jones', essay in catalogue of exhibition *David Jones*, Tate Gallery, London, 1981; Elizabeth Ward, *David Jones Myth-Maker*, Manchester University Press, 1983; *Agenda*, David Jones Special Issue, vol. 11/12, Autumn/Winter 1973; Introduction by Tom Dilworth, *Inner Necessities: The Letters of David Jones to Desmond Chute*, Toronto, Anson-Cartwright Editions, 1984; typescript of interview with Philip Hagreen by Douglas Cleverdon, 1982.

For Gill's London connections at this period: Robert Speaight, *William Rothenstein*, Eyre and Spottiswoode, 1962; John Rothenstein, 'Eric Gill: Some Recollections', *Chesterton Review*, Eric Gill Centenary number, vol. VIII, no. 4, 1982; Roger Lipsey, *Coomaraswamy, Vol. 3 His Life and Work*, Princeton University Press, 1977; Philip Mairet, *A. R. Orage: A Memoir*, J. M. Dent and Sons, 1936; Wallace Martin, *The New Age under Orage*, Manchester University Press, 1967; Frances Meynell, *My Lives*, Bodley Head, 1971.

On Gill's sculpture: John Skelton, 'Eric Gill – Sculptor', address at Spode House, 1982; essays by Richard Cork, Judith Collins and Terry Friedman in *Jacob Epstein: Sculpture and Drawings*, catalogue of exhibition at Leeds City Art Galleries, 1987; Richard Cork, 'The Cave of the Golden Calf', chapter in *Art Beyond the Gallery*, Yale University Press, 1985; Judith Collins, 'Eric Gill's Stations of the Cross in Westminster Cathedral', *Journal of the Decorative Arts Society*, no. 6, 1981.

CHAPTER SEVEN: DITCHLING VILLAGE 1907–13
'I have now moved' Eric Gill to William Rothenstein, 26 April 1908, quoted Shewring (ed.), *Letters of Eric Gill*, 1947
'If you have been a little child' Gill, *Autobiography*, p. 75
'There were things about our life' *ibid*., p. 239
'Met E. and the children' Gill diary, 26 October 1907. Clark
'E. is a dear' *ibid*., 3 February 1908. Clark
'and then, oh God' Gill, *Autobiography*, p. 239
'life and work and love' Eric Gill, Introduction to *Engravings*, 1929
'the very hard bread' Geoffrey Keynes, *The Gates of Memory*, Oxford University Press, 1981
'When a man dresses himself' Eric Gill, 'Society and the Arts and Crafts', lecture reprinted in *Swallow*, 1907. Clark
Romney Gill's tool-shed in New Guinea described by Cecil Gill, *Awara*, unpublished typescript
'Later, as a schoolboy' Cecil Gill, Clark Library Symposium, 1967
'Isadora Duncan!!' Gill diary, 8 July 1908. Clark
'We had intimate friends in common' Eric Gill in *New English Weekly*, 15 November 1934
'The literary generation of his time' Augustus John, *Chiaroscuro*, Jonathan Cape, 1952
Gill's list of London buildings Eric Gill to H. G. Wells, 24 September 1905. University of Illinois at Urbana-Champaign.
' "Oh I have a flair" ' Cecil Gill, 'My Brother Eric Gill', typescript of talk, 18 November 1949. Clark
'Such is the beauty of bones' Eric Gill, *Typography*, 1931
'You can *see* the boys don't drink' Gill, *Autobiography*, p. 164
'I spend all my spare time' Eric Gill to Romney Green, 6 September 1909. Ayres/Hasler
'And so, just as on the first occasion' Gill, *Autobiography*, pp. 158–9
'round and smooth and lovely images' *ibid*., p. 163
'like undressing a girl' Robert Gibbings, *Coming Down the Wye*, J. M. Dent and Sons, 1942
'It is as though I went to the door' William Rothenstein to Eric Gill, 30 August 1910. Clark
'Saw Ed. Lutyens – nice chap' Gill diary, 21 July 1910. Clark.
'*a most splendid* paper' Gill diary, 10 January 1908. Clark
'They avoided the model' Eric Gill, Introduction to Ananda Coomaraswamy, *Visvakarma*, privately printed, 1914
'I agree with your suggestion' Eric Gill to William Rothenstein, 6 January 1911. Clark
'in his own line of business' Gill, *Autobiography*, p. 182

'The similarity in our ideas' Eric Gill, draft letter to Count Kessler, enclosed with letter to William Rothenstein, 20 January 1910. Clark
'Mended chair for Ethel' Gill diary, 10 April 1910. Clark
'At Eric Gill's instigation' Augustus John, *Chiaroscuro*, Jonathan Cape, 1952
'as a contribution to the world' Eric Gill to William Rothenstein, 25 September 1910. Clark
'You are wonderful' William Rothenstein to Eric Gill, 26 September 1910. Clark
'Quite mad on sex' Gill diary, 9 December 1913. Clark
'What does your staff think of it?' Geoffrey Keynes, quoted John Skelton, 'Eric Gill – Sculptor', Spode House, 1982.
'whoever was willing to take his or her clothes off' Gill, *Autobiography*, p. 162
'except for my sisters' Eric Gill, *He and She*, April 1913. Clark
'Mr. Gill has tried to express the instinct of maternity' Arthur Clutton-Block, review in *The Times*, 27 January 1911
'The result is that these figures' Roger Fry, review in *Nation*, 15 February 1911
'You make me feel a rich woman' Rose Gill to Eric Gill, 1 February 1911. Clark
'small, excellent and ribald' Wyndham Lewis to T. Sturge Moore, c.Feb. 1911. University of London Library
'I think he's frightened of it' Eric Gill to William Rothenstein, 15 July 1911. Clark
on the Post-Impressionists Eric Gill to William Rothenstein, 5 December 1910. Clark
'Between, shall we say' David Jones, 'Eric Gill as Sculptor', *Blackfriars*, February 1941
'He was delighted with the barns' William Rothenstein, *Men and Memories*, vol. II, Faber and Faber, 1932
'out of a sort of idea' Mary Gill, *He and She*, 1913. Clark
'Sold Acrobatic paperweights' Gill diary, 5 April 1912. Clark
'to see abt. gilding' *ibid.*, 29 July 1912. Clark
'What ho! for the Golden Calf' *ibid.*, 9 July 1912. Clark
'Very interesting and in many ways admirable' *ibid.*, 6 September 1911. Clark
'A great bare white stone room' Eric Gill to Jacques Raverat, 3 September 1911. Clark
description of Gill's clothes John Rothenstein, 'Eric Gill: Some Recollections', *Chesterton Review*, vol. VIII, no. 4, 1982
'A Religion so splendid' Eric Gill to William Rothenstein, 5 December 1910. Clark
'Atheistical beggars' Gill diary, 18 January 1913. Clark
'real things' Frances Cornford to Eric Gill, 26 October 1910. Clark
'Walk to Madingley' Gill diary, 11 February 1912. Clark
'awfully alone down here' Eric Gill to Wilfred Meynell, 1912. Meynell Collection, Cambridge University Library
postcard from Louvain Eric Gill to Mary Gill, May 1912. Gleeson
'There seemed to be a smell of bad breath' Gill, *Autobiography*, p. 185
'Pas symbolique, pas symbolique' *ibid.*
'straight up-and-down' Walter Ritchie interview, 24 March 1987
'At Louvain, after the slow procession' Gill, *Autobiography*, p. 186
'Fry v. antagonistic re. Catholicism' Gill diary, 8 August 1912. Clark
'It is aweful, almost frightening about Christianity' Jacques Raverat to Eric Gill, 1912. Clark
'I would not have anyone think' Gill, *Autobiography*, p. 247
'Deo Gratias' Gill diary, 22 February 1913. Clark

CHAPTER EIGHT: DITCHLING COMMON 1913–24

'In 1913 a Catholic family' Memorandum of Guild of SS Joseph and Dominic, February 1922. Dominican Archive
'Those WERE the days' Peter Anson, quoted *Aylesford Review*, Spring 1965

'a neat square toy of a house' Desmond Chute, 'Eric Gill: A Retrospect', *Blackfriars*, 1950
'*I* shall pay the interest' Eric Gill to William Rothenstein, 31 July 1913. Clark
'Very muddy job' Gill diary, 8 April 1915. Clark
'Made chicken run' *ibid.*, 10 March 1914. Clark
'home in middle of day' *ibid.*, 2 January 1914. Clark
'stacking faggots etc.' *ibid.*, 5 May 1914. Clark
'We had a man' Eric Gill to Max Plowman, 15 July 1940, quoted *Adelphi*, December 1940
'It looks like a Daily Mirror picture' Eric Gill to Evan Gill, 1914. Clark
'Dear Daddy, I hope you got to London' Petra Gill to Eric Gill, 5 March 1914. Clark
'too amiable' Gill diary, 24 March 1916. Clark
'A kind of Fairy Land Ship' Edward Johnston to Sydney Cockerell, quoted Priscilla
 Johnston, *Edward Johnston*, 1959
'Can't you think of any work?' Douglas Pepler to Edward Johnston, *ibid.*
'Upon which side?' Eric Gill to Jacques Raverat, 23 February 1915. Clark
'Giotto etc.' Eric Gill to William Rothenstein, 25 February 1915. Clark
'specimens of semen' Gill diary, 25 September 1916. Clark
'Having reached the cross roads' Peter Anson, *A Roving Recluse*, 1946
'Practically I stand for a new beginning' Eric Gill, in *Observer* interview, 17 October 1915
'I really was the boy for the job' Gill, *Autobiography*, p. 200
'to dig the earth' *ibid.*, p. 233
'Cribb to London' Gill diary, 25 March 1913. Clark
'They say there are more Roman Catholics' Gill, *Autobiography*, p. 164
'by thought and concentration' Gill diary, 7 March 1915. Clark
'Alas for me' Gill diary, 9 March 1915. Clark
'We cannot keep our thoughts secret' Eric Gill, *Autobiography*, p. 224
'as plumb in the middle of the note' Desmond Chute, 'Eric Gill: A Retrospect', *Blackfriars*,
 1950
'There was a certain spartan simplicity' Peter Anson, *A Roving Recluse*, 1946
'We killed our first pig today!' Gill diary, 1 October 1914. Clark
'bt a flute 14/-!' Gill diary, 6 March 1915. Clark
'The most private' Roderick Cave, quoted Brocard Sewell, *Three Private Presses*, 1979
'The first thing which struck me' Hilary Pepler, *A Letter from Sussex*, Cherryburn Press,
 Chicago, 1950
'I find them beautiful' Hilary Pepler to Eric Gill, 29 October 1916. Clark
'What is it to the Sussex shore' Eric Gill, *The Game*, March 1922
'*roominess* of mind' André Raffalovich to Eric Gill, 1 July 1914. Clark
'Artist to artist' Michael Field to Eric Gill, 3 June 1913. Clark
'You ask "Is Ditchling practicable?" ' Father Vincent McNabb, quoted Attwater, *A Cell
 of Good Living*, 1969
'the association of Eric Gill' Donald Attwater, *A Cell of Good Living*, 1969
'We only have gentlemen's children' Petra Tegetmeier, interview, 24 September 1986
'Dear Desmond' Douglas Cleverdon, interview, 5 July 1985
'St of X ix all day' Gill diary, 5 April 1918. Clark
'You will see from the above address' Desmond Chute to Mother Mary Teresa Jocelyn,
 Lady Abbess of Syon, 9 June 1918. Dominican Archive
'An opening between' Desmond Chute, 'Eric Gill: A Retrospect', *Blackfriars*, 1950
'my dear and loving steward' Eric Gill to Desmond Chute, 25 September 1918. Gleeson
'It is the greatest possible blessing' Eric Gill to Desmond Chute, 22 September 1918.
 Gleeson
'a life just thrown away' Gill diary, October 1918. Clark
'It was like a marriage feast' Gill diary, 19 October 1918. Clark

'facetious, complacent, evasive' Graham Greene, review in *New Statesman and Nation*, 13
 March 1948
'I am only looking' quoted Priscilla Johnston, *Edward Johnston*, 1959
'It was meat and drink to us' Philip Mairet, *Autobiographical papers*, 1981
'so good and holy and odd' Evelyn Waugh, *Spectator* review of *Edward Johnston*, 24 July
 1959
'Those are pleasant days' Gill, *Autobiography*, p. 206
'I saw visions' Hilary Pepler to Father Conrad Pepler, 17 August 1942. Dominican Archive
'That state is a state of Slavery' Eric Gill, *Slavery and Freedom*, St Dominic's Press, 1917
'In his black and white Dominican habit' Bernard Wall, *Headlong into Change*, Harvill
 Press, 1969
'great arguement' Gill diary, 18 August 1918. Clark
'We received the Papal Blessing' *ibid.*, 6 October 1917. Clark
'*put on the habit*' *ibid.*, 19 January 1919. Clark
'Much good it did him!' Father Brocard Sewell to the author, 5 March 1987
'We are here' Eric Gill to Desmond Chute, 20 January 1919. Gleeson
'Long arguments with the Fathers and S. Spencer' Gill diary, 18 January 1919. Clark
'Five of us here are Dominican Tertiaries' Eric Gill to André Raffalovich, 16 June 1920.
 Clark
'We have been trying to say the Office' Eric Gill to Betty Gill, 4 May 1922. Helen Davies
'There was a cross on Calvary' Enid Clay, *English Review*, December 1923
'The love of God' Constitution and Rules of Guild of SS Joseph and Dominic. Dominican
 Archive
'the blasphemy of Bird's Custard Powder' *Of Things Necessary and Unnecessary*, St
 Dominic's Press, 1921; reprinted in *Art-Nonsense*
'The platform was filled' Eric Gill to Desmond Chute, 6 June 1921. Gleeson
'He taught us to see' Father Reginald Ginns to the author, 14 November 1985
'a very great Godsend' Eric Gill to Desmond Chute, 18 February 1922. Gleeson
'The men were just coming out from Vespers' Valentine KilBride, unpublished
 autobiography. Jenny KilBride
'It was a craftsman's home' Spike Hughes, *Opening Bars*, 1946
'In remembering Eric's and Hilary's households' Brother David Lawson, 'Memories of
 Ditchling', *Aylesford Review*, Spring 1965
'shrivelled, keen, cutting little man' C. R. Ashbee, unpublished journals, November 1923.
 King's College, Cambridge
'a great time in bed' Gill diary, 3 March 1915. Clark
'Why should it contract?' Gill diary, 15 July 1921. Clark
'stayed ½ hour' Gill diary, 12 January 1920. Clark
'she's been taken on' Eric Gill to the Revd John O'Connor, 13 September 1921. Clark
'Confession to Fr. O'Connor' Gill diary, 25 July 1921. Clark
'Began drawing' Gill diary, 18 August 1922. Clark
'the most perfect little town' Gill diary, 4 October 1921. Clark
'I wish I could get you to see the point' Eric Gill to Reyner Heppenstall, 12 September
 1934. Texas
'Have you felt the smooth whiteness' Gill, *Autobiography*, p. 227
'As I passed out of our little Station Chapel' Romney Gill to Eric Gill, 12 January 1925.
 Clark
'it was the drill' René Hague, *David Jones*, 1975
'very exciting and foolish' Gill diary, 20 May 1923. Clark
'It will amuse and interest you' Eric Gill to William Rothenstein, 22 July 1916. Clark
'Nude models are mostly fools' *War Memorial*, Welfare Handbook no. 10, St Dominic's
 Press, 1923. Tate Gallery Library

'A fine draughtsman' Michael Sadler diary, quoted Robert Speaight, *The Life of Eric Gill*, 1966
'a very happy feast' Gill diary, 25 June 1923. Clark
'I expect you have heard' Eric Gill to Desmond Chute, 25 June 1924. Gleeson
'Bro. Eric thought' Minute Book of the Dominican Tertiaries, 11 March 1921. Dominican Archive
'very satisfactory' Gill diary, 13 June 1924. Clark
'Jolly glad to get back home' Joseph Cribb diary, 13 March 1924. Peter Cribb
'Everyone loves HP' Eric Gill, rough notes attached to Guild of SS Joseph and Dominic documents. Clark
'Eric had to be the Abbot' Philip Hagreen to the author, 1986
'non-contemplative streak' Hilary Pepler to Father Conrad Pepler, c.1943. Dominican Archive
'My reasons for this' Eric Gill and Guild of SS Joseph and Dominic, exchange of letters, July 1924. Clark
'Your gift of Whitsun cream' Father Vincent McNabb to Hilary Pepler, 26 May 1931, quoted 'Handwork or Landwork', *Blackfriars*, August 1943
'Ditchling was rather crude' Desmond Chute to Eric Gill, Whit Sunday 1925. Clark
'the great ten years' Hilary Pepler to Father Conrad Pepler, 8 July 1948. Dominican Archive
'I think his singing' Hilary Pepler, Eric Gill obituary, *Blackfriars*, February 1941
'I was walking in heaven' Gill, *Autobiography*, p. 208

WELSH MOUNTAINS AND PYRENEES

Main sources: Clark Library and Gleeson Library material as for Ditchling chapters; records of the Guild of SS Joseph and Dominic and Hilary Pepler–Father Conrad Pepler correspondence in the English Dominican Archive, Carisbrooke, Isle of Wight. Gill *Autobiography* and *Letters of Eric Gill*. Typescripts of BBC radio interviews for the 1961 Gill profile with Father Conrad Pepler, René and Joan Hague, David Jones, Donald Attwater, Petra and Denis Tegetmeier, Stanley Morison, Beatrice Warde. Author's interviews with Philip Hagreen, Douglas Cleverdon, Walter Shewring, Petra Tegetmeier, Helen and Wilf Davies, Jane Cribb.

Accounts of Gill at Capel-y-ffin included in: Peter Anson, *A Roving Recluse*, Mercier Press, Cork, 1946; Count Harry Kessler, *The Diaries of a Cosmopolitan 1918–1937*, Weidenfeld and Nicolson, 1971; John Rothenstein, chapter on 'David Jones' in *Modern English Painters*, Macdonald and Jane's, 1976. Donald Attwater's *A Cell of Good Living*, George Chapman, 1969, gives the most authentic description of life at Capel at this period.

For Salies-de-Béarn: besides Gill's own memoirs, the most vivid description is given in the letters of Joan Gill, Clark Library.

On Gill and David Jones: as for Ditchling chapters.

On Gill's association with Stanley Morison, Beatrice Warde and Monotype: Douglas Cleverdon, 'Stanley Morison and Eric Gill 1925–33', *Book Collector*, Spring 1983; Douglas Cleverdon, Foreword, and John Dreyfus, Introduction, *A Book of Alphabets drawn by Eric Gill*, Christopher Skelton, September Press, Wellingborough, 1987; Nicolas Barker and Douglas Cleverdon, *Stanley Morison 1889–1967*, printed version of BBC radio portrait, W. S. Cowell, Ipswich, 1969, reprinted in *Matrix 7*, 1987; Nicolas Barker, *Stanley Morison*, Macmillan, 1972; James Moran, *Stanley Morison: His Typographical Achievement*, Lund Humphries, 1971; James Moran, *Stanley Morison 1889–1967*, special issue of the *Monotype Recorder*, Autumn 1968; Brooke Crutchley, 'Logic, Lucidity and Mr Morison', *Matrix 5*, 1985; John Dreyfus, 'Beatrice Warde: First Lady of Typography', typescript of

Stanley Morison Memorial Lecture, 26 November 1985; Beatrice Warde, 'The Diuturnity of Eric Gill', *Penrose Annual*, volume LIII, 1959.

On Gill's association with Cleverdon: Douglas Cleverdon, 'Fifty Years', printed version of talk given at PLA, *The Private Library*, Private Libraries Association, 1978.

On Robert Gibbings and the Golden Cockerel Press: Robert Gibbings, 'Memories of Eric Gill', *Book Collector*, Summer 1953; Robert Gibbings, *Coming Down the Wye*, J. M. Dent and Sons, 1942; John Hadfield, 'Robert Gibbings: a Memoir', *Matrix 1*, December 1981; Colin Franklin, chapter on Golden Cockerel in *The Private Presses*, Studio Vista, 1969.

On Gill's sculpture at Capel: John Skelton, 'Eric Gill, Sculptor', typescript of talk given at Capel-y-ffin, 1974.

CHAPTER NINE: CAPEL-Y-FFIN 1924–8

'I do think' Eric Gill to G. K. Chesterton, 6 August 1924; quoted Shewring (ed.), *Letters of Eric Gill*, 1947
'*no extra charge*' Eric Gill to John O'Connor, 16 March 1924. Clark
'In 1923 the Monastery' Donald Attwater, *A Cell of Good Living*, 1969
'I used to feel' Mary Gill to Desmond Chute, the Feast of the Holy Cross 1924. Gleeson
'Everyone most kind' Gill diary, 14 August 1924. Clark
'Well – we are all settling down' Philip Hagreen to Desmond Chute, 16 September 1924. Gleeson
'The days are all too short' Mary Gill to Desmond Chute, the Feast of the Holy Cross 1924. Gleeson
'about the only carving' Gill, *Autobiography*, p. 219
'the anonymous and inevitable quality' David Jones, Eric Gill obituary, *Tablet*, 30 November 1940
'the greatest English sculptor of all time' *Western Mail and South Wales News*, Cardiff, 21 February 1929
'Tombstones, Tombstones, Tombstones' Eric Gill to William Rothenstein, 1 February 1913. Clark
'the fly-wheel and the safety valve' Eric Gill to William Rothenstein, 17 December 1912. Clark
'Doing my own printing' Eric Gill to Desmond Chute, 23 May 1926. Gleeson
'air of mild between-the-wars eroticism' Colin Franklin, *The Private Presses*, Studio Vista, 1969
'absolutely legible-to-the-last-degree letters' Eric Gill to Desmond Chute, 23 May 1925. Gleeson
'They are creations' Stanley Morison, printed version of BBC radio portrait, 1969
'Those were idyllic days' Robert Gibbings, 'Memories of Eric Gill', *Book Collector*, 1953
'Bath after supper' Gill diary, 30 November 1925. Clark
'A man's penis' Gill diary, 22 June 1927. Clark
'No – I don't know' Eric Gill to Evan Gill, 15 July 1915. Ayres/Hasler
'Midday left for Abergavenny' Count Henry Kessler, *The Diaries of a Cosmopolitan*, 1971
'mendicant friar' *ibid.*
'He was rather short in stature' Douglas Cleverdon, 'Stanley Morison and Eric Gill', *Book Collector*, Spring 1983
'Gill knew quite well' Stanley Morison, BBC radio portrait of Eric Gill, 1961
'If the stone floors were cold' Robert Gibbings, *Coming Down the Wye*, 1942
'I view all "art work"' Eric Gill, *Art-Nonsense*, 1929
'At last I feel' Desmond Chute to Eric Gill, 2 January 1926. Clark
'Just as in retrospect' René Hague, *David Jones*, 1975
'cut René H.'s hair' Gill diary, 5 August 1925. Clark

'the strong hill-rhythms' David Jones, 'Autobiographical Talk', BBC broadcast 1954, reprinted in *Epoch and Artist*, Faber and Faber, 1959

'A few moments after my arrival' John Rothenstein, 'David Jones', chapter in *Modern English Painters*, Macdonald and Jane's, 1976

'my noble pupil' Gill, *Autobiography*, p. 219

'too good to live' Eric Gill to Desmond Chute, 23 May 1925. Gleeson

For discussion of working methods Cribb correspondence, quoted Robert Harling, *The Letter Forms and Type Designs of Eric Gill*, 1976

'It's rather fun' Eric Gill to Desmond Chute, 23 May 1925. Gleeson

'sorting and signing prints' Gill diary, 28 December 1926. Clark

'Enjoying life all day' Gill diary, 26 April 1925. Clark

'And we bathed naked' Gill, *Autobiography*, p. 229

'You can't discuss with women' Eric Gill to Desmond Chute, 15 November 1924. Gleeson

'The Guild is founded' Philip Hagreen to the author, November 1986

'a kingdom in which his fads were law' *ibid.*

'The well-known sculptor' Eric Gill to Father Austin Barker, 2 August 1924. Dominican Archive

'The finance of Ditchling' *ibid.*

'I cannot remember' Clare Pepler to Eric Gill, late 1924. Dominican Archive

'Instr. to B.' Gill diary, 14 April 1927. Clark

'all overish' Eric Gill to Desmond Chute, 25 March 1925. Gleeson

'dim feeling' Frances Cornford to Eric Gill, 26 October 1910. Clark

'the experience of living' Eric Gill, Introduction to *Twenty-Five Nudes*, 12 September 1938

'I am simply bubbling' Mary Gill to Eric Gill, 21 February 1928. Clark

'How many times a day' Gill, *Autobiography*, p. 222

'There is no such thing as impropriety' quoted Donald Attwater, *A Cell of Good Living*, 1969

'It is becoming clearer' Eric Gill to Father Austin Barker, 15 March 1926. Dominican Archive

'God won't split' Eric Gill to Douglas Cleverdon, 25 September 1928. Gleeson

'me and the Pope are pals' Eric Gill to Desmond Chute, 15 November 1924. Gleeson

'If I were not a Catholic' quoted Robert Speaight, *The Life of Eric Gill*, 1966

'He was simple at heart' Dom Ignatius Rice, obituary of Monsignor John O'Connor, *Tablet*, 23 February 1952

'He wasn't going to label' John O'Connor, quoted Stormont Murray, 'Eric Gill', *Adelphi*, December 1940

'The right and proper Naughtiness of Life' Eric Gill to Desmond Chute, 5 May 1926. Gleeson

For discussion of Gill's privilege of innocence Father Bernard Delaney to Eric Gill, 7 July 1931. Clark

CHAPTER TEN: SALIES-DE-BÉARN 1926–8

'have reason after experiment' Gill diary, 14 May 1911. Clark

'a strange place' Gill diary, 16 May 1926. Clark

'a great circular *mirror*' Eric Gill to Mary Gill, 11 May 1926. Gleeson

'There was a young lady with balls' Eric Gill Love Drawings Collection, British Museum

'rather old and dodery' Joan Gill to Mary Gill, 10 October 1925. Clark

'a perfectly topping little villa' *ibid.*

'quite a solid little place' Eric Gill to Desmond Chute, 15 May 1926. Gleeson

'On feast days we had holidays' Gill, *Autobiography*, p. 234

'black coffee in bowels' Joan Gill to Mary and Eric Gill, 12 November 1925. Clark

'that heavenly Jerusalem' Gill, *Autobiography*, p. 237
'There's nothing holy here' Eric Gill, quoted John Middleton Murry, obituary in *Blackfriars*,
 February 1941
'What ho!' Eric Gill to Desmond Chute, 10 June 1928. Gleeson
'This magnificent torso' P. G. Konody, *Observer*, 4 March 1928
'the perfect formal relations' *Daily Mail*, 6 March 1928
'I can't think what I'm doing' Eric Gill to Mary Gill, 13 November 1927. Clark
'It's now 7.30' Eric Gill to Mary Gill, 1 November 1927. Clark
'I'm dying for a scrap with you' Eric Gill to Mary Gill, 12 February 1928. Clark
'A splendid place' Desmond Chute to Eric Gill, October–November 1928. Clark

HOME COUNTIES

This chapter is based mainly on Gill's diary and job books and the large collection of Gill's
correspondence with friends and clients now in the Clark Library, UCLA. Also the
Gill–Chute correspondence in the Gleeson Library at the University of San Francisco and
Walter Shewring's *Letters of Eric Gill*, Jonathan Cape, 1947. Gill's own *Autobiography*,
written in the last few months before his death, is a valuable source for his views of this
period.

Additional information from typescripts of BBC interviews for the 1961 Gill profile with
Joan and René Hague, Petra and Denis Tegetmeier, David Jones, Stanley Morison, Michael
Richey, Francis Meynell, Father Martin D'Arcy, Beatrice Warde. Author's interviews and
correspondence with Ralph Beyer, Tom Burns, the late Douglas Cleverdon, David Gill,
Harman Grisewood, the late Joan and René Hague, Robert Harling, Edgar Holloway, David
Kindersley, Hew Lorimer, Patrick Nuttgens, Donald Potter, Michael Richey, Walter
Ritchie, Sir John Rothenstein, Colette Rubbra, Father Brocard Sewell, Walter Shewring,
Christopher Skelton, John Skelton, Adam Tegetmeier, Petra Tegetmeier.

Accounts from those who worked with Gill at Pigotts: David Kindersley, *Eric Gill: Further
Thoughts by an Apprentice*, Wynkyn de Worde Society, 1982; Donald Potter, *My Time
with Eric Gill*, Walter Ritchie, Kenilworth, 1980; John Skelton, typescript of interview by
Dr Bernard Robinson, 'My Time at Pigotts, 1940', 1987; Ralph Beyer, typescript of
interview by Stephen Raw, 30 December 1975; Reynolds Stone, Introduction to *Reynolds
Stone*, John Murray, 1977.

For accounts of Gill at Pigotts and the Catholic-political background of the period: Rayner
Heppenstall, *Four Absentees*, Barrie and Rockliff, 1960; Harman Grisewood, *One Thing
at a Time*, Hutchinson, 1968; Bernard Wall, *Headlong into Change*, Harvill Press, 1969;
René Hague, *Dai Greatcoat: a self-portrait of David Jones in his letters*, Faber and Faber,
1980, and *David Jones*, University of Wales Press for Welsh Arts Council, 1975; Peter Anson,
A Roving Recluse, Mercier Press, Cork, 1946; Brocard Sewell, *My Dear Time's Waste*, St
Albert's Press, Aylesford, 1966; Joseph Nuttgens, typescript of interview by Stephen Raw,
6 April 1974; Patrick Nuttgens, 'The Bitter Irony of Gill's Typeface', *Times Higher
Educational Supplement*, 23 May 1980. These aspects are well covered in Robert Speaight's
Life of Eric Gill, 1966.

On the Hague and Gill Press: Christopher Skelton, 'René Hague and the Press at Pigotts',
talk given at Spode Conference Centre, 1982, reprinted in *Matrix 2*, 1982; Christopher
Skelton, 'Eric Gill's *Typography* Examined', *Matrix 7*, 1987. On Gill's engravings:
Christopher Skelton, *The Engravings of Eric Gill*, 1983. On Gill's lettering: Robert Harling,
The Letter Forms and Type Designs of Eric Gill, Westerham Press, 1976. On Gill's sculpture
of this period: Richard Cork, *Art Beyond the Gallery*, Yale University Press, 1985, and
John Skelton, 'Eric Gill – Sculptor', typescript of talk at Spode House, 1982. On Gill's
architecture: Peter Hammond, *Liturgy and Architecture*, Barrie and Rockliff, 1960.

After Gill's death, there were a number of Eric Gill memorial publications of which the most interesting are the *Blackfriars* Eric Gill Memorial Number, February 1941; David Jones's appreciation in the *Tablet*, 30 November 1940; and Walter Shewring's slightly later assessment of Gill in the *Dictionary of National Biography*, Oxford, 1949.

CHAPTER ELEVEN: PIGOTTS 1928–40

'Eric Gill, with his beard' Graham Greene, 'Eric Gill', *Collected Essays*, The Bodley Head, 1969
'If this isn't providential' Eric Gill to Desmond Chute, 8 October 1928. Gleeson
'what a luxury' René Hague, *David Jones*, University of Wales Press for Welsh Arts Council, 1975
'the blooming show' Eric Gill to Desmond Chute, 25 March 1928. Gleeson
'You'd somehow got a lot of' Eric Gill to John Rothenstein, 1 May 1927. Rothenstein
'Started Holden sculpture job' Gill diary, 13 October 1928. Clark
'irate and emotional' Gill diary, 11 February 1929. Clark
'I am at present doing' Eric Gill to Graham Carey, 2 December 1928. Clark
'the making of a collation' Eric Gill, Introduction to *Engravings*, Douglas Cleverdon, 1929
'Walter Shewring' and 'Eric Gill' MS additions to Rampant Lions Press *Clerihews*, 1938. Gleeson.
'At one moment' Douglas Cleverdon, 'Stanley Morison and Eric Gill', *Book Collector*, Spring 1953.
'To BW in eve' Gill diary, 1 May 1930. Clark
'I dare say that you will feel' Eric Gill to Desmond Chute, 8 October 1931. Gleeson
'Very tired' Gill diary, 3 November 1929. Clark
'of a startling impropriety' John Rothenstein, *Summer's Lease*, Hamish Hamilton, 1965
'MEG came to see me' Gill diary, 6 October 1930. Clark
'*confession to him*' Gill diary, 7 October 1930. Clark
'seemed strange at first' Eric Gill to Romney Gill, 19 July 1931. Ayres/Hasler.
'The only real enjoyment' Eric Gill, *Autobiography*, p. 212
'I don't think he realizes' Eric Gill to Joan Gill, 7 July 1926. Clark
'Bath and slept' Gill diary, 1 November 1929. Clark
'Expt. with dog' Gill diary, 8 December 1929. Clark
'Bath. Continued experiment' Gill diary, 13 December 1929. Clark
'the real distinction' Eric Gill, letter in the *Monotype Recorder*, 1933
'delight and enthusiasm' René Hague, Eric Gill obituary, *Blackfriars*, February 1941
'the most individual and successful' Robert Harling, *The Letter Forms and Type Designs of Eric Gill*, 1976
'the proper speech of man to God' Eric Gill, Introduction to *Engravings*, Douglas Cleverdon, 1929
'beautiful figure' Eric Gill to Leslie French, 9 January 1931. Fine Arts Society
'It was nearly always' Leslie French to Robert Speaight, 15 January, 1965; quoted in *The Life of Eric Gill*, 1966
'Printing "label" with Gordian' Gill diary, 12 August 1929. Clark
'We started work' Donald Potter, *My Time with Eric Gill*, 1980
'Apprentices, Pupils or Assistants' listed in Evan Gill, *Inventory of Inscriptional Work of Eric Gill*, 1964
'you've disentangled more muddles' Prudence Pelham to Eric Gill, 4 January 1940. Clark
'It was glorious' Eric Gill to Mary Gill, 13 November 1927. Clark
'He dresses in a long alpaca gown' Mansfield Forbes to Raymond McGrath, 12 June 1929; quoted Hugh Carey, *Mansfield Forbes and his Cambridge*, Cambridge University Press, 1984

'the Mediterranean seaboard' Prospectus for European Mediterranean Academy, 1933. Clark

'GOD IS LOVE' and Ravilious's background J. M. Richards, *Memoirs of an Unjust Fella*, Weidenfeld and Nicolson, 1980.

'To Garstang for night' Gill diary, 4 June 1933. Clark

Gill's design for three-wheel vehicle David Kindersley recalled Gill working on his car project, but so far the design has not been traced

For Lawrence and the visual scene see Frances Spalding's Introduction to the exhibition 'Lawrence and the Visual Arts', Castle Museum, Nottingham, 1985

'This is not a novel' Eric Gill, manuscript of fragment of novel, 1928. Clark

'Mr. Gill is not a born writer' D. H. Lawrence, review of Eric Gill's *Art-Nonsense*, *Book Collector's Quarterly*, October–December 1933

'I think he is probably right' Eric Gill to Frieda Lawrence, 17 April 1933. Clark

'The men who have not known it' D. H. Lawrence, review of *Art-Nonsense*, *ibid*.

'women have rarely been' Eric Gill, *Art-Nonsense*, 1929

'scents, paint, closely clothed hips' Eric Gill, *Trousers and the Most Precious Ornament*, 1937

'simply masturbation *à deux*' Eric Gill, *Clothes*, 1931

'Take a lover' Juliette Huxley, *Leaves of the Tulip Tree*, John Murray, 1986

'All artists are self-centred' Helena Wright to Barbara Evans, quoted Barbara Evans, *Freedom to Choose*, The Bodley Head, 1984

'You don't seem to see' Eric Gill to Helena Wright, 31 January 1933, *ibid*.

'such a dear charming woman' Mary Gill to Eric Gill, 21 February 1928. Clark

'for a little while' Gill diary, 5 December 1932. Clark

'Clare Leighton came in m.' Gill diary, 24 August 1933. Clark

'except what she looked like' Gill, *Autobiography*, p. 21

'Is it the same with women?' *ibid*., p. 223

'as it were eye to eye' *ibid*., p. 253

'Very nice little cabins' Gill, *The Jerusalem Diary*, 10 March 1934. Shewring

'We are in Palestine' *ibid*., 22 March 1934

'the head thing (*caphia*)' *ibid*., 7 May 1934

For account of Gill and the beggar woman David Jones, typescript of BBC interview, 9 April 1961

'excruciating scraping operation' Gill diary, 31 July 1934. Clark

'On the one hand' Gill, *Autobiography*, p. 226

'a mere critic of the mechanistic system' *ibid*., p. 257

'bed full of fleas' Eric Gill to Desmond Chute, 15 November 1924. Gleeson

'quite the proper thing' Eric Gill to Rose Gill, 25 May 1929. Clark

'an ever-growing correspondence' Peter Anson, *A Roving Recluse*, 1946

'sweet and good' Eric Gill to Desmond Chute, 29 November 1937. Gleeson

'little naked children' S. E. Morison to Norreys Jephson O'Conor, 22 September *c*.1934. Huntington Library, San Marino

'No one who has not witnessed' Gill, *Autobiography*, p. 226

'Where are you going?' Adam Tegetmeier, interview, 16 October 1985

'Tea was in the studio' Rayner Heppenstall, *Four Absentees*, 1960

'Plenty biz. no do!' quoted David Kindersley, *Eric Gill*, 1982

'The atmosphere of work and worship' Reynolds Stone, Introduction to *Reynolds Stone*, John Murray, 1977

'is not a propagandist' Eric Gill to Father Bede Jarrett, 25 July 1926. Dominican Archive

'All Art is Propaganda' published in collection of AIA Lectures, *Five on Revolutionary Art*, Wishart, 1935

'a touch of the inspired Russian clown' C. P. Snow, *Variety of Men*, Macmillan, 1967

'What shd. we know' Eric Gill to Douglas Cleverdon, 16 July 1932; quoted Shewring (ed.), *Letters of Eric Gill*, 1947

'speaking in a light voice' *News Chronicle*, 8 January 1938

'Catholic Craftsman Eric Gill' *Catholic Herald*, 11 December 1936. Clark

'very much shocked' Monsignor Valentine Elwes to Father Bernard McElligott, 4 November 1935. Clark

'the ridding of Europe' Gill, *Autobiography*, p. 249

'the last and greatest hypocrisy' *ibid.*, p. 250

'Imagine the centre panel' Eric Gill to Anthony Eden, 27 June 1935. Clark

'He dined with us' Ronald Armstrong to Eric Gill, 8 May 1936. Clark

'I thank God' quoted Robert Speaight, *The Life of Eric Gill*, 1966

'too late to go' Gill diary, 26 April 1935. Clark

'Arr. Rapallo 3.15' Gill diary, 5 December 1936. Clark

'To be seen lately at Rapallo' Professor Pietro Berri, quoted Brocard Sewell, 'Desmond Chute: Aesthete and Churchman', Spode House conference, 1980

'a dance place' Eric Gill to Desmond Chute, 24 January 1937. Gleeson

'I did go and see' Eric Gill to Graham Carey, 7 July 1937. Clark

'REMEMBER ME' Donald Potter, letter to the author, October 1987

'About that tombstone' Eric Gill to Graham Carey, 15 October 1938. Clark

'a working builder' Eric Gill to the Bishop of Northampton, 23 June 1938. Clark

'It is of course actually impossible' Eric Gill to Father Thomas Walker, June 1938. Clark

'Because he loved the ecclesia' Revd Neville Gorton, Eric Gill obituary, *Blackfriars*, February 1941

'Many people rightly think' Eric Gill to Father Thomas Walker, June 1938. Clark

'give my love to J' Eric Gill, *The Jerusalem Diary*, 24 March 1934. Shewring

'All very clean and tidy' *ibid.*, 27 April 1934. Shewring

'made promise with DH' Gill diary, 11 January 1937. Clark

'heaven forbid' Eric Gill, *Drawings from Life*, 1940

'the only nobility left' Desmond Chute, Introduction, *ibid.*

'MR made me' Gill diary, 14 September 1937. Clark

'hell', and succeeding account Gill diary, 13 May 1939 *et seq.* Clark

'brother Max is so *virtuous*' Eric Gill to Romney Green, 23 July 1940. Ayres/Hasler

'the moving stairway' John Betjeman, *Daily Herald*, 8 July 1944

'caused only a knowing smile' Graham Greene, 'Eric Gill', *Collected Essays*, 1969

'They don't believe' Eric Gill to Cecil Gill, 15 April 1935. Clark

'René came in' Gill diary, 20 July 1940. Clark

'completely rotten' Eric Gill to Desmond Chute, 29 April 1940. Gleeson

'more or less stuck' Eric Gill to Donald Attwater, 4 August 1940; quoted Shewring (ed.), *Letters of Eric Gill*, 1947

'We talked about the visual effect' Harman Grisewood, *One Thing at a Time*, Hutchinson, 1968

'What are those lovely creatures' Gill, *Autobiography*, p. 225

'Really it amounts to' Eric Gill to Donald Attwater, 4 August 1940; quoted Shewring (ed.), *Letters of Eric Gill*, 1947

'fallacy of perfectionism' Father Martin D'Arcy, BBC radio interview, 1961

'Letters with Colette Y' Gill diary, 28 August 1940. Clark

'I think it is' Eric Gill to the Association for Moral and Social Hygiene, 5 October 1940. Clark

'As he rolled a cigarette' Cecil Gill, 'My Brother Eric Gill', typescript of talk, 18 November 1949. Clark

'quite gay and lighthearted' Cecil Gill, *ibid.*

'carving ladies' bottoms' quoted Robert Speaight, *The Life of Eric Gill*, 1966

'One never rises so high' Eric Gill to Father Conrad Pepler, 4 November 1940. Dominican Archive

'There was a beautiful serene expression' quoted Robert Speaight', *The Life of Eric Gill*, 1966.

'darling and most dear' Eric Gill, Memorandum *re* funeral etc., 25 October 1940. Clark

Eric Gill's will draft and codicil, 1937. Clark

'not a star' Philip Hagreen, letter to the author, 15 January 1988

SELECT BIBLIOGRAPHY

ERIC GILL'S OWN WRITING:
MAJOR BOOKS AND COLLECTED ESSAYS

Art-Nonsense and other Essays, Cassell, 1929
Clothes, Jonathan Cape, 1931
An Essay on Typography, Sheed & Ward, 1931
Beauty Looks After Herself, Sheed & Ward, 1933
Art and a Changing Civilisation, The Bodley Head, 1934
Money and Morals, Faber and Faber, 1934
Work and Leisure, Faber and Faber, 1935
The Necessity of Belief, Faber and Faber, 1936
Trousers & the Most Precious Ornament, Faber and Faber, 1937
Work and Property, J. M. Dent and Sons, 1937
Autobiography, Jonathan Cape, 1940
Drawings from Life, Hague and Gill, 1940
Last Essays, Jonathan Cape, 1942
In a Strange Land, Jonathan Cape, 1944
ed. Walter Shewring, *Letters of Eric Gill*, Jonathan Cape, 1947
From the Jerusalem Diary of Eric Gill, privately printed, 1953

BIBLIOGRAPHY AND ANTHOLOGY

Evan Gill, *Bibliography of Eric Gill*, Cassell, 1953
ed. Brian Keeble, *A Holy Tradition of Working*, Golgonooza Press, Norwich, 1983

MAIN BIOGRAPHICAL STUDIES OF GILL

Donald Attwater, *Eric Gill: Workman*, Devin-Adair, New York, 1947
— *A Cell of Good Living: The Life, Work and Opinions of Eric Gill*, Chapman, 1969
Robert Speaight, *The Life of Eric Gill*, Methuen, 1966
Malcolm Yorke, *Eric Gill, Man of Flesh and Spirit*, Constable, 1981

MAIN BOOKS AND ARTICLES
ON ASPECTS OF GILL'S WORK

Roy Brewer, *Eric Gill, The Man Who Loved Letters*, Frederick Muller, 1973
Sebastian Carter, chapter on Gill in *Twentieth-Century Type Designers*, Trefoil, 1987
Engravings by Eric Gill: A Selection, Douglas Cleverdon, Bristol, 1929
Engravings 1928–33 by Eric Gill, Faber and Faber, 1934
The Engravings of Eric Gill, Christopher Skelton, 1983
Evan Gill, *The Inscriptional Work of Eric Gill: An Inventory*, Cassell, 1964
Robert Harling, *The Letter Forms and Type Designs of Eric Gill*, Westerham Press, 1976
Wolfgang Ker, 'Eric Gill als Schriftkünstler', article in *Börsenblatt für den Deutschen Buchhandel*, Frankfurt, September 1961
David Peace, Introduction to *Addenda and Corrigenda to the Inscriptional Work of Eric Gill*, Brick Row Bookshop, San Fransciso, 1972
— chapter on Gill in *Glass Engraving: Lettering and Design*, Batsford, 1985
John Physick, *The Engraved Work of Eric Gill*, HMSO for the Victoria and Albert Museum, 1963 and (Large Picture Book edition) 1977
John Rothenstein, *Eric Gill*, Ernest Benn, 1927
Christopher Skelton, *A Book of Alphabets for Douglas Cleverdon drawn by Eric Gill*, September Press, Wellingborough, 1987
— *The Engraved Bookplates of Eric Gill 1908–1940*, Book Club of California, San Francisco, 1986
Joseph Thorp, *Eric Gill*, Jonathan Cape, 1929

CATALOGUES OF MAJOR COLLECTIONS
AND RETROSPECTIVE EXHIBITIONS

'Eric Gill, Master of Lettering', Monotype House, London, 1958
'Eric Gill: Stone Carver, Wood Engraver, Typographer, Writer', with essays by David Kindersley, John Rothenstein, Douglas Cleverdon, Dartington Cider Press and Kettle's Yard, Cambridge, 1979
'Strict Delight: The Life and Work of Eric Gill 1882–1940', Whitworth Art Gallery, University of Manchester, 1980
'Eric Gill 1882–1940: Centenary Exhibition', Pallant House Gallery, Chichester, 1982
'Eric Gill 1882–1940: Drawings and Carvings', Anthony d'Offay, London, 1982
The Eric Gill Collection at Chichester, Introduction by Walter Shewring, West Sussex County Council, 1982
The Eric Gill Collection of the Humanities Research Center, University of Texas at Austin, Introduction by John Dreyfus, 1982

MEMOIRS AND CRITICAL STUDIES

Gill became, in his own lifetime, something of a cult figure, and there are numerous references to him in books and articles, contemporary and retrospective. Listed here are the ones I found most pertinent.

Other publications, relating to more detailed aspects of Gill's life and work and to his friends and followers, are included in the source notes on each chapter.

Peter Anson, *A Roving Recluse*, Mercier Press, Cork, 1946

— 'Memories of Eric Gill', obituary in *Pax: The Quarterly Review of the Benedictines of Prinknash*, vol. XXXI, no. 218, Spring 1941

Nicolas Barker and Douglas Cleverdon, 'Stanley Morison 1889–1967', printed version of BBC radio portrait, W. S. Cowell, Ipswich, 1969

Paul Beaujon (Beatrice Warde), 'The Diuturnity of Eric Gill', article in *The Penrose Annual*, vol. LIII, 1959

Blackfriars, Eric Gill Memorial Number, vol. XXII, no. 251, February 1941

Chesterton Review, Eric Gill Centenary Number, vol. VIII, no. 4, November 1982

Desmond Chute, 'Eric Gill: A Retrospect', series of articles in *Blackfriars*, vol. XXXI, no. 369, December 1950

— 'Eric Gill: The Man and the Maker', article in *Good Work*, vol XXVII, no. 1, Catholic Art Association, Buffalo NY, Winter 1964

Douglas Cleverdon, 'Fifty Years', printed version of talk given to Private Libraries Association. *The Private Library*, 1978

Peter Faulkner, *William Morris and Eric Gill*, William Morris Society, 1975

Fine Print, Eric Gill Centenary Issue, vol. VIII, no. 3, San Francisco, July 1982

Peter Fuller, 'Eric Gill', chapter in *Images of God: The Consolations of Lost Illusions*, Chatto and Windus, 1985

Robert Gibbings, 'Memories of Eric Gill', article in the *Book Collector*, vol. II, no. 2, Summer 1953

Cecil Gill, Beatrice Warde and David Kindersley, *The Life and Works of Eric Gill*, papers from Clark Library Symposium, University of California, Los Angeles, 1968

Nicolete Gray, 'William Morris, Eric Gill and Catholicism', article in the *Architectural Review*, vol. LXXXIX, March 1941

Graham Greene, 'Eric Gill', chapter in *Collected Essays*, The Bodley Head, 1969

Rayner Heppenstall, *Four Absentees*, Barrie and Rockliff, 1960; Sphere Books, 1988

David Jones, 'Eric Gill, An Appreciation', obituary in the *Tablet*, 30 November 1940

David Kindersley, *Eric Gill: Further Thoughts by an Apprentice*, Wynkyn de Worde Society, 1982

James Laver, 'As I Knew Him: Eric Gill', article in the *Listener*, 3 May 1951

New Blackfriars, Eric Gill Centenary Number, vol. LXIII, nos. 745/6, Summer 1982

Pax Bulletin, Eric Gill Memorial Number, no. 20, February 1941

Conrad Pepler, 'A Study in Integrity. The Life and Teaching of Eric Gill', article in *Blackfriars*, vol. XXVIII, no. 326, May 1947

Hilary Pepler, *A Letter from Sussex by H. D. C. Pepler about his Friend Eric G.*, Cherryburn Press and The Society of Typographic Arts, Chicago, 1950

Donald Potter, *My Time with Eric Gill*, Walter Ritchie, Kenilworth, 1980

Herbert Read, 'Eric Gill', chapter in *A Coat of Many Colours*, Routledge and Kegan Paul, 1945

Brocard Sewell, 'Aspects of Eric Gill', article in *Chesterton Review*, vol. VIII, no. 4, November 1982

Walter Shewring, Eric Gill entry in the *Dictionary of National Biography*, Oxford, 1949

— 'Considerations on Eric Gill', article in the *Dublin Review*, October 1944; revised version included in *Making and Thinking*, Hollis and Carter, 1957

Roger Smith, 'Eric Gill and Today's Problem', article in *Good Work*, vol. XXIX, no. 1, Catholic Art Association, Buffalo NY, Winter 1966

ACKNOWLEDGEMENTS

The main collection of biographical material is in the William Andrews Clark Memorial Library, University of California, Los Angeles. This includes the original of Eric Gill's diaries, of which there is a copy at the Archive of the Tate Gallery, London.

There are important Gill collections in the Richard A. Gleeson Library, University of San Francisco; the Harry Ransom Humanities Research Center, University of Texas at Austin; the West Sussex Record Office, Chichester; the English Dominican Archive, Carisbrooke Priory, Isle of Wight; the St Bride Printing Library, London; the Department of Designs, Prints and Drawings, and the National Art and Design Library, Victoria and Albert Museum; the Department of Prints and Drawings, British Museum; the Henry Moore Centre for the Study of Sculpture, Leeds City Art Gallery.

I have also consulted material relating to Gill in the following collections: Rare Books Room, Cambridge University Library; Jonathan Cape Archive, University of Reading; the Dora Lewis Rare Book Room, University of Waterloo, Ontario; the Newberry Library, Chicago; the Reference Library, University of Kentucky. Other more specific sources are acknowledged in the notes relating to each chapter. For general background on the period I have drawn upon the London Library's extraordinary collection of nineteenth- and twentieth-century memoirs and biography, both mainstream and obscure.

I have talked to and/or corresponded with the following people who knew or worked with Gill: Ralph Beyer, Tom Burns, Will Carter, the late Douglas Cleverdon, the late Joseph Cribb, Peter Cribb, Brooke Crutchley, the late Father Reginald Ginns OP, the late Philip Hagreen, the late Cecilia KilBride, David Kindersley, Hew Lorimer, Patrick Nuttgens, David Peace, Father Conrad Pepler OP, Donald Potter, Michael Richey, Walter Ritchie, Sir John Rothenstein, Colette Rubbra, Rachel Ward.

My conversations with members of Gill's family have been particularly illuminating. I am grateful to Christopher and John Skelton, Rosemary Stewart-Jones, Margaret Breitenbach, Judith Bradley, Adam Tegetmeier, Jane Cribb, Helen Davies, David Gill, and most of all to Petra and the late Denis Tegetmeier, Gordian Gill and the late Joan and René Hague.

I am also much indebted to Walter Shewring, Gill's literary executor, for his constant interest and support; to Father Brocard Sewell O. Carm., who first led me to Ditchling Common; and to the late Douglas Cleverdon for making available to me the transcripts of the interviews carried out for the BBC Third Programme portrait of Eric Gill in 1961.

I have been assisted in my research by a great many people in different ways, including: Andrew Anderson, Father Bede Bailey OP, Nicolas Barker, Simon Beer, John Bidwell, Paul Birkel, Jennifer Booth, Michael Bott, Robert Buhler, Alban Caroe, Josephine Cashman, Sir Hugh Casson, Heather Child, Nest Cleverdon, Mary Corell, D. Steven Corey, Janet Cribb, John Dreyfus, Jennifer Freeman, Dr Terry Friedman, Patricia Gill, John Ginger, Adrian Glew, Michael Harvey, Edgar Holloway, Sir Simon Hornby, Jenny KilBride, Angela Lowery,

Timothy McCann, Patrick McCloskey, Charles Mann, James Mosley, Terence Pepper, John Physick, John Randle, Dr B. W. Robinson, Dr Nicholas Robinson, Monica Savic, Hubert Grant Scarfe, Peyton Skipwith, Roger Smith, Albert Sperisen, Colin Stansfield, Simon Verity, Lynne Walker, Malcolm Yorke.

My manuscript was typed by Betty Wilson with great patience and skill. Charlotte Clarke assisted with research.

I have enjoyed working with Ron Costley, the designer of the book at Faber and Faber, and have admired his sensitivity in the marrying up of illustrations with text.

My special thanks to Harman Grisewood for much wise counsel through the progress of this book, and to a succession of my editors: Robert Harling, editor of *House & Garden* and author of *The Letter Forms and Type Designs of Eric Gill*, whose enthusiasm for Gill both as designer and as adventurer in life equals my own; Christopher Driver, my former Features Editor on the *Guardian*, whose comments on my original typescript have been of immense value in the shaping of this final version; Philip Howard, Literary Editor of *The Times* for myriad encouragements; and Giles de la Mare, my editor at Faber and Faber.

Acknowledgement is also due to Walter Shewring, Eric Gill's literary executor, for permission to quote from Gill's correspondence and unpublished writings; to Julia Hasler and Yvonne Ayres for Gill family correspondence; to Margaret Breitenbach for Enid Clay's poem, 'There was a cross on Calvary'; to The Bodley Head for the extract from Barbara Evans's *Freedom to Choose: The Life and Work of Helena Wright*; to Jonathan Cape for extracts from Eric Gill's *Autobiography* and *Letters*, and from Augustus John's *Chiaroscuro*; to Cambridge University Press for Hugh Carey's *Mansfield Forbes and his Cambridge*; to the Carcanet Press for Philip Mairet's *Autobiographical and other papers*; to the *Catholic Herald* for the 1936 article on Gill; to Nest Cleverdon for the introduction to Douglas Cleverdon's 1929 edition of Eric Gill's *Engravings* and Cleverdon's article 'Stanley Morison and Eric Gill' published in the *Book Collector*; to the executors of Stanley Morison for the extract from *Stanley Morison 1889–1967*; to Helen Davies for the letter from Eric Gill to Betty Gill in her possession; to J. M. Dent for extracts from Eric Gill's *Typography*; to the English Dominican Archive for quotations from correspondence in the Archive, and the Memorandum and Constitution of the Guild of SS Joseph and Dominic; to Faber and Faber for Priscilla Johnston's *Edward Johnston*; to David Gill for Cecil Gill's unpublished memoirs, *Awara*; to Hamish Hamilton for Wilfred Blunt's *S. C. Cockerell*; to Heinemann for Graham Greene's essay 'Eric Gill' in *Collected Essays*; to Century Hutchinson for Harman Grisewood's *One Thing at a Time*; to David Higham Associates for Robert Speaight's *The Life of Eric Gill*, published by Methuen; to Jenny KilBride for Valentine KilBride's unpublished autobiography; to Felicity Ashbee for C. R. Ashbee's *Journals* in King's College Library, Cambridge; to Macdonald for John Rothenstein's 'David Jones' in *Modern English Painters*; to the *Observer* for Gill interview, 1915, and review, 1928; to Donald Potter and Walter Ritchie for extracts from *My Time with Eric Gill*; to Father Brocard Sewell for the quotation from 'Desmond Chute: Aesthete and Churchman' and for material originally published in *The Aylesford Review*; to the *Tablet* for obituaries of Eric Gill and Monsignor John O'Connor; to Insel Verlag, Frankfurt, for Count Kessler's *Tagebücher, 1918–1937*; to Margaret Heppenstall for the extract from Rayner Heppenstall's *Four Absentees*, first published by Barrie and Rockliff; to the Welsh Arts Council for René Hague's monograph on David Jones; finally, to the Clark Library, University of California, Los Angeles, the Gleeson Library, University of San Francisco, and the Harry Ransom Humanities Research Center, University of Texas at Austin, for permission to quote from the Gill material in their collections.

LIST OF ILLUSTRATIONS
& ACKNOWLEDGEMENTS

28 Self-portrait in the workshop, 23 January 1908. *Source*: Clark Library, University of California, Los Angeles

29 A. R. Orage. *Source*: John Carswell

30 Ananda Coomaraswamy, *c*.1909. *Source*: Roger Lipsey, *Coomaraswamy*, vol. III, 1977

31 Study for *Estin Thalassa*, 1910. *Source*: Harry Ransom Humanities Research Center, University of Texas at Austin

32 Jacob Epstein with plaster model for *Dancing Girl*, 1907–8. *Source*: *Epstein: An Autobiography*, 1955; Leeds City Art Gallery, Henry Moore Centre for the Study of Sculpture (Epstein archive)

33 *Cupid*, 1910. *Source*: Harry Ransom Humanities Research Center, University of Texas at Austin

34 *Eric Gill and the Artist's Wife*, *c*.1913, by Sir William Rothenstein. *Source*: National Portrait Gallery

35 *Ecstasy*, *c*.1910 Tate Gallery. *Source*: Leeds City Art Gallery, Henry Moore Centre for the Study of Sculpture (Gill archive)

36 Portrait of Gill's sister, Gladys, 1909. *Source*: Rosemary Stewart-Jones

37 *Votes for Women*, 1910. *Source*: Leeds City Art Gallery, Henry Moore Centre for the Study of Sculpture (Gill archive)

38 *Mother and Child*, 1910. *Source*: National Museum of Wales.

39 Hopkins Crank, Ditchling Common, 1913. *Source*: John Skelton

40 Postcard showing the Gills on Ditchling Common, 1914. *Source*: Clark Library, University of California, Los Angeles.

41 *Agnes Weller*, 1915. British Museum. *Source*: Peter Cribb

42 *Joseph Cribb*, 1915. British Museum. *Source*: Peter Cribb

43 *The Hampshire Hog*, 1915. *Source*: Christie, Manson and Woods

44 Station V of the Stations of the Cross, Westminster Cathedral, 1913–18. *Source*: Fine Art Department, University of Manchester

45 *The Foster Father*, 1923. *Source*: Leeds City Art Gallery, Henry Moore Centre for the Study of Sculpture (Gill archive)

46 *Madonna and Child*, 1914. *Source*: Anthony d'Offay

47 *André Raffalovich*, *c*.1920. *Source*: Brocard Sewell, *Two Friends*, 1963

48 *Canon John Gray*, 1928. *Source*: West Sussex Record Office (Gill Collection)

49 Father Vincent McNabb in the 1920s. *Source*: Father Ferdinand Valentine, *Father Vincent McNabb*, 1955

50 *St Sebastian*, 1919. Tate Gallery. *Source*: Victoria and Albert Museum

51 *Gordian Gill*, aged four, 1921. *Source*: Anthony d'Offay

52 Guild craftsmen in the cloister at Ditchling in the 1920s. *Source*: Peter Cribb

53 The Revd Desmond Chute with his mother, Mrs Abigail Chute. *Source*: English Dominican Archive

54 The Pepler family outside Fragbarrow Farm, 1921. *Source*: Father Conrad Pepler

55 Study for sculpture, *Mulier*, 1911. *Source*: Harry Ransom Humanities Research Center, University of Texas at Austin

56 The Gills outside the workshop on Ditchling Common with the *Mulier* carving. *Source*: Angela Lowery

57 Letter to Gill's daughter Betty from the army camp at Lewes, August 1915. *Source*: Clark Library, University of California, Los Angeles

58 *Elizabeth, Petra, Joanna and Gordian Gill*, 1914 and 1920. *Source*: Anthony d'Offay

59 *Elizabeth, Petra and Joanna Gill*, by David Jones, 1924. *Source*: Anthony d'Offay

60 *Splits No. 2*, 1923. University of Texas at Austin. *Source*: John Rothenstein, *Eric Gill*, 1929

61 Fourth Station of the Cross, St Cuthbert's Church, Bradford. *Source*: John Rothenstein, *Eric Gill*, 1929

SOURCES

62 *Adam and Eve*, 1920. University of California, Los Angeles. *Source*: Clark Library, University of California, Los Angeles

63 Page from Eric Gill's job book, June 1920. *Source*: Clark Library, University of California, Los Angeles.

64 *Christ Driving the Moneychangers from the Temple*. Leeds University war memorial.

65 Eric Gill, 1924. *Source*: Petra Tegetmeier

66 *Y Twympa, Nant Honduu*, by David Jones, 1926. *Source*: Anthony d'Offay

67 Capel-y-ffin, the Gothic monastery and the ruins of Father Ignatius's church. *Source*: Helen Davies.

68 The family chapel at Capel-y-ffin. *Source*: John Skelton

69 *Mary Gill Knitting*, 1928. *Source*: Harry Ransom Humanities Research Center, University of Texas at Austin

70 *Deposition*, 1924. King's School, Canterbury. *Source*: Leeds City Art Gallery, Henry Moore Centre for the Study of Sculpture (Gill archive)

71 *The Sleeping Christ*, 1925. Manchester City Art Galleries. *Source*: Manchester City Art Galleries

72 *Girl*, 1925. *Source*: Joseph Thorp, *Eric Gill*, 1929

73 *K L on Sofa*, 1925-8. *Source*: Sotheby's/National Portrait Gallery

74 *Douglas Cleverdon*, by Methven Brownlee, 1924. *Source*: *Book Collector*, Spring 1983

75 *Stanley Morison*, by William Rothenstein. *Source*: St Bride Printing Library

76 Beatrice Warde in the early 1920s. *Source*: St Bride Printing Library

77 Robert Gibbings, 1931. *Source*: *Graphic*, 25 July 1931/Will Carter

78 Fascia board painted for Douglas Cleverdon's bookshop off Park Street in Bristol, 1926. *Source*: Evan Gill, *Bibliography of Eric Gill*, 1953

79 Gill Sans typeface for Monotype. Capitals alphabet, dated 1927. *Source*: St Bride Printing Library

80 Gill Sans lower-case alphabet, 1928. *Source*: St Bride Printing Library

81 *Eric Gill Engraving*, by Howard Coster, 1928. *Source*: National Portrait Gallery

82 Eric Gill in his workroom at Capel-y-ffin with Joseph Thorp. Photograph by Howard Coster. *Source*: National Portrait Gallery

83 Page from Eric Gill's diary for 16 to 19 July 1925. *Source:* Clark Library, University of California, Los Angeles

84 *David Jones*, by Desmond Chute, 1926. *Source*: National Museum of Wales

85 Mary Gill playing the clavichord at Capel. *Source*: Petra Tegetmeier

86 *Petra*, by Methven Brownlee, c.1928. *Source*: Petra Tegetmeier

87 *Father John O'Connor*, 1929. *Source*: Gill, *Autobiography*, 1940

88 The Gills in the garden at Capel-y-ffin. *Source*: Christopher Skelton

89 The Gills on the hillside at Capel-y-ffin. *Source*: Janet Cribb

90 *Mr Gill's Hay Harvest*, by David Jones, 1926. *Source*: Redfern Gallery

91 Eric Gill with David Pepler and his daughter Betty, 1927. *Source*: Helen Davies

92 Eric Gill and Donald Attwater at Betty's wedding. *Source*: Petra Tegetmeier

93 *Mankind in the Making*, 1928. *Source*: Joseph Thorp, *Eric Gill*, 1929

94 View of Salies-de-Béarn. *Source*: David Mellor

95 Eric Gill, summer 1926. *Source*: Clark Library, University of California, Los Angeles

96 *At Loustau's, Salies-de-Béarn*, 1928. *Source*: Clark Library, University of California, Los Angeles

97 *Villa Les Palmiers at Salies-de-Béarn*, 1926. *Source*: Clark Library, University of California, Los Angeles

98 Pigotts in the snow. *Source*: Petra Tegetmeier

99 Tea in the garden at Pigotts, early 1930s. *Source*: John Skelton

100 Four generations of Gills. *Source:* John Skelton

101 Mary Gill at Pigotts, c.1930. *Source*: Petra Tegetmeier

102 René Hague at the Hague and Gill Press, late 1930s. Photograph by Howard Coster. *Source*: John Skelton

103 *The East Wind*, 1928. Tate Gallery. *Source*: Tate Gallery

104 Laurie Cribb with sheep, in the stone shop. *Source*: Janet Cribb

105 Gill working on the *Prospero and Ariel*, carving 1931.

106 *Lady Prudence Pelham*, 1938. *Source*: Anthony d'Offay

107 *Lady Prudence Pelham*, by David Jones, 1930. *Source*: Anthony d'Offay

108 *David Pepler*, September 1934. *Source*: Speaight, *The Life of Eric Gill*, 1966

109 *Betty*, Gill's daughter, 1939. *Source*: Piccadilly Gallery

110 Eric Gill and the *Flying Scotsman*, 1932. *Source*: St Bride Printing Library

111 Gill in the engraving shop at Pigotts, *c*.1940. Photograph by Howard Coster. *Source*: John Skelton

112 May Reeves. *Source*: Petra Tegetmeier

113 Family group at Pigotts. *Source*: Petra Tegetmeier

114 Distraught postcard to Joanna Hague from her father, September 1937. *Source*: Clark Library, University of California, Los Angeles

115 Il Reverendo Desmond Chute in his Rapallo period. *Source*: English Dominican Archive

116 Eric Gill, photographed by Howard Coster. *Source*: National Portrait Gallery

117 Gill's *Creation* sculpture for the League of Nations Building in Geneva. Photograph by Howard Coster, 1937. *Source*: National Portrait Gallery

118 MacDonald Gill, Eric's brother, 1930. *Source:* National Portrait Gallery

119 Memorial tablet for Lady Ottoline Morrell, 1939. *Source*: Speaight, *The Life of Eric Gill*, 1966

120 Architect's drawing for the church of St Peter the Apostle at Gorleston-on-Sea, Norfolk, 1938. *Source*: Clark Library, University of California, Los Angeles

121 *Interior of the Church at Gorleston*, 1939. *Source*: Anthony d'Offay

122 Interior of the church at Gorleston, photographed *c*.1970. *Source:* Anthony Mannall

123 Eric Gill photographed at Pigotts by Claire Loewenthal in 1938. *Source*: Ralph Beyer

124 Daisy Monica Hawkins at Pigotts, 1937. *Source*: Edgar Holloway

125 The Gills with their grandchildren, Hayling Island, September 1938. *Source*: Helen Davies

126 *Daisy Hawkins*, 1939. *Source*: Clark Library, University of California, Los Angeles

127 Tea in the kitchen at Pigotts. *Source*: *Bystander* article, 30 October 1940

128 Eric Gill and Dr Flood photographed for an article in the *Bystander*, 30 October 1940. *Source*: John Skelton

129 Eric and Mary Gill's gravestone in the cemetery at Speen, 1940. *Source*: History of Art Department, University of Manchester

FIGURES IN THE TEXT

*The source for all figures is Christopher Skelton
unless otherwise stated.*

1 *Hand and Eye*, originally designed as Gill's own device or mark

2 *St John's, Bognor*, 1899. *Source*: West Sussex Record Office (Gill Collection)

3 Self-portrait, 1908

4 Lettering for the Medical School, Downing Street, Cambridge, 1903. *Source*: David Peace

5 *Hand and Cross*, 1920

6 Christmas card design, 1908

7 Designs for stationery for the Fabian Arts Group, 1908

8 Masthead for *New Age*, 1907

LIST OF ILLUSTRATIONS & ACKNOWLEDGEMENTS

We are grateful to the following for supplying photographs:

Beaver Photography, plates 8, 9, fig. 2

Prudence Cuming Associates, plates 66, 107

Fine Art Department, University of Manchester, plate 64, fig. 53

Pete Hill, plates, 1, 2, 3, 10, 11, 15, 21, 23, 29, 30, 39, 47, 49, 52, 53, 54, 56, 60, 61, 74, 75, 77, 78, 87, 89, 91, 100, 102, 105, 108, 111, 115, 119, 120, 121, 123, 124, 125, 127, figs. 44, 48, 52

Larkfield Photography, plates 35, 37, 45, 70

Godfrey New, plates, 13, 76, 110, fig. 9

Walter Ritchie, plate 72

Newbery Smith Associates, plates, 46, 51, 58, 106

Roger Smith, plates 6, 7, 12

Tate Gallery Archive, plate 93

Adam Tegetmeier, plates, 27, 65, 85, 86, 92, 98, 101, 112, 113

Malcolm Yorke, plate 122

INDEX

Académie Européenne Méditerranée (AEM), 253–4
Adams, Katharine, 77–8
adherents, Gill's:
 see Anson; Attwater; Barker; Burns, Tom; Carey; Cleverdon; Chute; Grisewood; Hague; Jones; Lawson; Rothenstein, John; Shewring; Tegetmeier; Yardley
Ajanta, Gill's vision of, 100
alphabets and typefaces, Gill's:
 Arabic, 284, 291
 for Army and Navy Stores, 200
 for W. D. Caröe, 54
 for Douglas Cleverdon, 192
 Golden Cockerel, 187; fig. 34
 Joanna, 243, 245; fig. 52
 More's Utopian, fig. 38
 Perpetua, 187–8, 232; figs. 44, 52
 Sans-serif, 120, 187, 192; fig. 52, pls. 79, 80
 for Smith, W. H. & Son, pls. 18, 19
 Solus, 187
 in Typography, fig. 49
 see also inscriptions; typography
Angelic Warfare, Confraternity of the, 143–4
Anglican Mission, 17
Anselm, Father, OSB, 113
Anson, Peter, 124, 127, 266
Ansted, René, 205–6
apprentices, pupils and assistants, Gill's:
 see Beyer; Chute, Desmond; Cribb, Joseph (first apprentice); Cribb, Lawrence; Foster; Gill, Vernon; Hagreen; Jones; Kindersley; Lorimer, Hew; McDougall; Meacham; Pelham; Potter; Richey;

Ritchie; Sharpe; Skelton, John (last apprentice); Tegetmeier
Aquinas, St Thomas, 142–3, 144, 161
architecture, Gill's:
 theories of, 21–2, 28, 33, 38–9, 41, 54–5, 68, 76–7, 92–3, 229–31, 252–3, 279–80
 pupilage with Caröe, 38–55
 Blundell's School, 280
 chapel at Ditchling, 145
 St Peter's, Gorleston-on-Sea, 279–81; pls. 120, 121, 122
Armstrong, Ronald, 275
Arnold House School, Hove, 14–16
Artificers' Guild, 65
artistic affiliations, Gill's with:
 Anglo-Saxon carving, 28
 Artists' Internationalism, 272–5
 Arts and Crafts movement, 18, 41–2, 44, 51–2, 55, 60, 62, 64–5, 70–2, 78, 85, 93–4, 96, 119, 140, 271, 281
 calligraphic revival, 42–4, 51, 67
 carved sculpture revival, 97–101
 classicism, 106, 220, 228
 functionalism, 68, 252–3, 281
 Garden City movement, 68
 Gothic revivalism, 38, 229, 281
 India movement, 15, 98–100, 102–3, 106
 medievalism, 26, 27, 96, 129, 250
 modernism, 93, 107, 252–3
 New Religion, 102–3, 111
 Post-Impressionism, 106, 107
 Pre-Raphaelites, 30, 40
 primitivism, 27, 102, 106, 122, 125, 179, 185
 private press movement, 64, 128–9, 186–7

development of community buildings at,
145–6, 148–9, 151
chapel on, 145
farm at, 123, 139–40, 152
Guild of St Joseph and St Dominic, 116,
147–9, 151, 171, 173–4
St George's Retreat, 116
'Sorrowful Mysteries, the', 151–2
Spoil Bank Association, 148–9
Spoil Bank crucifix, 145, 146–7, 148,
281
Third Order of St Dominic at, 144,
145–6, 151, 165, 170, 266
see also St Dominic's Press
Ditchling Dramatic Club, 131
Ditchling Village:
Gill in (1907–13), 78–9; Gill household
at Sopers, 83, 86; Gill's view of,
84–5
Ditchling Women's Institute, 117
Dominican order, see religious affiliations
Doves Press, 64, 202–3
Downs, Sussex, 84, 85–6, 120
drawings, Gill's:
theories on, 43, 208, 284
locomotive, early, 13, 16, 26; pl. 8
architectural, early, 22, 23–4, 26, 29,
38, 39, 40
of Bill, Elizabeth, 208
Chichester Cathedral, pl. 10
Chichester Market Cross, pl. 11
Countess of Huntingdon's Chapel, pl. 6
Cribb, Joseph, 119–20; pl. 42
in Drawings from Life, 281, 294
Gill, Betty, pl. 109
Gill, Elizabeth, Petra, Joanna and
Gordian, pl. 58
Gill, Gladys, pl. 36
Gill, Gordian, pl. 51
Gill, Mary, Knitting, 196, pl. 69
Gray, Canon John, pl. 48
of Hawkins, Daisy, 208, 281–4, 294;
figs. 57, 58, pl. 126
KL on Sofa, 191–2; pl. 73
Loustau's, At, pl. 96
Madonna and Child, pl. 46
Mulier, study for, pl. 55
O'Connor, Father John, pl. 87
parts, drawings of, 160, 190, 192, 205,
260, 294
Pelham, Lady Prudence, pl. 106
Pepler, David, 265; pl. 108
Portfield Parish Church, 38
Raffalovich, André, pl. 47
of Reeves, May, 255, 294
St John's Bognor, fig. 2
St Peter's, Gorleston, pls. 120, 121, 122

self-portrait in workshop, pl. 28
of Taylor, Elizabeth (Coles), 237
in Twenty-Five Nudes, 234, 255, 281;
figs. 57, 58
Villa Les Palmiers, pl. 97
of Warde, Beatrice, 234–5
Weller, Agnes, 119–20, pl. 41
Duncan, Isadora, 90, 271

Eden, Sir Anthony, 275–6
Eder, Dr M. D., 92
Edinburgh, Gill in, 132–4
education, Gill's:
see Carpenter, Alice; Browne, the
Misses; Arnold House School, Hove;
Chichester Technical and Art School;
Central School of Arts and Crafts;
Westminster Technical Institute
Elwes, Monsignor Valentine, 274–5
engravings and woodcuts, Gill's:
theories and techniques, 94, 129–30,
161, 186
early experiments with, 66, 128
Actor on Stage, fig. 16
Animals All, 123–4; fig. 13
for Autumn Midnight, fig. 29
Chalice and Host, fig. 24
Belle Sauvage, 232; figs. 44, 45
for Canterbury Tales, The, fig. 32
Chinese Maidservant, The, 205; fig. 36
for Clothes, fig. 56
Convert, The, fig. 26
Cupid Looking Down on Lovers, 205;
fig. 35
for Devil's Devices, 128, 167
Divine Lovers, 161; fig. 25
Domestic Hose, The, fig. 43
for Dramatische Dichtungen, fig. 9
Earth Receiving, 209; fig. 37
ER Monogram, fig. 51
for Fabian Arts Group, fig. 7
Female Nude, Seated, fig. 57
Female Nude, Standing, fig. 58
for Four Gospels, The, 187, 243–4, 245;
fig. 53
Garden Enclosed, A, 165; fig. 28
Girl with Deer, fig. 10
Girl in Bath, 156; fig. 21
for Glue and Lacquer, 292
Good Shepherd, The, fig. 24
Hair Combing, 156; fig. 22
Hand and Book, fig. 42
Hand and Cross, fig. 5
Hand and Eye, 13; fig. 1
Hog and Wheatsheaf, fig. 12
Hog in Triangle, fig. 14
Hound of St Dominic, fig. 31

Servile State, The (Hilaire Belloc), 141–2
sexual tendencies, Gill's:
 bestiality, 123, 239–41
 casual liaisons, 46, 47, 58, 98, 126, 278
 *droit de seigneur*ism, 75, 120, 157–65,
 205, 235, 281–2, 291
 homosexuality, 135, 191
 incest, 17, 104–5, 155–7, 204, 239, 282
 ménages à trois, 76, 108, 190–1, 235
 New Women, attraction to, 75–6,
 205–8, 232–6
 phallic fixation, 20, 46, 102, 162–3,
 205, 259
 pubescent girls, attraction to, 20, 156,
 282
 uxoriousness, 58, 155, 200, 221
 voyeurism, 52, 104, 195, 204–5
 women in uniform, attraction to, 238,
 259, 282
Sewell, Father Brocard, O. Carm, 132
Sharp, Clifford, 92
Sharpe, John, 248, 282
Shaw, George Bernard, 65, 72, 158
Shaw, Harold, 50
Shewring, Walter, 195, 231–2, 277
Shove, Commander Herbert, 145
Shove, Rose, 145
Skelton, John, Gill's nephew, 248, 291
Smith, W. H. & Son, *see* alphabets and
 typefaces; typography
Socialist League, 63
Sopers, *see* Ditchling Village
South Sea missions, 5–6, 17, 27
Speen, Gill's grave at, 293
Spencer, Edward, 65
Spencer, Sir Stanley, 144–5, 195
Spoil Bank Association, *see* Ditchling
 Common
Stabler, Harold, 78, 93, 271
Stanbrook Abbey, 158
Stations of the Cross, *see* sculpture
Stephens, W. Reynolds, 54
Stone, Reynolds, 271–2
Stonehenge, Gill at, 103
Stopes, Dr Marie, 149–50, 211
Strindberg, Madame, 108–9
Sumner, Heywood, 54
Sussex, Gill in, *see* Brighton; Chichester
Sutton, Monsignor, 292
Swallow, the, 70
Switzerland, Gill in, *see* Geneva

Tabard Inn Library, 56
Tablet, the, 213
Tagore, Rabindranath, 100
tastes, Gill's, in:
 art, 40, 92–3, 122–3

architecture, 21–2, 28, 33, 37, 49, 76–7,
 92, 237
daily routines, 39, 102, 126, 146, 200,
 218, 249
dancing, 90, 190, 217, 278
decoration, 40, 49, 56–7, 67, 110,
 152–3, 207, 266
dress, 58, 63, 107, 110, 143–4, 195,
 196, 247, 256, 264
drink, 122, 140, 276
entertainment, 68, 91, 104, 108, 110,
 112, 122, 154, 167–8, 191, 200,
 217, 237, 278
exercise, 86
female physiognomy, 43, 46, 53, 59,
 122
food, 55, 86, 127, 130, 153, 221
games and puzzles, 120–1, 152, 183,
 231
household ritual, 67, 88, 127, 153, 167,
 183, 200, 270, 287
jokes, 69, 194–5, 269
music, 29, 43, 76, 107–8, 110, 113,
 122, 127, 175, 190, 218–19, 250,
 264, 278
reading, 15, 31, 41, 67, 75, 138, 256,
 278, 291
religious ritual, 127, 137, 143, 148, 241,
 267, 291
sayings and slogans, 41, 60, 272,
 274
smoking, 23, 61, 249, 291
sport, 15, 77, 219, 231
things, 57, 92, 93, 122–3, 231
travel, 13, 56, 251–2, 255–6
see also artistic affiliations;
 characteristics; political affiliations;
 religious affiliations; sexual
 tendencies
Tate Gallery, 101, 104, 165, 220
Taylor, Elizabeth (*née* Coles), 237, 269
Tegetmeier, Adam, 268
Tegetmeier, Denis, Gill's son-in-law, 151,
 203, 226, 237, 268–9, 293
Tegetmeier, Petra: *see* Gill, Petra
Tennyson, Alfred, Lord, 8, 26
Terry, Ellen, 70
Theosophical Society, 76
Third Order of St Dominic, *see* Ditchling
 Common; religious affiliations
Thomism, *see* religious affiliations
Thorp, Joseph, 228
Toison d'Or, Tournament and Exposition
 of the, 77
Townsend, Charles Harrison, 54
Trafalgar Square demonstration, 74
Trappes-Lomax, Michael, 274